THE LETTERS
OF VINCENT VAN GOGH

THE LETTERS OF VINCENT VAN GOGH

Selected, Edited and Introduced by
MARK ROSKILL

Atheneum

NEW YORK 1974

Published by Atheneum
Reprinted by arrangement with
William Collins Sons & Co. Ltd., London

This translation copyright 1927, 1929 by Constable & Co.
This selection, introduction and notes copyright © 1963
 by William Collins Sons & Co. Ltd.
All rights reserved
Library of Congress catalog card number 63-13089
ISBN 0-689-70167-5
Manufactured in the United States of America by
The Murray Printing Company, Forge Village, Massachusetts
First Atheneum Printing July 1963
Second Printing August 1967
Third Printing June 1970
Fourth Printing June 1972
Fifth Printing March 1974

EDITORIAL NOTE

The English text of the *Letters* presented here is basically taken from the three-volume edition published by Constable in 1927/29; and thanks are due to the proprietors of that edition and to the Engineer V. W. van Gogh for their co-operation in permitting its re-use. Thirty years after the first and only appearance of that edition, it has seemed appropriate to use my editorial licence rather freely in the making of textual revisions of various kinds, and the recording of omissions that have since come to light. Similarly I have included in the form of additional footnotes a certain amount of explanatory comment on persons, places or situations that are referred to, together with translations of such quotations or special phrases as are given in French within the letters themselves, and a few incidental observations of a broader sort that may interest the general reader.

Each letter selected for inclusion has been captioned with its place of origin and a date. Letters that were dated by van Gogh himself are given with their original headings; for the most part, however, the artist refrained from dating his letters, and in all such cases a conjectural date in square brackets has been given. The sources for these conjectural dates are threefold. Some of them go back to the earliest editorial work carried out by Mme. J. van Gogh-Bonger—and in certain cases are based on evidence or reasoning that can no longer be reconstructed. Others are owed to a series of articles recently published in the Dutch periodical *Maatstaf* by Dr. Jan Hulsker of The Hague; I am personally grateful to Dr. Hulsker for his permission to make use of his findings for the present edition, and though I have kept to a rather broader system of date-brackets than the one he presented himself, I would like to make warm acknowledgement of the assistance received from this quarter. The third and final source has been my own research, independent from that of

Dr. Hulsker; study of the Arles letters in another connection had equipped me with a scheme of dates in this area which indeed largely agrees with his, and I have also, for this edition specifically, re-checked some of Dr. Hulsker's findings and worked over the periods not covered in his articles.

The choice of plates has been made with a view to providing a conspectus of van Gogh's artistic development, and also with a view to illustrating some of the principal subjects or treatments that are referred to in the letters selected.

My thanks are due to Mr. Richard Ollard of Collins for watching over the destiny of this book from first to last, and to my wife for all kinds of help that made progress speedier and more pleasant.

M. R.

NOTE: Apart from a few minor changes of punctuation the Memoir of Vincent by his sister-in-law has been reprinted here exactly as it first appeared.

CONTENTS

PLATES

(between pages 176 and 177)

INTRODUCTION

There are two great works of the nineteenth century which, more than any other writings of the time, give us a sense of what it was like to be a real creator in the visual arts during that marvellously rich and strenuous era. The inner order which they possess is not based on any literary kind of design, but stems from the character and momentum of the painter's life itself. One of them is the Journal of Eugène Delacroix; the other is the correspondence of Vincent van Gogh.

If we want an analogy nearer our own day to van Gogh's total personality—its strength of character, powers of insight, and rough-hewn forcefulness of language—we may find it in the correspondence of D. H. Lawrence. The ways in which the two men suffered and their ideals for art and society were in many ways akin. Despite the laborious and searing character of the struggles of both men to survive materially, to love sincerely and to create, one can equally say of the letters of van Gogh what was written very recently about those of Lawrence: "no-one halfway alive could be untouched by the joy of living that breathes in the slightest of them."[1]

What sort of value and importance do the *Letters to Theo* have for today's reader? The answer is fourfold. First of all they provide a narrative of van Gogh's life. They unfold its main events and disclose in so doing a wealth of passing thoughts and small factual details:

Now I have met Christine [i.e. Sien]. As you know, she was pregnant, ill, out in the cold; I was all by myself . . . I took to her, though not immediately with the idea

[1] "Friends and Enemies," *Times Literary Supplement*, 27 April 1962.

of marrying her; but when I got to know her better, it
became plain to me that if I wanted to help her, I had to
do it seriously . . . she said, " I will stay with you, how-
ever poor you may be." And this is how it all came
about.

(May, 1882)

Today I saw Dr. Gachet again and I am going to paint
at his house on Tuesday morning, then I shall dine
with him and afterwards he will come to look at my
paintings. He seems very sensible, but he is as dis-
couraged about his job as a country doctor as I am about
my painting. Then I said to him that I would gladly
exchange job for job.

(May, 1890)

Always informative and often most moving from such a point
of view, they speak on this count for themselves (with the
memoir by the artist's sister-in-law, reprinted here, to fill in
the early background and supply necessary strands of con-
tinuity). At the same time, too, we learn from them the
influences to which van Gogh was subject at differing times—
what books he read and how he reacted to them, in what
ways the works of other artists appealed to him (especially
the older masters whom he had cause to admire), what
thinkers nourished his own philosophy of art:

I remember quite well having been very much im-
pressed . . . by a drawing by Daumier, an old man under
the chestnut trees in the Champs Elysées (an illustra-
tion for Balzac) . . . [there was] something so strong and
manly in Daumier's conception that I thought, it must
be a good thing to think and feel that way, and to over-
look or pass by many things in order to concentrate on
things that provide food for thought, and touch us as
human beings more directly and personally than meadows
or clouds. And so I always feel greatly drawn to the
figures either of the English graphic artists or of the

English authors, because of their Monday-morning-like sobriety and studied simplicity and gravity and analytical candour, as something solid and robust which can give us strength in our times of weakness. The same holds good, among French authors, for Balzac and Zola too. (October, 1882)

I have been re-reading Dickens' *Christmas Books* these days. There are things in them so profound that one must read them over and over; there are tremendously close connections with Carlyle. (April, 1889)

Comments like these tell us not only the kind of man that van Gogh was, but also the way in which his essential ideas grew up and took wing.

Secondly, the letters document the succession of paintings and drawings in a very rich way. Indispensable in this way to the scholar (who uses them in detail for the construction of a full chronology), they have also the more general interest of giving, in many instances, a running commentary upon work in progress:

This week I have done some rather large studies in the woods, and I tried to put into these more vigour and finish than the first ones had. The one which I believe succeeded best is of nothing but a piece of dug-up earth —white, black and brown sand after a downpour of rain. Here and there the clods of earth caught the light and stood out in bold relief. After I had been sitting sketching that patch of ground for quite a while, there was another violent thunderstorm with a tremendous cloudburst, which went on for at least an hour. I was so keen to resume work that I stayed at my post and sheltered myself as well as I could behind a large tree.

(August, 1882)

I have a model at last—a Zouave—a lad with a small face, the neck of a bull, the eye of a tiger, and I began with

one portrait and made a fresh start with another; the half-length that I did of him was fearfully harsh, in a uniform the colour of saucepans enamelled with blue, with braids of a faded russet-orange, and two stars on his breast, an ordinary blue and really hard to do. His feline and highly bronzed head, with its reddish cap, I focused against a green door and the orange bricks of a wall. (June, 1888)

Passages like these portray, for one particular canvas or another, the context of the creative process.

Then again the letters are a source of psychological insight. First and foremost they show us the inner workings of van Gogh's relationship with his brother; for example:

I am writing specially in order to tell you how thankful I am for your visit. It was a long time since we had seen each other or corresponded, as we used to do. It is better, all told, to be friends than to be dead to one another . . . The hours that we spent together have at least given us the assurance that we are both still in the land of the living. When I saw you again and walked with you, I had a feeling of the kind which I used once to experience more than I do now—a feeling that life was, so to say, something good and precious which one ought to value; and I felt more cheerful and alive than I had for a long time. (October, 1879)

And then, over and above this, they illumine such things as the artist's rate of work,

I am always afraid of not working enough; I think I can do so much better still, and that is what I am aiming for, sometimes with a kind of fury. (May, 1883)

I shall be all in when the " Orchards " are over . . . We would not have too many of them, even if I could bring

off twice as many ... You will see that the rose-coloured peach trees were painted with a certain passion. I must also have a starry night with cypresses, or perhaps sur-mounting a field of ripe corn ... I am in a continual fever of work. (April, 1888)

the ever nervous and broken quality of his pictorial hand writing,

Here is a sketch of an orchard ... It's absolutely clear and absolutely straight off the cuff. A frenzy of impastos faintly tinged with yellow and lilac, worked into a body of paint that was initially white. (April, 1888)

... Nowadays I am putting pressure on myself to find a brushwork without stippling or anything else, nothing but the varied stroke. (August, 1888)

The " Olives " ... are exaggerations from the point of view of arrangement, their lines are warped like the ones you find in old forests. (September, 1889)

and the underlying tenor of his imagery:

I have two new drawings now, one of a man reading his Bible and the other of a man saying grace before his dinner, which is out on the table ... My intention in these two ... is one and the same; namely to express the peculiar sentiment of Christmas and the New Year. In Holland and England alike this is always more or less religious ... (December, 1882)

Spring is tender, green young corn and pink apple blossoms. Autumn is the contrast of the yellow leaves against violet tones. Winter is the snow with black silhouettes. (June/July 1884)

Passages such as these make plain how well van Gogh was capable of knowing his desires, and with what control he could set out to realize them.

Lastly one can draw out of the letters revealing parallels to van Gogh's total output of paintings, its constants and its variables. Descriptions of sights in nature that amount to "unpainted pictures" can be compared year by year in their imagery with actual contemporaneous treatments of landscape or figure subjects:

Yesterday . . . in the Noordeinde [part of The Hague] I saw workmen busy pulling down the section opposite the palace, fellows all white with lime dust, with drays and horses. It was cool, windy weather, the sky was grey and the spot was very characteristic.

Then two other larger compositions of labourers in the dunes . . . are the things I should most like to finish. Long rows of diggers—paupers employed by the municipality—before a patch of sandy ground, which has to be dug.

(July, 1883)

This morning I saw the country from my window a long time before sunrise, with nothing but the morning star, which looked very big.

I have two landscapes in hand . . . views taken into the hills, one is the country that I see from the window of my bedroom. In the foreground a field of corn ruined and cast to the ground after a storm. A boundary wall, and beyond the grey foliage of a few olive-trees, some huts and the hills. Finally at the top of the canvas a great white and grey cloud drowned in the azure.

(June, 1889)

Similarly van Gogh's ways of translating the ideas and theories

of others into personal terms can be compared with the
"translations" that he did in line or paint after the works
of earlier masters—Rembrandt, Millet, Delacroix:

> Meanwhile, I have started on copying the Millets. The
> "Sower" is finished, and I have sketched the "Four
> Hours of the Day."

> I told him plainly: "De Bock, . . . if we do not draw
> the figure or draw trees as if they were figures, we are
> people without backbone, or else with a weak one. Do
> you think Millet and Corot, whom we both love so much,
> could draw figures, yes or no? I think those masters
> could do anything.
>
> (May and October, 1881)

> Alone or almost alone amongst painters Rembrandt has
> . . . that heartbroken tenderness, that glimpse into a
> superhuman infinitude that seems so natural there; you
> come upon it in many places in Shakespeare.

> I am perhaps going to try to work from Rembrandt. I
> have especially an idea of doing the "Man at Prayer" in
> the colour-scale that runs from light yellow up to violet.
>
> (June/July, 1889 and May, 1890)

Another most suggestive analogy between the letters and the
paintings involves the interplay of past and present. One can
look for correspondences in the comparative importance of
their roles at different times, and in the ways in which they
were brought into synthesis with one another. For example:

> I think that the town of Arles was infinitely more glori-
> ous once as regards the beauty of its women and the
> beauty of its costumes. Now everything has a worn and

sickly look about it. But when you look at it for long,
the old charm revives.

Do you remember that wonderful page in *Tartarin*
[i.e. *Tartarin de Tarascon* by Alphonse Daudet], the
complaint of the old Tarascon stage-coach? Well, I have
just painted that red and green vehicle in the courtyard
of the inn . . . Here's to the country of good old Tar-
tarin, I am enjoying myself in it more and more, and it
is going to become our second fatherland.

(September and October, 1888)

I shall attack the cypresses and the mountains. I think
that this will be the core of the work that I have done
here and there in Provence . . .

I am thinking of doing a new version of the picture
of peasants at dinner with the lamplight effect [i.e. the
Potato-Eaters of 1885] . . . Then, if you like, I will do
the old tower of Nuenen again and the cottage.

(November, 1889 and April, 1890)

In particular the question of how much his Dutch background
continued to mean to van Gogh during his later years in
France can fruitfully be studied by looking at the two sorts of
record side by side:

Involuntarily—is it the effect of this Ruysdael country?
[Jacob Ruysdael was a Dutch landscapist of the seven-
teenth century]—I keep thinking of Holland, and across
the twofold remoteness of distance and of time gone by
these memories have a kind of heartbreak in them.

What I learnt in Paris [sc. about painting] *is leaving
me*, and . . . I am returning to the ideas I had in the
country before I knew the impressionists.

(July and August, 1888)

And the answer that comes back from such extracts and others like them is undoubtedly in favour of Holland.

All in all, the *Letters to Theo* are a supremely eloquent record of the ways in which van Gogh's art and life interacted with one another. One particularly telling and wide-ranging example of such interaction is the history told there of van Gogh's appreciation of Japanese art, and its influence on his attitude to the South of France during and after his move to Provence in the spring of 1888. One of van Gogh's reasons for going South came from his discovery of Japanese prints in Antwerp at the end of 1885.[1] During the subsequent two years spent in Paris this original, limited interest widened considerably. In Paris he saw the formal influence of Japanese art extending right across the generation of " impressionist " painters—to use his own blanket term—to which he then attached himself. Out of this, van Gogh developed an inescapable sense of commitment. He saw it as desirable that the " return to nature " of the impressionists be extended still further, and the South, with its natural colouring and bright sunshine, offered a " second Japan." Faced also with his own unhappiness and ill-health, he looked to a climate in which his own modes of feeling would assimilate themselves to those of Japanese painters. He felt it important to investigate what Japanese art would convey, when studied against and within the landscape of this " second Japan "; he was to hang Japanese prints on the walls of his studio just as soon as he took over the Yellow House at Arles, and from the very first he was to see the local countryside (under snow as well as in sunshine) as mirroring the major motifs of Japanese nature-painting. He believed that other artists beside himself could acquire an awareness of how the drawing and colour in Japanese prints were vehicles for the Oriental artists' feelings towards nature. Individuality of expression and technical expansion would then freely bene-

[1] He had known something of Japanese art as far back as his days in Nuenen, but the revelation of Japanese line and colour together came only now.

fit; and European nature-painting as a whole, present and future, would thereby gain immeasurably:

> . . . Other artists will rise up in this lovely country [i.e. Provence] and do for it what the Japanese have done for theirs.
>
> (May, 1888)

Most concrete of all was van Gogh's idea of establishing a colony in the South; a community, that is, to which a whole group of Parisian artists could periodically move—following the path that he had taken himself for the time being—whenever too much exposure to the dank climate of the metropolis and its moral and social hurly-burly put them in need of a change of scene and a refreshment of the sensibility. More than that, once the group arrangement was established, the " studio of the South " would offer an atmosphere that was sunny in its co-operative spirit as well as being warmed by natural sunshine. Under such conditions, the straightforward, simple values exemplified in Japanese art could be nourished, in place of the spiritually damaging effects of social convention and intellectual over-education; for the " clearer sky " of the South seems to have symbolized for van Gogh a moral order founded upon clarity and simplicity. Besides the practical consequences of companionship and cheaper living, van Gogh envisioned also a further co-operative venture (itself modelled on Japanese precedent) for the exchange of works between artists in different centres. In sum, as the scheme of ideas crystallized that committed van Gogh to his great campaign of work in the South of France, four different sorts of concern drove it along: æsthetic, practical, metaphysical and humane. And the letters show how each and all of these concerns were bound up in van Gogh's urge to live his life to the full.

It was in 1893, only three years after Vincent's suicide, that the first batch of his letters to his brother Theo to appear in print came out in the *Mercure de France*. Emile Bernard,

Vincent's friend and correspondent who had already arranged memorial exhibitions of his work, was responsible for their publication. More letters were subsequently printed in the same magazine, and Theo's widow, Mme. J. van Gogh-Bonger, took on the task of transcribing and editing the whole sequence of letters that, over eighteen years, Theo had so faithfully preserved. The first collected edition was published in 1914, and further letters have come to light since then. In all, some 670 of the letters that Vincent wrote to Theo are known to-day to have survived.

The present edition is the only one to offer a small and representative group of letters, each of which has some special distinction of its own. It is also the only one to give the reader the maximum of editorial help, as he moves along from subject to subject or from one letter to another.

While the earliest of the extant letters dates from 1872, it was not until mid-1880 that the correspondence opened up and acquired a powerful inner rhythm of its own, which only van Gogh's death would interrupt. Before that time, while Vincent was in turn representative for a firm of art-dealers, schoolmaster, bookshop assistant, student preparing for the University and lay preacher, he had written to Theo as the occasion prompted; and the subject of art was mentioned only incidentally, in reference to a picture or print or spectacle of nature that had appealed to him, or in regard to a sketch that he had done. The first letter that dealt explicitly and at length with Vincent's desire and ambition to become an artist was written in July 1880—it appears in this selection :

But you will ask : What is your definite aim? That aim becomes more definite, will stand out slowly and surely, just as the rough draft becomes a sketch, and the sketch becomes a picture . . .

From then on, for almost exactly ten years, Theo loyally continued to provide the financial support which had originally

enabled his brother to commit himself completely to painting. He did this in the form of regular payments out of his own salary as a dealer. And throughout the decade in question Vincent wrote to Theo with an equal regularity; though it is exceptional for his letters of this period to carry precise dates, it would seem that in normal circumstances the artist must have written at least once a week, and sometimes twice weekly or even twice in a single day (excluding that two-year period between 1886 and 1888 when the brothers were sharing rooms in Paris). Concurrently, there were certain other familiars with whom Vincent communicated regularly— extended sequences of letters survive that went to his sister Wil and to his artist friends Anthon van Rappard and Emile Bernard. But in none of these cases was the correspondence anywhere nearly as heavy as that with Theo; and almost invariably, where the subject matter treated is identical, it is the account to Theo that was more detailed and explicit.

What began, then, as an exchange of personal news between highly affectionate brothers temporarily separated developed into a phenomenon of far broader scope. It is not simply the fact of sheer quantity. Owing in part to the power of attraction exerted in our time by the artistic personality as such—a power of attraction extending to every available private and intimate detail of an artist's thought and conduct—there is a strong tendency to regard Vincent's letters to Theo as simply a "confessional" record, a convenient means for Vincent to unload his immediate feelings. If indeed the artist is to be looked on as a romantic figure, standing apart from the everyday world and unfettered by its conventions, then van Gogh, it may be held, poignantly epitomizes such a condition. But to accept the above interpretation solely and entirely is to disregard the strong element of calculation in van Gogh's personality, a very complex element even more conspicuous in the correspondence with Theo than in the paintings themselves.

The major clue here is the direct relationship between what Vincent wrote and what Theo was paying him. It is scarcely a coincidence that the increase of correspondence after

mid-1880 followed upon Theo's pledge of financial support; that its mood and tempo fluctuated on Vincent's side according as he felt that Theo's attitude gave cause for alarm; or that the first of Vincent's mental breakdowns was closely associated with the news of Theo's imminent marriage and the clear threat this imposed on Theo's capacity to go on providing for him. Enough, moreover, survives of Theo's side of the correspondence—some forty letters, all dating from the last four years of Vincent's life—to make plain that Theo's mind and heart were equally involved. Even where Theo's letters are not preserved, the very ways in which Vincent expressed himself can be seen as contingent upon his brother's reactions. He consistently reported the details of his budget at length, and whenever he ran short of money he would set out in strategically persuasive fashion the reasons why it was desirable that Theo should send him more than usual, or dispatch his regular sum in advance of the customary date. Further, when discussing deeper concerns of his, he characteristically related his hopes and ambitions to the prospect of achieving sales through Theo's agency as a dealer, or to the possibility that his day-to-day living expenses might in some way be reduced.

Vincent expected from his brother both the reassurance that he was doing the right thing in continuing to paint and the faith that the money devoted to his support constituted a sound investment. The very tentativeness with which he phrased his continuous flood of inquiries and suggestions was motivated by the need to draw from this, his most permanent relationship with another human being, self-confidence both in his moral purpose and in his artistic future—so that he could order his doings accordingly and feel sustained by the knowledge that here at least the basic human needs of love and trust were under constant renewal. Because Theo on his part gave his mind to each new problem in turn, offered encouragement, invited clarifications and gave justifications for the best that he could do—because, in other words, his sympathy and solicitude were direct and immediate—the correspondence reflects a psychological relationship to which

the nearest parallel in normal experience would be the effect upon a man and woman of years of living together. Far from being a merely one-sided form of emotional release the correspondence took on the function, chiefly under Vincent's impetus, of intensifying a close blood-relationship and common interest in the arts into a form in which two people, spiritually and intellectually, depended on one another in an almost absolute way.

The written word and the painted image are of their nature more deliberate than ordinary speech or action; and the pattern of the letters, side by side with his art, gave Vincent a necessary conviction that a shape and scheme existed in a life which otherwise appeared troubled and lacking in design. It was a shape and scheme which, by its very continuity, implied the possibility of resistance to those forces of psychic disturbance that might otherwise carry the brothers apart and leave Vincent utterly alone—a palpable expression, in fact, of a kinship that prolonged scrutiny of each other's words and actions at close quarters would certainly have destroyed, to judge from the rank disharmony that sprang up during the two-year period when they were living together. When, at last, the same psychic disruptions took their toll on one side, driving the painter to shoot himself, the results on the other side were equally disastrous. Less than three months after Vincent's funeral, Theo himself went mad while straining to organize a commemorative exhibition; he had to be removed from the Paris scene and died immediately afterwards. There, in postscript form, lies the most dramatic of all evidence as to what exactly the dependance between the two brothers entailed.

The relationship by letter with his brother involved van Gogh, as described, in the retailing of every kind of information that was of practical consequence: the state of his health and energies and his consequent rate of work, the amount he was spending on food and rent, the quality of the paints and canvas that could be afforded on his behalf, the current weather conditions and the supply of local people willing to act as models, the disposal of his finished work and the choice

of suitable frames. Again and again the first things that he
had to report ran along lines like these :

As soon as I received your letter I bought 7 guilders'
worth of colour at once, so as to have some provisions
and to replenish my box. Throughout the week we have
had a lot of wind, storm and rain, and I went several
times to Scheveningen to see it. I brought home from
there two small seascapes . . . But another souvenir is
that I caught cold again, with all the outcomes you know,
and this forces me to stay at home for a few days . . .
When you next send money I shall buy some good
marten brushes, which are the real *drawing* brushes, as
I have discovered, for *drawing* a hand or a profile in
colour . . . My painting paper is also almost used up—
towards the first of September I shall have to buy a few
more supplies, but I shall not need more than the usual
allowance.

(August, 1882)

Thank you for your letter, but I've had a poor time of it
these last days; my money ran out on *Thursday,* and
so it proved a *hellishly long time* between then and
Monday noon. During these four days I have lived
mainly off coffee, 23 cups of it, with bread which I still
have to pay for. You are not to blame, if anyone is it's
me. Because I had a furious desire to see my pictures in
frames, and I had ordered rather too many of them for
my budget, seeing that the month's rent and the char-
woman had to be paid also. Even now, too, I shall be
drained dry to-day, since I must buy canvas also and pre-
pare it myself . . . I am so much involved in work that
I cannot stop myself short. Rest assured, the bad weather
will stop me only too soon—the way it was today, yes-
terday and the day before as well.

(October, 1888)

And then too, alongside such prosaic details of an average

week's existence, the correspondence involved van Gogh in
the formulation of a theory of art; that is, in statements
setting out the nature and direction of his current artistic
efforts and the conceptual significance for him of his com-
pleted pictures, or in discussions of the artists of the past
that he admired most and the future of art as a whole. For
example :

> I told you about my plan for a large drawing—well, I
> started it the very same day that I wrote to you . . . I
> have worked on it since then . . . I saw it clearly before
> me and wanted to carry it through. I made the composi-
> tion simpler still, only one row of diggers. I sketched
> seven figures in it, five men and two women; the rest
> are smaller, on the second plane. It is the strongest
> drawing I have ever made. As to the conception . . . I
> adopted the manner of certain English artists, without
> thinking of imitating them—rather, no doubt, because I
> am attracted by the same kinds of thing in nature; these
> are taken up by relatively few, so that if one wants to
> make use of them one must seek a way to express what
> one feels and venture a little outside the ordinary rules
> in order to render them exactly as one wants.
>
> (June, 1883)

> Who will be in figure painting what Claude Monet is in
> landscape? . . . the painter of the future will be *a colour-
> ist such as has never yet been* . . . This painter who is to
> come—I can't imagine him living in little cafés, working
> away with several false teeth and going to the Zouaves'
> brothels, as I do. But I think that I am right when I feel
> that in a later generation it will come, and that as for us
> we must work as we can towards that end, without
> doubting and without wavering.
>
> (May, 1888)

Between practical information and pronouncements in the
realm of art-theory, two aspects of Vincent's personality and

vision revealed themselves as dominant. One of these was his conception of success, and the forms of self-criticism that attended it; the other was his propensity to relate every form of experience to his personal feelings, and instinctively find an identity for it in terms of this kind. For example:

I think that it would greatly help me in my work if I had an opportunity to see more of printing, for instance . . . if I could get work in a printer's office or some such job, it would be a help rather than a hindrance . . . I am willing to try my hand at *anything* of that kind, especially if a living may be earned in that way. Indeed, I believe that there will come a time when it will not be necessary for me to earn a living in any other way than by painting.

(November, 1883)

I wanted to express how those ruins show that *for ages* the peasants have been laid to rest in the very fields which they dug up when alive—I wanted to say what a simple thing death and burial is, just as simple as the falling of an autumn leaf—just a bit of earth dug up—a wooden cross.

(June, 1885)

In fact self-improvement, where his art was concerned, was for van Gogh both a moral and a technical affair. His work, as he saw it, could constantly be bettered by dint of attentive study and practice; to engage in this task in the right spirit and faith would at the same time bring a progressive deepening of his capacities for human understanding. What could be learnt on the technical side from past masters like Rembrandt and Delacroix and from the renewal of self-discipline from work to work merged with what was offered in the theoretical writings of men like Carlyle and Tolstoy, thinkers who believed that art could once more become supremely relevant to the workings of society as a whole. In his invariable optimism about the future, van Gogh set enormous store

by the prospect of his making good—not so much because success would vindicate his presumed abilities, as because it would bear witness when it came to the essential "rightness" of the universe. It was not that the world owed him a debt and would eventually be compelled to pay it, but rather that the world would one day receive what he had it in him to give; and then success would bring repayment to those who had trusted in him, most especially his brother, and would increase the expectation at large for the generation of artists to which he belonged himself, and for other generations to come.

In the same way van Gogh's absolutely personal way of translating experience into words or paint merged the concrete and the theoretical as if there was no kind of a gap between them. The coalescence that he made between the visible aspects of experience and their internal or philosophic meaning was supremely intense; so intense, indeed, that it can almost be compared as a pattern of thought with the idea of the primitive tribesman that his wooden rain-god *is* the rain itself. Among many allusions in the letters illustrative of this point, the most recurrent are van Gogh's admiration of the works of earlier artists for the reflection he found in them of his own feelings for the subjects they had depicted, and, conversely, his use of some familiar pictorial image as a term of reference for identifying emotions aroused in him by particular sights and scenes:

Israëls' *An Old Man* . . . is sitting in a corner near the hearth, on which a small piece of peat is faintly glowing in the twilight. For it is a dark little cottage where that old man sits, an old cottage with a small white-curtained window. His dog, that has grown old with him, sits beside his chair—those two old friends look at each other, they look into each other's eyes, the dog and the man. And meanwhile the old man takes his tobacco pouch from his pocket and lights his pipe in the twilight; that is all, the twilight, the silence, the loneliness

of those two old friends, the man and the dog, the understanding between those two . . .

(March, 1882)

One evening recently at Montmajour I saw a red sunset, shooting its rays on to the trunks and foliage of pines that were rooted in a conglomeration of rocks, colouring the trunks and foliage a fiery orange, while other pines on planes further back in space were silhouetted in Prussian blue against a sky of tender blue-green, cerulean. So it gave the effect of that Claude Monet, it was superb.

(May, 1888)

Whenever in fact van Gogh linked two categories of experience in order to recreate the newer of them for his own and his reader's benefit, it was characteristic of him to urge their complete identity.

Many artists of the past century who have written about their own work have done so *post facto* and with some kind of public audience in mind (however indirectly); most often they have tended to make their case by abstracting from current literary and æsthetic speculation whatever suited their individual requirements. Van Gogh's theory of art, on the other hand, set out to prescribe, not to explain. Indeed, in view of the inclusiveness of its recommendations, it lays claim to interpretation as a comprehensive artistic ideology.

Certainly the way of thinking in question here had an essential solidity, however far and wide it ranged in the promotion of more or less remote possibilities. Van Gogh's thought was centred always around a nucleus of ideological belief, and he modified his principles of life and art in the light of new experiences only to the degree and in the direction permitted by these underlying convictions. This was true of his visual experiences before both art and nature; of his experiences of literature—he was an avid reader all his life, constantly ready to identify himself with the central character of each book in turn; of his reactions to æsthetic

theories that he read about or heard discussed. He was not averse to provisional experiment, but in the long run he always fell back on to fundamentals; the content of the Bible, for example, was as much of a fundamental to him at the end of his life as it had been in his youth, even though specific reference to it came to play a much smaller part in his letters than it had in the years when religion had offered him a practical goal. There is, therefore, a good deal of repetition in his correspondence—even between letters widely separated in date. There is perhaps also less of an expansion of ideas between 1880 and 1890 than one might expect a man of such extraordinary sensitivity to reveal between the ages of twenty-seven and thirty-seven. It would be wrong, however, to assume on these counts that van Gogh was inflexible either as a human being or as a thinker. The fact is rather that, given the way of thinking that he instinctively made his own, his development was bound to follow a self-extending pattern; and what this self-extension reached out for was the finding that in fundamentals lay the true and permanent source of creative energy.

The solidity of van Gogh's thought has a further and broader aspect. In terms of the cultural predicament of his time, this took the form of a passion for wholeness to set against the fragmentation of artistic sensibility that had increasingly characterized the nineteenth century. In terms of his personal life, it expressed a determination to keep his mind from, literally, going under—because van Gogh knew in advance what mental breakdown meant, he had the will and the drive to prescribe preventative measures. As he saw it, men were the poorer in that art was no longer something one felt called to, in the way that he did, as a way of transmitting the basic common truths of love and faith and suffering. Instead, the subjects of art had split apart from one another and so had its technical means (landscape and figure, for example, colour and modelling). It was above all necessary that art absorb back into its bloodstream the universals of human existence. Vincent's thought, then, required the firmness of bulwarks built against an encroaching tide: the

tide of decadence and disorder. It had to command the presence of values, now lost, in works of art and literature transmitted from the past, through which the guide-lines of a continuing tradition were taken to run; and it needed also a wholesome and godly soundness of its own. Other nineteenth century thinkers before van Gogh—notably the proponents of the Gothic Revival—had similarly pleaded for restoration of the values of an earlier age, so that art and society, religion and culture might be re-unified. Certain of these thinkers had carried the Romantic concept of freedom to its logical conclusion, abandoning the present altogether in an advocacy of the past which was tantamount to escapism. But for van Gogh the processes of resistance and re-creation were not inherently divisible.

So finally one comes to the total picture of van Gogh which the *Letters to Theo* proclaim. Precisely where the paintings themselves might most readily tend to mislead, with their dynamic energy and their arbitrariness of colouring, these writings of the artist offer a firm corrective. They show an extraordinarily articulate man—anything but naïve and crazy, as a popular form of myth tends even now to imply. Van Gogh was in fact deeply interested in the contemporary intellectual scene and very much in control of his own destiny for all but a few weeks of his later career—the weeks in which he was actually struck down by his mental disease. Above all he was a man who committed himself to his work and his beliefs to the highest degree. " How difficult life must be," he wrote to Theo in one of his earliest letters, " if it is not strengthened and comforted by faith." And just a few weeks before his death he was able to say : " I still love art and life very much indeed."

M. R.

Cambridge, Mass.
August, 1962

MEMOIR OF VINCENT VAN GOGH

BY HIS SISTER-IN-LAW

The family name, van Gogh, is probably derived from the small town Gogh on the German frontier, but in the 16th century the van Goghs were already established in Holland. According to the "Annales Généalogiques" of Arnold Buchelius, there lived at that time a Jacob van Gogh at Utrecht "In the Owl behind the Town Hall," and Jan Jacob's son, who lived "In the Bible under the flax market," selling wine and books, was Captain of the Civil Guard.

Their coat-of-arms was a bar with three roses, which is still the family crest of the van Goghs.

In the 17th century we find many van Goghs occupying high offices of state in Holland. Johannes van Gogh, magistrate of Zutphen, is appointed High Treasurer of the Union in 1628; Michel van Gogh, at first Consul General in Brazil, afterwards treasurer of Zeeland, belongs to the Embassy that welcomes Charles II of England on his ascent to the throne in 1660. In about the same period, Cornelius van Gogh is a Remonstrant clergyman at Boskoop, and his son Matthias, at first a physician at Gouda, is afterwards. clergyman at Moordrecht.

In the beginning of the 18th century the social standing of the family is somewhat lowered. A David van Gogh, who settled at The Hague, is a gold-wire drawer, like his eldest son Jan, who married Maria Stalvius, both belonging to the Walloon Church.

David's second son, Vincent (1729-1802), was a sculptor by profession, and is said to have been in Paris in his youth; in 1749 he was one of the Cent Suisses. With him the practice of art seems to have come into the family, together with fortune; he died single and left some money to his nephew Johannes (1763-1840), the son of his elder brother Jan van Gogh.

This Johannes was at first a gold-wire drawer like his father, but he afterwards became a Bible teacher, and clerk in the Cloister Church at The Hague. He was married to Johanna van der Vin of Malines, and their son Vincent (1789-1874) was enabled, by the legacy of his great uncle Vincent, to study theology at the University of Leiden. This Vincent, the grandfather of our painter, was a man of great intellect and extraordinarily strong sense of duty. At the Latin school he distinguished himself and won all prizes and testimonials; " the diligent and studious youth, Vincent van Gogh, fully deserves to be set up as an example to his fellow students for his good behaviour as well as for his persistent zeal," declares the rector of the school, Mr. de Booy, in 1805. At the University of Leiden he finishes his studies successfully, and graduates in 1811 at the age of twenty-two. He makes friends; his " album amicorum" preserves their memory in many Latin and Greek verses; a little silk embroidered wreath of violets and forget-me-nots, signed, E. H. Vrydag 1810, is wrought by the hand of the girl who became his wife as soon as he got the living of Benschop. They lived long and happily together, first at the parsonage of Benschop, then at Ochten, and from 1822 at Breda, where his wife died in 1857, and where he remained until his death, a deeply respected and honoured man.

Twelve children were born to them, of which one died in infancy; there was a warm cordial family feeling between them, and however far the children might drift apart in the world, they remained deeply attached and took part in each other's weal and woe. Two of the daughters married high placed officers, the Generals Pompe and 's Graeuwen; three remained single.

The six sons all occupied honourable positions in the world. Johannes went to sea and reached the highest rank in the navy, that of Vice-Admiral; at the time that he was commandant of the Navy Yard at Amsterdam in 1877, his nephew Vincent lived at his house for a time. Three sons became art dealers; the eldest Hendrik Vincent, " Uncle Hein " as he was called in the letters, had his business at first at Rotterdam

and afterwards settled at Brussels. Cornelius Marinus became
the head of the firm C. M. van Gogh, so well known in
Amsterdam. (His nephews often called him by his initials
C. M.). The third, who had the greatest influence on the
lives of his nephews Vincent and Theo, was Vincent, whose
health in his youth had been too weak to enable him to go to
college, to the deep regret of his father, who based the great-
est expectations on him. He opened a little shop at The
Hague, where he sold colours and drawing materials, and
which he enlarged in a few years to an art gallery of
European renown. He was an extraordinarily gifted, witty,
and intelligent man, who had great influence in the world of
art at that time; Goupil in Paris offered him the partnership
in his firm, which only after van Gogh joined it reached its
highest renown. He settled in Paris and Mr. Tersteeg be-
came the head of the firm in The Hague in his place. It
was here that Vincent and Theo got their first training in
business; Goupil was "the house" that played such a large
part in their lives, where Theo remained and made a success-
ful career, where Vincent worked for six years, and to which
his heart clung in spite of all, because in his youth it had
been to him "the best, the grandest, the most beautiful in
the world" (letter 332).

Only one of parson van Gogh's six sons chose the profes-
sion of his father. Theodorus (8 Febr. 1822-26 March 1885)
studied theology at Utrecht, graduated, and in 1849 got the
living of Groot-Zundert, a little village in Brabant on the
Belgian frontier, where he was confirmed by his father.
Theodorus van Gogh was a man of prepossessing appearance
("the handsome dominie" he was called by some), of a
loving nature and fine spiritual qualities, but he was not a
gifted preacher, and for twenty years he lived forgotten in
the small village of Zundert ere he was called to other
places, and even then only to small villages like Etten, Hel-
voirt and Nuenen. But in his small circle he was warmly
loved and respected, and his children idolized him.

In May 1851 he married Anna Cornelia Carbentus, who
was born in 1819 at The Hague, where her father Willem

Carbentus was a flourishing bookbinder. He had bound the first Constitution of Holland and thereby earned the title of " bookbinder to the King." His youngest daughter Cornelia was already married to Vincent van Gogh, the art dealer; his eldest daughter was the wife of the well-known clergyman Stricker at Amsterdam. The marriage of Theodorus van Gogh and Anna Carbentus was a very happy one. He found in his wife a helpmate, who shared with all her heart in his work; notwithstanding her own large family that gave her so much work, she visited his parishioners with him, and her cheerful and lively spirit was never quenched by the monotony of the quiet village life. She was a remarkable, lovable woman, who in her old age (she reached her 87th year), when she had lost her husband and three grown-up sons, still retained her energy and spirit and bore her sorrow with rare courage.

One of her qualities, next to her deep love of nature, was the great facility with which she could express her thoughts on paper; her busy hands, that were always working for others, grasped so eagerly not only needle and knitting needle, but also the pen. " I just send you a little word " was one of her favourite expressions, and how many of these " little words " came always just in time to bring comfort and strength to those to whom they were addressed. For almost twenty years they have been to myself a never failing source of hope and courage, and in this book, that is a monument to her sons, a word of grateful remembrance is due to their mother.

On the 30th of March 1852 a dead son was born at the vicarage of Zundert, but a year after on the same date Anna van Gogh gave birth to a healthy boy who was called Vincent Willem after his two grandfathers, and who in qualities and character, as well as in appearance took after his mother more than after his father. The energy and unbroken strength of will which Vincent showed in his life were, in principle, traits of his mother's character; from her also he took the sharp inquisitive glance of the eye from under the protruding eyebrows. The blonde complexion of both the parents turned in Vincent to a reddish hue; he was of medium height, rather

broad shouldered, and his appearance made a strong, sturdy impression. This is also confirmed by the words of his mother, that none of the children *except* Vincent was very strong. A weaker constitution than his would certainly have broken down much sooner under the heavy strain Vincent put upon it. As a child he was of difficult temper, often troublesome and self-willed, and his bringing up was not fitted to counter-balance these faults, as the parents were very tender-hearted especially for their eldest. Once grandmother van Gogh, who had come from Breda to visit her children at Zundert, witnessed one of the naughty fits of little Vincent; she who had been taught by experience with her own twelve babies, took the little culprit by the arm and with a sound box on the ears put him out of the room. The tender-hearted mother was so indignant at this that she did not speak to her mother-in-law for a whole day, and only the sweet-tempered character of the young father succeeded in bringing about a reconciliation. In the evening he had a little carriage brought around, and drove the two women to the heath, where under the influence of a beautiful sunset they forgave each other.

Little Vincent had a great love for animals and flowers, and made all kinds of collections; of any extraordinary gift for drawing there was as yet no sign; it is only noted that at the age of eight he once modelled a little elephant of clay, that drew his parents' attention, but he destroyed it at once when according to his notion such a fuss was made about it. The same fate befell a very curious drawing of a cat, which his mother always remembered. For a short time he attended the village school, but his parents found that the intercourse with the peasant boys made him too rough, so a governess was sought for the children of the vicarage, whose number had meanwhile increased to six. Two years after Vincent a little daughter had been born and again two years later on the 1st of May 1857, came a son who was called after his father. After him came two sisters and a little brother. (The younger sister Willemien, who always lived with her mother, was the only one to whom Vincent wrote on rare occasions.) Theo was more tender and kind than his brother, who was four

years older; he was more delicately built and finer featured, but of the same reddish fair complexion and he had the same light blue eyes, that sometimes darkened to a greenish blue.

In letter 338 Vincent himself describes the similarity and the difference in their looks, and in 1889 Theo wrote to me the following about Vincent's appearance, referring to Rodin's marble sculpture, the head of John the Baptist. " The sculptor has conceived an image of the precursor of Christ that exactly resembles Vincent. Yet he never saw him. That expression of sorrow, that forehead distorted by deep furrows, which denotes high thinking and iron self discipline, is Vincent's, though his is somewhat more sloping; the form of nose and structure of the head are the same." When I afterwards saw the marble I found in it a perfect resemblance to Theo.

The two brothers were strongly attached to each other from childhood; whereas the eldest sister, recalling youthful memories, speaks of Vincent's teasing ways, Theo only remembers that Vincent could invent such delightful games that once they made him a present of the most beautiful rose bush in their garden, to show their gratitude. Their childhood was full of the poetry of Brabant country life; they grew up among the cornfields, the heath and the pine forests, in that peculiar sphere of a village parsonage, the charms of which remained with them all their lives. It was not perhaps the best training to fit them for the hard struggle that awaited them both; they were still so very young, when they had to go out into the world, and with what bitter melancholy, and with what inexpressible home-sickness did they long during many years for the sweet home in the little village on the heath.

Vincent came back there several times, and remained always in appearance the " country boor," but Theo, who had become quite a refined Parisian, also kept in his heart something of the " Brabant boy" as he laughingly liked to call himself.

Like Vincent once rightly observes: " there will always remain in us something of the Brabant fields and heath," and

when their father had died and mother had to leave the parsonage, he complains, "now there is none of us left in Brabant." When afterwards, in the hospital of Arles, the faithful brother visited him and in tender pity laid his head on the pillow beside him, Vincent whispered: "just like Zundert," and shortly after he writes: "during my illness I have seen every room in the house at Zundert, every path, every plant in the garden, the fields around, the neighbours, the churchyard, the church, our kitchen garden behind it— and even the magpie's nest in the high acacia in the church- yard" (letter 573).

So ineffaceable were those first sunny childhood's recol- lections. When Vincent was twelve years old he was sent to the boarding school of Mr. Provily at Zevenbergen; about this period not a single particular has been found, except that one of the sisters afterwards writes to Theo: "Do you remember how on mother's birthday Vincent used to come from Zevenbergen and what fun we had then?" Of friends in that time nothing is known.

When he was sixteen years old the choice of a profession became urgent and in this Uncle Vincent was consulted.

The latter, who meanwhile had acquired a large fortune as an art dealer, had been obliged by his feeble health to retire early from the strenuous business life in Paris—though still financially connected with the firm—and had settled at Prin- cenhage, near his old father at Breda, and near his favourite brother at Zundert. Generally he passed the winter with his wife at Mentone in the south of France, and on his journey thither he always stayed some time at Paris, so that he re- mained in touch with the business. His beautiful country house at Princenhage had been enlarged by a gallery for his rare picture collection, and it was here that Vincent and Theo received their first impressions of the world of art. There was a warm cordial intercourse between the Zundert parsonage and the childless home of Princenhage; "the car- riage" from there was always loudly cheered by the children at Zundert, for it brought many surprises of flowers, rare fruits and delicacies, while on the other hand the bright,

lively presence of the brother and sister from Zundert often
cast a cheerful sunbeam on the life of the patient at Princen-
hage. These brothers, Vincent and Theo too, who differed
but one year in age, were thoroughly attached to each other,
and the fact of their wives being sisters made the attachment
stronger still. What was more natural than that the rich art
dealer destined the young nephew who bore his name as his
successor in the firm—perhaps even to become his heir?

Thus in 1869 Vincent entered the house of Goupil & Co.,
at The Hague, as youngest employee under the direction of
Mr. Tersteeg, now a bright future seemed to lie in store for
him. He boarded with the family Roos on the Beestenmarkt,
where Theo afterwards lived also. It was a comfortable home
where his material needs were perfectly provided for, but
without any intellectual intercourse. This he found at the
homes of various relations and friends of his mother, where
he often visited, i.e. the Haanebeek's, the van Stockum's and
aunt Sophy Carbentus with her three daughters, one of whom
married our famous Dutch painter, A. Mauve, a second the
less known painter, A. le Comte. Tersteeg sent to the parents
good reports about Vincent's zeal and capacities, and like his
grandfather in his time, he is " the diligent studious youth "
whom everybody likes.

When he had been at The Hague for three years, Theo, who
is still at school at Oisterwijk (near Helvoirt, to which village
their father has been called), comes to stay with him for a
few days. It is after that visit in August 1872 that the cor-
respondence between the two brothers begins, and from this,
now faded, yellow, almost childish, little note it is carried on
uninterruptedly until Vincent's death, when a half-finished
letter to Theo was found on him, of which the desponding
" que veux-tu " (what can I say) at the end, seems like a
gesture of resignation with which he parted from life.

The principal events of both their lives are mentioned in
the letters and are completed in this biographical notice by
particulars, either heard from Theo himself, or found in the
correspondence of the parents with Theo, also preserved in
full. (Vincent's letters to his parents were unfortunately de-

stroyed.) They date from January 1873, when Theo, then only fifteen years old, went to Brussels to be also brought up as an art dealer.

These letters, full of the tenderest love and care for the boy who left home at such a tender age—" well Theo you are quite a man now at fifteen," says his mother in one of her letters; the boy to whom they clung so fondly, because he, more than any of the other children, repays their love with never failing tenderness and devotion, and grows up to be " the crowning glory of their old age," as they were so fond of calling him—these letters tell of all the small events of daily life at the parsonage; what flowers were growing in the garden, and how the fruit trees bore, if the nightingale had been heard yet, what visitors had come, what the little sisters and brother were doing, what was the text of father's sermon, and among all this, many particulars about Vincent.

In 1873 the latter has been appointed to the firm in London. When leaving The Hague he gets a splendid testimonial from Mr. Tersteeg, who also writes to the parents that at the gallery everybody likes to deal with Vincent— amateurs, clients, as well as painters—and that he certainly will succeed in his profession. " It is a great satisfaction that he can close the first period of his career in that way, and withal he has remained just as simple as he was before," writes mother. At first everything goes well with him in London; Uncle Vincent has given him introductions to some of his friends and he busies himself with great pleasure in his work; he earns a salary of £90 a year, and though living is expensive, he manages to lay by some money to send home now and then. Like a real business man he buys himself a top hat, "you cannot be in London without one," and he enjoys his daily trips from the suburbs to the gallery in Southampton Street in the city.

His first boarding-house is kept by two ladies, who own two parrots, the place is good but somewhat expensive for him, therefore he moves in August to the house of Mrs. Loyer, a curate's widow from the south of France, who with her daughter Ursula keeps a day school for little children.

Here he spends the happiest year of his life. Ursula makes a
deep impression upon him—" I never saw nor dreamt of any-
thing like the love between her and her mother " he writes
to one of his sisters, and : " love her for my sake."

He does not mention it to his parents, for he has not even
confessed his love to Ursula herself,—but his letters home
are radiant with happiness. He writes that he enjoys his life
so much—" Oh fulness of rich life, your gift, Oh God."[1]

In September an acquaintance is going over to London
and undertook to carry a parcel for Vincent, and it is charac-
teristic to hear that it contains, among other things, a bunch
of grass leaves and a wreath of oak leaves, made at home
during the holidays by Theo, who has meanwhile been ap-
pointed from Brussels to the House Goupil at The Hague.
Vincent must have something in his room to remind him of
the beloved fields and woods.

He celebrates a happy Christmas with the Loyers, and in
those days he sends home now and then a little drawing, from
his house and the street and from the interior of his room,
" so that we can exactly imagine how it looks, it is so well
drawn," writes his mother. In this period he seems to have
weighed the possibility of becoming a painter; afterwards
from Drenthe he writes to Theo : " how often have I stood
drawing on the Thames Embankment, as I went home from
Southampton Street in the evening—and the result was
nihil; had there been somebody then to tell me what perspec-
tive was, how much trouble would have been spared me, how
much farther should I be now."

At that time he now and then met Matthew Maris,[2] but was
too bashful to speak out freely to him, and shut up all his
longings and desires within himself—he had still a long road
of sorrow to go ere he could reach his goal.

In January his salary is raised and until spring his letters
remain cheerful and happy; he intends to visit Holland in
July and before that time seems to have spoken to Ursula of
his love. Alas it turns out that she is already engaged to

[1] First line of a well known Dutch poem.
[2] Famous Dutch painter, living in London.

somebody, who boarded with them before Vincent came. He tries all his influence to make her break this engagement but does not succeed, and with this first great sorrow there comes a change in his character; when he comes home for the holidays he is thin, silent, dejected, a changed being. But he *draws* a great deal. Mother writes: "Vincent made many a nice drawing, he drew the bedroom window and the front door, all that part of the house, and also a large sketch of those houses in London upon which their window looks out; it is a delightful talent, that can be of great value to him."

Accompanied by his eldest sister, who wants to find a situation, he returns to London; he takes furnished rooms in Ivy Cottage, 395 Kensington New Road, and there without any family life he grows more and more silent and depressed and also more and more religious.

His parents were glad he left the Loyers—"there were too many secrets and it was not a family like others; but it must have been a great disappointment to him that his illusions were not realized," father writes, and mother complains, "the evenings are so long already and his work finishes early, he must be lonely, if it only does not harm him."

They feel uneasy and worried about his solitary, secluded life. Uncle Vincent also insists upon his mixing more with other people, "that is just as necessary as to learn business"; but the depressed mood continues, letters home grow more and more scarce, and mother begins to think that the London fog depresses him and that even a temporary change might do him good—"poor boy, he means so well, but I believe things are very hard for him just now."

In October 1874, Uncle Vincent effects indeed a short removal to the firm in Paris, but Vincent himself is little pleased by this, in fact he is so angry that he does not write home, to the great grief of his parents. "He is only in a bad temper," his sister says, and Theo comforts, "he is doing all right."

Towards the end of December he returns to London where he takes the same rooms and leads the same retired life. Now for the first time the word *eccentric* is applied to him. His

love for drawing has ceased, but he reads much and the quotation from Renan that closes the London period clearly shows what filled his thoughts and how he aimed even then at the high ideal: "to sacrifice all personal desires, to realize great things, to obtain nobleness of mind, to surpass the vulgarity in which the existence of nearly all individuals is spent." He did not know yet which way he had to go to reach that aim.

In May 1875, he is placed permanently in Paris and assigned especially to the picture gallery, where he feels himself quite out of place; he is more at home in his "cabin," the little room at Montmartre where, morning and evening, he reads the Bible with his young friend, Harry Gladwell, than among the mondaine Parisian public.

His parents read from his letters that things are not going well, and when he comes home at Christmas and everything is talked over, father writes to Theo: "I almost think that Vincent had better leave Goupil in two or three months; there is so much that is good in him, but yet it may be necessary for him to change his position, he is certainly not happy." And they love him too well to persuade him to stay in a place where he would be unhappy; he wants to live for others, to be useful, to bring about something great, *how* he does not know as yet, but *not* in an art gallery. On his return from Holland he has the decisive interview with Mr. Boussod (the son-in-law and successor of Mr. Goupil) that ends with his dismissal on the 1st of April, and he accepts it without bringing in any excuses for himself. One of the grievances against him was that he had gone home to Holland for Christmas and New Year, the busiest time for business in Paris.

In his letters he seems to take it rather lightly, but he feels how gloomily and threateningly the clouds begin to gather around him. At the age of twenty-three years he is now thrown out of employment, without any chance of a better career; Uncle Vincent is deeply disappointed in his namesake and washes his hands of him; his parents are well-meaning, but they cannot do much for him having been

obliged to touch their capital for the education of their children. (The pastor's salary was about 820 guilders a year.) Vincent has had his share, now others must have theirs. It seems that Theo who becomes so soon the helper and adviser of all, has already at that time suggested Vincent's becoming a painter, but for the moment he will not hear of it. His father speaks of a position in a museum and advises him to open a small art gallery for himself, as Uncle Vincent and Uncle Cor have done before; he would then be able to follow his own ideas about art and be no longer obliged to sell pictures which he considered bad—but his heart again draws him to England and he plans to become a teacher.

Through an advertisement, in April 1876 he gets a position in Ramsgate at Mr. Stokes', who moves his school in July to Isleworth. He received only board and lodging, but no salary, so he soon accepts another position at the somewhat richer school of Mr. Jones, a Methodist preacher, where Vincent acts finally as a kind of curate.

His letters home are gloomy. " It seems as if something were threatening me," he writes, and his parents perceive full well that teaching does not satisfy him. They suggest his studying for a French or German college certificate, but he will not hear of it. " I wish he could find some work in connection with art or nature," writes his mother, who understands what is going on within him. With the force of despair he clings to religion, in which he tries to find satisfaction for his craving for beauty, as well as for his longing to live for others. At times he seems to intoxicate himself with the sweet melodious words of the English texts and hymns, the romantic charm of the little village church, and the lovely, holy atmosphere that envelops the English service. His letters in those days bear an almost morbid sensitiveness. Often and often he speaks about a position related to the church—but when he comes home for Christmas, it is decided that he will not go back to Isleworth, because there is absolutely no prospect for the future. He remains on friendly terms with Mr. Jones, who afterwards comes to stay a few days at the Nuenen parsonage, and whom he later meets in

Belgium. Once more Uncle Vincent uses his influence and procures for him a place in the bookshop of Blussé and Braam at Dordrecht. He accepts it, but without great enthusiasm. Characteristic are the words written to Theo by one of the sisters. "You think that he is something more than an ordinary human being, but I think it would be much better if he thought himself just an ordinary being." Another sister writes, "His religion makes him absolutely dull and unsociable."

To preach the Gospel still seems to him the only desirable thing, and at last an attempt is made to enable him to begin the study of Theology. The uncles in Amsterdam promised to give their aid; he can live with Uncle Jan van Gogh, Commandant of the Navy Yard, which will be a great saving of expenses : Uncle Stricker finds out the best teacher in the classical languages, the well-known Dr. Mendes da Costa, and gives him some lessons himself; in the art gallery at Uncle Cor's he can satisfy his love for pictures and prints and so everybody tries to make it easy for him, all except Uncle Vincent, who is strongly opposed to the plan and will not help to forward it—in which he proved to be right after all. Full of courage Vincent sets to work, he must first prepare himself for a State examination before he can be admitted to the University; it will take him seven years ere he is ready; anxiously the parents ask themselves whether he will have the strength to persevere, and whether he who has never been used to regular study will be able to force himself to it at the age of twenty-four.

That period in Amsterdam from May 1877 to 1878 is one long tale of woe. After the first half-year Vincent begins to lose ardour and courage; the writing of exercises and the study of grammar is not what he wants—he desires to comfort and cheer people by bringing them the Gospel,—and surely he does not need so much learning for that! He actually longs for *practical* work, and when at last his teacher also perceives that Vincent never will succeed, he advises him to give up the study. In the "Handelsblad" of the 30th of November 1910, Dr. Mendes da Costa writes his personal

recollections of the afterwards so famous pupil, of whom he tells many characteristic particulars : his nervous, strange appearance, that yet was not without charm, his fervent intention to study well, his peculiar habit of self-discipline, self-chastisement, and finally his total unfitness for regular study. Not along that path was he to reach his goal! Openly he confesses that he is glad things have gone so far and that he can look towards his future with more courage than when he devoted himself hopelessly to Theological study, which period he afterwards called " the worst time of his life."

He will remain " humble " and now wants to become an Evangelist in Belgium; for this no certificates are required, no Latin nor Greek; only three months at the school of Evangelisation at Brussels—where lessons are free and only board and lodging are charged for—and he can get his nomination. In July he travels thither with his father, accompanied by Mr. Jones who on his way to Belgium has spent a few days with them at Etten, and together they visit the different members of the Committee of Evangelization : the Rev. van den Brink from Rousselaere, Rev. Pietersen from Malines, and Rev. de Jong from Brussels. Vincent explained his case clearly and made a very good impression. His father writes : " His stay abroad and that last year at Amsterdam have not been quite fruitless after all, and when he takes the trouble to exert himself he shows that he has learned and observed much in the school of life," and Vincent consequently is accepted as a pupil. But the parents regard this new experiment with fresh anxiety : " I am always so afraid that wherever Vincent may be or whatever he may do, he will spoil everything by his eccentricity, his queer ideas and views on life," his mother writes, and his father adds, " It grieves us so when we see that he literally knows no joy of life, but always walks with bent head, whilst we did all in our power to bring him to an honourable position! It seems as if he deliberately chooses the most difficult path."

In fact that was Vincent's aim—to humble himself, to forget himself, to sacrifice himself, " mourir à soi-même," (to sacrifice every personal desire), that was the ideal he tried to

reach as long as he sought his refuge in religion, and he never did a thing by halves. But to follow the paths trodden by others, to submit to the will of other people, that was not in his character, he wanted to work out his own salvation. Towards the end of August he arrives at the school at Brussels, which had only been recently opened and counted but three pupils; in the class of Mr. Bokma he certainly was the most advanced, but he does not feel at home at the school, he is "like a fish out of water" he says, and is ridiculed for his peculiarities in dress and manners. He also misses the talent of extemporizing and is therefore obliged to read his lectures from manuscript; but the greatest objection against him is, "he is not submissive," and when the three months have elapsed he does not get his nomination. Though he writes it (in letter 126) in an off-hand way to Theo, he seems to have been greatly upset by it. His father receives a letter from Brussels, probably from the school, saying that Vincent is weak and thin, does not sleep, and is in a nervous and excited state, so that the best thing will be to come and take him home.

Immediately he travels to Brussels and succeeds in arranging everything for the best. Vincent goes at his own risk to the Borinage where he boards at 30 fr. a month with M. Van der Haegen, Rue de L'Eglise 39, at Paturages near Mons. He teaches the children in the evening, visits the poor and gives lectures from the Bible, and when in January the Committee meets, he will again try to get a nomination. The intercourse with the people there pleases him very well; in his leisure hours he draws large maps of Palestine, of which his father orders four at 10 fr. apiece, and at last, in January 1879, he gets a temporary nomination for six months at Wasmes at 50 fr. a month for which he must give Bible lectures, teach the children and visit the sick—the work of his heart. His first letters from there are very contented and he devotes himself heart and soul to his work, especially the practical part of it; his greatest interest is in nursing the sick and wounded. Soon, however, he falls back to the old exaggerations—he tries to put into practice the doctrines of Jesus, gives away every-

thing, his money, clothes and bed, he leaves the good board-
ing-house at Denis, in Wasmes, and retires to a miserable hut
where every comfort is wanting. Already they had written to
his parents about it and when, towards the end of February,
the Rev. Rochelieu comes for inspection, the bomb explodes,
for so much zeal is too much for the committee and a person
who neglects himself so cannot be an example to other people.
The Church Council at Wasmes have a meeting and they
agree that if he does not listen to reason he will lose his
position. He himself takes it rather coolly. "What shall we
do now?" he writes, "Jesus was also very calm in the storm,
perhaps it must grow worse before it grows better." Again his
father goes to him, and succeeds in stilling the storm; he
brings him back to the old boarding-house, advises him to be
less exaggerated in his work, and for some time everything is
all right, at least he writes that no reproofs are made. About
that time a heavy mine explosion occurs and a strike breaks
out, so Vincent can devote himself completely to the miners,
and his mother in her naïve religious faith writes, "Vincent's
letters that contain so many interesting things prove that with
all his singularities he yet shows a warm interest in the poor
and that surely will not remain unobserved by God." In that
same time he also writes that he tries to *sketch the dresses
and tools of the miners and will show them when he comes
home.* In July bad tidings come again, "he does not comply
with the wishes of the committee and nothing will change
him. It seems that he is deaf to all remarks that are made to
him," writes his mother, and when the six months of his
temporary nomination are past, he is not appointed again, but
they give him three months to look out for another position.
He leaves Wasmes and travels on foot to Brussels to ask the
Rev. Pietersen, who has moved thither from Malines, for
advice. The latter paints in his leisure hours and has a
studio, which probably was the reason why Vincent went to
him for help. Tired and hot, exhausted and in a nervous
condition he arrives there and so neglected was his appear-
ance that the daughter of the house who opened the door for
him was frightened, called for her father and ran away. The

Rev. Pietersen received him kindly; procured him good lodgings for the night, invited him to his table the next day, showed him the studio, and as Vincent had brought some of his sketches of the miners, they probably talked as much about drawing and painting as about Evangelization.

" Vincent gives me the impression of somebody who stands in his own light," writes the Rev. Pietersen to his parents, and mother adds, " how lucky it is that still he always finds somebody who helps him on, as now the Rev. Pietersen has."

In accordance with the latter's advice, Vincent resolves to stay in the Borinage at his own expense, as he cannot be in the service of the committee, and that he will board with the Evangelist Frank, at Cuesmes. About the middle of August, at his parents' request, he visits them again at Etten. " He looks well, except for his clothes, he reads Dickens all day and speaks only when he is addressed, about his future not a single word," writes his mother. What could he say about his future? Did it ever look more hopeless than it did now? His illusion of bringing through the Gospel comfort and cheer into the miserable lives of the miners had gradually been lost in the bitter strife between doubt and religion, which he had to fight at that time, and which made him lose his former faith in God. (The Bible texts and religious reflections which became more and more rare in his last letters now stop entirely.) No other thing has taken its place yet; he draws much and reads much, among others, Dickens, Beecher Stowe, Victor Hugo, and Michelet, but it is all done without system or aim. Back in the Borinage he wanders about without work, without friends and very often without bread, for though he receives money from home and from Theo, they cannot give him more than is strictly necessary, and as it comes in at very irregular times and Vincent is a very poor financier, there are days and even weeks when he is quite without money.

In October Theo, who has got a permanent position at Goupil's in Paris, comes to visit him on his journey thither and tries in vain to bring him to some fixed plan for the

future; he is not yet ripe to take any resolution; before he becomes conscious of his real power he has still to struggle through the awful winter of 1879-80, that saddest, most hopeless time of his never very fortunate life. In these days he undertakes, with ten francs in his pocket, the hopeless expedition to Courrières, the dwelling place of Jules Breton, whose pictures and poems he so much admires, and with whom he secretly hopes to come in contact in some way or other. But the only thing that becomes visible to him is the inhospitable exterior of Breton's newly built studio and he lacks the courage to introduce himself. Disappointed in his hope, he has to undertake the long journey home; his money is all spent, generally he sleeps in the open air or in a hay loft. Sometimes he exchanges a drawing for a piece of bread, and he undergoes so much fatigue and want that his health always suffered from the consequences. In spring he comes once more to the vicarage of Etten and speaks again about going to London. " If he really wants it, I shall enable him to go," writes his father, but finally he returns again to the Borinage and lives that summer of 1880 at the house of the miner Charles Decrucq at Cuesmes. There he writes in July the wonderfully touching letter (133) that tells of what is going on in his innermost self—" My only anxiety is what can I do . . . could I not be of use, and good for something?" It is the old wish, the old longing to serve and comfort humanity, which made him write afterwards, when he had found his calling, " And in a picture I wish to say something that would console me as music does." Now in the days of deepest discouragement and darkness at last the light begins to dawn. Not in books shall he find satisfaction, not in literature find his work, as his letters sometimes suggested; he turns back to his old love, " I said to myself, I'll take up my pencil again, I will take up drawing, and from that moment everything has changed for me." It sounds like a cry of deliverance, and once more, " do not fear for me, if I can continue my work I will succeed." At last he has found his work and herewith the mental equilibrium is restored; he no

longer doubts of himself and however difficult or heavy his
life may become the inward serenity, the conviction of his
own calling never more deserts him.

The little room in the house of the miner Decrucq, which
he has to share with the children, is his first studio. There he
begins his painter's career with the first original drawing of
miners who go to work in the early morning. There he copies
with restless activity the large drawings after Millet, and
when the room is getting too narrow for him, he takes his
work out into the garden.

When the cold autumn weather prevents his doing this, and
as his surroundings at Cuesmes are getting too narrow for
him, he moves in October to Brussels where he settles in a
small hotel on the Bd. du Midi 72. He is longing to see
pictures again, but above all he hopes to become acquainted
with other artists. Deep in his heart there was such a great
longing for sympathy, for kindness and friendship, and
though his difficult character generally prevented him from
finding this and left him isolated in life, yet he always kept on
longing for somebody with whom he could live and work.

Theo, who meanwhile had acquired a good position in
Paris, could now assist him in word and deed. He brought
Vincent into relation with the young Dutch painter van
Rappard, who had worked some time in Paris and now
studied at the academy at Brussels. At first the acquaintance
did not progress, for the outward difference between the rich
young nobleman and the neglected wanderer from the Borin-
age was too great to ripen the acquaintance at once into
friendship; yet the artistic taste and opinions of both were
too similar for them not to find each other; a friendship
arose—perhaps the only one that Vincent ever had in Hol-
land—it lasted for five years and then was broken through a
misunderstanding, which van Rappard always regretted,
though he acknowledged that intercourse with Vincent was
very difficult.

"I remember as if it happened yesterday the moment of
our first meeting at Brussels when he came into my room at
nine o'clock in the morning, how at first we did not get on

very well together, but so much the better after we had worked together a few times," writes van Rappard to Vincent's mother after the latter's death. And again, " whoever has witnessed this wrestling, struggling and sorrowful existence could not but feel sympathy for the man who demanded so much of himself, that it ruined body and mind. He belonged to the race that produces the great artists.

" Though Vincent and I had been separated the last years by a misunderstanding which I have often regretted—I have never ceased to remember him and the time we spent together with great sympathy.

" Whenever in the future I shall remember that time, and it is always a delight for me to recall the past, the characteristic figure of Vincent will appear to me in such a melancholy but clear light, the struggling and wrestling, fanatic, gloomy Vincent, who used to flare up so often and was so irritable, but who still deserved friendship and admiration for his noble mind and highly artistic qualities."

Vincent's own opinion of van Rappard is clearly shown in his letters. A second acquaintance that Vincent made through Theo, with the painter Roelofs, was of less-during importance. Roelofs' advice to enter the Academy was not followed by Vincent, perhaps they did not admit him because he was not far enough advanced, but probably he had more than enough of academical institutions and theories, and in painting as well as in theology he preferred to go his own way; that is the reason he did not come into contact with other Dutch painters who were at that same time at the Academy at Brussels, for instance, Haverman.

He studied anatomy by himself, drew diligently from the living model, and from a letter to his father it seems that he took lessons in perspective from a poor painter at 1.50 fr. a lesson of two hours : it has not been possible to fix the name of the painter, it may have been Madiol.

At the end of the winter when van Rappard goes away, in whose studio he has often worked because his own little bedroom was too small, he longs for other surroundings, especially for the country; the expenses in Brussels are also some-

what heavy, and he thinks it will be cheapest to go to his parents at Etten where he has board and lodging free and can use all money he receives for his work.

He stays there for eight months, and this summer of 1881 is again a happy time for him. First, van Rappard comes to stay with him and he too always remembers with pleasure his stay at the vicarage, "And my visit at Etten! I see you still sitting at the window when I came in," he writes to Vincent's mother in the letter quoted above, "I still enjoy that beautiful walk we all took together that first evening, through the fields and along the small path! And our excursions to Seppen, Passievaart, Liesbosch, I often look through my sketch books for them."

In the beginning of August Theo comes over from Paris; shortly after Vincent makes an excursion to The Hague to consult about his work with Mauve, who firmly encourages him, so that he continues with great animation, and finally in those days he meets for the second time a woman who has great influence on his life. Among the guests who spent that summer at the vicarage at Etten was a cousin from Amsterdam—a young widow with her little four-year-old son. Quite absorbed in her grief over the loss of her husband, whom she had loved so tenderly, she was unconscious of the impression which her beauty and touching sorrow made on the cousin, who was a few years her junior. "He was so kind to my little boy," she said when she afterwards remembered that time. Vincent who had great love for children, tried to win the heart of the mother by great devotion to the child. They walked and talked much together, and he has also drawn a portrait of her (which seems to have been lost), but the thought of a more intimate relation did not occur to her, and when Vincent spoke to her at last about his love, a very decided *no* was the immediate reply. She went back to Amsterdam and never saw him again. But Vincent could not abide by her decision, and with his innate tenacity he keeps on persevering and hoping for a change in her feelings for him; when his letters are not answered, he accuses both his and her parents of opposing the match, and only a visit to

Amsterdam, where she refuses to see him, convinces him of the utter hopelessness of his love.

"He fancied that he loved me," she said afterwards, but for him it was sad earnest, and her refusal becomes a turning point in his life. If she had returned his love it would perhaps have been a spur to him to acquire a social position, he would have had to provide for her and her child; as it is he loses all worldly ambition and in the future lives only for his work, without taking one step to make himself independent. He cannot bear to stay in Etten any longer, he has become irritable and nervous, his relations to his parents become strained, and after a violent altercation with his father, in December he leaves suddenly for The Hague.

The two years he spends there are, for his work, a very important period of which his letters give a perfect description. His low spirits rise at first, by the change of surroundings and the intercourse with Mauve, but the feeling of having been slighted and wronged does not leave him and he feels himself utterly abandoned. When he meets in January a poor neglected woman approaching her confinement, he takes her under his protection, partly from pity but also to fill the great void in his life. "I hope there is no harm in his so-called model. Bad connections often arise from a feeling of loneliness, of dissatisfaction," writes his father to Theo, who is always the confidant of both parties and has to listen to all the complaints and worries; father is not far wrong. Vincent could not be alone, he wanted to live for somebody, he wanted a wife and children, and as the woman he loved had rejected him, he took the first unhappy woman who crossed his path, with children that were not his own. At first he feigns to be happy and tries to convince Theo in every letter how wisely and well he has acted, and the touching care and tenderness with which he surrounds the woman when she leaves the hospital after her confinement, strike us painfully when we think on whom that treasure of love was lavished. He prides himself now on having a family of his own, but when their living together has become a fact and he is continually associated with a coarse, uneducated woman,

marked by smallpox, who speaks with a low accent and has a spiteful character, who is addicted to liquor and smokes cigars, whose past life has not been irreproachable, and who draws him into all kinds of intrigues with her family,[1] he soon writes no more about his home life; even the posing, by which she won him (she sat for the beautiful drawing, "Sorrow"), and of which he had expected so much, soon ceases altogether. This unfortunate adventure deprives him of the sympathy of all in The Hague who took an interest in him. Neither Mauve nor Tersteeg could approve of his taking upon himself the cares of a family, and such a family! while he was financially dependent on his younger brother. Acquaintances and relatives are shocked to see him walk about with such a slovenly woman; nobody cares to associate with him any longer and his home life is such that nobody comes to visit him. The solitude around him becomes greater and greater and as usual it is only Theo who understands and continues to help him.

When the latter comes to visit Vincent for the second time in The Hague, in the summer of 1883, and witnesses the situation—finds the household neglected, everything in bad condition and Vincent deeply in debt—he too advises to let the woman go her own way as she is not fit for a regulated life. She herself had already felt that things could not continue like that, because Vincent wants too much money for his painting to leave enough for the support of her and the children, and she was already planning with her mother to earn money in another way. Vincent himself feels that Theo is right, and in his heart he longs for a change of surroundings, and liberty to go where his work calls him, but it costs him a bitter struggle to give up what he had taken upon himself, and to leave the poor woman to her fate. Till the last he defends her, and excuses her for her faults with the sublime words, " she has never seen what is good, so how can she be good?"

In those days of inward strife he allows Theo to read deeper than ever into his heart. These last letters from The

[1] This is in fact an exaggerated picture of the woman's character. [Ed.]

Hague (letters 313 to 322) give the key to many things that
were incomprehensible until now. For the first time he speaks
openly about what has happened at the time of his dismissal
from Goupil, for the first time he explains his strange indif-
ference to show his own work or to try to make it productive,
when he writes, " it is so painful for me to speak to people. I
am not afraid to do so, but I know I make a disagreeable
impression; I am so much afraid that my efforts to introduce
myself will do me more harm than good," and how naïvely
he adds, " human brains cannot bear everything as is shown
by van Rappard, who had brain fever and now has gone to
Germany to recover." As if he wanted to say : " do not let
me make efforts to know strange people, as the same thing
might happen to me." Once more he touches the old love
story of Etten, " a single word made me feel that nothing is
changed in me about it, that it is and remains a wound, which
I carry with me, but it lies deep and will never heal, it will
remain in after years just what it was the first day." And he
expresses openly how different his life would have been with-
out this disappointment in his love.

When at last he starts alone in September for Drenthe, he
has made all possible provisions for the woman and the
children, and there is a sorrowful parting, especially from the
little boy to whom he had become attached as if it were his
own child.

The trip to Drenthe proves a failure instead of doing him
good. But some of his most beautiful letters date from those
days. The season was too far advanced, the country too in-
hospitable, and what Vincent so ardently desired—to come
into contact with some artists, for instance, Lieberman—was
not realized.

Bitter loneliness and want of money put a too heavy strain
on his nerves. He is afraid of falling ill, and in December
1883 hastens back to the parental vicarage, the only place
where he can find a safe shelter.

His father had meanwhile left Etten and been nominated
to Nuenen, a village in the neighbourhood of Eindhoven, and
the new place and surroundings pleased Vincent so well that

instead of paying a short visit, as first was his intention, he stays there for two years.

To paint the Brabant landscape and the Brabant types is now his aim, and to accomplish that aim he overlooks all other difficulties.

To live together with his parents was for him as well as for them a very difficult thing. In a small village vicarage, where nothing can happen without the whole village knowing it, a painter is obviously an anomaly; how much more a painter like Vincent, who had so completely broken with all formalities, conventionalities and with all religion, and who was the last person in the world to conform himself to other people. On both sides there must have been great love and great patience to put up with it so long. When his letters from Drenthe to his parents became more and more melancholy, his father anxiously had written to Theo, " it seems to me that Vincent is again in a wrong mood. He seems to be in a melancholy state of mind; but how can it be otherwise? Whenever he looks back into the past and recalls to his memory how he has broken with all former relations, it must be very painful to him. If he had only the courage to think of the possibility that the cause of much which has resulted from his eccentricity lies in himself. I don't think he ever feels any self-reproach, only soreness against others, especially against the gentlemen at The Hague. We must be very careful with him for he seems to be in a fit of contrariness."

And they *are* so careful. When he comes back to them of his own will, they receive him with so much love and try all in their power to make him comfortable; they are proud too of the progress in his work, of which it must be said they had no great expectations at first. "Do you not like the pen drawings of the tower that Vincent sent you? It seems to come to him so easily," writes his father in the first days of December to Theo, and then on the twentieth of December, "You will be longing to know how things are getting on with Vincent. At first it seemed hopeless, but by and by things have arranged themselves, especially since we approved of his staying here for some time to make studies. He wanted the

inner room fitted up for him; we did not think it a very fit abode for him, but we had a nice stove put there; as the room had a stone floor we had it covered with boards, and made it as comfortable as possible: we put a bed in it on a wooden stand, that it might not be too damp. Now we will make the room nicely warm and dry, so that it may turn out better than we expected. I proposed to have a large window made in it but he did not want that. In short, with real courage we undertake this new experiment and we intend to leave him perfectly free in his peculiarities of dress, etc. The people here have seen him anyhow, and though it is a pity he is so reserved in manner, we cannot change the fact of his being eccentric. . . ." " He seems to occupy himself a great deal with your plans for the future, but you will be wise enough not to let yourself be influenced to do things that are not practical, for alas that certainly is his foible. One thing is certain, he works hard and finds here lots of subjects, he has made already several drawings, which we like very much." Such is the feeling from their side; but Vincent is not satisfied with all that kindness and wants a deeper understanding of his innermost self than his parents can give, however much they try. When about the middle of January '84 his mother meets with an accident and is brought home from Helmond with a broken leg, the relations become less strained. Vincent, who has become an expert nurse in the Borinage, helps to nurse his mother with the greatest devotion, and in every letter of that time they praise him for his faithful help. " Vincent is untiring, and the rest of his time he devotes to his painting and drawing with the greatest zeal." " The doctor praised Vincent for his ability and care." " Vincent proves an ideal nurse and at the same time he works with the greatest ambition." " I fervently hope that his work may find success for it is edifying to see how much he works," is told in the letters of February.

Vincent's own letters at that time are gloomy and full of complaints and unjust reproaches to Theo that he never sells anything for him and does not even try to, ending at last with the bitter cry: " A wife you cannot give me, a child you

cannot give me work you cannot give me—money yes, but what is the use of it when I must miss all the rest!" And Theo, who always understands him, never gives a sharp or angry answer to those reproaches : a light sarcasm is the only reply he sometimes gives to such outbursts. In May Vincent's spirits rise somewhat on his moving into a new, larger studio, two rooms in the house of the sexton of the Catholic church. Shortly after, van Rappard comes to spend some time with him again, and besides, Vincent had during his mother's illness come more in contact with neighbours and friends of the village, who daily came to visit the patient, so that he writes in those days, " I have had a much pleasanter time with the people here than at first, which is worth a great deal to me, for one must have some distraction now and then, and when one feels too lonely the work suffers from it." But with a prophetic glance he continues, " One must keep in mind however that these things do not always last." Indeed, difficult times were approaching for him again. With one of his mother's visitors, the youngest of three sisters who lived next door to the vicarage, he had soon got into a more intimate relation; she was much older than he and neither beautiful nor gifted, but she had an active mind and a kind heart. She often visited the poor with Vincent; they walked much together, and on her part at least the friendship soon changed into love. As to Vincent, though his letters do not give the impression of any passionate feeling for her (the fact is he writes very little about it), yet he seems to have been inclined to marry her, but the family vehemently protested against the plan, and violent scenes took place between the sisters, which were not conducive to keep Vincent in a pleasant mood.

" Vincent works hard but he is not very sociable," writes his mother in July, and it will get worse still, for the young woman, violently excited by the scenes with her sisters, tries to commit suicide, which fails, but shocks her health so much that she had to be nursed at a doctor's in Utrecht. She quite recovered and after half a year she came back to Nuenen,

but their relations were broken for ever and the whole affair left Vincent in a gloomy, bitter mood.

For his parents the consequences were also painful, because the neighbours avoided the vicarage from that time, not wishing to meet Vincent, " which is a great privation for me, but it is not your mother's way to complain," the latter writes in October of that year. It is in those days that van Rappard once more comes to stay with them. " He is not a talkative person, but a hard worker," writes mother, and van Rappard himself writes in 1890, in the letter to her, quoted above, " how often do I think of the studies of the weavers which he made in Nuenen, with what intensity of feeling did he depict their lives, what deep melancholy pervaded them, however clumsy the execution of his work may have been then. And what beautiful studies he made of the old church tower in the churchyard. I always remember a moonlight effect of it, which particularly struck me at that time. When I think of those studies in those two rooms near the church, it recalls to my mind so many memories, and reminds me of the whole surroundings, the cheerful hospitable vicarage with its beautiful garden, the family Begemann, our visits to the weavers and peasants, how I did enjoy it all."

After van Rappard's visit Vincent has no other distraction than a few acquaintances in Eindhoven, with whom he has come into contact through the house painter, who furnishes his colours. They are a former goldsmith, Hermans, a tanner, Kersemakers, and also a telegraphist whose name is not mentioned, all of whom Vincent initiates into the art of painting. Mr. Kersemakers has recorded his reminiscences of that time in the weekly " De Amsterdammer " of the 14th and 21st of April 1912, and gives among others the following description of Vincent's studio, which according to him looked quite " Bohemian."

" It was quite astonishing to see how crowded the place was with pictures, with drawings in water-colour and chalk; heads of men and women whose negro-like turned up noses, projecting jaw-bones and large ears were strongly accentuated,

the fists callous and furrowed; weavers and weavers' looms, women driving the shuttle, peasants planting potatoes, women busy weaving, innumerable still-lives, at least ten studies in oil of the old church tower at Nuenen, of which he was so fond, and which he had painted in all seasons of the year and in all weathers (afterwards this old tower was demolished by the Nuenen Vandals, as he called them).

Heaps of ashes around the stove, which never had seen brush or polish, a few frayed out rush-bottomed chairs, and a cupboard with at least thirty different birds' nests, all kinds of moss and plants brought from the heath, some stuffed birds, shuttles, spinning-wheel, bed-warmer, all sorts of farmers' tools, old caps and hats, dirty women's bonnets, wooden shoes, etc." He also tells about their trip to Amsterdam (in the autumn of 1885) to see the " Ryksmuseum," how Vincent in his rough ulster and his inseparable fur cap was calmly sitting painting a few small views of the town in the waiting room of the station; how they saw the Rembrandts in the museum, how Vincent could not tear himself away from the " Jewish Bride" and said at last, " Do you know that I would give ten years of my life if I could sit here before this picture a fortnight, with nothing but a crust of dry bread for food."

Dry bread was nothing unusual to him; according to Kerse-makers, Vincent never ate it otherwise, in order not to indulge himself too much. His impression of Vincent's work is given as follows: " At my first visit in Nuenen I could not understand it at all, it was so totally different from what I expected, it was so strong, so coarse and unfinished that I could not possibly admire it or see anything in it.

" At my second visit the impression was already much better, though I thought in my ignorance that he could not draw, or totally neglected the drawing of the figures, and I took the liberty of telling him straight out. I did not make him angry, he only laughed and said : ' You will think differently about it later on.' "

Meanwhile the winter days passed on gloomily enough at the vicarage. " For Vincent I should wish that the winter

were over, he cannot work out of doors and the long evenings are not profitable for his work. We often think that it would be better for him to be among people of his own profession, but we cannot dictate to him," writes his father in December, and mother complains, "how is it possible to behave so unkindly? If he has wishes for the future, let him exert himself, he is still young enough; it is almost impossible to bear it. I think he wants a change, perhaps he might find something that would give him inspiration, here it is always the same thing and he never speaks to anyone." But still she finds one luminous point to mention: "we saw that Vincent received a book from you, he seems to read it with much pleasure. I heard him say 'that is a fine book,' so you have given him great pleasure. I am glad that we regularly get books from the reading club; the illustrations in the magazines interest him most, and then there is the Nouvelle Revue, etc., every week something new is a great pleasure to him." Incessantly Vincent continues his work in the gloomy cottages of peasants and weavers. "I never began a year of a more gloomy aspect, in a more gloomy mood," he writes on New Year's Day '85. "He seems to become more and more estranged from us," complains his father, whose letters became more and more melancholy, as if he is not equal to the difficulties of living together with his gifted, unmanageable son, and feels himself helpless against his unbridled violence. "This morning I talked things over with Vincent; he was in a kind mood and said there was no particular reason for his being depressed," says the latter, "may he meet with success anyhow," are the last words he writes about Vincent in a letter of the 25th of March. Two days later, coming home from a long walk across the heath, he fell down on the threshold of his home and was carried lifeless into the house. Hard times followed in the vicarage; mother could remain there another year, but for Vincent it brought immediate changes. In consequence of several disagreeable discussions with the other members of the family, he resolved to live no longer at the vicarage, but took up his abode in the studio, where he stayed from May to November. Henceforth there is

not a single thing to distract him from his aim—to paint the peasant life. He spends those months in the cottages of the weavers or with the peasants in the field. " It is a fine thing to be right in the snow in winter, right in the yellow leaves in autumn, in summer right in the ripe corn, in spring right in the grass, always with the peasant girls and reapers, in summer under the open skies, in winter near the open fire-place, and to know that it has always been so and will always be" (letter 425). He is now in harmony with himself and his surroundings, and when he sends Theo his first great picture, " The Potato-Eaters," he can say in good reason that it is " from the heart of peasant life."

An uninterrupted series of studies follow each other; the cottages of the old peasants and their witch-like wives, the old church tower of the cemetery, the autumn landscapes and the birds' nests, a number of still-lives and the strong draw-ings of the Brabant peasants. In Nuenen he also writes the beautiful passages about colour, in reference to Delacroix's laws of colours. It seems strange to hear him, who was called afterwards one of the first Impressionists, even Neo-impres-sionists, declare, " there is a school I think of impressionists, but I do not know much about it" (letter 402), and in his usual spirit of contradiction he afterwards adds, " from what you have told me about impressionism I have learned that it is different from what I thought it was, but as to me I find Israëls for instance so enormous that I am little curious about or desirous of anything different or new. I think I shall change a great deal in touch and colour but I expect to be-come rather more dark than lighter." As soon as he came to France he thought differently of it.

During the last days of his stay in Nuenen difficulties arise between him and the Catholic priest, who has long since looked askance at the studio next to his church, and now forbids his parishioners to pose for Vincent. The latter was already thinking about a change. He gives notice of leaving his studio the first of May, but starts for Antwerp, towards the end of November, leaving all his Brabant work behind. When in May his mother also leaves Nuenen, everything

belonging to Vincent is packed in cases, left in care of a carpenter in Breda and—forgotten! After several years the carpenter finally sold everything to a junk dealer.

What Theo's opinion about his brother was at that time is shown in the letter to his sister of the 13th of October '85, in which he writes : " Vincent is one of those who has gone through all the experiences of life and has retired from the world, now we must wait and see if he has genius. I think he has. . . . If he succeeds in his work he will be a great man. As to the worldly success, it will perhaps be with him as with Heyerdahl[1] : appreciated by some but not understood by the public at large. Those however who care whether there is really something in the artist, or if it is only outward shine, will respect him, and in my opinion that will be sufficient revenge for the animosity shown him by so many others."

In Antwerp Vincent rents for 25 fr. a month a little room over a small paint-dealer's shop in the "Rue des Images" 194. It is but a very small room but he makes it cosy with Japanese prints on the wall, and when he has rented a stove and a lamp, he feels himself safe and writes with profound satisfaction, "no fear of my being bored I can assure you." On the contrary he spends the three months of his stay in one feverish intoxication of work. The town life which he has missed so long fascinates him; he has not eyes enough to see, nor hands enough to paint : to make portraits of all the interesting types he meets is his delight, and in order to pay the models he sacrifices everything he has. As for food he does not bother. " If I receive money my first hunger is not for food, though I have fasted ever so long, but the desire for painting is ever so much stronger, and I start at once hunting for models till there is nothing left," he writes.

When he sees in January that he cannot go on like that, the expenses being too heavy, he becomes a pupil of the Academy, where the teaching is free and where he finds models every day. Hageman and de Baseleer were there among his fellow pupils and from Holland there was Briët. In the evening he worked again in the drawing class and after that,

[1] Norwegian painter, then in Paris.
L.V.G.

often till late at night, at a club where they also draw from life. His health cannot stand such a strain and in the beginning of February he writes that he is literally worn out and exhausted, according to the doctor it is complete prostration. He seems not to think about giving up his work, however, though he begins to make projects for a change, for the course at the Academy is almost finished and he has already had many disagreements with his teachers, for he is much too independent and self-willed to follow their guidance. Something must be done. Theo thinks it better for Vincent to go back to Brabant, but he himself wants to go to Paris. Then Theo proposes to wait at least till June, when he shall have rented a larger apartment, but with his usual impetuosity Vincent cannot wait so long, and one morning in the end of February, Theo receives in his office at the Boulevard a little note written in chalk, that Vincent had arrived and awaits him in the Salon Carré of the Louvre. Probably he left all his work in Antwerp, perhaps his landlord the paint-dealer kept it for the unpaid rent of the room. Certain it is that none of the studies about which he writes, the view of the Park, of the Cathedral, Het Steen, etc., ever has been found again.

The meeting in the Louvre took place, and since then Vincent lived with Theo in the latter's apartment in the Rue de Laval. As there was no room for a studio he worked during the first month at Cormon's studio, which did not satisfy him at all, but when they moved in June to the Rue Lepic 54, on Montmartre, he had there a studio of his own and never went back to Cormon.

The new apartment on the third floor had three rather large rooms, a cabinet and a kitchen. The living room was comfortable and cosy with Theo's beautiful old cabinet, a sofa and a big stove, for both the brothers were very sensitive to the cold. Next to that was Theo's bedroom. Vincent slept in the cabinet and behind that was the studio, an ordinary sized room with one not very large window. Here he first painted his nearest surroundings—the view from the studio window, the Moulin de la Galette viewed from every side, the window of Madame Bataille's small restaurant where he

took his meals, little landscapes on Montmartre which was at that time still quite countrified, all painted in a soft tender tone like that of Mauve. Afterwards he painted flowers and still-life and tried to renew his palette under the influence of the French " plein air " painters such as Monet, Sisley, Pisarro, etc., for whom Theo had long since opened the way to the public. The change of surroundings and the easier and more comfortable life, without any material cares, at first greatly improved Vincent's health. In the summer of '86 Theo writes to his mother, " we like the new apartment very much; you would not recognize Vincent, he is so much changed, and it strikes other people more than it does me. He has undergone an important operation in his mouth, for he had lost almost all his teeth through the bad condition of his stomach. The doctor says that he has now quite recovered his health; he makes great progress in his work and has begun to have some success. He is in much better spirits than before and many people here like him . . . he has friends who send him every week a lot of beautiful flowers which he uses for still-life, he paints chiefly flowers, especially to make the colours of his next pictures brighter and clearer. If we can continue to live together like this, I think the most difficult period is past, and he will find his way." To continue living together, that was the great difficulty, and of all that Theo did for his brother, there is perhaps nothing that proved greater sacrifice than his having endured living with him for two years. For when the first excitement of all the attractions in Paris had passed, Vincent soon fell back to his old irritability; perhaps the city life did not agree with him either and overstrained his nerves. Whatever might be the cause, his temper during that winter was worse than ever, and made life very hard for Theo, whose own health was not of the best at that time. Circumstances put too heavy a strain on his strength. His own work was very strenuous and exhausting, he had made the gallery on the Boulevard Montmartre a centre of the Impressionists, there were Monet, Sisley, Pissarro and Raffaelli, Degas who exhibited nowhere else, Seurat, etc. But to introduce that work to the public, which

filled the small entresol every afternoon from five until seven, what discussions, what endless debates, had to be held, and on the other hand how he had to defend the rights of the young painters against " ces messieurs," as Vincent always called the heads of the firm. When he came home tired out in the evening he found no rest, but the impetuous, violent Vincent began to expound his own theories about art and art-dealing, which always came to the point that Theo ought to leave Goupil and open a gallery for himself. And this lasted till far into the night, ay sometimes he sat down on a chair before Theo's bed to spin out his last arguments. " Do you feel how hard it sometimes is to have no other conversation than with gentlemen who speak about business, with artists whose life generally is difficult enough, but never to come in contact with women and children of your own sphere? You can have no idea of the loneliness in a big city," writes Theo once to his youngest sister and to her he sometimes opens his heart about Vincent: "my home life is almost unbearable, no one wants to come and see me any more, because it always ends in quarrels, and besides he is so untidy that the room looks far from attractive. I wish he would go and live by himself, he speaks sometimes about it, but if I were to tell him to go away, it would be just a reason for him to stay; as it seems I do him no good. I only ask him one thing, to do me no harm and by his stay—he does so, for I can hardly bear it." " It seems as if he were two persons in one, one marvellously gifted, tender and refined, the other egoistic and hard-hearted. They present themselves in turns, so that one hears him talk first in one way, then in the other, and always with arguments on both sides. It is a pity that he is his own enemy, for he makes life hard not only for others but also for himself." But when his sister advises him to " leave Vincent for God's sake," to himself, Theo answers, " it is such a peculiar case. If he only had another profession I would long ago have done what you advise me, and I have often asked myself if I have not been wrong in helping him continually. I have often been on the point of leaving him to his own devices. After receiving your letter I have thought it

over again, but I think in this case I must continue in the same way. He is certainly an artist and if what he makes now is not always beautiful, it will certainly be of use to him afterwards, and then his work will perhaps be sublime, and it would be a shame to keep him from his regular study. However unpractical he may be, if he succeeds in his work there will certainly come a day when he will begin to sell his pictures. . . .

" I am firmly resolved to continue in the same way as till now, but I do hope that he will change his lodgings in some way or other."

However, that separation did not take place. The old love and friendship which bound them together since childhood, did not fail them even now. Theo managed to restrain himself, and in the spring he wrote, " as I feel much stronger than last winter I hope to be able to bring a change for the better in our relations; there will be no other change for the present and I am glad of it. We are already most of us so far from home that it would be no use to bring about still more separation." And full of courage he continues to help Vincent bear the burden of his life.

With spring there came in all respects a better time. Vincent could again work in the open air and painted much at Asnières where he painted the beautiful triptych of " l'Isle de la grande Jatte," the borders of the Seine with their gay, bright restaurants, the little boats on the river, the parks and gardens, all sparkling with light and colour. At that time he saw much of Emile Bernard, a young painter fifteen years younger than himself, whom he had met at Cormon's and who had a little wooden studio in his parents' garden at Asnières, where they sometimes worked together and where Vincent began a portrait of Bernard. But one day he fell into a violent quarrel with old Mr. Bernard about the latter's projects for his son. Vincent could bear no contradiction, he ran away in a passion with the still wet portrait under his arm, and he never set foot again in the house of the Bernards. But the friendship with the young Bernard remained, and in his " Letters of Vincent van Gogh," (published at Vollard's

in Paris), are the most beautiful pages written about Vincent.

In the winter of '87-'88, Vincent again paints portraits—the famous self-portrait before the easel, and many other self-portraits, as well as father Tanguy, the old merchant of colours in the Rue Clausel, in whose show-window his customers were allowed to exhibit their pictures by turns, and who unjustly sometimes has been described as a Mæcenas, the qualities for which were absolutely wanting in the poor old man, and even if he had possessed them, his shrewd wife would not have allowed him to use them. He sent, and justly too, very proper bills for the colours he furnished, and did not understand very much about the pictures that were exposed in his window.

From that time dates also the famous picture, "Interior with Lady by a Cradle," and when Theo who has bought that winter a few pictures from young artists, to help them, and wants to do the same for Vincent, the latter paints for him the beautiful "Still Life in Yellow," sparkling and radiant as from an inward glow, and with red letters he graves the dedication "To my brother Theo."

Toward the end of the winter he is tired of Paris, city life is too much for him, the climate too grey and chilly, in February '88 he travels toward the south. "After all these years of care and misfortune his health has not grown stronger and he decidedly wanted to be in a milder climate," Theo writes. "He has first gone to Arles to look around him, and then will probably go to Marseilles.

"Before he went away I went a few times with him to hear a Wagner concert; we both enjoyed it very much. It still seems strange that he is gone. He was so much to me the last time." And Bernard tells how Vincent was busy that last day in Paris arranging the studio, "So that my brother will think me still here."

At Arles, Vincent reaches the summit of his art. After the oppressiveness of Parisian life he, with his innate love of nature, revives in sunny Provence. There follows a happy time of undisturbed and immense productivity. Without paying much attention to the town of Arles itself with its

famous remains of Roman architecture, he paints the land-scape, the glorious wealth of blossoms in Spring in a series of orchards in bloom, the cornfields under the burning sun at harvest time, the almost intoxicating richness of colours of the autumn, the glorious beauty of the gardens and parks, " The Poet's Garden," where he sees as in a vision the ghosts of Dante and Petrarch roaming about. He paints " The Sower," " The Sunflowers," " The Starlit Night," the sea at St. Marie : his creative impulse and power are inexhaustible. " I have a terrible lucidity at moments, when nature is so glorious in those days I am hardly conscious of myself and the picture comes to me like in a dream," and rapturously he exclaims, " Life is after all enchanting."

His letters henceforth, written in French, give a complete image of what passes within him. Sometimes when he has written in the morning, he sits down again in the evening to tell his brother how splendid the day has been. " I never had such a chance, nature is extraordinarily beautiful here," and a day later, " I know that I wrote to you yesterday but the day has been again so glorious. My only regret is that you cannot see what I see here."

Completely absorbed in his work as he is, he does not feel the burden of the great loneliness that surrounds him in Arles, for except a short acquaintance with MacKnight, Bock and the Zouave lieutenant Milliet, he has no friends whatever. But when he has rented a little house of his own on the Place Lamartine, and arranges it after his own taste, decorates it with his pictures, makes it a " maison d'artiste," then he feels the old longing again, which he has already uttered at the beginning of his painting career in 1880, to associate himself with another artist, to live together and to work together. Just then he receives a letter from Paul Gauguin from Bretagne, who is in the greatest pecuniary embarrass-ment, and who tries in this roundabout way to ask Theo to try to sell some of his pictures for him : " I wanted to write to your brother but I am afraid to bother him, he being so busy from morning until night. The little I have sold is just enough to pay some urgent debts and in a month I shall have

absolutely nothing left. Zero is a negative force . . . I do not want to importune your brother, but a little word from you on this head would set my mind at ease or at least help me to have patience. My God, how terrible are these money questions for an artist."

At once Vincent grasps at the idea of helping Gauguin. He must come to Arles and they will live and work together. Theo will pay the expenses and Gauguin will give him pictures in exchange. Again and again he insists on this plan with his innate perseverance and stubbornness, though Gauguin at first did not seem at all inclined to it. They had made each other's acquaintance in Paris, but it had been no more than a superficial acquaintance, and they were too different in talent and character ever to harmonize in the daily intercourse.

Gauguin, born in Paris in 1848, was the son of a Breton father, a journalist in Paris, and a Creole mother. His youth was full of adventures, he had gone to sea as a cabin boy, had worked in a banker's office and had only painted in his leisure hours. Then after he had married and had a family, he devoted himself wholly to his art. His wife and children returned to her native city Copenhagen, as he was not able to provide for them, and he himself made a journey to Martinique where he painted, among others, his famous picture "The negresses." He was now in Pont Aven in Brittany, without any source of income, so that the great need of money made him accept Vincent's proposition and come to Arles. The whole undertaking was a sad failure and had for Vincent a fatal end.

Notwithstanding the months of superhuman exertion which lay behind him, he strained every nerve in a last manifestation of power before the arrival of Gauguin. "I am conceited enough to want to make a certain impression on Gauguin by my painting. I have finished as far as possible the things I had undertaken, pushed by the great desire to show him something new, and not to undergo his influence before I have shown him indisputably my own originality," writes Vincent in letter 556. When we know that to this last work belongs

one of Vincent's most famous pictures, " la chambre à coucher," and the series, " The Poet's Garden," it makes us feel rather sceptical about Gauguin's later assertion that before his arrival Vincent had only been bungling a little, and that he only made progress after Gauguin's lessons. We know then what to think of Gauguin's whole description of the episode at Arles, which is such a mixture of truth and fiction.

The fact is that Vincent was completely exhausted and overstrained, and was no match for the iron Gauguin with his strong nerves and cool arguing. It became a silent struggle between them, and the endless discussions held while smoking in the little yellow house were not fit to calm Vincent. " Your brother is indeed a little agitated and I hope to calm him by and by," Gauguin writes to Theo, shortly after his arrival at Arles. And to Bernard he tells more intimately how little sympathy there really is between Vincent and himself. " Vincent and I generally agree very little, especially about painting. He admires Daudet, Daubigny, Ziem, and the great Rousseau, all people whom I cannot bear. And on the contrary he detests Ingres, Raphaël, Degas, all people whom I admire. I answer, ' Brigadier, you are right,' in order to have peace. He loves my pictures very much, but when I make them he always finds I am wrong in this or that. He is romantic and I rather inclined to the primitive state."[1] And in later years when Gauguin again remembers this period he writes, " between two beings, he and I, he like a Vulcan, and I boiling too, a kind of struggle was preparing itself. . . ."[2] The situation in consequence becomes more and more strained. In the latter half of December Theo receives from Gauguin the following letter: " Dear Mr. van Gogh,—I would be greatly obliged to you for sending me a part of the money for the pictures sold. After all I must go back to Paris, Vincent and I simply cannot live together in peace, in consequence of incompatibility of temper, and he as well as I, we need quiet for our work. He is a man of remarkable intelli-

[1] " Paul Gauguin," by Chas. Morice, " Mercure de France," 1903.

[2] From Gauguin's later narrative of the events at Arles, in his Avant et Après, a set of memoirs written in 1903. [Ed.]

gence, whom I highly respect and leave with regret, but I repeat it is necessary. I appreciate all the delicacy in your conduct towards me and I beg you to excuse my decision." Vincent also writes, in letter 565, that Gauguin seems to be tired of Arles, of the yellow house, and of himself. But the quarrel is made up, Gauguin asks Theo to consider his return to Paris as an imaginary thing, and the letter he had written him as a bad dream. But it is only the calm before the storm.

The day before Christmas,—Theo and I were just engaged to be married and intended to go together to Holland—(I was staying in Paris with my brother A. Bonger, the friend of Theo and Vincent)—a telegram arrived from Gauguin which called Theo to Arles. Vincent had on the evening of the 24th of December, in a state of violent excitement, "un accès de fièvre chaude," (an attack of high fever) cut off a piece of his ear and brought it as a gift to a woman in a brothel. A big tumult had been raised. Roulin the postman had seen Vincent home, the police had interfered, had found Vincent bleeding and unconscious in bed, and sent him to the hospital. Theo found him there in a severe crisis, and stayed with him during the Christmas days. The doctor considered his condition very serious. "There were moments while I was with him that he was well, but very soon after he fell back into his worries about philosophy and theology. It was painfully sad to witness, for at times all his suffering overwhelmed him and he tried to weep but he could not; poor fighter and poor, poor sufferer; for the moment nobody can do anything to relieve his sorrow and yet he feels deeply and strongly. If he might have found somebody to whom he could have disclosed his heart, it would perhaps never have gone thus far," Theo wrote to me after he had come back to Paris with Gauguin, and a day later, "there is little hope, but during his life he has done more than many others, and he has suffered and struggled more than most people could have done. If it must be that he dies, be it so, but my heart breaks when I think of it." The anxiety lasted a few more days. Dr. Rey, the house doctor of the hospital, to whose care

Theo had entrusted him so urgently, kept him constantly informed. "I shall always be glad to send you tidings, for I too have a brother, I too have been separated from my family," he writes the 29th of December when the tidings are still very bad. The Protestant clergyman, the Rev. Salles, also visits Vincent and writes to Theo about his condition, and then there is last but not least the postman, Roulin, who is quite dismayed at the accident that befell his friend Vincent, with whom he spent so many pleasant hours at the "Café de la Gare" of Joseph Ginoux, and who has painted such beautiful portraits of him and his whole family! Every day he goes to the hospital for tidings and conveys them faithfully to Paris; as he is not a good penman, his two sons, Armand and Camille, serve him in turn as secretary. His wife too who posed for the "Berceuse" (Mme. Ginoux was the original of the "Arlésienne") visits her sick friend, and the first sign of recovery is when Vincent asks her about little Marcelle, the handsome baby he had painted such a short time ago. Then there comes a sudden change for the better in his condition. The Rev. Salles writes on the 31st of December that he had found Vincent perfectly calm, and that he is longing to start work again. A day later, Vincent himself writes a short note in pencil to reassure Theo, and on the second of January there comes another note from him, to which Dr. Rey has added a word of reassurance. The 3rd of January an enthusiastic letter of Roulin's, "Vincent has quite recovered. He is better than before that unfortunate accident happened to him," and he, Roulin, will go to the doctor and tell him to allow Vincent to go back to his pictures. The following day they had been out and spent four hours together. "I am very sorry my first letters were so alarming and I beg your pardon; I am glad to say I have been mistaken in this case. He only regrets all the trouble he has given you, and he is sorry for the anxiety he has caused. You may be assured that I will do all I can to give him some distraction," writes Roulin.

On the 7th of January Vincent leaves the hospital, apparently entirely recovered, but, alas, at every great excitement or

fatigue, the nervous attacks return . . . they last longer or
shorter, but leave him also periods of almost perfect health,
during which he goes back to his work with the old vigour.
In February he is taken back to the hospital for a short time,
but after his return to his little house, the neighbours have
grown afraid of him and send a petition to the mayor, saying
that it is dangerous to leave him at liberty, in consequence of
which he is actually again sent to the hospital on the 27th of
February—this time without any cause. Vincent himself for
a whole month keeps the deepest silence about this unhappy
affair, but the Rev. Salles sends Theo a faithful report. On
the 2nd of March he writes, " The neighbours have raised a
tumult out of nothing. The acts with which they have re-
proached your brother (even if they were exact), do not
justify taxing a man with alienation or depriving him of his
liberty. Unfortunately, the foolish act which necessitated his
first removal to the hospital made people interpret in a quite
unfavourable way every singular deed which the poor young
man might perform; from anyone else it would remain un-
observed, from him, everything takes at once a particular
importance. . . . As I told you yesterday, at the hospital he
has won everybody's favour and after all it is the doctor and
not the chief of police who has to judge in these matters."
The whole affair makes a deep impression on Vincent and
again causes an attack from which he recovers with astonish-
ing rapidity. It is again the Rev. Salles who tells Theo of
Vincent's recovery. On the 18th of March he writes, " Your
brother has spoken to me with perfect calmness and lucidity
of mind about his condition and also about the petition signed
by his neighbours. The petition grieves him very much. ' If
the police,' he says, ' had protected my liberty by preventing
the children and even the grown-ups from crowding around
my house and climbing the windows as they have done, (as if
I were a curious animal), I should have more easily retained
my self-possession, at all events I have done no harm to
anyone.' In short, I found your brother transformed, may
God maintain this favourable change. His condition has some-
thing indescribable, and it is impossible to understand the

sudden and complete changes which have taken place in him.
It is evident that as long as he is in the condition in which I
found him, there can be no question of interning him in an
asylum; nobody, as far as I know, would have this sinister
courage." A day after this interview with the Rev. Salles,
Vincent himself for the first time writes again to Theo and
justly complains that such repeated emotions might become
the cause of a passing nervous attack changing to a chronic
evil. And with quiet resignation, he adds, " to suffer without
complaint is the only lesson we have to learn in this life."

He soon recovers his liberty but continues to live in the
hospital for a short time, until the Rev. Salles shall have
found him new lodgings in a different part of the town. His
health is so good that the Rev. Salles writes on the 19th of
April, " sometimes even no traces seem left of the disease
which has affected him so vividly." But when he was going
to arrange with the new landlord, he suddenly avowed to the
Rev. Salles that he lacked the courage to start again a new
studio, and that he himself thought it best to go to an asylum
for a few months. " He is fully conscious of his condition,
and speaks with me about his illness, which he fears will
come back, with a touching openheartedness and simplicity,"
writes the Rev. Salles. " I am not fit," he told me the day
before yesterday, " to govern myself and my affairs. I feel
quite different than I was before." The Rev. Salles had then
looked around and advised the asylum of St. Rémy, situated
quite near Arles; he adds that the doctors at Arles approve of
it, " given the state of isolation in which your brother would
find himself upon leaving the hospital."

It was that which troubled Theo mostly. " Yes," he wrote
to me, shortly before our marriage, in answer to my question
if Vincent would not rather return to Paris, or spend some
time with his mother and sisters in Holland, as he was so
alone in Arles, " one of the greatest difficulties is, that whether
in good or bad health his life is so barren of distraction. But
if you knew him you would feel doubly how difficult is the
solution of the question what must and can be done for him.

" As you know he has long since broken with what is called

convention. His way of dressing and his manners show directly that he is an unusual personality and people who see him say, 'he is mad.' To me it does not matter, but for mother that is impossible. Then there is something in his way of speaking that makes people either like or dislike him strongly. He has always people around him, who sympathize with him, but also many enemies. It is impossible for him to associate with people in an indifferent way. It is either the one or the other, even to those who are his best friends it is difficult to remain on good terms with him, as he spares nobody's feelings. If I had time for it, I would go to him and, for instance, take a walking tour with him. That is the only thing, I imagine, that would do him good. If I can find somebody among the painters who would like to do it, I will send him. But those with whom he would like to go, are somewhat afraid of him, a circumstance which the visit of Gauguin did not change, on the contrary.

"Then there is another thing which makes me afraid to have him come here. In Paris he saw so many things which he liked to paint, but again and again it was made impossible for him to do so. Models would not pose for him, he was forbidden to paint on the street, and with his irascible temper this caused many unpleasant scenes, which excited him so much that he became unapproachable to everybody and at last he got a great dislike of Paris. If he himself had wanted to come back here, I would not hesitate for a moment . . . but again I think I can do no better than to let him follow his own wishes. A quiet life is impossible for him, except alone with nature or with very simple people like the Roulins, for wherever he passes he leaves the trace of his passing. Whatever he sees that is wrong he must criticize and that often occasions strife.

"I hope that he will find, some time, a wife who will love him so much that she will share his life but it will be difficult to find one who would be fit for that. Do you remember that girl in 'Terre Vierge' by Tourgenief, who is with the nihilists and brought the compromising papers across the frontiers? I imagine she should be like that, somebody who

has gone through life's misery to the bottom. . . . It pains me not to be able to do something for him, but for uncommon people uncommon remedies are necessary and I hope these will be found where ordinary people would not look for them."

When Vincent himself now resolves to go to St. Rémy, Theo's first impression is that this may be a kind of self-sacrifice so as to be in nobody's way, and he writes to him once more asking with emphasis, whether he would not rather go to Pont-Aven or go to Paris.

But as Vincent sticks to his resolution Theo writes to him: " I do not consider your going to St. Rémy a retreat as you call it, but simply as a temporary rest cure which will make you come back with renewed strength. I for my part attribute your illness principally to the fact that your material existence has been too much neglected. In an establishment like that of St. Rémy there is a great regularity in the hours for meals, etc., and I think that regularity will do you no harm, on the contrary." When Theo has arranged everything with the director of the establishment, Dr. Peyron, a free room for Vincent and a room where he can paint, and as much liberty as possible to wander about as he likes, Vincent leaves for St. Rémy on the 8th of May accompanied by the Rev. Salles who writes to Theo the next day : " Our voyage to St. Rémy has been accomplished under the most excellent conditions; Monsieur Vincent was perfectly calm and himself has explained his case to the director as a man who is fully conscious of his condition. He remained with me till my departure and when I took leave of him he thanked me warmly and seemed somewhat moved, thinking of the new life he was going to lead in that house. Monsieur Peyron has assured me that he will show him all the kindness and consideration which his condition demands." How touching sounds that, " somewhat moved," at the departure of the faithful companion! His leave-taking broke the last tie that united Vincent with the outer world and he stayed behind in what was worse than the greatest loneliness, surrounded by neurotics and lunatics, with nobody to whom he could talk, nobody who understood him.

Dr. Peyron was kindly disposed, but he was a reserved silent character, and the monthly letters by which he keeps Theo informed of the situation are not full of the warm sympathy which the doctors in the hospital at Arles showed him.

A full year Vincent spent amid these cheerless surroundings, struggling with unbroken energy against the ever returning attacks of his illness, but continuing his work with the old restless zeal, which alone can keep him living now that everything else has failed him. He paints the desolate landscape which he sees from his window at sunrise and sunset, he undertakes long wanderings to paint the wide fields, bordered by the range of hills of the Alps, he paints the olive orchards with their dismally twisted branches, the gloomy cypresses, the sombre garden of the asylum, and he painted also the "Reaper," "that image of death as the great book of Nature represents it to us."

It is no longer the buoyant, sunny, triumphant work from Arles; there sounds a deeper sadder tone than the piercing clarion sounds of his symphonies in yellow of the last year: his palette has become more sober, the harmonies of his pictures have passed into a minor key.

"To suffer without complaint," well had he learned that lesson; and when in August the treacherous evil attacks him again, just when he had hoped to be cured for good, he only utters a desponding sigh, "I can see no possibility of again having hope or courage."

Having painfully struggled through the winter, in which however he paints some of his most beautiful works, the "Pietà" after Delacroix, the "Resurrection of Lazarus," and the "Good Samaritan" after Rembrandt, the "Quatre heures du jour" after Millet, a few months follow during which he is not able to work, but now he feels that he would lose his energy for ever if he stayed longer in those fatal surroundings, he *must* get away from St. Rémy. For some time Theo had been looking around for a fit opportunity—near Paris and yet in the country—where Vincent could live under the care of a physician, who would at the same time be a friend to him, and when he had found this at last, by the recommendation of

Pissarro at Auvers sur Oise, an hour by train from Paris, where lived Dr. Gachet who had been in his youth a friend of Cézanne, Pissarro and the other Impressionists, then Vincent returns from the south on the 17th of May 1890. First he was going to spend a few days with us in Paris; a telegram from Tarascon informed us that he was going to travel that night and would arrive at ten in the morning. Theo could not sleep that night for anxiety—if anything happened to Vincent on the way, he had but scarcely recovered from a long and serious attack and had refused to be accompanied by anyone. How thankful we were when it was at last time for Theo to go to the station!

From the Cité Pigalle to the Gare de Lyon is a long distance, it seemed an endless time before they came back and I began to be anxious that something had happened, when I saw at last an open fiacre enter the Cité, two merry faces nodded to me, two hands waved—a moment later Vincent stood before me.

I had expected to see a patient and there stood before me a strong, broad-shouldered man, with a healthy colour, a smile on his face and an expression of great resoluteness in his whole appearance; from all the self-portraits the one before the easel is most like him at that period. Apparently there had again come such a sudden puzzling change in his state as the Rev. Salles had already observed to his great surprise at Arles.

" He seems perfectly well, he looks much stronger than Theo," was my first thought.

Then Theo drew him to the room where was the cradle of our little boy, that had been named after Vincent : silently the two brothers looked at the quietly sleeping baby—both had tears in their eyes. Then Vincent turned smilingly to me and said, pointing to the simple crocheted cover on the cradle : " Do not cover him too much with lace, little sister."

He stayed with us three days and was all the time cheerful and lively. St. Rémy was not mentioned. He went out by himself to buy olives which he used to eat every day and which he insisted on our eating too; the first morning he was

up very early and was standing in his shirt-sleeves looking at his pictures of which our apartment was full; the walls were covered with them—in the bedroom the "Blooming Orchards," in the dining-room over the mantelpiece the "Potato Eaters," in the sitting-room (salon was too solemn a name for the cosy little room) the great "Landscape from Arles," and the "Night View on the Rhône," besides to the great despair of our *femme de ménage,* there were under the bed, under the sofa, under the cupboards, in the little spare room, huge piles of unframed canvases, that were now spread out on the ground and studied with great attention.

We had also many visitors, but Vincent soon perceived that the bustle of Paris did him no good and he was longing to set to work again. So he started the 21st of May for Auvers, with an introduction to Dr. Gachet, whose faithful friendship was to become his greatest support during the short time he was to spend at Auvers. We promised to come and see him soon, and he also wanted to come back to us in a few weeks to paint our portraits. In Auvers he took up his lodgings at an inn and immediately set to work.

The hilly landscape with the sloping fields and thatched roofs of the village pleased him, but what he enjoyed most was to have models again, and again to paint figures. One of the first portraits he painted was that of Dr. Gachet, who immediately felt great sympathy for Vincent, so that they spent most of their time together and became great friends—a friendship not ended by death, for Dr. Gachet and his children continued to honour Vincent's memory with rare piety, that became a form of worship, touching in its simplicity and sincerity. "The more I think of it the more I think Vincent was a giant. Not a day passes that I do not look at his pictures, I always find there a new idea, something different each day. . . . I think again of the painter and I find him a colossus. Besides he was a philosopher. . . ."

So Gachet wrote to Theo shortly after Vincent's death and speaking of the latter's love for art he says : "The word love of art is not exact, one must call it *faith,* a faith to which

Vincent fell a martyr!" None of his contemporaries had
understood him better.

It was curious to note that Dr. Gachet himself somewhat
resembled Vincent physically (he was much older) and his son
Paul—then a boy of fifteen years—resembled Theo a little.

Their house, built on a hill, was full of pictures and
antiques, which received but scanty daylight through the
small windows; before the house there was a splendid terraced
flower-garden, behind, a large yard where all kinds of ducks,
hens, turkeys and peacocks walked about in the company of
four or five cats; it was the home of an original, but an
original of great taste.

The doctor no longer practised in Auvers, but had an office
in Paris where he gave consultations a few days a week, the
rest of the time he painted and etched in his room, that looked
most like the workshop of an alchemist of the Middle Ages.
Soon after, the 10th of June, we received an invitation from
him to come with the baby and spend a whole day in Auvers.
Vincent came to meet us at the train and he brought a bird's
nest as a plaything for his little nephew and namesake. He
insisted upon carrying the baby himself and had no rest until
he had shown him all the animals in the yard, where a too-
loudly crowing cock made the baby red in the face for fear
and made him cry, whilst Vincent cried laughingly, "the
cock crows cocorico," and was very proud that he had intro-
duced his little namesake to the animal world. We lunched
in the open air and after lunch took a long walk; the day was
so peacefully quiet, so happy, that nobody would have sus-
pected how tragically a few weeks later our happiness was to
be destroyed for ever. In the first days of July, Vincent
visited us once more in Paris; we were exhausted by a serious
illness of the baby—Theo was again considering the old plan
of leaving Goupil and setting up his own business, Vincent
was not satisfied with the place where the pictures were kept,
and our removal to a larger apartment was talked of; so
those were days of much worry and anxiety. Many friends
came to visit Vincent, among others, Aurier, who had written

recently his famous article about Vincent,[1] and who now came again to look at the pictures with the painter himself, and Toulouse Lautrec who stayed for lunch with us and made many jokes with Vincent about an undertaker they had met on the stairs. Guillaumin was also expected to come, but it became too much for Vincent, so he did not wait for this visit but hurried back to Auvers—overtired and excited, as his last letters and pictures show, in which the threatening catastrophe seems approaching like the ominous black birds that dart through the storm over the cornfields.

" I hope he is not getting melancholy or that a new attack is threatening again, everything has gone so well lately," Theo wrote to me the 20th of July, after he had taken me with the baby to Holland and himself had returned to Paris for a short time, till he also should take his holidays. On the 25th he wrote to me, " there is a letter from Vincent which seems very incomprehensible; when will there come a happy time for him? He is so thoroughly good." That happy time was never to come for Vincent; fear of the again threatening attack or the attack itself, drove him to death.

On the evening of the 27th of July, he tried to kill himself with a revolver. Dr. Gachet wrote that same evening to Theo the following note, " With the greatest regret I must bring you bad tidings. Yet I think it my duty to write to you immediately. At nine o'clock in the evening of to-day, Sunday, I was sent for by your brother Vincent who wanted to see me at once. I went there and found him very ill. He has wounded himself . . . as I did not know your address and he refused to give it to me, this note will reach you through Goupil." The letter reached Theo in consequence only the next morning and he immediately started for Auvers. From there he wrote to me the same day, the 28th of July : " This morning a Dutch painter[2] who also lives in Auvers brought me a letter from Dr. Gachet that contained bad tidings about Vincent and asked me to come. Leaving everything I went

[1] " Les Isolés," " Mercure de France," Janvier 1890.
[2] Hirschig.

and found him somewhat better than I expected. I will not write the particulars, they are too sad, but you must know dearest, that his life may be in danger. . . .

" He was glad that I came and we are together all the time . . . poor fellow, very little happiness fell to his share and no illusions are left him. The burden grows too heavy for him, at times he feels so alone. He often asks for you and the baby, and said that you would not imagine there was so much sorrow in life. Oh! if we could give him some new courage to live. Don't make yourself too anxious, his condition has been so hopeless before, but his strong constitution deceived the doctors." That hope proved idle. Early in the morning of the 29th of July Vincent passed away.

Theo wrote to me, " one of his last words was : ' I wish I could die now,' and his wish was fulfilled. A few moments and all was over. He had found the rest he could not find on earth. . . . The next morning there came from Paris and elsewhere eight friends who decked the room where the coffin stood with his pictures, which came out wonderfully. There were many flowers and wreaths. Dr. Gachet was the first to bring a large bunch of sunflowers, because Vincent was so fond of them. . . .

" He rests in a sunny spot amidst the cornfields. . . ."

From a letter of Theo's to his mother : " One cannot write how grieved one is nor find any comfort. It is a grief that will last and which I certainly shall never forget as long as I live ; the only thing one might say is, that he himself has the rest he was longing for . . . life was such a burden to him ; but now, as often happens, everybody is full of praise for his talents. . . . Oh! mother he was so my own, own brother."

Theo's frail health was broken. Six months later, on the 25th of January 1891, he had followed his brother.

They rest side by side in the little cemetery between the cornfields of Auvers.

J. VAN GOGH-BONGER

December, 1913

EARLY YEARS

The Hague, January 28 1873

Dear Theo,

I was glad you answered me so soon and that you like Brussels and have found a nice boarding-house. Don't lose heart if it is very difficult at times, everything will come out all right and nobody can in the beginning do as he wishes.

How I pity Uncle Hein, I heartily hope he will recover, but, Theo, I fear he will not. Last summer he was still full of enthusiasm and had so many plans and told me that business was flourishing. It's very sad. Last Sunday I was at Uncle Cor's and spent a very pleasant day there as you can imagine, and saw so many beautiful things. As you know, Uncle has just come back from Paris and brought some beautiful pictures and drawings with him. I remained in Amsterdam till Monday morning and went to see the museums again. Do you know that they are going to build a large new museum in Amsterdam, instead of the Trippenhuis? I think it is right, for the Trippenhuis is small and many pictures are hung so that they can hardly be seen.

How I should have liked to see that picture by Cluysenaer, I have only seen a few pictures of his and those I liked very much. Tell me if that other picture is by " *Alfred* " Stevens, or else what the first name is. I know the photograph after the Rotta[1] and have even seen the picture at the Exhibition in Brussels. Be sure to let me know what pictures you see, I am always glad to know. The album of which you gave me the title is not the one I meant, which is *only* lithographs after Corot. But I thank you for the trouble you have taken. I hope to get a letter from sister Anna soon, she is rather laggard about writing of late. Do surprise her with a letter, that would be such a pleasure to her. I suppose you are very

[1] Italian painter (Venice).

busy, but that is not bad. It is cold here and they are skating already. I walk as much as I can. I wonder if you will have any chance to skate. Enclosed you will find my photograph, but if you write home don't mention it, as you know it is for father's birthday. I have already sent you my congratulations upon that day. My best compliments to Uncle and Aunt, also to Mr. Schmidt and Eduard. Always

<div style="text-align:right">Your loving brother,
Vincent</div>

Kind regards from everybody at Haanebeek's, Aunt Fie and Roos.

<div style="text-align:right">London, July 31 1874</div>

Dear Theo,

I am glad you have read Michelet[1] and that you understand him so well. Such a book teaches us that there is much more in love than people generally suppose.

That book has been a revelation to me as well as a Gospel at the same time, " no woman is old." (That does not mean that there are no old women, but that a woman is not old as long as she loves and is loved.) And then such a chapter as " The Aspirations of Autumn," how beautiful it is.

That a woman is quite a different being than a man, and a being that we do not yet know, at least only quite superficially, as you said, yes, I am sure of it. And that man and wife can be one, that is to say one whole and not two halves, yes, I believe that too.

A. keeps well, we take beautiful walks together. It is so beautiful here if one has only an open and simple eye with few beams in it. But if one has that it is beautiful everywhere.

That picture by Thijs Maris which Mr. Teersteg[2] has bought must be beautiful, I have heard about it already and I myself have bought and sold one quite similar.

Since my return to England my love for drawing has

[1] Author of *L'Amour* and *la Femme*.
[2] Representative of Goupil & Co. in The Hague.

stopped, but perhaps I will take it up again some day or other. I am reading a great deal just now.

Probably we move on the 1st of January, 1875, to another larger house. Mr. Obach is in Paris just now to decide whether we shall take over that other business or not. Don't speak about it for the moment to anybody.

I hope you are all right and will write to us soon. A. begins to enjoy seeing pictures and sees them pretty well, she likes Boughton, Maris and Jacquet, so that is a beginning. *Entre nous*, I think it will be very difficult to find something for her, they say everywhere that she is too young, and generally German is required, but at all events, she has more chances here than in Holland. Adieu.

Vincent

You can imagine how pleasant it is to be here together with A. Tell Mr. Tersteeg the picture arrived in good order and that I will write to him soon.

London, March 6 1875

Dear Theo,

Bravo, Theo. Your appreciation of that girl in "Adam Bede" is very good. That landscape—in which the fallow, sandy path runs over the hill to the village, with its clay or white-washed cottages, with mossgrown roofs, and here and there a black thornbush, on either side of the brown heath, and a gloomy sky over it, with a narrow white streak at the horizon—it is out of Michel.[1]

But there is a still purer and nobler sentiment in it than in Michel. To-day I enclose, in the box we send, the little book containing poetry I spoke of. Also "Jesus" by Renan and "Joan of Arc" by Michelet and also a portrait of Corot from the "London News," which hangs in my room too.

I do not think you have any immediate chance of being transferred to the house in London.

[1] The French landscapist of the early nineteenth century, Georges Michel—much influenced by the landscapes of Rembrandt.

Don't regret that your life is too easy, mine is rather easy too; I think that life is pretty long and that the time will arrive soon enough in which "another shall gird thee and carry thee where thou wouldst not."[1]

Adieu, remember me to all the friends. With a firm handshake,

<div align="right">Vincent</div>

<div align="right">Paris, July 24 1875</div>

Dear Theo,

A few days ago we received a picture by de Nittis, a view of London on a rainy day, Westminster Bridge and the Houses of Parliament. I used to pass Westminster Bridge every morning and every evening and know how it looks when the sun sets behind Westminster Abbey and the Houses of Parliament, and how it looks early in the morning, and in winter in snow and fog.

When I saw the picture I felt how much I loved London. Still I think that it is better for me that I left it.

This in answer to your question.

I certainly do not believe that you will be sent to London.

Thanks for the "Springtime of Life." And "At Midnight" by Rückert. The first is very beautiful, the latter reminds me of "September Night" by de Musset. I wish I could send it you, but I do not possess it.

Yesterday we sent a box to The Hague in which you will find what I promised you.

I hear that Anna and Liesbeth are at home, I should like to see them.

Be as happy as you can and write to me soon. With a firm handshake,

<div align="right">Your loving brother,</div>
<div align="right">Vincent</div>

[1] *John* XXI 18.

Paris, September 17 1875

Dear Theo,

A feeling, even a keen one for the beauties of Nature is not the same as a religious feeling, though I think these two stand in close relation to one another.

Almost everybody has a feeling for nature, one more, the other less, but there are a few who feel that God is a spirit and they who worship Him must worship Him in spirit and in truth.[1] Our parents belong to those few; I think Uncle Vincent does too.

You know that there is written: " The world passeth away and the lust thereof."[2] And that there is mention also on the other hand of " a good part that shall not be taken away from us,"[3] and, " a well of water springing up into everlasting life."[4] Let us also pray that we become rich in God; but do not think too deeply about these things, gradually they will become clearer to you, and do as I suggested. Let us ask that our part in life should be to become the poor in the kingdom of God, God's servants. We are still far from it; let us pray that our eye may become single and then our whole body shall be full of light.[5]

Compliments to Roos and to anybody who asks about me.

Your loving brother,

Vincent

It is the same with the feeling for art. Don't give yourself utterly to that. Keep by all means love for your work and respect for Mr. Tersteeg. Later on you will see better than now how much he deserves it.

[1] *John* IV 24. [2] I *John* II 17.

[3] *Luke* X 42: the closing words of the episode at the house of Martha and Mary—an episode which must have appealed to Vincent in a deep way in terms of the characters involved.

[4] *John* IV 14, describing the meeting with the woman of Samaria —another New Testament character who must have appealed deeply to Vincent, given the close familiarity with the text in point that is indicated by two citations from it in this single short letter.

[5] See *Luke* XI 34, the Biblical metaphor of light was again one of deep significance.

However you need not exaggerate this.

Is your appetite good? Eat especially as much bread as you like. Good night, I must give my boots a shine for to-morrow.

Paris, Sept. 25 1875

Dear Theo,

The path is narrow, therefore we must be careful. You know how others have arrived where we want to go, let us take that simple road too.

*Ora et labora,*1 let us do our daily work, whatever the hand finds to do, with all our strength and let us believe that God will give good gifts, a part that will not be taken away, to those who ask Him for it.

" Therefore if any man be in Christ, he is a new creature : old things are past away; behold all things are become new!" (2 Cor. v. 17.)

I am going to destroy all my books by Michelet, etc. I wish you would do the same.

How I am longing for Christmas, but let us have patience, it will come soon enough.

Courage, lad; my compliments to all the friends, and believe me,

Your loving brother,

Vincent

As soon as possible I will send the money for the frames. When I write to Mr. Tersteeg, I will tell him that for the moment I am rather short of cash; I asked our cashier to hold back every month a part of my salary as I shall want a lot of money around Christmas for my journey, etc., however I hope to send it before long.

Paris, October 14 1875

Dear Theo,

I send you again a few words to cheer myself as well as you. I advised you to destroy your books, and do so now;

1 " Pray and work "

yes, do so, it will give you rest; but take care all the same not to become narrow-minded and afraid of reading what is well written; on the contrary doing that is a *comfort* in life. "Whatsoever things are true, whatsoever things are honest, whatsoever things are just, whatsoever things are pure, whatsoever things are lovely, whatsoever things are of good report; if there be any virtue, and if there be any praise, think on these things."[1]

Look for light and freedom and *do not ponder too deeply over the evil in life.*

How I should like to have you here and show you the Luxembourg and the Louvre; but I think you too will come here after a while. Father wrote to me once, "Do not forget the story of Icarus, who wanted to fly to the sun and arrived at a certain height, then lost his wings and dropped into the sea." You will often feel that neither you nor I are what we hope to become some day and that we are still far beneath father and other people; that we are wanting in solidity, simplicity and sincerity; one cannot become simple and true in one day. But let us persevere, *above all let us have patience; those who believe hasten not;* still there is a difference between our longing to become real Christians and that of Icarus to fly to the sun. I think there is no harm in having a relatively strong body, take care to feed yourself well, and if sometimes you are very hungry, or rather have an appetite, eat well then. I assure you that I often do the same, and certainly used to do so. Especially bread, boy, "Bread is the staff of life," is a proverb of the English (though they are very fond of meat too, and in general take too much of it). And now write to me soon and put in the things of everyday life.

Keep good courage and give my compliments to everybody who asks about me; within a month or two I hope we shall see each other.

With a firm handshake, I am always

Your loving brother,

Vincent

[1] *Philippians* IV 8.

Paris, February 19 1876

Dear Theo,

Thanks for your last letter and also for the catalogue sent in the last box.

Have I thanked you already for Andersen's tales, if not I do so now. From home I have heard that this spring you will have to travel on business, you will not be sorry for that I suppose, it is a good exercise and you will see many beautiful things in your travels.

In the next box you will find Longfellow. Yesterday evening Gladwell was with me, he comes every Friday and we read poetry together.

I have not read " Hyperion " yet, but I have heard that it is very beautiful, I have just read a very beautiful book by Eliot, three tales, called " Scenes from Clerical Life "; the last story in particular, " Janet's Repentance," struck me very much.[1] It is the life of a clergyman who lives chiefly among the inhabitants of the dirty streets of a town, his study looks out on the gardens with stumps of cabbage, etc., and on the red roofs and smoking chimneys of poor tenements. For his dinner he usually had nothing but underdone mutton and watery potatoes. He died at the age of thirty-four and during his long illness he was nursed by a woman who was a drunkard, but by his teaching, and leaning as it were on him, she had conquered her weakness and found rest for her soul. At his burial they read the chapter which says, " I am the resurrection and the life, he that believeth in me, though he were dead, yet shall he live."[2] And now it is again Saturday evening, for the days pass so quickly and the time for my

[1] Vincent's paraphrase of the story which follows offers many striking parallels with his own subsequent life; it was characteristic of him to identify himself with fictional heroes, and to pick out from the books he read whatever seemed to have a moral and spiritual application to his own destiny.

[2] *John* XI 25.

departure will soon be here. No answer as yet from Scar-
borough. Kind greetings and a handshake, always

 Your loving brother,
 Vincent

 Ramsgate, England, April 28 1876
Dear Theo,

Many happy returns, my best wishes for this day, may our
mutual love increase with the years.

I am so glad that we have so many things in common, not
only memories of childhood but also that you are working in
the same business in which I was till now and know so
many people and places which I know also, and that you
have so much love for nature and art.

Mr. Stokes[1] has told me that he intends to move after the
holidays, of course with the whole school, to a little village
on the Thames about three hours from London. There he will
organize his school somewhat differently and perhaps enlarge
it.

Now I am going to tell you about a walk we took yester-
day. It was to an inlet of the sea, and the road thither led
through fields of young corn and along hedges of hawthorn,
etc.

Arriving there, we saw to our left a high steep ridge of sand
and stone as tall as a two-storey house. On the top of it were
old, gnarled hawthorn bushes, whose black and grey moss-
grown stems and branches were all bent to one side by the
wind, there were also a few elder bushes.

The ground on which we walked was covered all over with
big grey stones, chalk and shells.

To the right lay the sea, as calm as a pond and reflecting
the light of the transparent grey sky where the sun was
setting.

The tide was out and the water very low.

Thanks for your letter of yesterday, I am very glad that

[1] Head of the school; the move was to Isleworth.

Willem Valkis is also an employee of the house. Give him my best regards. I wish I could walk once more with you through my woods, to Scheveningen.

Have a pleasant day to-day and give my love to all who may ask about me and believe me,

Your loving brother,

Vincent

Once more my best wishes, lad, I hope you will begin a happy and prosperous year. These are important years that we are living through now and much depends on them. May everything come out all right.

A hearty handshake. à Dieu.

Ramsgate, England, May 31 1876

Dear Theo,

Bravo, that you got yourself to Etten on the 21st of May, so that four of the six children were at home. Father wrote me in detail how the day was spent.

Thanks also for your last letter.

Did I tell you about the storm I saw lately? The sea was yellowish especially near the shore; at the horizon a streak of light and above it the immense dark grey clouds from which the rain poured down in slanting streaks. The wind blew the dust from the little white path on the rocks into the sea and swayed the blooming hawthorn bushes and wallflowers that grow on the rocks. To the right were fields of young green corn and in the distance the town that looked like the towns that Albrecht Dürer used to etch. A town with its turrets, mills, slate roofs and houses built in Gothic style, and below, the harbour between two dykes, projecting far into the sea. I also saw the sea last Sunday night, everything was dark and grey, but at the horizon the day began to dawn.

It was still very early but a lark was singing already. So were the nightingales in the gardens near the sea. In the distance shone the light from the lighthouse, the guardship, etc.

That same night I looked from the window of my room on the roofs of the houses that can be seen from there and on the tops of the elm trees, dark against the night sky. Over those roofs, one single star, but a beautiful, large, friendly one. And I thought of you all and of my own past years and of our home, and in me arose the words and the feeling: " Keep me from being a son who makes ashamed, give me Thy blessing, not because I deserve it but for my mother's sake. Thou art love, cover all things. Without Thy continued blessings we succeed in nothing."

Enclosed is a little drawing of the view from the window of the school, through which the boys wave good-bye to their parents after a visit when they are going back to the station.

None of us will ever forget the view from the window. *You ought to have seen* it this week when we had rain, especially in the twilight when the lamps were on and their light reflected in the wet street.

Days like that could put Mr. Stokes into a bad temper, and when the boys made more noise than he liked, it sometimes happened that they had to go without their supper.

I wish you could have seen them then looking from the window, it was rather melancholy; they have so little else except their meals to look forward to and to help them pass their days. I also should like you to see them going from the dark stairs and passage to the dining-room, a place of bright sunshine.

Another curious place is the room with the rotten floor, where are six washing basins in which they have to wash themselves and where a dim light flows through the window with its broken panes on the washing stand, this a rather a melancholy sight. I should like to spend a winter with them or have spent a winter with them in the past to know what it is like. The boys made an oil stain on your drawing, please excuse them.

Enclosed a little note for Uncle Jan. And now good night, if anybody should enquire after me give them my kind regards. Do you visit Borchers now and then, if you see him

L.V.G.

greet him for me, also Willem Valkis and all at Roos'. A handshake from

<div align="center">
Your loving brother,

Vincent
</div>

Isleworth, England, October 7 1876

Dear Theo,

It is Saturday again and I write once more. How I long to see you again, Oh! my longing is sometimes so strong. Write soon, a little word as to how you are.

Last Wednesday we took a long walk to a village an hour's distance from here. The road led through meadows and fields, along hedges of hawthorn, full of blackberries and clematis, and here and there a large elm tree. It was so beautiful when the sun set behind the grey clouds, and the shadows were long. By chance we met the school of Mr. Stokes, where there are still several of the boys I knew.

The clouds retained their red hue long after the sun had set and the dusk had settled over the fields, and we saw in the distance the lamps lit in the village. While I was writing to you, I was called to Mr. Jones, who asked if I would walk to London to collect some money for him. And when I came home in the evening, hurrah, there was a letter from Father with tidings about you. How I should like to be with you both, my boy. And thank God there is some improvement, though you are still weak. And you will be longing to see Mother, and now that I hear that you are going home with her, I think of the words of Conscience:[1]

" I have been ill, my mind was tired, my soul disillusioned and my body suffering. I whom God has endowed at least with moral energy and a strong instinct of affection, I fell in the abyss of the most bitter discouragement and I felt with horror how a deadly poison penetrated my stifled heart. I spent three months on the moors, you know that beautiful region where the soul retires within itself and enjoys a

[1] A Flemish author.

delicious rest, where everything breathes calm and peace; where the soul in presence of God's immaculate creation throws off the yoke of conventions, forgets society, and loosens its bonds, with the strength of renewed youth; where each thought takes the form of prayer, where everything that is not in harmony with fresh and free nature quits the heart. Oh, there the tired souls find rest, there the exhausted man regains his youthful strength. So I passed my days of illness. . . . And then the evening! To be seated before the big fireplace with one's feet in the ashes, one's eyes fixed on a star that sends its ray through the opening in the chimney as if to call me, or absorbed in vague dreams too much to look at the fire, to see the flames rise, flicker, and supplant one another as if desirous to lick the kettle with their tongues of fire, and to think that such is human life : to be born, to work, to love, to grow and to disappear."

Mr. Jones has promised me that I shall not have to teach so much in future, but that I may work in his parish, visiting the people, talking with them, etc. May God give His blessing to me.

Now I am going to tell you about my walk to London. I left here at twelve o'clock in the morning and reached my destination between five and six. When I came into that part of the town where most of the picture galleries are, around the Strand, I met many acquaintances : it was dinner-time, so many were in the street, leaving the office or going back there. First I met a young clergyman who once preached here, and with whom I then became acquainted, and then the employee of Mr. Wallis, and then one of the Messrs. Wallis himself, whom I used to visit now and then at his house, now he has two children; then I met Mr. Reid and Mr. Richardson,[1] who are already old friends. Last year about this time Mr. Richardson was in Paris and we walked together to Père Lachaise.

After that I went to van Wisselingh, where I saw sketches

[1] Reid was an English art-dealer; Richardson was the travelling representative for Theo's firm.

for two church windows. In the middle of one window stands
the portrait of a middle-aged lady, oh, such a noble face,
with the words " Thy will be done," over it, and in the other
window the portrait of her daughter, with the words, " Faith
is the substance of things hoped for, the evidence of things
not seen."[1] There, and in the gallery of Messrs. Goupil &
Co., I saw beautiful pictures and drawings. It is such an
intense delight to be so often reminded of Holland by art.

In the City I went to see Mr. Gladwell and to St. Paul's
Church. And from the City to the other end of London,
where I visited a boy who had left the school of Mr. Stokes
because of illness and I found him quite well, playing in the
street. Then to the place where I had to collect the money
for Mr. Jones. The suburbs of London have a peculiar
charm, between the little houses and gardens are open spots
covered with grass and generally with a church or school or
workhouse in the middle between the trees and shrubs, and
it can be so beautiful there, when the sun is setting red in
the thin evening mist.

Yesterday evening it was so, and afterwards I wished you
could have seen those London streets when the twilight began
to fall and the lamps were lit, and everybody went home;
everything showed that it was Saturday night and in all that
bustle there was peace, one felt the need of and the excite-
ment at the approaching Sunday. Oh, those Sundays and all
that is done and accomplished on those Sundays, it is such a
comfort for those poor districts and crowded streets.

In the City it was dark, but it was a beautiful walk along
the row of churches one has to pass. Near the Strand I took
a bus that took me quite a long way, it was already pretty late.
I passed the little church of Mr. Jones and saw in the dis-
tance another one, where at that hour a light was still burn-
ing; I entered and found it to be a very beautiful little
Catholic church, where a few women were praying. Then I
came to that dark park about which I have written you already
and from there I saw in the distance the lights of Isleworth

[1] *Hebrews* XI 1.

and the church with the ivy, and the churchyard with the weeping willows beside the Thames.

To-morrow I shall get for the second time some small salary for my new work, and with it buy a pair of new boots and a new hat. And then, with God's will, I shall go fitted out afresh.

In the London streets they sell scented violets everywhere, they flower here twice a year. I bought some for Mrs. Jones to make her forget the pipe I smoke now and then, especially late in the evening on the playground, but the tobacco here has a touch of gloom about it.

Well, Theo, try to get well soon and read this letter when Mother is sitting with you, because I should like to be with you both in thought. I cannot tell you how glad I am that Mr. Jones has promised to give me work in his parish, so that I shall find by and by what I want. I am longing so much for you. A handshake for yourself and one for Mother when she is sitting beside you. Many regards to the Roos family and to everyone I know, especially to Mr. Tersteeg. Tell Mother it was delightful to put on a pair of socks knitted by her, after that long walk to London.

This morning the sun rose so beautifully again, I see it every morning when I wake the boys, à Dieu.

Your loving brother,

Vincent

[Dordrecht, Holland, April 16 1887]

Dear Theo,

Thanks for your letter, be strong and He will strengthen your heart.[1] To-day I received a long letter from home, in which father asked me if we could arrange to go together to Amsterdam next Sunday, to visit Uncle Cor. If you agree I will arrive at The Hague Saturday night at eleven o'clock, and we can go on to Amsterdam by the first train the next morning.

I think we had better do so, Father seems to have set his

[1] See *Psalms* XXVII 14.

heart upon it, and it will be nice to spend another Sunday together. Can I stay over night with you—otherwise I could go to a hotel. Write me a postcard if it is all right, let us keep close together.

It is already late, this afternoon I took a long walk, because I felt I needed it, first around the cathedral, then past the New Church, and then along the dyke, where the mills are that one sees in the distance as one walks near the station. There is so much expressed in this peculiar landscape and surrounding, it seems to say: "Be of good courage, fear not."[1]

Oh! might I be shown the way to devote my life more completely to the service of God and the Gospel. I keep praying for it and I think I shall be heard, I say it in all humility. Humanly speaking, one would say it cannot happen, but when I think seriously about it and penetrate under the surface of what is impossible to man, then my soul is in communion with God, for it is possible to Him, who speaks and it is done; who commands and it stands fast.[2]

Oh! Theo, Theo boy, if I might only succeed in this, if that heavy depression because everything I undertook failed, that torrent of reproaches which I have heard and felt, if it might be taken from me, and if there might be given to me both the opportunity and the strength needed to come to full development and to persevere in that course for which my father and I would thank the Lord so fervently. A handshake and kind regards to Roos,

<div style="text-align:right">Ever your loving brother,
Vincent</div>

<div style="text-align:right">Amsterdam, May 30 1877</div>

Dear Theo,

Thanks for your letter that arrived to-day, I am very busy and write in a hurry. I gave your letter to Uncle Jan, he sends you his greetings and thanks for it.

There was a sentence in your letter that struck me, " I wish

[1] See *Deuteronomy* XXXI 6, etc. [2] See *Psalms* XXXIII 9.

I were far away from everything, I am the cause of all, and bring only sorrow to everybody, I alone have brought all this misery on myself and others." These words struck me because that same feeling, just the same, not more nor less, is also on my conscience.

When I think of the past,—when I think of the future of almost invincible difficulties, of much and difficult work, which I do not like, which I, or rather my evil self, would like to shirk; when I think the eyes of so many are fixed on me,—who will know where the fault is, if I do not succeed, who will not make me trivial reproaches, but as they are well tried and trained in everything that is right and virtuous and fine gold, they will say, as it were by the expression of their faces : we have helped you and have been a light unto you,—we have done for you what we could, have you tried honestly? what is now our reward and the fruit of our labour? See! when I think of all this, and of so many other things like it, too numerous to name them all, of all the difficulties and cares that do not grow less when we advance in life, of sorrow, of disappointment, of the fear of failure, of disgrace,—then I also have the longing—I wish I were far away from everything!

And yet I go on, but prudently and hoping to have strength to resist those things, so that I shall know what to answer to those reproaches that threaten me, and believing that notwithstanding everything that seems against me, I yet shall reach the aim I am striving for, and if God wills it, shall find favour in the eyes of some I love and in the eyes of those that will come after me.

There is written : " Lift up the hands which hang down, and the feeble knees,"[1] and when the disciples had worked all night and had not caught any fish, they were told " go out into the deep and cast your nets again into the sea."[2]

My head is sometimes heavy and often it burns and my thoughts are confused,—I don't see how I shall ever get that difficult and extensive study into it—to get used to and per-

[1] A free paraphrase of *Isaiah* xxxv 3.
[2] A free paraphrase of *Luke* v 4.

severe in simple regular study after all those emotional years is not always easy.[1] And yet I go on; if we are tired isn't it then because we have already walked a long way, and if it is true that man has his battle to fight on earth, is not then the feeling of weariness and the burning of the head a sign that we have been struggling? When we are working at a difficult task and strive after a good thing we fight a righteous battle, the direct reward of which is that we are kept from much evil.

And God sees the trouble and the sorrow and He can help in spite of all. The faith in God is firm in me—it is no imagination, no idle faith—but it is so, it is true, there is a God Who is alive and He is with our parents and *His eye is also upon us,* and I am sure He plans our life and we do not quite belong to ourselves as it were—and this God is no other than Christ of Whom we read in our Bible and Whose word and history is also deep in our heart. If I had only given all my strength to it before, yes, I should have been further now,—but even now He will be a strong support, and it is in His power to make our lives bearable, to keep us from evil, to let all things contribute towards a good end, to make our end peaceful.

There is much evil in the world and in ourselves, terrible things, and one does not need to be far advanced in life, to be in fear of much and to feel the need of a firm faith in life hereafter, and to know that without faith in God one cannot live, one cannot bear it.—But with that faith one can go on for a long time.

When I was standing beside the corpse of Aerssen the calmness and dignity and solemn silence of death contrasted with us living people to such an extent, that we all felt the truth of what his daughter said with such simplicity: "he is freed from the burden of life, which we have to go on bearing." And yet we are so much attached to the old life, because next to our despondent moods we have our happy moments when heart and soul rejoice, like the lark that

[1] Vincent had just begun preparing for the State Examination that would admit him to the University to study theology.

cannot keep from singing in the morning, even though the soul sometimes sinks within us and is fearful. And the memories of all we have loved stay and come back to us in the evening of our life. They are not dead but sleep, and it is well to gather a treasure of them.

A handshake and write soon to

Your loving brother,

Vincent

Amsterdam, September 18 1877

Dear Theo,

The time approaches when you will go on your business trip for Messrs. Goupil and Co., and I enjoy beforehand the prospect of seeing you again. I want to ask you one thing: could not you arrange it so that we could be quietly and calmly together for at least one whole day?

This week Mendes is out of town, spending a few days with the Rev. Schröder at Zwolle, a former pupil of his. So having some leisure I could carry out an old plan to go and see the etchings by Rembrandt in the Trippenhuis, I went there this morning and I am glad I did so. While there, I thought, could not Theo and I see them together some day? Think it over, whether you could spare a day or two for such things. How would a man like Father, who so often goes long distances even in the night with a lantern, to visit a sick or dying man, to speak with him about One whose word is light even in the night of suffering and agony, how would he feel about the etchings of Rembrandt, for instance "The Flight to Egypt in the Night" or the "Burial of Jesus"? The collection in the Trippenhuis is splendid, I saw many I had never seen before, they also told me there about drawings by Rembrandt at the Fodor Museum. If you think it possible, speak about it with Mr. Tersteeg and drop me a line when you are coming, then I can finish my work and shall be free and quite at your disposal when you come.

I never see things of that kind, etchings or paintings too, but I think of you and all at home.

But I am up to my ears in my work, for it is becoming clear to me what I really must know, what *they* know and what inspires *those* whom I should like to follow. "Examine the Scriptures" is not written in vain, but that word is a good guide and I should like to become the sort of scribe, who from his treasure brings forth old and new things.

[There follows a section in which Vincent writes of the family life of Kee Vos and her husband as he had experienced it on a recent visit—Vincent was later to fall in love with her as a widow—and of two sermons he had recently heard.]

Father wrote me that you had been to Antwerp, I am longing to hear what you saw there. Long ago I too saw the old pictures in the Museum, and I think I even remember a beautiful portrait by Rembrandt; if one could remember things clearly, that would be fine, but it is like the view on a long road, in the distance things appear smaller and in a haze.

One evening there was a fire here on the river—a boat loaded with arrack, or something like it, was burning: I was with Uncle on the Wassenaar, there was, relatively speaking, no danger as they had removed the burning steamer from between the other ships and had fastened it to the moorings. When the flames rose high one saw the Buitenkant and the black row of people that stood looking there, and the little boats that were hovering around the blaze of the fire looked also black in the water in which the flames were reflected; I do not know if you remember the photographs after the works of Jazet that were in the Galerie Photographique at the time, but have been destroyed since, "Christmas Eve," "The Fire," and others, this was something like them.

Twilight is falling, "blessed twilight," Dickens called it and indeed he was right. Blessed twilight, especially when two or three are together in harmony of mind and like scribes bring forth out of their treasure things old and new.[1]

[1] *Matthew* XIII 52.

Blessed twilight, when two or three are gathered together in His name and He is in the midst of them,[1] and blessed is the man who knows these things and follows them too.

Rembrandt knew that, for from the rich treasure of his heart he brought forth among other things that drawing in sepia, charcoal, ink, etc. which is at the British Museum, representing the house in Bethany. In that room twilight has fallen, the figure of our Lord, noble and impressive, stands out serious and dark against the window through which the evening twilight is shedding itself. At the feet of Jesus sits Mary who has chosen that good part which shall not be taken away from her,[2] and Martha is in the room busy with something or other, if I remember well she stirs the fire or something like it. That drawing I hope never to forget nor what it seems to tell me: "I am the light of the world, he that followeth me shall not walk in darkness, but shall have the light of life."[3]

[A further group of Biblical texts then follows.]

Such things twilight tells to those who have ears to hear and a heart to understand and to believe in God—blessed twilight! And in that picture by Ruyperez, the "Imitation of Jesus Christ," it is also twilight, and also in another etching by Rembrandt: David in Prayer to God.

But it is not always blessed twilight, as you can see from my handwriting, I am sitting upstairs by the lamp, for there are visitors downstairs and I cannot sit there with my books. Uncle Jan sends you his compliments. . . .

Have a good time, write soon and come soon, for it is well to see each other again and to talk things over, perhaps this summer we can go and see the exhibition that will be opened a few days from now. Compliments to the Rooses, à Dieu, a handshake from

<div style="text-align:right">Your loving brother,
Vincent</div>

[1] See *Matthew* XVIII 20.
[2] See *Luke* X 42.
[3] *John* VIII 12.

Amsterdam, April 3 1878[1]

I have been thinking over what we have been talking about and involuntarily I thought of the saying, " nous sommes aujourd'hui ce que nous étions hier." That does not mean that one must stand still and may not try to develop oneself, on the contrary there is an urgent reason for doing so and succeeding in it. But in order to remain true to that saying one must not slide back and if one has begun to look at things in a free and open way, one must not give it up or deviate from it.

Those who said : " We are the same today as we were yesterday," were " honest men," which is proved by the Constitution they made, which will remain for all time, and which has been said to be written " avec le rayon d'en haut," and " d'un doigt de feu."[2] It is good to be an " honest man " and to try to become so more and more, and he who believes that to be " homme intérieur et spirituel "[3] is part of it also, is right.

The man aware with security and certainty that he belonged to them would always go quietly and calmly on his way, not doubting of the good result in the end.—There was a man who went to church one day and asked : " Can it be that my zeal has deceived me, that I have taken the wrong road, and have not planned it well? Oh! if I might be freed from this uncertainty, and might have the firm conviction that I shall conquer and succeed in the end!" And then a voice answered him : " And if you knew that for certain, what would you do then?—act now as if you knew it for certain, and you will not be confounded." Then the man went forth on his way, believing instead of unbelieving, and he went back to his work, no longer doubting or wavering.

As to being " homme intérieur et spirituel," could not one develop that by the knowledge of history in general and of

[1] In this letter Vincent in his haste omits the " Dear Theo."
[2] " with a ray from on high ", " by a finger of fire ".
[3] " an inner and spiritual man ".

certain persons from all ages, especially from the history of the Bible to that of the Revolution and from the Odyssey to the books of Dickens and Michelet? And could not one learn something from the works of such as Rembrandt and from "Mauvaises Herbes" by Breton, or "The Hours of the Day" by Millet, or "Bénédicité" by de Groux or Brion, or "The Conscript," by de Groux, or the one by Conscience, or "The Large Oaks," by Dupré, or even from "The Mills and Sandy Plains," by Michel?

We have talked a good deal about our duty, and how we could attain the right goal and we came to the conclusion, that in the first place our aim must be to find a steady position and a profession to which we can entirely devote ourselves.

And I believe that we also agreed on this point, that one must especially have the end in mind, and that the victory one would gain after a whole life of work and effort is better than one that is gained sooner. Whoever lives sincerely and encounters much trouble and disappointment, but is not bowed down by them, is worth more than one who has always sailed before the wind and has only known relative prosperity. For who are those that show some sign of higher life? They are those to whom may be applied the words : " Laboureurs, votre vie est triste, laboureurs, vous souffrez dans la vie, laboureurs, vous êtes bien-heureux,"[1] they are those that bear the signs of "toute une vie de lutte et de travail soutenu sans fléchir jamais."[2] It is good to try to become as much. So we go forth on our way, "indefessi favente Deo."[3] As to me I must become a good clergyman, who has something to say that is right and may be of use in the world, and perhaps it is better that I have a relatively long time of preparation, and am strongly confirmed in a staunch conviction before I am called to speak to others about it. . . . If only we try to live sincerely, it will go well with us, even though we are certain to experience real sorrow, and great disappointments,

[1] " Labourers, your life is sad, labourers, you suffer in this life, labourers, you are blessed ".

[2] " a full life of struggle and toil borne without ever bowing ".

[3] " unwearied, thanks to the grace of God ".

and also will probably commit great faults and do wrong things, but it certainly is true, that it is better to be high-spirited, even though one makes more mistakes, than to be narrow-minded and all too prudent. It is good to love many things, for therein lies the true strength, and whosoever loves much performs much, and can accomplish much, and what is done in love is well done; if one is struck by some book or other, for instance, by one of Michelet's, like " L'Hirondelle," " L'Alouette," " Le Rossignol," " Les Aspirations d'Aut-omne," " Je vois d'ici une dame," " J'aimais cette petite Ville singulière " it is because it is written from the heart in sim-plicity and meekness of mind. It is better to say few words that have real significance than to say many that are but idle sounds, and are just as useless as they are easy to utter.

If one keeps on loving faithfully what is really worth loving, and does not waste one's love on insignificant and unworthy and meaningless things, one will get more light by and by and grow stronger.

The sooner one tries to master a certain profession and a certain handicraft and adopt a fairly independent way of thinking and acting, and the more one keeps to strict rules, the firmer the character one will acquire, and for all that one need not become narrow-minded.

It is wise to do so, for life is but short, and time passes quickly; if one is master of one thing and understands one thing well, one has at the same time insight into and under-standing of many things into the bargain. Sometimes it is well to go into the world and converse much with people, and at times one is obliged to do so, but whoever would prefer to be quietly alone with his work, and who wants but very few friends, he will go safest through the world and among people. One must never trust the occasion when one is with-out difficulties, or some care or trouble, and one must not take things too easily. And even in the most refined circles and the best surroundings and circumstances one must keep some-thing of the original character of a Robinson Crusoe or anchorite, for otherwise one has no root in oneself, and one must never let the fire go out in one's soul, but keep it burn-

ing. And whoever chooses poverty for himself and loves it, possesses a great treasure, and will always clearly hear the voice of his conscience; he who hears and obeys that voice, which is the best gift of God, finds at last a friend in it, and is never alone. . . .

So be it with us, boy, and may you have blessings on your way, and God be with you in all things and make you succeed, that is the wish, with a hearty handshake on your departure from[1]

<div align="center">Your so loving brother,
Vincent</div>

Laeken, a suburb of Brussels, November 15, 1878

Dear Theo,

On the evening of the day we spent together, which passed only too quickly for me, I want to write to you again. It was a great joy for me to see you again and to talk with you, and it is a blessing that such a day, that passes in a moment, and such a joy that is of so short duration, stays in our memory and will never be forgotten. When we had taken leave I walked back, not along the shortest way but along the tow-path. Here are workshops of all kinds that look picturesque, especially in the evening with the lights, and to us who are also labourers and workmen, each in his sphere and in the work to which he is called, they speak in their own way, if we only listen to them, for they say: Work while it is day, the night cometh when no man can work.

It was just the moment when the street cleaners came home with their carts with the old white horses. A long row of these carts were standing at the so-called Terme des boues, at the beginning of the tow-path. Some of these old white horses resemble a certain old aquatint engraving, which you perhaps know, an engraving that has no great art value, it is true, but which struck me, and made a deep impression upon me. I mean the last from that series of prints called " The Life of

[1] Theo had been temporarily transferred to the Goupil house in Paris.

a Horse."[1] It represents an old white horse, lean and ema-
ciated, and tired to death by a long life of heavy labour, of
too much and too hard work. The poor animal is standing on
a spot utterly lonely and desolate, a plain scantily covered
with withered dry grass, and here and there a gnarled old
tree broken and bent by the storm. On the ground lies a
skull, and at a distance in the background a bleached skeleton
of a horse, lying near a hut where lives a man who skins
horses. Over the whole is a stormy sky, it is a cold, bleak
day, gloomy and dark weather.

It is a sad and very melancholy scene, which must strike
everyone who knows and feels that we also have to pass one
day through the valley of the shadow of death, and "que la
fin de la vie humaine, ce sont des larmes ou des cheveux
blancs."[2] What lies beyond this is a great mystery that only
God knows, but He has revealed absolutely through His word
that there is a resurrection of the dead.

The poor horse, the old faithful servant, is standing there
patiently and meekly, yet bravely and unflinchingly; like the
old guard who said, "la garde meurt mais elle ne se rend
pas,"[3] it awaits its last hour. Involuntarily I was reminded
of that engraving, when I saw tonight those horses of the
ashcarts.

As to the drivers themselves with their filthy dirty clothes,
they seemed sunk and rooted still deeper in poverty than that
long row or rather group of paupers, that Master de Groux
has drawn in his "Bench of the Poor." It always strikes me,
and it is very peculiar, that when we see the image of in-
describable and unutterable desolation,—of loneliness, of
poverty and misery, the end of all things, or their extreme,
then rises in our mind the thought of God. At least this is
the case with me and does not Father also say: "There is no
place where I like better to speak than in a churchyard,
for there we are all on equal ground; not only that,

[1] Ten years later, Vincent was to compare the Impressionist artists
he had known in Paris with broken-down old cab-horses.
[2] "that the end of human life partakes of tears or white hairs".
[3] "the guard accepts death, but never surrender".

there we always *realize* it." I am glad that we had time to see the museum together and especially the work of de Groux and Leys, and so many other interesting pictures, like that landscape of Cooseman's for instance. I am very pleased with the two prints you gave me, but you ought to have accepted from me that small etching, "The Three Mills." Now you have paid it all yourself, and not allowed me to pay half as I wished to do. But you must keep it for your collection, for it is remarkable, even though the reproduction is not so very good. In my ignorance, I should ascribe it rather to Peasant Breughel than to Velvet Breughel. I enclose the little hasty sketch, "Au Charbonnage."[1]

I should like to begin making rough sketches from some of the many things that I meet on my way, but as it would probably keep me from my real work, it is better not to begin. As soon as I came home I began a sermon about the "barren fig tree," Luke XIII 6-9.

That little drawing "Au Charbonnage" is nothing specially remarkable, but the reason I made it is that one sees here so many people that work in the coal mines, and they are rather a characteristic kind of people. This little house stands not far from the road; it is a small inn attached to the big coal shed, and the workmen come there to eat their bread and drink their glass of beer during the lunch hour.

When I was in England I applied for a position as Evangelist among the miners in the coal mines, but they turned me down, stating that I had to be at least twenty-five years old. You know how one of the roots or foundations, not only of the Gospel, but of the whole Bible is, "Light that rises in the darkness,"[2] *from darkness to light*. Well, who will need this most, who will be open to it? Experience has taught that those who walk in the darkness, in the centre of the earth, like the miners in the black coal mines for instance, are very much impressed by the words of the Gospel, and believe it too. Now there is in the south of Belgium, in

[1] "The Miner's Inn".

[2] Vincent may have been thinking of *John* I 5, or of *Matthew* IV 16, where *Isaiah* IX 2 is quoted.

Hainault, in the neighbourhood of Mons, up to the French frontiers, aye, even far across it, a district called the Borinage, that has a special population of labourers who work in the numerous coal mines. In a little handbook of geography I found the following about them : " The Borins (inhabitants of the Borinage, situated west of Mons) find their work exclusively in the coal mines. These mines are an imposing sight, 300 metres underground, into which daily descend groups of working men, worthy of our respect and our sympathies. The miner is a special Borinage type, for him daylight does not exist, and except on Sunday he never sees the sunshine. He works laboriously by a lamp whose light is pale and dim, in a narrow tunnel, his body bent double and sometimes he is obliged to crawl along; he works to extract from the bowels of the earth that mineral substance of which we know the great utility; he works in the midst of thousands of ever-recurring dangers; but the Belgium miner has a happy disposition, he is used to that kind of life, and when he descends the shaft, carrying on his hat a little lamp that is destined to guide him in the darkness, he trusts himself to God, Who sees his labour and Who protects him, his wife and his children."

So the Borinage is situated south of Lessines, where one finds the stone quarries.

I should very much like to go there as an Evangelist. The three months' trial demanded of me by the Rev. de Jong and the Rev. Pietersen is almost over. St. Paul was three years in Arabia before he began to preach, and before he started on his great missionary journeys and his real work among the heathen. If I could work quietly for about three years in such a district, always learning and observing, then I should not come back from there without having something to say that was really worth hearing. I say so in all humility and yet with confidence. If God wills, and if He spares my life, I would be ready about my thirtieth year, starting out with a peculiar training and experience, being able to master my work better, and riper for it than now.

I write you this again although we have already spoken about it many a time.

There are already in the Borinage many little Protestant communities and certainly schools also. I wish I could get a position there as Evangelist in the way we spoke about, preaching the Gospel to the poor, that means those who need it most and for whom it is so well suited, and then during the week devoting myself to teaching.

You have certainly visited St. Gilles? I too made a trip there, in the direction of the Ancienne Barrière. Where the road to Mont St. Jean begins there is another hill, the Alsemberg. To the right is the cemetery of St. Gilles, full of cedars and evergreen, from where one has a view over the whole city.

Proceeding further one arrives at Forest. The neighbourhood is very picturesque there, on the slope of the hills are old houses, like those huts in the dunes that Bosboom has sometimes painted. One sees all kinds of field labour performed there, the sowing of corn, the digging of potatoes, the washing of turnips, and everything is picturesque, even the gathering of wood, and it looks much like Montmartre. There are old houses covered with evergreen or vines, and pretty little inns; among the houses I noticed one was that of a mustard manufacturer, a certain Verkisten, his place was just like a picture by Thijs Maris for instance. Here and there are places where stone is found, so they have small quarries, through which hollowed out roads pass, with deeply cut wagon ruts, where one sees the little white horses with red tassels, and the drivers with blue blouses; shepherds are to be found there too, and women in black with white caps, that remind one of those of de Groux. There are some places here, thank God one finds them everywhere, where one feels more at home than anywhere else, where one gets a peculiar pristine feeling like that of homesickness, in which bitter melancholy plays some part; but yet its stimulation strengthens and cheers the mind, and gives us, we do not know how or why, new strength and ardour for our work. That

day I walked on past Forest and took a side path leading to a
little old ivy-grown church. I saw many linden trees there,
still more interwoven, and more Gothic so to say, than those
we saw in the Park, and at the side of the hollowed road
that leads to the churchyard there were twisted and gnarled
stumps and tree roots, fantastical like those Albert Dürer
etched in "Ritter, Tod and Teufel."[1] Have you ever seen a
picture or rather a photograph of Carlo Dolci's work "The
Garden of Olives"? There is something Rembrandtesque in
it; I saw it the other day. I suppose you know that large
rough etching on the same theme after Rembrandt, it is the
pendant of that other, "The Bible Reading," with those two
women and a cradle? Since you told me that you had seen the
picture by Father Corot on that same subject, I remembered it
again; I saw it at the exhibition of his works shortly after
his death and it deeply appealed to me.

*How rich art is, if one can only remember what one has
seen, one is never empty of thoughts or truly lonely, never
alone.*

A Dieu, Theo, I heartily shake hands with you in thought.
Have a good time, have success in your work, and meet many
good things on your road, such as stay in our memory and
enrich us, though apparently we possess little. When you
see Mauve greet him for me and believe me,

Your loving brother,

Vincent

I kept this letter for a few days; the 15th of November is
passed, so the three months have elapsed. I spoke with the
Rev. de Jong and Master Bokma, they tell me that I cannot
attend the school on the same conditions as they allow to the
native Flemish pupils; I can follow the lessons free of
charge if necessary—but this is the only privilege,—so in
order to stay here longer I ought to have more financial means
than I have at my disposal, for they are nil. So I shall per-
haps soon try that plan involving the Borinage. Once I am in
the country I shall not soon go back to a large city.

It would not be easy to live without the Faith in Him and

[1] "The Knight, Death and the Devil."

the melancholy that hopes and aspires and seeks, to that which despairs in stagnation and woe. So I studied fairly seriously the books within my reach, like the Bible, and the "French Revolution" by Michelet, and last winter Shakespeare and a few Victor Hugo and Dickens, and Beecher Stowe, and lately "Æschylus," and then several others, less classical, several great "little masters." You know that among those "little masters" are people like Fabritius or Bida.

Now he who is absorbed in all this is sometimes "choquant," shocking to others, and unwillingly sins on occasion against certain forms and customs and social conventions.

It is a pity however when this is taken in bad part. For instance you know that I have often neglected my appearance; this I admit, and I admit that it is shocking. But look here, poverty and want have their share in the cause, and deep discouragement comes in too for a part, and then it is sometimes a good way to assure oneself the necessary solitude for concentration on some study that preoccupies one.

A very necessary study is that of medicine; there is scarcely anybody who does not try to know a little of it, who does not try to understand what it is about, and you see I do not know as yet one word about it. Yet all this absorbs and preoccupies one, all this gives one something about which to dream, to reflect, to think. Now for more than five years already, I do not know exactly how long, I have been more or less without employment, wandering here and there; you say: since a certain time you have gone downhill, you have deteriorated, you have not done anything. Is this quite true?

It is true that now and then I have earned my crust of bread, now and then a friend has given it to me in charity. I have lived as I could, as luck would have it, haphazardly; it is true that I have lost the confidence of many, it is true that my financial affairs are in a sad state, it is true that the future is only too sombre, it is true that I might have done better, it is true that just from earning my bread I've lost time, it is true that even my studies are in a rather sad and hopeless condition, and that my needs are greater, infinitely greater than my possessions. But is this what you call going down-

hill, is this what you call doing nothing? You will say, perhaps : but why did you not continue as they wanted you to do, they wanted you to continue through the University? My only answer to this is : the expenses were too heavy, and besides, that future was not much better than the one on the road now before me.

But on the path I have taken now I must keep going; if I don't do anything, if I do not study, if I do not go on seeking any longer, then I am lost. Then woe is me.

That is how I look at it; to continue, to continue, that is what is necessary. But you will ask : What is your definite aim? That aim becomes more definite, will stand out slowly and surely, just as the rough draught becomes a sketch, and the sketch becomes a picture, little by little, by working seriously on it, by pondering over the idea, vague at first, over the thought that was fleeting and passing, till it gets fixed. I must tell you that it is with evangelists as with artists. There is an old academic school, often detestable, tyrannical, the accumulation of horrors, men who wear a cuirass, a steel armour of prejudices and conventions; those people, when they are at the head of affairs, dispose of positions, and by a bureaucratic system they try to keep their protégés in their places, and to exclude the other man. Their God is like the God of Shakespeare's drunken Falstaff, " le dedans d'une église,"[1] indeed some of those evangelical gentlemen find themselves by a curious chance having the same point of view on spiritual things as that drunken type (perhaps they would be somewhat surprised to find it so, if they were capable of human emotions). But there is little fear of their blindness ever changing to clear-sightedness in these matters.

This state of affairs has its bad side for him who does not agree, but protests against it with all his soul and all his heart, and all the indignation of which he is capable. I for my part respect academicians, that are not of this kind, but the respectable ones are more rare than one would believe at first. Now one of the reasons why I am out of employment

[1] "The inside of a church" (see 1 Hen. IV, III 3).

now, why I have been out of employment for years, is simply that I have other ideas than the gentlemen who give the places to men who think like they do. It is not merely a question of the dress over which they have hypocritically reproached me, it is a much more serious question, I assure you.

Why do I tell you all this?—not to complain, not to excuse myself for things in which I may more or less have been wrong, but simply to reply to you. During your visit last summer, when we walked together near the abandoned pit which they call "La Sorcière," you reminded me that there had also been a time when we two had walked together near the old canal and mill of Ryswyk, "and then," you said, "we agreed in many things," but you added, "since then you have changed so much, you are not the same any longer." Well, that is not quite true. What has changed is that my life was then less difficult, and my future seemed less dark; but as to the inward state, as to my way of looking at things, and my way of thinking, they have not changed. If there has been any change at all, it is that I think and believe and love more seriously now what I already thought and believed and loved then.

So you would be wrong in persisting in the belief that, for instance, I should now be less enthusiastic for Rembrandt, or Millet, or Delacroix, or whoever it may be, for the contrary is true. But you see, there are many things which one must believe and love. There is something of Rembrandt in Shakespeare, and of Correggio in Michelet, and of Delacroix in Victor Hugo, and then there is something of Rembrandt in the Gospel, or something of the Gospel in Rembrandt, as you like it——it comes to the same, if one only understands the thing in the right way, without misinterpreting it and assuming the equivalence of the comparisons, which do not pretend to lessen the merits of the original personalities. And in Bunyan there is something of Maris or of Millet, and in Beecher Stowe there is something of Ary Scheffer.

If now you can forgive a man for making a thorough study of pictures, admit also that the love of books is as sacred as

the love of Rembrandt, and I even think the two complete each other.

I am very fond of the portrait of a man by Fabritius, which one day, when we were walking together, we stood looking at a long while in the museum at Haarlem. Yes, but I am as fond of Sydney Carton, in the "Tale of Two Cities" by Dickens, and I could show you other figures as curiously striking in other books, with a more or less remarkable resemblance. And I think that Kent, a character in Shakespeare's "King Lear," is as noble and distinguished a personage as a figure by Th. de Keyser, though Kent and King Lear had lived in a much earlier period. Not to say more about it. My God, how beautiful Shakespeare is! Who is mysterious like him? His language and style can indeed be compared to an artist's brush, quivering with fever and emotion. But one must learn to read, exactly as one must learn to see, and learn to live.

So you must not think that I disavow things; I am rather faithful in my unfaithfulness, and though changed, I am the same, and my only anxiety is: how can I be of use in the world, cannot I serve some purpose and be of any good, how can I learn more and study certain subjects profoundly? You see, that is what preoccupies me constantly, and then I feel myself imprisoned by poverty, excluded from participating in certain work, and certain necessary things are beyond my reach. That is one reason for not being without melancholy, and then one feels an emptiness where there might be friendship and strong and serious affections, and one feels a terrible discouragement gnawing at one's very moral energy, and fate seems to put a barrier to the instincts of affection, and a flood of disgust rises to choke one. And one exclaims " How long, my God!"

Well, what shall I say; our inward thoughts, do they ever show outwardly? There may be a great fire in our soul, but no one ever comes to warm himself at it, and the passers-by see only a little bit of smoke coming through the chimney, and pass on their way. Now, look here, what must be done, must one tend that inward fire, have salt in oneself, wait

patiently yet with how much impatience for the hour when somebody will come and sit down near it,—to stay there maybe? Let him who believes in God wait for the hour that will come sooner or later.

Now for the moment things appear to be going very badly with me, and this has been so for a considerable time already, and may continue so in the future for a while; but after everything has seemed to go wrong, there will perhaps come a time when things will go right. I do not count on it, perhaps it will never happen, but if there should come a change for the better, I would consider it so much gain, I would be contented, I would say: at last! you see *there was something after all!* But you will say: "Yet you are an intolerable being, because you have impossible ideas about religion and childish scruples of conscience." If my ideas are impossible or childish, I hope to get rid of them, I ask no better. But here is a glimpse of what I think on the subject. You will find it in the "Philosophe sous les Toits" by Souvestre how a man of the people, a simple miserable labourer, pictures to himself his own country. "You have perhaps never thought what is really your own country," he said, putting his hand on my shoulder; "it is everything that surrounds you, everything that has brought you up and nourished you, everything you have loved—those fields that you see, those houses, those trees, those young girls that laugh as they pass, that is your country! The laws that protect you, the bread with which your labour is repaid, the words you speak, the joy and the sorrow that come to you from the people and the things among which you live, that is your country! The little room where you used to see your mother, the memories which she has left you, the earth in which she reposes, that is your country! You see it, you breathe it, everywhere! Figure to yourself the rights and the duties, the affections and the needs, the memories and the gratitude, gather all that under one name, and that name will be your country."

Now in the same way I think that everything that is really good and beautiful, of inner moral, spiritual and sublime beauty in men and their works, comes from God, and that all

that is bad and wrong in men and in their works is not of God, and God does not approve of it.

But I always think that the best way to know God is to love many things. Love a friend, a wife, something, whatever you like, and you will be on the right way to knowing more about it, that is what I say to myself. But one must love with a lofty and serious intimate sympathy, with strength, with intelligence, and one must always try to know deeper, better and more. That leads to God, that leads to unwavering faith.

To give you an example: someone loves Rembrandt, but seriously,—that man will know that there is a God, he will surely believe it. Someone studies the history of the French Revolution—he will not be unbelieving, he will see that in great things also there is a sovereign power manifesting itself.

Maybe for a short time somebody has followed a free course at the great university of misery, and has paid attention to the things he sees with his eyes and hears with his ears, and has thought them over; he too will end in believing, and he will perhaps have learned more than he can tell. To try to understand the real significance of what the great artists, the serious masters, tell us in their masterpieces, *that* leads to God. One man has written or told it in a book, another in a picture. Then simply read the Gospel and the Bible, that makes you think, and think much, and think all the time. Well, think much and think all the time, that unconsciously raises your thoughts above the ordinary level. We know how to read, well then let us read!

It is true that there may be moments in which one becomes somewhat absent-minded, somewhat visionary; there are those who become too absent-minded, too visionary. This is perhaps the case with me, but it is my own fault; maybe after all there is some excuse, there was some reason for me to be absorbed, preoccupied, troubled but one overcomes this. The dreamer sometimes falls in a well, but he is said to get out of it afterwards. And the absent-minded man has also, in compensation, his lucid intervals. He is sometimes a person who has his reasons for being as he is, but those are not

always understood at first, or are unconsciously forgotten most of the time, from lack of interest. A man who has been tossed to and fro for a long time, as if he were tossed on a stormy sea, at last reaches his destination; a man who has seemed good for nothing and incapable of any employment, any function, ends in finding one, and becoming active and capable of action, he shows himself quite different from what he seemed at first. I write somewhat at random whatever comes to my pen. I should be very glad if you could see in me something besides an idle fellow.

Because there are two kinds of idleness, that form a great contrast. There is the man who is idle from laziness, and from lack of character, from the baseness of his nature. You may if you like take me for such an one.

Then there is the other sort of idle man, who is idle in spite of himself, who is inwardly consumed by a great longing for action, yet does nothing because it is impossible for him to do anything, because he seems to be imprisoned in some cage, because he does not possess what he needs to make him productive, because the fatality of circumstances brings him there; such a man does not always know what he could do, but he feels by instinct : all the same I am good for something, my life has an aim after all, I know that I might be quite a different man! How can I then be useful, of what service can I be! There is something inside of me, what can it be?

This is quite a different kind of idle man; you may if you like take me for such an one. A caged bird in spring knows quite well that he might serve some end; he feels well enough that there is something for him to do, but he cannot do it. What is it? He does not remember too well. Then he has some vague ideas and says to himself, " The others make their nests and lay their eggs and bring up their little ones," and so he knocks his head against the bars of the cage. But the cage remains and the bird is maddened by anguish.

" Look at the lazy animal," says another bird that passes by, " he seems to be living at his ease." Yes the prisoner lives, he does not die, there are no outward signs of what passes within him; his health is good, he is more or less gay when

the sun shines. But then comes the season of migration, bringing attacks of melancholia. "But he has got everything he wants," say the children that tend him in his cage, while he looks through the bars at the overcast sky, where a thunderstorm is gathering, and he inwardly rebels against his fate. "I am caged, I am caged, and you tell me I do not want anything, fools! You think I have everything I need! Oh! I beseech you, liberty, so that I can be a bird like other birds!"

A certain idle man resembles this idle bird.

And men are often prevented by circumstances from doing things, imprisoned in I do not know what horrible, horrible, most horrible cage. There is also, I know it, the deliverance, the tardy deliverance. A just or unjustly ruined reputation, poverty, inevitable circumstances, adversity, that is what makes men prisoners.

One cannot always tell what it is that keeps us shut in, confines us, seems to bury us, but still one feels certain barriers, certain gates, certain walls. Is all this imagination, fantasy? I do not think so. And then one asks: "My God! is it for long, is it for ever, is it for eternity?" Do you know what frees one from this captivity? it is very deep serious affection. Being friends, being brothers, love, that is what opens the prison by supreme power, by some magic force. But without this one remains in prison.

There where sympathy is renewed, life is restored.

And the prison is also called prejudice, misunderstanding, fatal ignorance of one thing or another, distrust, false shame.

But to speak of other things, if I have come down in the world, you on the contrary have risen. If I have alienated sympathies, you on the contrary have gained them. That makes me very happy, I say it in all sincerity, and it will always do so. If you had only a small degree of seriousness or depth, I would fear that it would not last, but as I think you are very serious and of great depth, I believe that it will. But I should be very glad if it were possible for you to see in me something else than an idle man of the worst type.

If ever then I can do anything for you, be of some use to you, know that I am at your disposal. If I have accepted

what you have given me, you might, in the event that I could render you some service, ask it of me; it would make me happy, and I would consider it a proof of confidence. We are rather far apart, and we have perhaps different views on some things, but nevertheless there may come an hour, there may come a day, when we may be of service to one another.

For the present I shake hands with you, thanking you again for the help you have given me.

If sooner or later you wish to write to me, my address is, care of Ch. Decrucq, Rue du Pavillon 3, Cuesmes, near Mons. And know that a letter from you will do me good.

<div style="text-align: right">Ever yours,
Vincent</div>

YEARS IN HOLLAND

1881-5

[Etten, Holland, probably November 3 1881]

Dear Theo,

There is something in my heart that I must tell you; perhaps you know about it already and it is not new for you. I want to tell you that this summer a deep love has grown in my heart for Kee;[1] but when I told her this, she answered me that to her, past and future remained one, so she could never return my feelings.

Then there was a terrible indecision within me as to what to do. Should I accept her " no, never never," or considering the question as not finished and decided, should I keep some hope and not give up?

I chose the latter. And up to now I do not repent of that decision, though I am still confronted by that " no, never never." Of course since that time I have met with many " petites misères de la vie humaine,"[2] which written in a book would perhaps serve to amuse some people, but can hardly be termed a pleasant sensation if one has to experience them oneself.

However, I have so far remained glad that I left the resignation of the " how not to do it " system to whoever may like it, and for myself kept some courage.

One of the reasons why I did not write to you about it before is that my position was so vague and undecided that I could not explain it to you. But now we have reached the point where I have spoken about it, besides to her, to Father and Mother, to Uncle and Aunt Stricker, and to Uncle and Aunt at Prinsenhage.

The only one who told me, but very informally and in

[1] Kee Vos, now a widow. [2] " Small miseries of human life "

128

secret, that there really was some chance for me, if I worked hard and had some success, was somebody from whom I did not expect it in the least: Uncle Vincent. He had rather liked the way in which I took Kee's " no, never never "—not taking it too seriously, but rather in a humorous way. Well, I hope to continue to do so, and to keep melancholy and depression far from me, meanwhile working hard; and since I have met her I get on much better with my work.

I told you that my position has become more sharply clarified; I think I shall have the greatest trouble with the older persons, who consider the question as settled and finished, and will try to force me to give it up. For the present I believe they will be very considerate to me, and keep me dangling and put me off with fair promises, until the silver wedding of Uncle and Aunt takes place in December. Then I fear measures will be taken to cut me off.

Pardon me these rather hard expressions, which I use to make the situation clear to you : I admit that the colours are somewhat harsh, and the lines somewhat forcibly drawn, but it will give you a clearer insight into the question than if I beat about the bush. So do not accuse me of disrespect towards the older people. I only believe that they are decidedly *against* it; they will take care that Kee and I cannot see each other or speak to each other or write to each other, because they know perfectly well that if we saw each other or wrote to each other or spoke to each other, there would be a chance of Kee changing her mind.

Kee herself thinks she will never change her mind, and the older people try to convince me that she cannot, yet they are afraid of that change. The older people will only change in this affair, not when Kee changes her mind, but when I have become somebody who earns at least 1000 guilders a year. Again forgive me the harsh outlines in which I draw things. You will perhaps hear it said about me that I try to force the situation, and similar expressions, but who would not understand that forcing is absurd in love. No, that intention is far, very far from me. But it is no unreasonable or unjust

L.V.G.

desire to wish that Kee and I might see each other, speak to each other and write to each other, in order to become better acquainted, and in this way to get a better insight into whether we are suited to one another or not.

A year of free intercourse with each other would be beneficial for both of us, but the older people are really obdurate on that point.

But now you understand that I hope not to leave a single thing undone that may bring me nearer to her, and it is my intention :

> *To love her so long*
> *That she'll love me in the end.*

Theo, are you perhaps in love too? I wish you were, for believe me, even the little miseries of it have their value. One is sometimes in despair, there are moments when one seems to be in hell, but—there are also other and better things connected with it. There are three stages.

1st. Not to love and not to be loved.

2nd. To love and not to be loved in return.[1]

3rd. To love and to be loved.

Now, I tell you that the second stage is better than the first, —but the third; that is the *best*.

Now, old boy, fall in love too, and then tell me about it. In my case give me your sympathy and take my part.

Rappard has been here; he brought water-colours with him that were very good. Mauve will come here soon, I hope, otherwise I will go to him. I am drawing hard, and believe I am improving; I work more with the brush than before. It is so cold now that I draw exclusively from the figure indoors, a seamstress, a basket-weaver, etc.

A handshake in thought, and write soon, and believe me,

> Yours,
>
> Vincent

If ever you should fall in love and get in answer " no, never never," do not resign yourself to it; but you are such a lucky fellow that I trust it will never happen to you.

[1] That is my case.

Dear Theo, [Etten, second half of December 1881]

I am afraid you sometimes cast aside a book because it is too realistic. Have pity and patience with this letter and read it through, though it may be rather crude.

As I wrote you from the Hague I have some things to talk over with you, now that I am back here. My trip to the Hague is something I cannot remember without emotion. When I came to Mauve[1] my heart palpitated a little, for I said to myself : Will he also try to put me off with fair promises, or shall I be treated differently here? And I found that he helped me in every way, practically and kindly, and encouraged me. Not however by approving of everything I did or said, on the contrary. But if he says to me : " this or that is not right," he adds at the same time : " but try it in this or that way," which is quite another thing than to criticize just for the sake of criticizing. If somebody says to you : " you are ill," that does not help you much, but if he says, " do this or that and you will recover," and his advice is not misguided, that is the thing that will help you.

So when I left him I had a few painted studies and a few water-colours. Of course they are no masterpieces, but still I believe that there is something sound and true in them, at least more than in what I produced before. And so I think this is the beginning of my making serious things. And as I now have a few more technical resources at my disposal, namely paint and brush, all things seem as it were new to me.

But—now we must put that into practice. And then the first thing is that I must find a room large enough to be able to take sufficient distance.

When Mauve saw my studies he said at once : " you are sitting too close to your model." That makes it in many cases almost impossible to take the necessary measurings for the proportion, so that it is certainly one of the first things I must attend to. So I must try to rent a large room somewhere, either a room or a barn. And that will not be so very

[1] Anton Mauve, the artist whom Vincent went to consult about his work.

expensive. A labourer's cottage in these parts costs no more than 30 guilders a year, so I think that a room twice as large as such a cottage would cost 60 guilders. And that is not beyond my reach. I have already seen a barn, but that had too many inconveniences, especially in winter time. But at least when the weather gets somewhat milder I could work there. And then I think, if difficulties should arise here, I could find models not only in Etten, but also in other villages here in Brabant.

However, though I love Brabant very much, I can also appreciate other figures than the Brabant peasant type. I continue, for instance, to find Scheveningen very, very beautiful. But now I am here and can live cheaper here. But I promised Mauve that I would try my best to find a better studio, and besides I must begin to use better paint and better paper now.

However, for studies and sketches the Ingres paper is excellent, and it is much cheaper to make my own sketch-books in different sizes, than to buy them ready made.

I still have some of that Ingres paper, but when you return that study to me, please enclose some of the same kind; you would greatly oblige me by doing so. But no dead white, rather the colour of unbleached linen, no cold tones.

Theo, what a great thing tone and colour are. And if someone does not learn to have a feeling for them, how far from real life he stands. Mauve has taught me to see many things I did not see before, and what he has told me I will try to tell you sometime, for perhaps there are a few things which you do not see well either. Well, I hope we shall discuss some artistic questions together some day. And you cannot imagine what a feeling of deliverance I begin to have, when I think of what Mauve told me about earning money.

Just think how I have been struggling along for years in a kind of false position. And now, now there comes a dawn of real light. I wish you could see the two water-colours which I brought away with me, for you would see they are water-colours like any other water-colours. There may be many imperfections in them; I would be the first to admit

that I am very much dissatisfied with them, but still they are quite different from what I made before, and look more bright and clear. That does not change the fact that others in the future may become brighter and clearer still, but one cannot do right away what one wants. It will come gradually.

I want to keep those two drawings myself for now in order to compare them with those I am going to make here, for I must carry them at least as far as the ones I made at Mauve's.

But though Mauve tells me that after having struggled on for a few more months, coming back to him, say in March, I shall then make salable drawings, still I am now in a very difficult period. The expenses for model, studio, drawing and painting materials increase and I do not earn anything as yet.

It is true Father has said that I need not worry about the necessary expenses, and Father is very happy with what Mauve told him, and also with the studies and drawings that I brought back. But I think it very lamentable indeed that Father will have to pay for it. We hope of course that it will turn out all right, but still it is a heavy load on my mind. For since I have been here Father has not by any means profited from me, and more than once he has for instance bought a coat or a pair of trousers for me, which I would rather not have had, though I needed them, just because I do not want Father to spend money. Particularly since the coat or trousers in question do not fit, and are of little or no use at all. Well, that is again one of the little miseries of human life. Besides, as I told you before, I hate not to be quite free, and though I do not literally have to account to Father for every cent, he always knows exactly how much I spend and on what. And though I have no secrets I do not like to show my hand to everybody, though even my secrets are no secrets for those with whom I am in sympathy. But Father is not a man for whom I can feel what I feel for instance for you or for Mauve. Of course I love Father, but it is quite a different affection from what I have for you or for Mauve. Father cannot sympathize with, or understand me and I cannot be reconciled to Father's system,—it oppresses me, it would choke me. I too read the Bible now and then, just as I read

Michelet or Balzac or Eliot; but in the Bible I see quite different things than Father does, and what Father draws from it in his academic way I cannot find in it at all.

Since the Reverend ten Kate translated Goethe's "Faust" Father and Mother have read that book, for now that a clergyman has translated it, it cannot be so very immoral??? (what does that mean?) But they consider it nothing but the fatal consequences of an ill-timed love. And neither do they understand the Bible. Now take Mauve for instance. When he reads something that is deep, he does not say at once: that man means this or that. For poetry is so deep and intangible that one cannot define everything systematically. But Mauve has a fine sentiment, and, you see, I think that sentiment worth so much more than definitions and criticism. And when I read, and really I do not read so much, only a few authors,—a few men that I discovered by accident—I do this because they look at things in a broader, milder and more affectionate way than I do, and because they know life better, so that I can learn from them; but all that rubbish about good and evil, morality and immorality, I care so very little for it. For indeed it is impossible always to know what is good and what is bad, what is moral and what is immoral. This morality or immorality brings me involuntarily back to Kee.

I have already written to you that it seemed less and less like eating strawberries in spring. Well, that is the truth; if I repeat myself you must forgive me, because I do not know exactly what I wrote to you about what happened in Amsterdam.

I went there thinking: perhaps the "no, never never" is thawing, the weather is so mild.

And on a certain evening I strolled along the Keizersgracht looking for the house, and I found it. I rang the bell and heard that the family were still at dinner. But then I was asked to come in. But they were all there except Kee. And all had a plate before them, but there was not one too many and this little detail struck me. They wanted to make me believe that Kee was out, and had taken away her plate, but I knew that she was there, and I thought this rather like a comedy or

a farce. After some time I asked: (after the usual greetings and small talk) " But where is Kee?" Then Uncle repeated my question, saying to his wife: " Mother, where is Kee?" And Mother answered " Kee is out." And for the moment I did not inquire further, and talked a little about the exhibition at Arti, etc. But after dinner the others disappeared and Uncle S. and his wife and the undersigned remained alone and settled down to discuss the case in question. Uncle S. opened the discussion as clergyman and father, and said that he was just about to send a letter to the undersigned, and that he would read that letter aloud. But I asked again: " Where is Kee?" (for I knew that she was in town). Then Uncle S. said " Kee left the house as soon as she heard that you were here." Well, I know her somewhat, but I declare that I did not know then, nor do I know with certainty now, whether her coldness and rudeness was a good or a bad sign. This much I do know, that I never saw her so apparently or really cool, brusque and rude to anyone but me. So I did not say much and remained very calm.

Let me hear that letter, or not hear it, I said, I don't care much about it.

Then came the letter. The document was very reverend and very learned, there was really nothing in it, except that I was requested to stop my correspondence and the advice was given me to make very energetic efforts to put the thing out of my mind. At last the reading of the letter was finished. I merely felt as if I had heard the clergyman in church, after a prance up and down with his voice, say amen; it left me just as cool as an ordinary sermon.

And then I began, and said as calmly and politely as I could: yes, I had heard those opinions before—but now— what further? But then Uncle S. looked up. He seemed full of consternation at my not being fully convinced that the utter limit of human capacity for feeling and thinking had been reached. According to him there was no " further " possible. So we continued, and Aunt M. said a word now and then, and I got somewhat excited and lost my temper. And Uncle S. lost his temper too, as much as a clergyman can do so.

And though he did not exactly say " damn you," any other but a clergyman in Uncle S.'s mood would have said so.

But you know that in my way I love Father and Uncle S., and so I shifted my position a little and I gave in a bit, so that at the end of the evening they told me I could stay the night if I wished. Then I said: " I am very much obliged, but if Kee leaves the house when I come, I do not think it the time to stay overnight; I will go to my lodgings." And then they asked: " Where do you board?" I said, " I do not know where as yet;" and then Uncle and Aunt insisted they should take me to a good and cheap place. And dear me, those two old people went with me through the cold, foggy, muddy streets, and they indeed showed me a very good and cheap inn. I insisted on their not coming, and they insisted on showing me the way.

And, you see, there was something humane in that, and it calmed me. I stayed in Amsterdam for two days and I had another talk with Uncle S., but Kee I did not see once; she kept out of my way whenever I came. And I said that they should know that, though they wished me to consider the question as settled and finished, I for my part could not do so. And then they firmly and steadily answered that I would learn to see that better subsequently.

Lately I read Michelet's "La Femme, la Religion et le Prêtre." Books like that are full of realism, but what is more real than reality itself, and where is more life than in life itself? And we who try our best to live, why do we not live more?

I felt quite lone and lorn during those three days in Amsterdam; I felt absolutely miserable, and that sort of kindness of Uncle and Aunt, and all those discussions, it was all so dismal. Till at last I began to feel quite depressed, and I said to myself: you are not going to become melancholy again, are you?

And then I said to myself: do not let yourself be stunned. And so, on a Sunday morning, I went for the last time to Uncle S. and said: " Just listen, dear Uncle, if Kee were an angel she would be too high for me, and I do not think I

could remain in love with an angel. If she were a devil I would not want to have anything to do with her. In the present case I see in her a true woman with a woman's passions and moods, and I love her dearly, and that is the truth and I am glad of it. As long as she does not become an angel or a devil, the case in question is not finished." And Uncle S. had not much to say in reply, and muttered something about a woman's passions—I do not remember well what he said on the subject, and then he went off to church. No wonder one becomes hardened there and turns to stone; I know it from my own experience. And so your brother in question did not want to be stunned, but notwithstanding that he had the feeling of being stunned, a feeling as if he had been standing too long against a cold, hard, whitewashed church wall. And—do you want me to tell you the rest, boy; it is somewhat risky to be a realist, but Theo, Theo, you yourself are also a realist, oh, bear with my realism. I told you that to some my secrets are no secrets. I do not take that back, think of me what you will, and whether or not you approve of what I did, that is of less consequence.

I continue. From Amsterdam I went to Haarlem and spent a few hours pleasantly with our little sister Willemien, and I walked with her, and in the evening I went to The Hague, and at about seven o'clock I arrived at Mauve's.

And I said: listen Mauve, you intended to come to Etten and were to initiate me, more or less, into the mysteries of the palette, but I thought that would not be a matter of a few days only, so I have come to you, and if you agree I will stay four or six weeks, or more or less if you say so, and then we must see what we can do. It is very bold of me to ask so much from you, but you see, *j'ai l'épée dans les reins.*[1] Then Mauve said: did you bring something with you? Yes, here are a few studies; and then he praised them a great deal too much, while at the same time he did criticize, but too little. Well, the next day we put up a still life and he began by telling me: this is the way to keep your palette. And since

[1] "I have a sword in my loins."

then I have made a few painted studies, and then afterwards two water-colours.

So that is the result of the work, but to work with the hands and the brains is not everything in life.

I still felt chilled through and through, to the depths of my soul, by the earlier mentioned real or unreal church wall. And I did not want to be stunned by that feeling. Then I thought: I should like to be with a woman, I cannot live without love, without a woman. I would not set any value on life, if there were not something infinite, something deep, something real. But then I said to myself: you said "she and no other," and you would go to another woman now, that is unreasonable, that is against all logic. And my answer to that was: who is the master, the logic or I, is the logic there for me or am I there for the logic, and is there no reason and no sense in my unreasonableness and lack of sense? And whether I do right or wrong, I cannot act otherwise, that damned wall is too cold for me, I need a woman, I cannot, I may not, I will not live without love. I am but a man, and a man with passions, I must go to a woman, otherwise I freeze or turn to stone, or in short am stunned. But under the circumstances I had a great battle within myself, and in the battle there remained victorious some things which I knew of physic and hygienics, and had learned by bitter experience. One cannot with impunity live too long without a woman. And I do not think that what some people call God and others supreme being, and others nature, is unreasonable and without pity, and in brief I came to the conclusion: I must see whether I can find a woman.

And dear me I had not far to seek. I found a woman,[1] not young, not beautiful, nothing remarkable if you like, but perhaps you are somewhat curious. She was rather tall and strongly built, she did not have a lady's hands like Kee, but the hands of one who works much; she was not coarse or common, and had something very womanly about her. She reminded me of some curious figure by Chardin or Frère, or perhaps Jan Steen. Well, what the French call "une ouv-

[1] Clasina Maria Hoornik, known as Sien.

rière."[1] She had had many cares, one could see that, and life had been hard for her, oh, she was not distinguished, nothing extraordinary, nothing unusual. " Toute femme à tout âge, si elle aime et si elle est bonne, peut donner à l'homme non l'infini du moment, mais le moment de l'infini."[2] Theo, to me there is such a wonderful charm in that slight fadedness, that something over which life has passed. Oh! she had a charm for me, I even saw in her something of Feyen-Perrin or Perugino. You see I am not quite as innocent as a green-horn or as a baby in the cradle. It is not the first time that I was unable to resist that feeling of affection, yes affection and love for those women, who are so damned and condemned and despised by the clergymen from the pulpit. I do not damn them or condemn them, neither do I despise them. I am almost thirty years old, would you think that I have never felt the need of love? Kee is even older than I am, she has also had experience of love, but just for that reason I love her the better. She is not ignorant, but neither am I. If she wants to live only on that old love and refuses the new, that is her business, and if she continues that and avoids me, I cannot smother all my energy and all my strength of mind for her sake. No, I cannot do that. I love her, but I will not freeze for her sake or unnerve myself. And the stimulus, the spark of fire we want, that is love and not exactly spiritual love.

That woman has not cheated me,—oh, he who regards all those women as cheats, how wrong he is, and how little understanding does he show. That woman has been very good to me, very good, very kind, in what way I shall not tell my brother Theo, because I suspect my brother Theo of having had some such similar experience—so much the better for him. Have we spent much money together? No, for I did not have much, and I said to her: listen, you and I need not make ourselves drunk to feel something for each other, just

[1] " a working woman."

[2] " Any woman at any age, provided she loves and is good-hearted, can give a man not the timelessness of a moment, but a moment of timelessness."

put in your pocket what I can spare. And I wish I could have spared more, for she was worth it.

And we talked about everything, about her life, about her cares, about her misery, about her health, and with her I had a more interesting conversation than for instance with my very learned, professor-like cousin. Now I tell you these things, hoping that you will see that though I have some sentiment, I do not want to be sentimental in a silly way, that I want to keep some vitality, and to keep my mind clear and my health in good condition, in order to be able to work. In this way I understand my love for Kee, and for her sake I will not be melancholy now that I have started to work, and I will not let myself be upset. The clergymen call us sinners, conceived and born in sin, bah! what dreadful nonsense that is. Is it a *sin* to love, to need love, not to be able to live without love? I think a life without love a sinful and an immoral condition.

If I repent of anything it is of the time when I was induced by mystical and theological notions to lead too secluded a life. Gradually I have thought better of that. When you wake up in the morning and find yourself not alone, but see there in the morning twilight a fellow creature beside you, it makes the world look so much more friendly. Much more friendly than religious diaries and whitewashed church walls, with which the clergymen are in love. It was a modest, simple little room in which she lived, the plain paper on the wall gave it a quiet grey tone, yet warm like a picture by Chardin; a wooden floor with a mat and a piece of old crimson carpet, an ordinary kitchen stove, a chest of drawers, and a large simple bed, in short the interior of a real working woman. She had to stand at the wash-tub the next day. Just so, quite right. In a black petticoat and dark blue camisole she would have been as charming to me as she was now in a brown or reddish-grey dress. And she was no longer young, was perhaps as old as Kee—and she had a child, yes, she had had some experience of life, and her youth was gone, gone?— " il n'y a point de vieille femme."[1] Oh, and she was strong

[1] " there is no such thing as an old woman."

and healthy,—and yet not coarse or common. Those who care so very much for distinction, are they always able to discern what is really distinguished? Dear me, people seek it often in the clouds or under the ground, when it is quite close at hand sometimes; even I did so now and then.

I am glad I acted as I did, because I think there is no earthly reason to keep me from my work, or cause me to lose my good spirits. When I think of Kee I still say, " she and no other," but those women who are condemned and damned by the clergymen, it is not just of late that I have a heart for them, that feeling is even older than my love for Kee. Often when I walked the streets quite lonely and forlorn, half ill and in misery, without money in my pocket, I looked after them and envied the men that could go with them, and I felt as if those poor girls were my sisters, in circumstances and experience. And you see that is an old feeling of mine, and is deeply rooted. Even as a boy I often looked up with infinite sympathy, and even with respect, into a half-faded woman's face, on which was written as it were: life in its reality has left its mark here.

But my love for Kee is something quite new and quite different. Without realizing it she sits in a kind of prison. She too is poor and cannot do as she wishes, and she feels a sort of resignation, and I think that the Jesuitism of clergymen and pious ladies often makes more impression on her than on me; they have no hold on me any longer, just because I have learned to detect some of the tricks, but she believes in them and would not be able to bear it, if the system of resignation, and sin, and God, and heaven knows what else proved to be idle.

And she never realizes, I fear, that God perhaps really begins when we say the word with which Multatuli[1] finishes his Prayer of an Unbeliever : " O God, there is no God." That God of the clergymen, he is for me as dead as a door-nail. But am I an atheist for all that? The clergymen consider me as such,—be it so—but I love, and how could I feel love if I did not live, and if others did not live; and then if

[1] Dutch author.

we live there is something mysterious in that. Now call that God, or human nature or whatever you like, but there is something which I cannot define systematically, though it is very much alive and very real, and see, that is God, or as good as God.

And dear me, I love Kee for a thousand reasons, but just because I believe in life and reality, I do not become abstract as I used to be, when I had the same thoughts as Kee seems to have now, about God and religion. I do not give her up, but that crisis of soul-anguish in which perhaps she is now must run its course, and I can have patience with it, and nothing that she may do or say makes me angry. But while she clings and holds to the old things, I must work and keep my mind clear for painting and drawing and business. So I have acted as I did from need of vital warmth and for hygienic reasons; I tell you these things also that you shall not think of me afresh as being in a melancholy or abstract, brooding mood. On the contrary I am generally occupied with, and only thinking of, paint, water-colours, finding a studio, etc. etc.

Boy, if only I could find a fitting studio!

Well, my letter has become very long.

I sometimes wish that the three months before I can return to Mauve were up. But they too will bring me some good of their own! Write to me now and then, is there a chance of your coming here this winter? And rest assured I will not take a studio without knowing what Mauve thinks of it; I agreed to send him the plan of the room, and perhaps he will then come and look at it himself. But Father must not meddle with it, Father is not the man to decide any artistic question. And the less Father is mixed up in my affairs the better I can get on with him, for I must be free and independent in many things. That is only natural.

I sometimes shudder when I think of Kee, and see how she buries herself in the past and clings to old dead ideas. There is a kind of fatality in it, and oh, she would not be the worse, if she changed her opinions; I think it rather probable there will come some reaction, there is so much that is healthy

and sound in her. And so in March I shall go to The Hague again, and to Amsterdam too. But when I left Amsterdam the last time I said to myself: by no means become melancholy or let yourself be stunned, so that your work suffers from it, just when it is beginning to progress. To eat strawberries in spring, yes, it is possible in life, but only for a short period of the year, and we are now far from it.

And so you envy me for some reason or other. Oh, boy, you must not, for what I am seeking can be found by everyone, perhaps even sooner by you than by me. And oh, in so many things I am very backward and narrow-minded; if I only knew exactly where the fault was and how I could manage to overcome it, but alas we often do not see the beams in our own eye. Write to me soon, and in my letters you must separate the chaff from the grain—if there is some good in them, some truth, so much the better; but of course there is much in them that is not right, more or less exaggerated perhaps, without my always being conscious of it. Indeed I am not a learned man, I am so very ignorant, oh, just like so many others, and even more than others, but I cannot fathom that myself, and much less can I fathom others, and I am often wrong. But in erring we sometimes find the right path, and " il y a du bon en tout mouvement "[1] (à propos I accidentally heard Jules Breton say that, and remembered the comment). Incidentally, did you ever hear Mauve preach? I heard him imitate several clergymen—once he preached about the fishing bark of Peter (the sermon was divided into three parts, 1st had he received or inherited that bark, 2nd had he bought it in instalment or shares, 3rd had he—oh! terrible thought —stolen it?); then he preached on the good intentions of the Lord, and on the " Tigris and Euphrates " and then he imitated Father Bernhard: God—God is Almighty—He has made the sea, He has made the earth, and the sky, and the stars, and the sun, and the moon; He can do everything— everything—everything—no, He is not almighty, there is one thing He cannot do. What is that thing the Almighty cannot do?

[1] " Every shift brings some sort of benefit "

God Almighty cannot cast out a sinner. . . .

Well, adieu, Theo, write to me soon, a handshake in thought, and believe me,

<div style="text-align: right">Yours,
Vincent</div>

Dear Theo, [The Hague, early March 1882]

Perhaps you will find rather harsh what I wrote you about Tersteeg.[1] But I cannot take it back. It must be told him straight out or else it does not penetrate his sheathing. He has considered me for years a kind of dreamer and duffer, he still considers me so, and even says about my drawing: "that is a kind of narcotic which you take in order not to feel the pain it costs you not to be able to make water-colours."

Well, it is all very fine to say this, but thoughtless, superficial and not to the point, the principal reason for my not being able to make water-colours is that I must draw still more seriously, paying more attention to proportion and perspective.

Enough of that, I do not deserve his reproaches and if my drawings do not amuse him, neither then does it amuse me to show them to him.

He condemns my drawings, which have a great deal of good in them, and I did not expect this from him.

If I make serious studies after the model, that is much more practical than his practical talks about what is salable or unsalable, a matter over which I do not need so much instruction as he supposes, having been in the business of selling pictures and drawings myself.

[1] Representative of Goupil & Co. in The Hague. He had told Theo the previous month that Vincent could always go to him whenever he wanted anything; Vincent therefore subsequently asked him for 10 francs, and Tersteeg complied, but only to the accompaniment of much unfriendly criticism of what the artist was doing. So Vincent refused to have any contact with him for another six months, and subsequently, on Theo's advice, returned the money.

So I would rather lose his friendship than give in to him in this matter.

Though there are moments when I feel overwhelmed by care, still I am calm, and my calmness is founded on my serious method of work, and on earnest reflection. Though I have moments of passion aggravated by my temperament, yet I am calm, as he who has been acquainted with me so long knows quite well. Even now he said to me : " you have too much patience."

That is not right, in art one cannot have *too much* patience, that word is out of proportion. Perhaps Mr. Tersteeg has in my case *too little* patience.

He must see now, once and for all, that I take things seriously and will not let myself be forced to produce work that does not show my own character. It is especially in my last drawings and studies, which Tersteeg condemned, that my own character is beginning to show.

Perhaps, perhaps I could succeed even now in making a water-colour that would sell if one tried very hard.

That would be forcing water-colours in a hothouse. Tersteeg and you must wait for the natural season, and that has not arrived yet.

He spoke English when he was here because of the model. I said to him : in due time you shall have your water-colours, now you cannot—they are not due as yet—take your time. And that is all I have to say. Enough of it.

Since Tersteeg's visit I have made a drawing of a boy from the Orphanage, blacking shoes. It may be this is done by a hand that does not quite obey my will, but still the type of the boy is there. And though my hand may be unruly, that hand will learn to do what my head wishes. So I have made a sketch of the studio with the stove, the chimney, easel, footstool, table, etc., of course not quite salable as things are, but very useful for practising perspective.

I am longing for your visit, there are so many things for you to see that I have made since you were here last summer. Theo, I count on your judging my work with sympathy and with confidence, and not with hesitation and dissatisfaction.

Because I work so much, Tersteeg thinks it is so easy, in this also he is quite wrong.

For in fact I am a drudge or a slow-going draught ox.

When you come, do not forget the Ingres paper. It is especially the *thick* kind that I like to use and which I think must also be good for studies in water-colour. Believe me, in things of art the saying is true : honesty is the best policy— rather more trouble on a serious study than a kind of chic to flatter the public. Sometimes in moments of worry I have longed for some of that chic, but thinking it over I say : No— let me be true to myself—and in a rough manner express severe, rough, but true things. I shall not run after the amateurs or dealers, let those who want to come to me. In due season we shall reap, if we faint not![1]

Well, I say, Theo, what a big man Millet was.

I borrowed from de Bock the great work by Sensier,[2] it interests me so much that it wakes me up in the night and I light the lamp and sit up to read. For in the day time I must work.

Do send me some money soon, if possible. I wish Tersteeg had to live for a week on what I have to spend, and had to do what I have to do; he would then see that it is not a question of dreaming and brooding, or taking narcotics, but that one must be wideawake to fight against so many difficulties. Neither is it easy to find models and to get them to sit for me. This discourages most painters. Especially when one must save on food, drink, and clothes to pay them.

Well, Tersteeg is Tersteeg, and I am I.

But I must tell you that I am not opposed or hostile to him, but I must make him understand that he judges me too super- ficially, and—and I believe that he will change his opinion; I fervently hope so, for it grieves and worries me, when there is an unfriendly feeling between us. I hope your letter will

[1] *Galatians* VI 9.
[2] A book on the art of Millet, from which Vincent quotes a passage later in the letter; Millet's work was to inspire numerous copies and variations from him at different times throughout his career.

come soon—I spent my last penny on a stamp for this letter. It is true I received only a few days ago the 10 guilders from Tersteeg, but that same day I had to pay 6 of them to the model, to the baker, to the little girl that sweeps the studio.

Adieu, I wish you health and good courage, notwithstanding everything. I myself am not without good courage.

<div style="text-align:center">Je te serre la main,[1]</div>

<div style="text-align:right">Vincent</div>

I have had a very pleasant visit from Jules Bakhuyzen[2] and I may go to see him whenever I like.

(POSTSCRIPT)

Theo, it is almost miraculous!!!

First comes your registered letter, secondly C. M.[3] asks me to make him 12 small pen drawings, views of The Hague, a propos of some that were ready. (The Paddemoes, the Geest, the Vleersteeg, were finished.) At 2.50 guilders a piece, price fixed by me, with the promise that if they suit him, he will take 12 more at his own price, which will be higher than mine. In the third place I have just met Mauve, happily delivered of his large picture, and he promised to come and see me soon. So, "ça va, ça marche, ça ira encore!"[4]

And another thing affected me—very very deeply—I had told the model not to come to-day,—I did not say why, but nevertheless the poor woman came and I protested. "Yes, but I do not come to pose, I just came to see if you had something for dinner"—she had brought me a dish of beans and potatoes. There are things that make life worth living after all. The following words in Sensier's "Millet" appealed to me, and touched me very much, sayings by Millet:

"L'art c'est un combat—dans l'art il faut y mettre sa peau."

[1] "I shake your hand"

[2] A Dutch artist friend.

[3] Vincent's uncle Cornelius Marinus (C. M. van Gogh), head of the family art-business in Amsterdam. This was to be Vincent's first sale of his work.

[4] "things are moving, things are progressing, they will go on doing so."

"Il s'agit de travailler comme plusieurs nègres : *J'aimerais mieux ne rien dire que de m'exprimer faiblement.*"[1]

It was only yesterday that I read this last saying by Millet, but I had felt the same thing before, that is why I sometimes like to scratch what I want to express, with a hard carpenter's pencil or a pen, instead of with a soft brush. Take care, Tersteeg, take care, you are decidedly in the wrong.

Dear Theo, [The Hague, early May 1882]
To-day I met Mauve and had a very painful conversation with him, which made it clear to me that Mauve and I are separated forever. Mauve has gone so far that he cannot retract, at least certainly would not want to do so. I had asked him to come and see my work and then talk things over. Mauve refused point-blank : " I will certainly not come to see you, that is all over."

At last he said : " you have a vicious character." Then I turned around, it was on the dunes, and I walked home alone.

Mauve takes offence at my having said, " I am an artist "— which I do not take back, because that word of course included the meaning : always seeking without absolutely finding. It is just the converse of saying, " I know it, I have found it."

As far as I know, that word means : " I am seeking, I am striving, I am in it with all my heart."

I have ears, Theo. If somebody says, " you have a vicious character," what ought I to do then?

I turned around and went back alone, but with a heavy heart, because Mauve had dared to say that to me. I shall not ask him to explain it, nor shall I excuse myself. And still— and still—and still—! I wish Mauve were sorry for it.

They suspect me of something,—it is in the air—I keep

[1] "Art is a battle—it costs one the skin off one's back. It is a matter of working like a bunch of negroes: *I would prefer to say nothing rather than express myself poorly.*"

something back. Vincent is hiding something that cannot
stand the light.

Well, gentlemen, I will tell you, you who prize good manners
and culture, and rightly so if only it be the true kind : which
is the more delicate, refined, manly, to desert a woman or to
stand by a forsaken woman?

This winter I met a pregnant woman, deserted by the man
whose child she bore.[1]

A pregnant woman who had to walk the streets in winter,
had to earn her bread, you understand how.

I took that woman for a model, and have worked with her
all winter. I could not pay her the full wages of a model,
but that did not prevent my paying her rent, and, thank God,
I have been able so far to protect her and her child from
hunger and cold, by sharing my own bread with her. When I
met that woman she attracted my notice because she looked
ill. I made her take baths, and as much nourishing food as I
could manage, and she has become much stronger. I went
with her to Leyden, where there is a maternity hospital in
which she will be confined. (No wonder she was ill, the
child was not in position, and she had to have an operation,
the child had to be turned with forceps. However, there is a
good chance of her pulling through. She will be confined in
June.)

It seems to me that every man worth a fig would have done
the same in a similar case.

What I did was so simple and natural that I thought I
could keep it to myself. Posing was very difficult for her,
but she has learned, and I have made progress in my drawing
because I had a good model. The woman is now attached to
me like a tame dove, I for my part can only marry once, and

[1] Sien, first mentioned in the letter of five months earlier included
here. Theo's reaction to Vincent's story did not, in fact, lead him to
cut off his financial support, as Vincent was afraid it might; but he
drew the line at the suggestion that they should marry, and ultimately,
exerted moral pressure strong enough to contribute to final break-
up of the relationship in September 1883.

how can I do better than marry her, because that is the only way to help her, and otherwise misery would force her back into her old road, that ends in a precipice. She has no money, but she helps me to earn money in my profession.

I am full of ambition and love for my work and profession; when I gave up painting and water-colours for some time it was because I felt so bad about Mauve's deserting me, and if he came back I would begin again with new courage. Now I cannot look at a brush, it makes me nervous.

I have written : Theo can you give me information about Mauve's behaviour, perhaps this letter can give you light. You are my brother, it is natural that I speak to you about private things, but anyone who says to me, "you have a vicious character," to such a person I cannot speak for the time being.

I could not do otherwise, I did what my hand found to do, I worked. I thought I should be understood without words, I had not forgotten another woman for whom my heart was beating,[1] but she was far away and refused to see me, and this one, she walked the street, sick, pregnant, hungry, in winter, I could not do otherwise. Mauve, Theo, Tersteeg, you have my bread in your hands, will you take it from me, or turn your back on me? Now I have spoken, and await what further will be said to me.

<div align="right">Vincent</div>

I send you a few studies because you can see from them that she helps me a great deal by posing.

My drawings are the work " of my model and me." The woman with a white bonnet is her mother.

But I should like to get these three back from you, as in a year, when I shall probably be drawing quite differently, my work will be founded on these studies, which I now make as conscientiously as I can. You see they are made with care. When later on I shall do an interior or a waiting-room or the like, these will be of use to me, because I shall have to consult them for the details. But I thought it would be well perhaps if you could see how I use my time.

[1] Kee Vos.

Those studies require a rather dry technique; had I worked after effect they would be of less use to me subsequently. But I think you will understand this yourself. The paper I should like best is that on which the bent woman's figure is drawn, but if possible the colour of unbleached linen. I have none of it left, *of that thickness*, I think they call it double Ingres, I cannot get it here. When you see how that drawing is carried out, you will understand that it could not be done on thin paper. I wanted to send you with it a small figure in black merino, but I cannot roll it. The chair near the large figure is not finished, because I want there an old oaken chair.

Dear Theo, [The Hague, mid May 1882]
To-day I sent you some drawings and sketches; what I want to show you first of all is that what I told you does not keep me from my work, on the contrary I am literally absorbed in my work and enjoy it, and have good courage.

Now I hope that you will not be angry at my saying so, but I am rather anxious, because you have not answered as yet. I do not believe that you will disapprove of my being with Christine. I do not believe that for that reason, or for the sake of appearances or I do not know what else, you would quite desert me. But can you wonder, after what happened with Mauve and Tersteeg, that I sometimes think with a certain melancholy; perhaps *he* will do the same.

At least I am eagerly looking out for a letter from you, but I know that undoubtedly you are very busy and that it is not so very long since you wrote. But perhaps you will experience it yourself sooner or later, when you are with a woman who is with child, that a day seems like a week, and a week longer than a month. And that is the reason why I write you so often these days, just as long as I have no answer.

I wrote to you about my intention of taking the house next door, it being more suitable than this one, which seems so easily blown apart, etc. But you surely know, don't you, that I do not ask imperatively for anything whatever. I only hope

that you will remain to me what you were; I do not think I lowered or dishonoured myself by what I did, though some perhaps will think so. I feel that my work lies in the heart of the people, that I must keep close to the ground, that I must grasp life at its deepest, and make progress through many cares and troubles.

I cannot think of any other way, and I do not ask to be free from trouble or care; I only hope the latter will not become unbearable, and that need not be so as long as I work and can keep the sympathy of people like you. It is in life as in drawing, one must sometimes act quickly and with decision, attack a thing with energy, trace the outlines as quickly as lightning.

This is not the moment for hesitation or doubt, the hand may not tremble, nor may the eye wander, but must remain fixed on what is before one. And one must be so absorbed in it that in a short time something is produced on the paper or the canvas that was not there before, so that afterwards one hardly knows how it got knocked into being. The time of discussing and thinking must precede the decided action. In the *action* itself there is little space for reflection or argument.

To act quickly is the function of a man, and one has to go through a great deal before one is able to do so. The pilot sometimes succeeds in making use of a storm to make headway, instead of being wrecked by it.

What I wanted to say to you again is this : I do not have great plans for the future; if for a moment I feel rising within me the desire for a life without care, for *prosperity,* each time I go fondly back to the trouble and the cares, to a *life full of hardship,* and think: it is better so, I learn more from it, it does not degrade me, this is not the road on which one perishes. I am absorbed in my work and I have confidence enough that with the help of such as you, as Mauve, as Tersteeg, though this winter we disagreed, I will succeed in earning enough to keep myself, not in luxury, but as one who eats his bread in the sweat of his brow. Christine is not a hindrance or a trouble to me, but a help. If she were alone,

she would perhaps succumb; a woman must not be alone in a society and a time like that in which we live, which does not spare the weak but treads them under foot, and drives over a weak woman when she has fallen down.

Therefore because I see so many weak ones trodden down, I greatly doubt the sincerity of much that is called progress and civilization. I do believe in civilization, even in such a time, but only in the kind that is founded on real humanity. What costs human life I think cruel, and I do not respect it. Well, enough of this. If it might be that I could rent the house next door and could have regular weekly wages, that would be delightful. If it cannot be, I will not lose courage and will wait a little longer. But if it can be, I shall be so happy, and it would save much of my strength for the work, which otherwise is absorbed by cares.

You will see there are all kinds of drawings in the portfolio.

Keep whatever you think best of what I send, then you can show them whenever there is a chance. The rest I should like to get back some time or other. If I thought you would come soon, I would of course keep these things until you came. But now it is perhaps good for you to see the things together, and I hope you will see from it that I do not live idly on your money. Considering it superficially you would perhaps view the affair with Christine quite differently from what it really is.

But when you have read this letter and my earlier one, it will be easier for you to understand.

I wish those who mean well by me would understand that my actions proceed from a deep feeling and need for love, that recklessness and pride and indifference are not the springs that move the machine, and this step is a proof of my taking root at a low level on life's way. I do not think I should do well in aiming at a higher station or in trying to change my character. I must have much more experience, I must learn still more, before I shall be ripe, but that is a question of time and perseverance. Adieu, write soon.

If you can send me something, it will certainly not be unwelcome. Believe me, with a handshake,

Yours,

Vincent

If I thought my leaving The Hague would please anyone I would do so, and go no matter where, rather than be in anybody's way.

But I do no harm to anybody, and after what you wrote me I suppose I must not take too seriously what Tersteeg said.

The house about which I wrote you is to let now, and I am afraid someone else will take it if I do not do so soon. That is another reason why I am looking out for your letter. For you will understand that after what happened with Mauve and Tersteeg, and after what I told you about Christine, I must ask you frankly: Theo, do these things make for a change or separation between you and me? If they do not, I would be so happy, and will be twice as glad for your help and sympathy as before; if they do, it is better for me to know the worst than to be kept in suspense.

I like to look things in the face, whether adversity or prosperity. I have got your answer on the question of Mauve and Tersteeg, not on the other one. That is something quite apart, there is a barrier between the artistic and the personal matters, but it is well to settle beforehand how we look at those things.

And therefore I say to you:

Theo, I intend to marry this woman, to whom I am attached and who is attached to me. If unfortunately this should bring about a change in your feelings towards me, I hope you will not withdraw your help without giving me warning some time before, and that you will always tell me frankly and openly what you think. Of course I hope that your help and sympathy will in no way be withdrawn, but that we shall continue to grasp hands fraternally, notwithstanding things which the " world " opposes. So, brother, if you have not written yet when you receive this letter, answer me by return of post, for after the things I wrote to you, I

must be reassured or must know the worst. Adieu, I hope the sky will remain clear between you and me.

Dear brother, [The Hague, second half of July 1882]

It is already late, but I want to write to you once more. You are not here, but I wish you were, and sometimes it seems to me that we are not far from each other.

To-day I promised myself something, that is to consider my illness, or rather the remains of it, as non-existent.[1] Enough time has been lost, the work must go on. So, well or not well, I shall set to drawing again, regularly from morning until night. I do not want someone to tell me again : " Oh! these are just old drawings."

To-day I made a drawing of the baby's cradle with a few touches of colour in it.

I am also working on a drawing like the one of the meadows I sent you recently. My hands have become too white, but am I to blame?

I will go out and work in the open air, even if it should cause the return of my illness. I cannot keep from working any longer.

Art is jealous, she does not want us to choose illness in preference to her, so I do as she wishes.

Therefore I hope you will again in a short while receive a few rather good new drawings. People like me *may* not be ill, so to speak.

You must understand properly my conception of art. In order to grasp the essence one must work long and hard. What I want and aim at is confoundedly difficult, and yet I do not think I aim too high.

I want to make drawings that *touch* some people. " Sorrow" is a small beginning, perhaps such small landscapes as the " Meerdervoort Avenue," the " Rijswijk Meadows," the " Fish-Drying Barn," are also a small beginning. In those there is at least something directly from my own heart.

[1] He had had to go into hospital with bladder trouble and insomnia.

Either in figure or in landscape I should wish to express, not sentimental melancholy, but serious sorrow.

In short, I want to reach so far that people will say of my work: he feels deeply, he feels tenderly—notwithstanding my so-called roughness, perhaps even because of this.

It seems pretentious now to speak this way, but that is the reason why I want to push on with full strength.

What am I in the eyes of most people?—a nobody, or an eccentric and disagreeable man—somebody who has no position in society and never will have, in short, the lowest of the low. Very well, even if that were true, then I should want to show by my work what there is in the heart of such an eccentric man, of such a nobody.

This is my ambition, which is, notwithstanding everything, founded less on anger than on love, founded more on serenity than on passion. It is true that I am often in the greatest misery, but still there is within me a calm pure harmony and music. In the poorest huts, in the dirtiest corner, I see drawings and pictures. And with irresistible force my mind is drawn towards these things.

More and more other things lose their interest, and the more I get rid of them, the quicker my eye grasps the picturesque things. Art demands persistent work, work in spite of everything, and a continuous observation.

By persistent, I mean in the first place continuous work, but also not giving up your opinion at the bidding of such and such a person. I do hope, brother, that within a few years, perhaps even now, little by little you will see things by me that will give you some satisfaction for your sacrifices.

I have had very little contact with other painters lately. I have not been the worse for it. It is not the language of painters but the language of nature to which one ought to listen. I can now understand better than six months ago why Mauve said: "do not speak to me about Dupré, talk rather about the bank of that ditch, or something of that sort." It sounds rather crude, but it is perfectly true. The feeling for the things themselves, for reality, is more important than the feeling for pictures, at least it is more fertile and more vital.

Because I now have such a broad, ample feeling for art and for life itself, of which art is the essence, it sounds to me so shrill and false when people try to compel me.

I for my part find in many modern pictures a peculiar charm which the old masters lack.

For me one of the highest and noblest expressions of art is always that of the English, for instance Millais and Herkomer and Frank Holl.[1] What I mean in regard to the difference between the old masters and the modern ones is—perhaps the modern ones are deeper thinkers.

There is a great difference in sentiment between the " Chill October " by Millais and the " Bleachery at Overveen " by Ruysdael, and also between the " Irish Emigrants " by Holl and the " Bible Reading " by Rembrandt.

Rembrandt and Ruysdael are sublime, for us just as much as for their contemporaries, but there is something in the modern painters that appeals to us more personally and intimately.

It is the same with the woodcuts by Swain and those of the old German masters.

So, I think it was a mistake when a few years ago the modern painters had a phase of imitating the old masters.

Therefore I think Father Millet is right in saying " Il me semble absurde que les hommes veuillent paraître autre chose que ce qu'ils sont."[2] It seems only a commonplace saying, yet it is fathomless, deep as the ocean, and I for my part think one would do well to take it to heart. I just wanted to tell you that I will set to work regularly again in spite of everything, and I want to add that I am longing so very much for a letter from you, and now I wish you goodnight. Adieu, with a handshake,

Yours,

Vincent

Please do not forget the *thick* Ingres if you can get it— I enclose a sample. I still have some of the thin kind. On

[1] Vincent knew these as graphic illustrators.

[2] " It seems absurd to me that men should want to appear other than they really are."

the thick Ingres I can wash with water-colours, on the other it always becomes blurred by no fault of mine.

I hope I shall be able to draw that little cradle *persistently* a hundred times more, not counting what I did to-day.

Dear Theo, [The Hague, July 31 1882]

Just a line to welcome you in anticipation of your arrival. Also to let you know of the receipt of your letter and the enclosed, for which I send my heartiest thanks. It was very welcome, for I am hard at work and need a few more things.

As far as I understand it, we of course agree perfectly about black in nature. Absolute black does not really exist. But like white, it is present in almost every colour, and forms the endless variety of greys,—different in tone and strength. So that in nature one really sees nothing else but those tones or shades.

There are but three fundamental colours—red, yellow and blue; " composites " are orange, green and purple.

By adding black and some white one gets the endless varieties of greys—*red*-grey, *yellow*-grey, *blue*-grey, *green*-grey, *orange*-grey, *violet*-grey. To say, for instance, how many green-greys there are is impossible, there are endless varieties.

But the whole chemistry of colours is not more complicated than those few simple rules. And to have a clear notion of this is worth more than seventy different colours of paint,— since with those three principal colours and black and white, one can make more than seventy tones and varieties. The colourist is he who seeing a colour in nature knows at once how to analyse it, and can say for instance: that green-grey is yellow with black and blue, etc.

In other words, someone who knows how to find the greys of nature on his palette. In order to make notes from nature, or to make little sketches, a strongly developed feeling for outline is absolutely necessary as well as for strengthening the composition subsequently.

But I believe one does not acquire this without effort, rather in the first place by observation, and then especially by

strenuous work and research, and particular study of anatomy and perspective is also needed. Beside me is hanging a landscape study by Roelofs, a pen sketch—but I cannot tell you how expressive that simple outline is, everything is in it.

Another still more striking example is the large woodcut of " The Shepherdess " by Millet, which you showed me last year and which I have remembered ever since. And then, for instance, the pen and ink sketches by Ostade and Peasant Breughel.

When I see such results I feel more strongly the great importance of the outline. And you know for instance from " Sorrow " that I take a great deal of trouble to make progress in that respect.

But you will see when you come to the studio that besides the seeking for the outline I have, just like everyone else, a feeling for the power of colour. And that I do not object to making water-colours; but the foundation of them is the drawing, and then from the drawing many other branches beside the water-colour sprout forth, which will develop in me in time as in everybody who loves his work.

I have attacked that old whopper of a pollard willow, and I think it is the best of the water-colours : a gloomy landscape— that dead tree near a stagnant pool covered with reeds, in the distance a car shed of the Rhine Railroad, where the tracks cross each other; dingy black buildings, then green meadows, a cinder path, and a sky with shifting clouds, grey with a single bright white border, and the depth of blue where the clouds for an instant are parted. In short, I wanted to make it as the signal man in his smock and with his little red flag must see and feel it when he thinks : " it is gloomy weather to-day."

I have worked with great pleasure these last days, though now and then I still feel the effects of my illness.

Of the drawings which I will show you now I think only this : I hope they will prove to you that I am not remaining stationary in my work, but progress in a direction that is reasonable. As to the money value of my work, I do not pretend to anything else than that it would greatly astonish me

if my work were not just as salable in time as that of others. Whether that will happen *now* or *later* I cannot of course tell, but I think the surest way, which *cannot* fail, is to work from nature faithfully and energetically. Feeling and love for nature sooner or later find a response from people who are interested in art. It is the painter's duty to be entirely absorbed by nature and to use all his intelligence to express sentiment in his work, so that it becomes intelligible to other people. To work for the market is in my opinion not exactly the right way, but on the contrary involves deceiving the amateurs. And true painters have not done so, rather the sympathy they received sooner or later came because of their sincerity. That is all I know about it, and I do not think I need know more. Of course it is a different thing to try to find people who like your work, and who will love it—that of course is permitted. But it must not become a speculation, that would perhaps turn out wrong and would certainly cause one to lose time that ought to be spent on the work itself.

Of course you will find in my water-colours things that are not correct, but that will improve with time.

But know it well, I am far from clinging to a system or being bound by one. Such a thing exists more in the imagination of Tersteeg, for instance, than in reality. As to Tersteeg, you understand that my opinion of him is quite personal, and that I do not want to thrust upon *you* this opinion that I am forced to have. So long as he thinks about me and says about me the things you know, I cannot regard him as a friend, nor as being of any use to me; quite the opposite. And I am afraid that his opinion of me is too deeply rooted ever to be changed, the more so since, as you say yourself, he will never take the trouble to reconsider some things and to change. When I see how several painters here, whom I know, have problems with their water-colours and paintings, so that they cannot bring them off, I often think : friend, the fault lies in your drawing. I do not regret for one single moment that I did not go on at first with water-colour and oil painting. I am sure I shall make up for that if only I work hard, so that my hand does not falter in drawing and in the

perspective; but when I see young painters compose and draw *from memory*—and then haphazardly smear on whatever they like, *also from memory*—then study it at a distance, and put on a very mysterious, gloomy face in the endeavour to find out what in heaven's name it may look like, and finally make something of it, always *from memory*—it sometimes disgusts me, and makes me think it all very tedious and dull.

The whole thing makes me sick!

But those gentlemen go on asking me, not without a certain patronizing air, "if I am not painting as yet?"

Now I too on occasion sit and improvise, so to speak, at random on a piece of paper, but I do not attach any more value to this than to a rag or a cabbage leaf.

And I hope you will understand that when I continue to stick to drawing I do so for two reasons, most of all because I want to get a firm hand for drawing, and secondly because painting and water-colouring cause a great many expenses which bring no immediate recompense, and those expenses double and redouble ten times when one works on a drawing which is not correct enough.

And if I got in debt or surrounded myself with canvases and papers all daubed with paint without being sure of my drawing, then my studio would soon become a sort of hell, as I have seen some studios look. As it is I always enter it with pleasure and work there with animation. But I do not believe that you suspect me of *unwillingness*. It only seems to me that the painters here argue in the following way. They say: you must do this or that; if one does not do it, or not exactly so, or if one says something in reply, there follows a: "so you know better than I?" So that immediately, sometimes in less than five minutes, one is in fierce altercation, and in such a position that neither party can go forward or back. The least hateful result of this is that one of the parties has the presence of mind to keep silent, and in some way or other makes a quick exit through some opening. And one is almost inclined to say: confound it, the painters are almost like a family, namely, a fatal combination of persons with contrary

L.V.G.

interests, each of whom is opposed to the rest, and two or more are of the same opinion only when it is a question of combining together to obstruct another member. This definition of the word family, my dear brother, is, I hope, not always true, especially not when it concerns painters or our own family. With all my heart I wish peace may reign in our own family, and I remain with a handshake,

<div align="right">Yours,</div>
<div align="right">Vincent</div>

This is nearly enough the effect of the pollard willow,[1] only in the water-colour itself there is no black, except a broken one.

Where in this little sketch the black is darkest, there in the water-colour are the strongest effects, dark green, brown and grey. Well, adieu, and believe me that sometimes I laugh heartily, because people suspect me of all kinds of malignity and absurdities, of which I do not nourish an inkling. (I who am really nothing but a friend of nature, of study, of work, and of people in particular.) Well, hoping to see you soon, with a handshake,

<div align="right">Yours,</div>
<div align="right">Vincent</div>

Dear Theo, [The Hague, early August 1882]

In my last letter you will have found a little sketch of that perspective frame I mentioned. I just came back from the blacksmith, who made iron points to go on the sticks and iron corners for the frame.

It consists of two long poles; the frame may be attached to them either upright or horizontally with strong wooden pegs.

So on the shore or in the meadows or in the fields one can look through it *as through a window*. The vertical lines and the perpendicular line of the frame and the diagonal lines and the point of intersection, or else the division in squares, certainly give a few basic markers, with the help of which

[1] Vincent included a sketch in the original letter.

one can make a firm drawing, from the indication of the
main lines and proportions—at least for those who have
some instinct for perspective and some understanding of the
reason why and the manner in which perspective gives an
apparent change of direction to the lines and a change of size
to the planes and to the whole mass. Without this the instru-
ment is of little or no use at all, and it makes one *dizzy* to
look through it. I think you can imagine how it is a delight-
ful thing to focus the viewer on the sea, on the green
meadows, or in winter on the snowy fields, or in autumn on
the fantastic network of thin and thick branches and trunks
or on a stormy sky.

With long and continuous practice it enables one to draw
quick as lightning,—and once the drawing is established, to
paint quick as lightning also.

In fact, *for painting* it is absolutely the thing, for to express
sky-earth-sea one needs the brush, or rather in order to ex-
press all that in drawing it is necessary to know and to under-
stand the treatment of the brush. I certainly believe that if I
paint for some time, it will have great influence on my
drawing. I already tried it in January, but then I had to stop,
the reason for my decision being, aside from a few other
things, that I was too hesitant in my drawing. Now six
months have passed that have been quite devoted to drawing.
Well, it is with new courage that I start to paint again. The
perspective frame is really a fine piece of workmanship; I am
sorry you did not see it before you left. It cost me quite a
bit, but I have had it made so solidly that it will last a long
time. So next Monday I begin to make large charcoal studies
with it, and begin to *paint* small studies. If I succeed in these
two things, then I hope that better painted things will follow
soon.

I want my studio to be a real painter's studio by the time
you come again. I had to stop in January, as you know, for
several different reasons, but after all it may be considered
like some defect in a machine, a screw or a bar that was not
strong enough and had to be replaced by a stronger one.

I bought a pair of strong and warm trousers, and as I had

bought a pair of strong shoes just before you came, I am now prepared to weather the storm and rain. It is my decided aim to learn from this painting of landscape a few things about *technique* which I feel I need for the *figure,* namely, to express different *materials,* and the *tone* and the *colour.* In one word, to express the bulk—the body—of things. Through your coming it became possible to me, but before you came there was not a day when I did not think in this way about it, only I should have had to keep exclusively to black and white and to the outline a little longer.—But now I have *launched my boat.* Adieu, boy, once more, a hearty handshake and believe me,

<div style="text-align:right">

Yours,
Vincent

</div>

Dear Theo, [The Hague, early September 1882]
<div style="text-align:right">Sunday morning</div>

I have just received your very welcome letter, and as I want to take some rest to-day I answer it at once. Many thanks for it and for the enclosure, and for the things you tell me.

And for your description of that scene with the workmen at Montmartre, which I found very interesting, as you describe the colours too, so that I can see it: many thanks for it. I am glad you are reading the book about Gavarni.[1] I thought it very interesting, and it made me love him twice as much.

Paris and its surroundings may be beautiful, but here we have nothing to complain of either.

This week I painted something which I think would give you the impression of Scheveningen as we saw it when we walked there together: a large study of sand, sea and sky—a big sky of delicate grey and warm white, with one little spot of soft blue gleaming through—the sand and the sea, light—so that the whole becomes blond, but animated by the typically strong and bright-coloured figures and fishing smacks, which are full of tone. The subject of the sketch is a fishing smack with its anchor being raised. The horses are ready to be

[1] French cartoonist and illustrator of the mid nineteenth century.

hitched to it and then to draw the boat into the water. I enclose a little sketch of it. It was a hard job. I wish I had painted it on a panel or on canvas. I tried to introduce more colour into it, namely depth and firmness of colour. How curious it is that you and I often seem to have the same thoughts. Yesterday evening, for instance, I came home from the wood with a study, and for the whole week, and especially then, I had been deeply absorbed in that question of depth of colour. And I would have liked to have talked it over with you, especially as regards the study I made, and, look here, in your letter of this morning you accidentally speak about being struck on Montmartre by the strong vivid colours, which even so remained harmonious.

I do not know if it was exactly the same thing that struck us both, but I well know that you also would have certainly felt what struck me so particularly, and probably you too would have seen it in the same way. I begin by sending you a little sketch of the subject and will tell you what it was about.

The wood is becoming quite autumnal—there are effects of colour which I rarely find painted in Dutch pictures.

Yesterday towards evening I was busy painting a rather sloping ground in the wood, covered with mouldered and dry beech leaves. That ground was light and dark reddish brown, made more so by the shadows of trees which threw more or less dark streaks over it, sometimes half blotted out. The question was, and I found it very difficult, to get the depth of colour, the enormous force and solidity of that ground—and while painting it I perceived only for the first time how much light there still was in that dusk—to keep that light, and to keep at the same time the glow and depth of that rich colour.

For you cannot imagine any carpet so splendid as that deep brownish-red, in the glow of an autumn evening sun, tempered by the trees.

From that ground young beech trees spring up which catch light on one side and are sparkling green there, and the shadowy side of those stems are a warm deep black-green.

Behind those saplings, behind that brownish-red soil, is a sky very delicate, bluish grey, warm, hardly blue, all aglow— and against it is a hazy border of green and a network of little stems and yellowish leaves. A few figures of wood gatherers are wandering around like dark masses of mysteri- ous shadows. The white cap of a woman, who is bending to reach a dry branch, stands out all of a sudden against the deep red-brown of the ground. A skirt catches the light—a shadow falls—a dark silhouette of a man appears above the underbrush. A white bonnet, a cap, a shoulder, the bust of a woman moulds itself against the sky. Those figures, they are large and full of poetry—in the twilight of that deep shadowy tone they appear as enormous clay figurines being shaped in a studio.

I describe nature to you; how far I rendered the effect in my sketch, I do not know myself; but this I know, that I was struck by the harmony of green, red, black, yellow, blue, brown, grey. It was very de Groux-like, an effect for in- stance like that sketch of "The Conscript's Departure" formerly in the Ducal Palace.

To paint it was a hard job. I used for the ground one large tube and a half of white—yet that ground is very dark— further red, yellow, brown ochre, black, sienna, bistre, and the result is a reddish-brown, but one that varies from bistre to deep wine-red, and even a pale blond ruddiness. Then there is still the moss on the ground, and a border of fresh grass, which catches light and sparkles brightly, and is very difficult to get. There you have at last a sketch which I maintain has some significance and which expresses some- thing, no matter what may be said about it.

While painting it I said to myself: I must not go away before there is something of an autumn evening air about it, something mysterious, something serious.

But as this effect does not stay, I needed to paint quickly —the figures were painted in at once with a few strong strokes with a firm brush. It struck me how firmly those little stems were rooted in the ground. I began on them with a brush, but because the base was already so clotted, a brush-stroke was

lost in it—so I squeezed the roots and trunks in from the tube, and modelled it a little with the brush.

Yes—now they stand there rising from the ground, strongly rooted in it. In a certain way I am glad I have not *learned* painting, because then I might have *learned* to pass by such effects as this. Now I say, no, this is just what I want, if it is impossible, it is impossible; I will try it, though I do not know how it should be done. How I paint it *I do not know myself.* I sit down with a white board before the spot that strikes me, I look at what is before me, I say to myself that that white board must become something; I come back dissatisfied—I put it away, and when I have rested a little, I go to look at it with a kind of fear. Then I am still dissatisfied, because I still have too clearly in my mind that splendid subject, to be satisfied with what I made of it. But after all I find in my work an echo of what struck me. I see that nature has told me something, has spoken to me, and that I have put it down in shorthand. In my shorthand there may be words that cannot be deciphered, there may be mistakes or gaps, but there is something in it of what wood or shore or figure has told me, and it is not a tame or conventional language, proceeding less from nature itself than from a studied manner or a system.

Enclosed another little sketch from the dunes. Small bushes are standing there, the leaves of which are white on one side and dark green on the other and constantly rustle and glitter. Dark trees to the rear.

You see I am absorbed with all my strength in painting; I am absorbed in colour—until now I have restrained myself, and I am not sorry for it. If I had not drawn so much, I would not be able to catch the impression of and get hold of a figure that looks like an unfinished clay figurine. But now I feel myself on the high sea—the painting must be continued with all the strength I can give to it.

When I paint on panel or canvas the expenses increase again. Everything is so expensive, the paint is also expensive, and is so soon gone. Well, those are difficulties all painters have. We must see what can be done. I know for sure that

I have an instinct for colour, and that it will come to me more and more, that painting is in my very bone and marrow. Doubly and twice doubly I appreciate your helping me so faithfully and in such measure. I think so often of you. I want my work to become firm, serious, manly, and that you too will get satisfaction from it as soon as possible.

One thing I want to call your attention to, as being of importance. Might it be possible to get colours, panels, brushes, etc., *wholesale*? Now I have to pay the retail price. Are you connected with Paillard or anyone like that? If so, I think it would be very much cheaper to buy wholesale—white, ochre, sienna, for instance, and we could then arrange about the money. It would of course be much cheaper. Think it over. Good painting does not depend upon using much colour, but in order to paint a ground emphatically, or to keep a sky clear, one must sometimes not spare the tube.

Sometimes the subject requires delicate painting, sometimes the material, the nature of the things themselves requires thick painting. Mauve, who in comparison with J. Maris, and still more in comparison with Millet or Jules Dupré, paints very soberly, has in the corners of his studio cigar boxes full of empty tubes, which are as numerous as the empty bottles in the corners of the rooms after a dinner or soirée, as Zola describes it for instance. Well, if there can be a little extra this month, that will be delightful. If not, it will be all right, too. I shall work as hard as I can. You inquire after my health, but how is yours? I am inclined to believe that my remedy would serve you also—to be in the open air, to paint. I am well, but when I am tired I still feel it. However, it is getting better instead of worse. I think it a good thing that I live as sparingly as possible, but painting is my special remedy. I heartily hope that you are having good luck and that you will find still more. A hearty handshake in thought and believe me,

<div style="text-align:right">

Yours,

Vincent

</div>

You see how in the sketch of the beach there is a blond

tender effect, and in the wood there is a more gloomy serious tone. I am glad both exist in life.

Dear Theo, [The Hague, beginning of November 1882]
 Your letter and its contents were very welcome to me. The question you refer to will perhaps become more and more urgent. People will be obliged to acknowledge that many a new thing in which one at first thought to find progress proves in fact to be less sound than the old ones, and in consequence the need for strong men to redress things will manifest itself. As arguing about this can do little good, I think it rather superfluous to write more about it.

 But I can hardly say that I share your thought which you express in the following words: "To me it seems quite natural that the desired change will occur." Just think how many great men are dead or will not be with us for long— Millet, Brion, Troyon, Rousseau, Daubigny, Corot—so many others are no longer among the living; think further back, Leys, Gavarni, de Groux (I name only a few), still further back, Ingres, Delacroix and Géricault, think how old *modern art* already is, add many others as well who have already reached old age.

 Up to Millet and Jules Breton, however, there was always in my opinion progress, but to surpass these two—don't even mention it.

 Their genius may be equalled in former, present or later times, but to surpass it is not possible. In that high range there is an equality of genius, but higher than the top of the mountain one cannot climb. Israëls, for instance, may equal Millet, but among genii superiority or inferiority is out of the question.

 Now in the realm of art the summit has been reached. Certainly we shall still see beautiful things in the years to come, but anything more sublime than we have seen already—no. And I for my part am afraid that perhaps in a few years there will be a kind of *panic* in this regard. Since *Millet* we

have greatly deteriorated; the word decadence, now whispered or pronounced in covert terms, (see Herkomer[1]) will then sound as an alarm bell. Many an one, for instance I myself, keeps quiet now because one is already labelled as a *mauvais coucheur*,[2] and to speak about it doesn't help. Speaking about it, that is to say, is not what one ought to do, one must work, even if it be with a sorrowful heart; those who will subsequently cry the hardest about decadence will be the most decadent themselves. I repeat—" By these fruits ye shall know them,"[3] by their work, nor will it be the most eloquent who will say the truest things, look at Millet himself, look at Herkomer; they are indeed no orators and they speak almost *à contre cœur*.[4]

Enough of this, I find in you someone who understands many of the great men, and I think it delightful to hear now and then things about them which I did not know; for instance, what you tell me about Daumier. The series of portraits of deputies, etc., the pictures " Third Class Railway Carriage," " The Revolution," I know none of them. It is true that your writing doesn't make me see them myself, but in my imagination Daumier's personality becomes more important as a result of it. I prefer to hear about such men more than, for instance, about the last Salon.[5]

Now what you write about the *Vie Moderne*, or rather about the kind of paper that Buhot promised you,—this is something which interests me very much. Do I understand rightly that this paper is such that when one makes a drawing on it (I suppose with autographic ink) this drawing *just as it is*, without the intermediary of a second draughtsman or engraver or lithographer, can be transferred on to a stone, or a cliché can be made of it, so that an indefinite number of

[1] Vincent's friend, Anthon van Rappard, had sent him a summary of an article by the English illustrator, Herkomer, about modern woodcuts, which had recently come out in an English art periodical.
[2] " an unpleasant customer "
[3] *Matthew* VII 20.
[4] " reluctantly "
[5] The official art-exhibition held annually in Paris.

copies can be pulled?—the latter then being facsimiles of the original drawing. If this is so, be so kind then as to give me all information you can pick up about the way in which one has to work on this paper, and try to get me some of it, so that I can give it a trial.

If I could have a trial before you come, we might on that occasion consult about what we can do with it.

I think it possible that within a relatively short time there will perhaps be a greater demand for illustrators than there is at present.

As for me, if I fill my portfolios with studies from every model I can get hold of, I will have enough of a skill to hope to get employment. *To keep* illustrating, as did for instance Morin, Lançon, Renouard, Jules Ferat, Worms in their times, one needs quite a lot of ammunition, in the form of different studies of all kinds of subjects.

Those I try to get together, as you know, and as you will see when you come.

By the by, I have not so far received the package of studies, which according to your letter you returned to me via the Rue Chaptal. Do you think they have already arrived at the Plaats? If you think so I will send for them, as they will be of use to me in connection with things which I have recently produced.

Do you know whose portrait I drew this morning? Blok, the Jewish book dealer—not David, but the little one who stands on the Binnenhof.

I wish I could draw more members of that family, for they are real good types.

It's awfully difficult to get the types that one likes best; meanwhile I think I'm right in working on *those I can get,* without losing sight of those I would draw if only I could get them.

I am very glad about Blok, he reminds me of things from many years ago. I hope he will come again some Sunday morning.

Of course one always feels, and one must feel, when at

work, a kind of dissatisfaction with oneself, a longing to do it much better; but still it is delightful and comforting little by little to get a collection of all kinds of figures together, though the more one makes the more one wants to make.

One cannot do everything at once, but it will be absolutely necessary for me to make a number of horse studies, not only just scratches made in the street, but to take a model for them. I know an old white horse, just the poorest nag imaginable (at the gas-works); but the man, who lets the poor beast do the hardest possible jobs, and draws from it what he can get, asked me a lot for it, namely, three guilders a morning to come to me and one guilder and a-half at least to come to him, but then it must be on a Sunday.

And when you consider that to get what I need, about thirty large studies for instance, I should have to work many a morning, it would prove to be too expensive. But I shall get a better chance some time.

I can get a horse here and there easily enough for a *very short* time, people are willing enough for that occasionally; but one *cannot* in a very short time do what really must be done, so that does not help me much.

I try to work quickly, for that is necessary, but a study that is of any use requires at least half an hour, on average, so one always falls back on to real posing. At Scheveningen, for instance, on the beach, I have had a boy or man standing for me for a moment, as they call it; the result was always a great longing in me for a longer pose, and the mere standing still of a man or a horse doesn't satisfy me.

If I am properly informed, the draughtsmen for the *Graphic* could always turn by turn find a model at their disposal in a studio at the office. Dickens tells a few good things about the painters of *his* time and their wrong way of working, namely, their following the model servilely, yet only half-way. He says : " Fellows, try to understand that your model is *not* your final aim, but *the means of giving form and strength to your thought and inspiration.* Look at the French (for instance, Ary Scheffer) and see how much better

they do it than you do." It seems the English listened to him; *they* continued working with the model, but they have learned to view the model in a broader, stronger way and to use it for healthier, nobler compositions than those of the painters of Dickens's time.

Two things that in my opinion reinforce one another and remain eternally true are : Do not quench your inspiration and your imagination, do not become the slave of your model; and again : Take the model and study it, otherwise your inspiration will never become plastically concrete.

When your letter came, I immediately had many things to pay for. I hope it will not inconvenience you to send again not later than the 10th of November. That question of the process about which Buhot spoke to you seems very important to me, you know. I shall be very happy to learn it and will try my best to do so.

Adieu, with a handshake,

Yours,

Vincent

Do you know what effects one sees here at present early in the morning?—it is splendid—the sort that Brion painted in his picture at the Luxembourg : " The End of the Deluge," namely that streak of red light on the horizon with rain clouds over it. This brings me to the landscape painters. Compare those of the time of Brion with the contemporaries. Is it better now? I doubt it.

I will readily acknowledge that they are more productive now, but though I cannot help admiring what is produced now, the old landscapes done in a more old-fashioned way please me whenever I see them. There was a time for instance when I passed a Schelfout thinking : that's not worth while.

But the modern way, though it has its attraction, doesn't make that strong, deep, durable impression, and when one has been looking for a long time at new things, one sees again with great pleasure a naïve picture like a Schelfout or a Ségé, a Jules Bakhuysen. It is really not intentionally that I feel rather disenchanted about the progress, on the contrary quite against my will; the feeling involuntarily entered my

thoughts, because I feel more and more a kind of void, which I cannot fill with the things of to-day.

While looking for an example, I happen to think of some old woodcuts by Jacque, which I saw at least ten years ago at Uncle Cor's; it was a series called "The Months", done in the manner of those etchings which appeared in yearly series, or even more old-fashioned still. There is less of the local tone in it than in his later work, but the drawing and an element of pithiness remind one of Millet. Look here, in the many sketches in today's magazines, it seems to me that a *not* quite *un*conventional elegance threatens to replace that typical, real rusticity of which the sketches of Jacque, which I mentioned, are an example.

Don't you think the cause of this lies also in the life and personality of the artists? I do not know your experience, but do you find, for instance at present, many people who like to take a lengthy walk in grey weather? You yourself would love it and enjoy it as I do, but for many people it would be unattractive. It also struck me that when one talks with painters, the conversation in most cases is *not* interesting. Mauve has at times the great power of describing a thing in such words that one sees it, and certainly others have that too, when they want to. But that peculiar open-air feeling when you speak to a painter—do you think it is as strong as it used to be?

I read this week in Forster's *Life of Charles Dickens* all kinds of particulars about long walks on Hampstead Heath, etc., outside London, with the object for instance of eating bacon and eggs in a little old inn far away, well out in the country. Those walks were very pleasant and merry, but for all that it was generally in this way that serious plans were made for books, or discussions were held about what changes Dickens should make in this or that figure. There is nowadays a hurry and bustle in everything that doesn't please me, and it seems as if the joy has gone out of most things. I wish your expectation would come true: "that the desired change will come," but to me it doesn't seem "quite natural."

However this may be, it is of very little use to fight back

in words, I think, and the thing for everyone to do who has an interest in the matter is to try in his little circle to make something or to help make something.

I worked again on a water-colour of miners' wives carrying bags of coal through the snow. But especially I drew about twelve studies of figures for it and three heads, and I am not ready yet. In the water-colour I think I found the proper effect, but I do not think it broad enough of character. In reality it is something like " The Reapers " by Millet, severe, so you understand that one mustn't make a snow effect of it, which would be merely an impression and would only then have its raison d'être if it were done by way of a landscape. I think I will start afresh, though I believe the studies that I have at the moment will please you, because they succeeded better than many others. It would really be fit for the *Vie Moderne,* I think. When I get the paper I shall anyhow have *one* of the figures to try out, but it must become a group of women, a small caravan.

[The Hague, end of November 1882]

Dear Theo, Sunday

Yesterday I happened to read a book by Murger, namely, " The Water Drinkers." I find something in it of the same charm there is, for instance, in the drawings by Nanteuil, Baron, Roqueplan, Tony Johannot, something witty, something bright.

Still, it is very conventional, at least this book is, I think. I haven't read other books of his as yet, and I think there is the same difference between him and, for instance, Alphonse Karr and Souvestre as there is between a Henri Monnier and a Comte-Calix and the above-mentioned artists. I try to choose the persons I compare all from the same period. It has a fragrance of the era of the Bohemian (though the reality of that time is suppressed in the book), and for that reason it interests me, but in my opinion it lacks originality and sincerity of sentiment. However, perhaps his books in which no artist types occur are better than this one; authors seem to be always unlucky with their types of painters. Balzac,

among others (his painters are rather uninteresting), Zola, even though his Claude Lantier is real[1]—there certainly are Claude Lantiers, but, after all, one would like to see another kind of painter depicted by Zola than Lantier, who seems to be drawn from life after somebody who certainly was not the worst example of that school, which I think is called impressionist. And it is not they who form the nucleus of the artistic corps.

On the other hand, I know very few well-drawn or well-painted types of authors; painters on that point generally fall into the conventional and make of an author a man who sits before a table full of papers, that's all, or they do not even go as far as that, and the result is a gentleman with a collar and a face devoid of expression.

There is a painting by Meissonier which I think beautiful, it is a figure seen from behind, stooping over, with his feet I think on the rung of the easel; one sees nothing but a pair of up-drawn knees, a back, a neck, and the back of a head, and just the glimpse of a fist holding a pencil or something similar. But the fellow is there, and one feels the action of strained attention just as in a certain figure by Rembrandt, a little fellow shown reading, who also stoops with his head leaning on his fist, and one feels at once that he is absolutely lost in his book.

Take Bonnat's Victor Hugo, fine, very fine, but I still prefer the Victor Hugo described in words by Victor Hugo himself, nothing but this : " Et moi je me taisais, tel que l'on voit se taire un coq sur la bruyère."[2]

Isn't it splendid, that little figure on the heath? Isn't it just as vivid as a little general of '93 by Meissonier—of about the size of one centimetre.

There is a portrait of Millet by Millet himself which I love, nothing but a head with a kind of shepherd's cap, but the look—from half-closed eyes, the intense look of a painter

[1] Hero of Zola's novel, L'Œuvre, first published in 1885/6; the model for Lantier was in principle Cézanne.

[2] " And as for me I was silent, like a cock seen keeping silence on the heath."

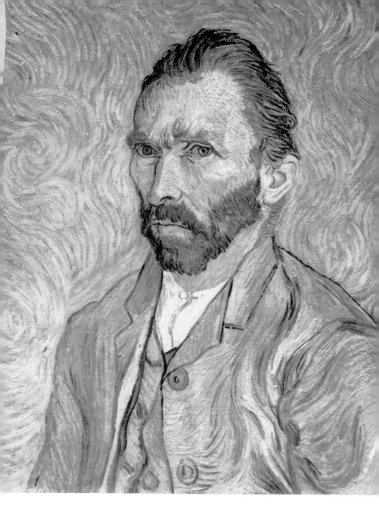

Self-portrait, oil, St.-Rémy, May 1890

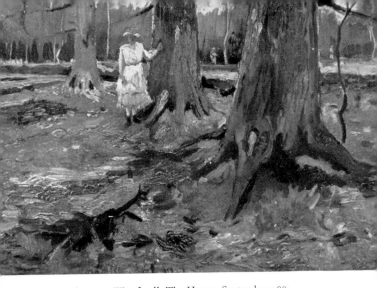

Autumn Wood, oil, The Hague, September 1882
(p. 165)

Miners' Wives Carrying Coal, watercolour,
The Hague, November 1882
(p. 175)

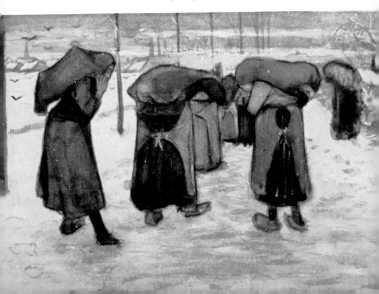

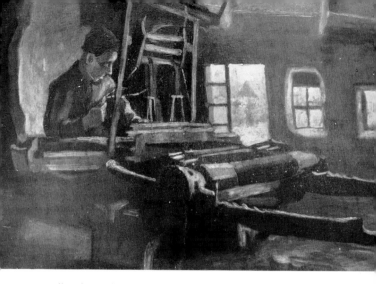

Interior with a Weaver, oil, Nuenen, June/July 1884 (p. 217)

Night Café, oil, Arles, September 1888 (pp. 275, 288-9)

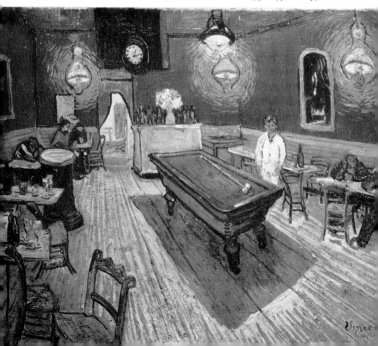

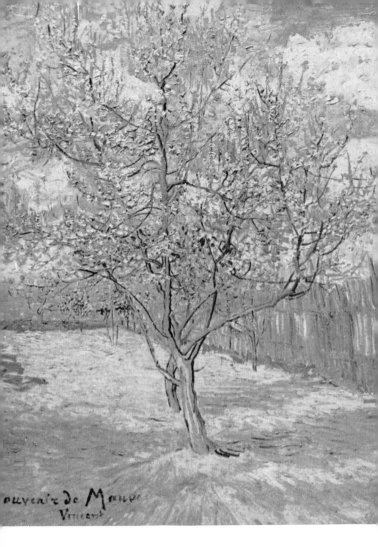

Flowering Tree, 'Souvenir de Mauve', oil, Arles, March 1888
(pp. 263, 265)

View of Saintes-Maries-sur-Mer, oil, Saintes-Maries, June 1888
(p. 267)

The Postman Roulin, oil, Arles, August 1888
(pp. 274, 278)

Sunflowers, oil, Arles, August 1888
(p. 284)

The Bedroom, oil, Arles, October 1888 (p. 297)

Falling Leaves in the Alyscamps Avenue, oil, Arles, November 1888 (p. 300)

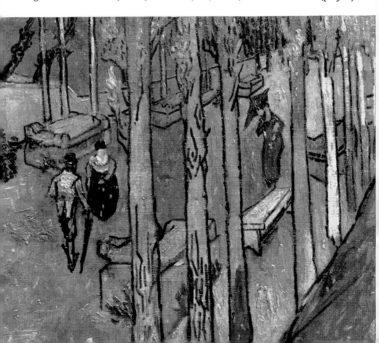

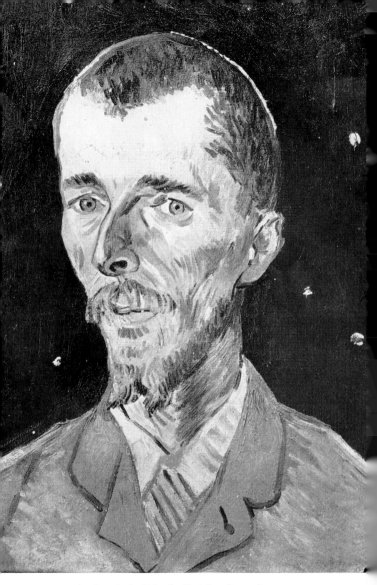

Portrait of an Artist Friend, oil, Arles, September 1888
(pp. 277-8, 285)

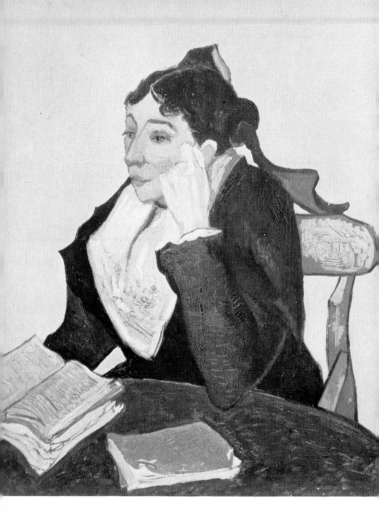

The Arlésienne, portrait of Mme. Ginoux, oil, Arles, November 1888
(pp. 298, 309)

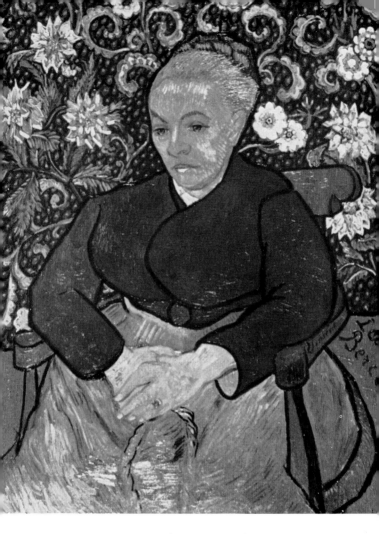

Woman Rocking a Cradle, oil, Arles, December 1888/January 1889
(p. 306)

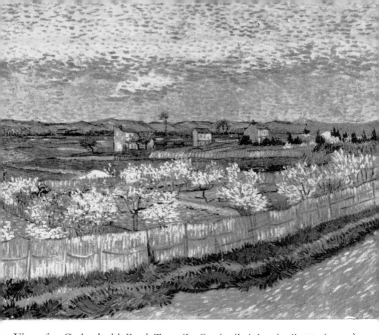

View of an Orchard with Peach Trees (Le Crau), oil, Arles, April 1889 (p. 315)

Cypresses and Stars, drawing, St.-Rémy, June 1889 (pp. 265, 319)

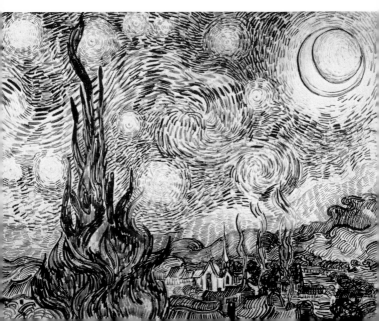

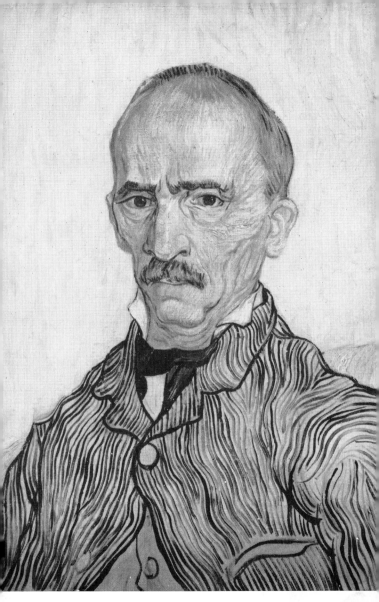

Portrait of the Head Warder at the Saint-Rémy Asylum, oil,
St.-Rémy, September 1889
(p. 323)

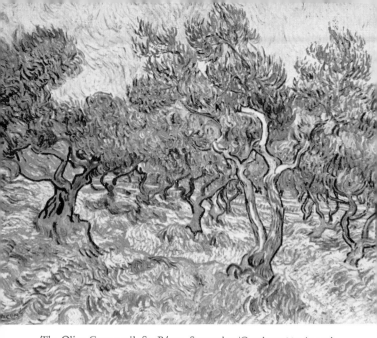

The Olive Grove, oil, St.-Rémy, September/October 1889 (p.329)

Girl with Coffee-Tinted Skin, oil, Arles, August 1888 (p. 283)

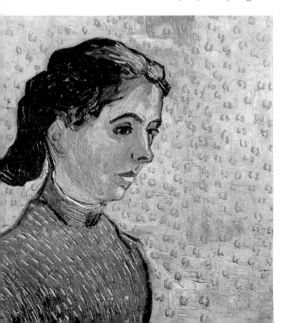

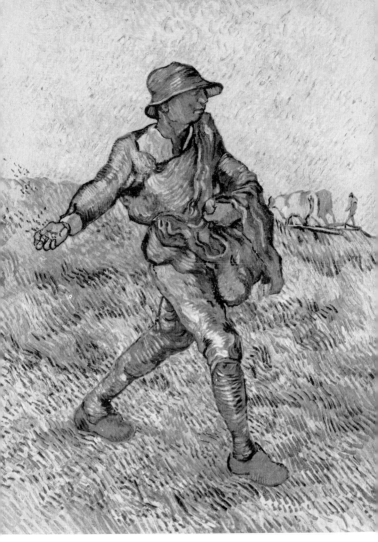

The Sower, after Millet, oil, St.-Rémy, February 1890
(p. 334)

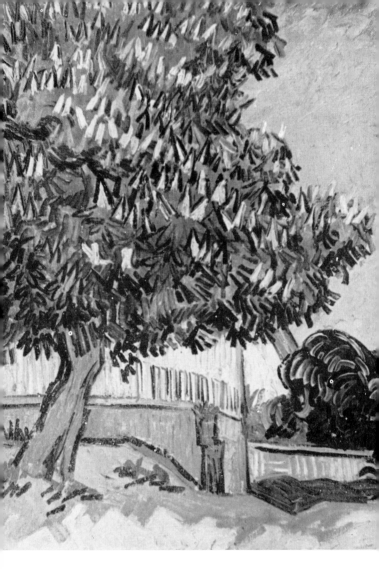

White Chestnuts, oil, Auvers, May, 1890
(p. 337)

—how beautiful it is—also that piercing gleam as in a cock's eye, if I may call it so.

It is Sunday again. This morning I took a walk on the Rijswijk road, the meadows are partly flooded, so that there was an effect of tonal green and silver with the rough black and grey and green trunks and branches of the old trees distorted by the wind in the foreground, a silhouette of the little village with its pointed spire against the clear sky in the background, here and there a gate or a dungheap on which a flock of crows sat pecking. How you would like such a thing, how well you would paint it if you tried.

It was extraordinarily beautiful this morning, and it did me good to take a long walk, for what with drawing and the lithography I had scarcely been outdoors this week.

As to the lithography, I hope to get a proof to-morrow of a little old man. I hope it will turn out well. I made it with a kind of chalk especially patterned for this process, but I am afraid that after all the common lithographic crayon will prove to be the best, and that I shall be sorry I did not use it.

Well, we must see how it turns out.

To-morrow I hope I shall learn several things about printing which the printer will show me. I should love to learn the printer's craft itself. I think it quite possible that this new method will bring new life into the art of lithography. I think there might be a way of combining the advantages of the new with the old way, one cannot tell for certain, but perhaps it may be the cause of new magazines being published.

Monday

I wrote this far last night, this morning I had to go to the printing office with my little old man, now I have witnessed everything, the transfer on to the stone, the preparation of the stone and the printing itself. And I have a better idea now of what changes I can still make by retouching. Enclosed you will find the first print, not counting one spoiled proof. After a time I hope to do better, this doesn't satisfy me at all, but well, the progress must come by work and trying. It

seems to me the duty of a painter to try to put an idea into his work. In this print I have tried to express (but I cannot do it well, or so strikingly as it is in reality, of which this is but a weak reflection in a dark mirror) what seems to me one of the strongest proofs of the existence of " quelque chose là-haut "[1] in which Millet believed, namely, the existence of God and eternity—certainly in the infinitely touching expression of such a little old man, of which he himself is perhaps unconscious, when he is sitting quietly in his corner by the fire.

At the same time there is something noble, something great that cannot be destined for the worms. Israëls has painted it so beautifully. In *Uncle Tom's Cabin*, the most beautiful passage is perhaps the one in which the poor slave, knowing that he must die, and sitting for the last time with his wife, remembers the words,

> *Let cares like a wild deluge come,*
> *And storms of sorrow fall,*
> *May I but safely reach my home,*
> *My God, my Heaven, my all.*

This is far from theology, simply a fact that the poorest little wood-cutter or peasant on the heath or miner can have moments of emotion and inspiration which give him a feeling of an eternal home to which he is near.

Returning from the printing office, I find your letter; I think your Montmartre splendid, and I certainly would have shared your emotion, in fact I think that Jules Dupré and Daubigny have often tried to conjure up these thoughts by their work. There is at times something indescribable in those aspects, all nature seems to speak, and on going home one has a feeling of the same sort as when one has finished a book by Victor Hugo, for instance. As for me, I cannot understand that not everybody sees it and feels it, nature or God does it for everyone who has eyes and ears and a heart to understand. For this reason I think a painter is happy because he is in harmony with nature as soon as he can express a little of what he sees.

And that's a great thing, one knows what one has to do,

[1] " something up there "

there are subjects in abundance, and Carlyle rightly says, "Blessed is he who has found his work."

If that work like that of Millet, Dupré, Israëls, etc., strives to bring peace, *sursum corda,* lift up your heart to Heaven, then it is doubly stimulating—one is then less alone also, because one thinks. It's true I'm sitting here lonely, but whilst I am sitting here in silence, my work perhaps speaks to my friend, and whoever sees it will not suspect me of being heartless.

But I tell you that dissatisfaction about bad work, the failure of things, the difficulties of technique can make one dreadfully melancholy. I can assure you that I am sometimes terribly discouraged when I think of Millet, Israëls, Breton, de Groux, so many others, Herkomer for instance; one only knows what these fellows are worth when one is oneself at work. And then to swallow that despair and that melancholy, to bear with oneself as one is, not in order to sit down and rest but to struggle on notwithstanding thousands of shortcomings and faults and the doubtfulness of conquering them, all these things are the reason why a painter is not happy either.

The struggle with oneself, the trying to better oneself, the renewal of one's energy, all this is complicated by material difficulties.

That picture by Daumier must be beautiful. It is a mystery why a thing that speaks as clearly as that picture, for instance, is not understood, at least that the situation is such that you are not sure of finding a buyer for it even at a low price.

This is for many a painter also something unbearable, or at least almost unbearable. One wants to be an honest man, one is so, one works as hard as a slave, but still one cannot make both ends meet; one must give up the work, there is no chance of carrying it out without spending more on it than one gets back for it, one gets a feeling of guilt, of short-coming, of not keeping one's promises, one is not honest as one would be if the work were paid for at its natural reason-able price. One is afraid of making friends, one is afraid of moving, like one of the old lepers, one would like to call from

afar to the people: Don't come too near me, for intercourse with me brings you sorrow and loss; with all that great load of care on one's heart, one must set to work with a calm, everyday face, without moving a muscle, live one's ordinary life, get along with the models, with the man who comes for the rent, with everybody in fact. With a cool head, one must keep one hand on the rudder to continue the work, and with the other hand try to do no harm to others.

And then storms arise, things one had not foreseen, one doesn't know what to do, and one has a feeling that one may strike a rock at any moment.

One cannot present oneself as somebody who comes to propose a good business transaction or who has a plan which will bring great profit. On the contrary, it is clear that it will end with a deficit, and still one feels a power surging within, one has work to do and it must be done.

One would like to speak like the people of '93: this and that must be done, first these have to die, then those, then the last ones, it is duty, so it is unarguable, and nothing more need be said.

But is it the time to combine and to speak out?

Or is it better, as so many have fallen asleep and do not like to be aroused, to try to stick to things one can do alone, for which one is alone liable and responsible, so that those who sleep may go on sleeping and resting.

Well, you see that for this once I express more intimate thoughts than usual, you yourself are responsible for it as you did the same.

About you I think this, you are certainly one of the watchers, not one of the sleepers—wouldn't you rather watch while painting than while selling pictures? I say this in all coolness without adding what in my opinion would be preferable, and with full confidence in your own insight into things. That there is a great chance of going under in the struggle, that a painter is something like a "lost sentinel", these and other things need no saying. You must not think of me as so readily scared—for instance, to paint the Borinage would be something so difficult, so relatively dangerous

as to make life a thing far removed from any rest or pleasure. Yet I would undertake it if I could, that is, if I didn't know for sure, as I do now, that the expenses would surpass my means. If I could find people who would interest themselves in such an enterprise, I would risk it. But just because you are really the only one for the moment who has a concern over what I do, the thing has to be put on the shelf for the present and must remain there, and meanwhile I will find other things to do. But I do not give it up to spare myself.

I hope you will be able to send the money not later than the 1st of December. Well, boy, hearty thanks for your letter and a warm handshake in thought, believe me,

<div style="text-align:right">Yours,
Vincent</div>

<div style="text-align:right">[The Hague, 1883]</div>

Dear Theo, February 8

My hearty congratulations for Father's birthday, and thanks for your letter, which I was very glad to receive just now. I congratulate you especially on the operation being over.[1] Such things as you describe make one shudder! May the worst be over now, at least the crisis past! Poor woman! If women do not always show in their thoughts the energy and elasticity of men, who are disposed towards reflection and analysis, we cannot blame them, at least in my opinion, because in general they have to spend so much more strength than we in suffering pain. They suffer more and are more sensitive.

And though they do not always understand our thoughts, they are sometimes truly capable of understanding when one is good to them. Not always, though, but "the spirit is willing," and there is in women sometimes a curious kind of goodness.

There must be a great load off your mind now that the operation is over.

[1] A young woman whom Theo had befriended when she was sick and alone in Paris—to Vincent's great pleasure, since this paralleled his own behaviour towards Sien—had had to be operated on for a tumour of the foot.

What a mystery life is, and love is a mystery within a mystery. It certainly never remains the same in a literal sense, but the changes are like the ebb and flow of the tide and leave the sea unchanged.

Since I wrote to you last, I have given my eyes some rest and it has done me good, though they still ache now and then.

Do you know what has come into my mind, that in the first period of a painter's life one unconsciously makes it very hard for oneself—by a feeling of not being able to master the work—by an uncertainty as to whether one will ever master it—by a great ambition to make progress, by a lack of self-confidence—one cannot banish a certain feeling of agitation, and one hurries oneself though one doesn't like to be hurried.

This cannot be helped, and it is a time which one must go through, and which in my opinion cannot and should not be otherwise.

In the studies, too, one is conscious of a nervousness and a certain dryness which is the exact opposite of the calm, broad touch one strives for, and yet it doesn't work well if one applies oneself too much to acquiring that broadness of touch.

This gives one a feeling of nervous unrest and agitation, and one feels an oppression as on summer days before a thunderstorm. I had that feeling again just now, and when I have it, I change my work, just to make a new start.

That trouble one has at the beginning sometimes gives an awkwardness to the studies.

But I do not take this as a discouragement, because I have noticed it in myself as well as in others, who afterwards just slowly got rid of it.

And I believe that *sometimes* one keeps that *painful* way of working one's whole life, but not always with so little result as in the beginning. What you write about Lhermitte is quite in keeping with the review of the exhibition of Black and White. They, too, speak about the bold touch which can almost be compared only to Rembrandt's. I should like to know such an artist's conception of Judas; you write of his

having drawn Judas before the scribes, and I think that Victor Hugo could describe that in detail, *so that one would see it,* but to paint those expressions would be more difficult still.

I found a page by Daumier: " ceux qui ont vu un drame " and " ceux qui ont vu une vaudeville."[1] I have developed a growing longing to see more of Daumier's work. There is pith and a sober depth in him, he is witty and yet full of sentimental passion; sometimes, for instance in " The Drunkards," and possibly also in " The Barricade," which I do not know, I find a passion which can be compared to the white heat of iron.

The same thing occurs in certain heads by Frans Hals, for instance, it is so sober that it seems cold; but when you look at it for a short while you are astonished to see how someone working apparently with so much emotion and so completely wrapped up in nature had at the same time the presence of mind to put it down with such a firm hand. I found the same thing in studies and drawings by de Groux; perhaps Lhermitte operates also at that white heat. And Menzel too.

There are sometimes passages in Balzac or Zola, for instance in *Père Goriot,* where words reach a degree of passion that is white hot.

I sometimes think I will make an experiment, and try to work in quite a different way, that is, to dare more and to risk more, but I am not sure that I should not first do more by way of studying the figure directly from the model.

I am also looking for a way to shut off the light in the studio, or to let it in as I please. It doesn't fall enough from above, I think, and there is too much of it. For the time being I shut it off with cardboard now and then, but I must try and get the landlord to produce some shutters.

What was in the letter I told you I had torn up was quite in keeping with what you say.

But while finding more and more that one is not perfect oneself, and makes mistakes, and that other people do like-

[1] " Spectators who have witnessed a drama " and " spectators who have been present at a vaudeville."

wise, so that difficulties continually arise which are the oppo-
site of illusions, I think that those who do not lose courage
and who do not become indifferent, ripen through it, and one
must bear hardships in order to ripen.

Sometimes I cannot believe that I am only thirty years old,
I feel so much older.

I feel older *only* when I think that most people who know
me consider me a failure, and how it really might be so, if
some things do not change for the better; and when I think
it might be so, I feel it so vividly that it quite depresses me
and makes me as downhearted as if it were really so. In a
calmer and more normal mood I am sometimes glad that
thirty years have passed, and not without teaching me some-
thing for the future, and I feel strength and energy for the
next thirty years, if I should live that long.

And in my imagination I see years of serious work before
me, and happier ones than the first thirty.

How it will be in reality doesn't depend *only* on myself,
the world and circumstances must also contribute to it.

What concerns me and is a source of responsibility is that
I should make the most of the circumstances and try my best
to make progress.

The age of thirty is, for the working man, just the begin-
ning of a period of some stability, and as such one feels
young and full of energy.

But, at the same time, a phase of life is past. This makes
one melancholy, thinking some things will never come back.
And it is no silly sentimentalism to feel a certain regret.
Well, many things really begin at the age of thirty, and cer-
tainly all is not over then. But one doesn't expect out of life
what one has already learned that it cannot give, but rather
one begins to see more and more clearly that life is only a
kind of sowing time, and the harvest is not here.

Perhaps that's the reason that one sometimes feels indiffer-
ent toward the opinion of the world, and if that opinion
depresses us all too strongly, one may throw it off.

Perhaps I had better tear up this letter as well.

I understand perfectly that you are quite absorbed by the

condition of the woman; that is one of the things which are necessary for her rescue, and also for her recovery.

For one must throw oneself headlong into it, and the English saying is true : " if you want it well done, you must do it yourself, you mustn't leave it to others." That means that one must keep in hand the care in general and the management of the whole.

We had a few real spring days, for instance last Monday, which I enjoyed very much.

The cycle of the seasons is a thing which is strongly felt by the people. For instance, in a neighbourhood like the Geest and in those courts of almshouses or " homes of charity," the winter is always a difficult, anxious and oppressive time, and spring is a deliverance. If one pays attention, one sees that such a first spring day is a kind of Gospel message.

And it is pathetic to see so many grey, withered faces come out of doors on such a day, not to do something special, but as if to convince themselves that spring is there. So, for instance, all kinds of people, of whom one would not expect it, throng the market around the spot where a man sells crocuses, snowdrops, bluebells and other bulbs. Sometimes a dried-up government clerk, apparently a kind of Jusserand in a threadbare black coat with greasy collar—that *he* should be beside the snowdrops is a pretty picture ! I think the poor people and the painters have in common that feeling for the weather and the cycle of the seasons. Of course everybody feels it, but for the well-to-do middle-class it is not so important, and it doesn't affect much their frame of mind in general. I thought it a characteristic saying for a navvy : " In winter I suffer as much from the cold as the winter corn does."

Now for your patient too spring will be welcome, may it do her good ! How terrible that operation was, at least I was frightened by the description.

Rappard is recovering, did I tell you he had brain fever? It will be some time before he can go to work again, but he is starting to take a walk now and then.

If my eyes do not improve, I'll follow your advice and bathe them with tea. As it is they are getting better, so for

the present I'll leave them alone. For they never troubled me before, except once this winter when I had toothache, so I believe it is nothing but strain and overwork.

On the contrary, lately my eyes can stand the fatigue of drawing better than previously.

Write soon again if you can, and believe me, with a handshake,

Yours,

Vincent

I do not know whether you know those little almshouses on the Brouwersgracht opposite the hospital. I should like to draw there when the weather permits. This week I made a few scratches there already. They are a few rows of small houses with little gardens which I think belong to the charity board.

Dear Theo, [The Hague, mid March 1883]

Thanks for your letter of the 9th of March, and for the enclosed. Is your patient improving? I hope in this case " no news is good news."

If it has been as cold in Paris as it was here last week, it cannot have agreed very well with her.

When you say that you sometimes wish we could talk together more, about a variety of things in art, I for my part have that longing continually, and sometimes very strongly.

So often I should like to know your opinion about this or that, about some studies, etc., for instance, if they might be of some use, or if it would be advisable, for some reason or other, to go more deeply into them.

So often I should like to have some more information about things on which you are better informed than I, and I should like to know more about the state of things, I mean what kind of work the painters are producing. One can write about it to some extent, but writing takes time, and one cannot always get to it, nor can one go enough into detail.

And just now, owing to a piling up of studies, it would be worth a great deal to me if we could talk things over

together, and I should also like so much to have you see how the studio is improved.

Well, let us hope that it will not be so very, very long before you come to Holland.

Be clear in your mind, dear brother, how strongly and intensely I feel the enormous debt I owe you for your faithful help.

It would be difficult for me to express all my thoughts about it. It constantly remains a source of disappointment to me that my drawings are not yet what I want them to be. The difficulties are indeed numerous and great, and cannot be overcome at once. To make progress is a kind of miner's work; it doesn't advance as quickly as one would like, and as others also expect, but as one stands before such a task, the basic necessities are patience and faithfulness. In fact, I do not think much about the difficulties, because if one thought of them too much one would get stunned or disturbed.

A weaver who has to direct and to interweave a great many little threads has no time to philosophize about it, but rather he is so absorbed in his work that he doesn't think but acts, and he *feels* how things must go more than he can explain it. Even though neither you nor I, in talking together, would come to any definite plans, etc., perhaps we might mutually strengthen that *feeling* that something is ripening within us. And that is what I should like.

This morning I was at Van der Weele's, who was working at a marvellous picture of diggers, horses, and sand wagons, large size. It was beautiful in tone and colour, a grey morning haze, it was virile in drawing and composition, there was style and character in it—in fact it was by far the most beautiful and strongest thing of his I have ever seen. He had also painted three very beautiful serious studies of an old white horse, and also a beautiful little landscape in the dunes.

This week he will probably look in at my studio, which I should like very much indeed.

Last week I met Breitner in the street; his position in Rotterdam frees him from much anxiety; however, Van der Weele had a little note from him just this morning, to the

effect that he was ill again. To tell you the truth, the impression I had when I saw him again was not very assuring; he had an air of disappointment, and he spoke in rather a queer way about his work.

Now I still have to tell you about the surprise I have had. I received a letter from Father, very cordial and cheerful, it seemed to me, with twenty-five guilders enclosed. Father wrote he had received some money, on which he had no longer counted, and he wanted me to share in it. Wasn't that nice of him, however it quite embarrasses me.

But, involuntarily, a thought occurred to me. Can it be, perhaps, that Father has heard, from someone or other, that I was very hard up? I hope that this was not his motive, for I think this idea of my circumstances would not be correct. And it might give Father anxieties which would be quite out of place. You will understand my meaning better than Father would if I were to try to explain it to him.

In my opinion, I am often *rich as Crœsus,* not in money, but (though it doesn't happen every day) rich, because I have found in my work something to which I can devote myself heart and soul, and which gives inspiration and significance to life.

Of course my moods vary, but there is an average of serenity. I have a sure *faith* in art, a sure confidence that it is a powerful stream, which bears a man to harbour, though he himself must do his bit too; and at all events I think it such a great blessing, when a man has found his work, that I cannot count myself among the unfortunate. I mean, I may be in certain relatively great difficulties, and there may be gloomy days in my life, but I shouldn't want to be counted among the unfortunate nor would it be correct.

You write in your letter something which I sometimes *feel also* : " Sometimes I do not know how I shall pull through."

Look here, I often feel the same *in more than one respect,* not only in *financial* things, but in art itself, and in *life* in general. But do you think that something exceptional? Don't you think every man with a little pluck and energy has those moments?

Moments of melancholy, of distress, of anguish, I think we all have them, more or less, and it is a condition of every *conscious* human life. It seems that some people have no self-consciousness. But those who have it, they may sometimes be in distress, but for all that they are not unhappy, nor is it something exceptional that happens to them.

And sometimes there comes relief, sometimes there comes new inner energy, and one rises up from it, till at last, some day, one perhaps doesn't rise up any more, *que soit,* but that is nothing extraordinary, and I repeat, *such is the common human fate, in my opinion.*

Father's letter was an answer to a letter of mine, which I remember quite well was very cheerful, for I told him about the changes in the studio, and I did not write anything to Father that could give rise to thoughts of my being in any difficulties, either financial or otherwise. In fact, Father doesn't write anything about it, and his letter is very cheerful and cordial, but the money came so unexpectedly that involuntarily the thought came into my head, can it be that Father is worried about me? If I am mistaken in this, it would be very much out of place to write as if that were the principal impression his kindness has made upon me—the principal impression being that I feel very grateful for having received something which enables me to do several things that otherwise I couldn't have done. But I tell you my thoughts about it, because in case you should perceive that Father is worrying about me, you would be better able to reassure him than I.

At the same time, you see from this that I have had a real stroke of luck. I intend to spend it on getting my water-colour things in good shape. I will pay off Leurs and will be able to arrange for different things in the studio, in order to make it even more practical.

It sometimes seems to me that the prices of the various painting and drawing materials are terribly inflated. So that it thwarts many a person from painting. One of my ideals is that there would be more institutions like the *Graphic,* for instance, where people who want to work can find all the

materials, on condition that a certain ability and energy is demonstrated.

Like Cadart, in his day, enabled many a man to etch, who wouldn't have been able to etch, because of the expenses, if he had had to pay them from his own pocket.

I am privileged above many others, but I cannot do everything which I might have the courage and energy to undertake. The expenses are so extensive, beginning with a model and food and housing, and ending with the different colours and brushes.

And that is also like a weaving loom, where the different threads must be kept apart.

But we all have to bear up against the same thing—so just because everyone who paints or draws has to bear it, and if alone would almost sink down under it, why shouldn't more painters join hands, to work together, like soldiers of the rank and file; and why, especially, are those branches of art which are least expensive so much despised?

As to the crayon, I do not know whether the one you gave me came from the Plaats, but I am quite sure that you gave it to me on your visit of last summer, or *perhaps when I was still in Etten.* In a drug store I found a few remnants, perhaps six pieces, but all in small bits. Please keep it in mind. When I again asked Leurs for it, he told me that Jaap Maris had asked him so often for it.

I have made two sketches with it again, a cradle, and one more like the one I sent you already, in which I washed a great deal with sepia. As to what you write about that sketch of those two figures, the one above the other, it is mainly an effect of perspective, and also of the great difference in size between the little child and the woman on the basket.

What I myself dislike more than that line of the composition is something which, in fact, you have noticed, that the two figures are too much of one tone, which is partly the fault of the crayon, which does not express all shades, and one would like to strengthen it with lithographic crayon, for instance. But I think that the principal reason is that I do not always have time enough to work as elaborately as I should

like. If one works a long time on a drawing, it is possible to go more into detail, to seek the different tones. But too often I must work in a hurry. I dare not ask too much from my models. If I paid them better, I should have the right to demand longer poses, and could make better progress.

At present, I often think I get more from them than a just return on what I pay them in money.

However, I do not mean to say that there is not a still more important reason, namely, that I must become more skilled than I am before I can be ever so slightly satisfied with myself. And by and by I hope to make better and more elaborate things in the same amount of time that I now spend on them.

Well, brother, my best wishes for your patient, I long sometimes for another description of an aspect of Paris from you, and—rest assured I'll make shift as best I can, with what your faithful help gives me—that I try and try to make an even better use of it, and especially that I blame myself for being unable to manage to do what I want with it. Adieu, with a handshake in thought,

Yours,
Vincent

Dear Theo, [The Hague, end of April 1883]
On your birthday I want you to receive a little word from me too. May it be a happy year for you, and may you have success in your work, and I do hope, especially, that you may have in this year some satisfaction for what you did for your patient; may she recover and start a new life. Do you know it is almost a year since you were here? Yes—I long very much for your coming. It is the work of that whole year that I have to show you, about which we must speak in regard to the future.

Do you think it will be about the same time as last year that you will come? Well, as soon as anything is decided about your coming, let me know.

Some time ago you told me many things about these Swedish painters, Heyerdahl, Edelfelt.

This week I found a reproduction of a picture by Edelfelt: "A Prayer-Meeting on the Beach." There is something in it of Longfellow's poems; it is very beautiful. It shows a sentiment of which I am very fond, and which I think does more good in the world than the Italians and Spaniards with their "Arms Merchants of Cairo," of which I get so tired in the long run.

This week I have been working on the figure of a woman on the heath, who is gathering cuts of peat.

And a kneeling figure of a man.

One must know the structure of the figures so thoroughly, in order to get the expression, at least I cannot see it differently.

The Edelfelt is indeed beautiful in its expression, however the effect lies not only in the expression of the faces, but in the whole position of the figures.

Do you know who has claims to being the cleverest of all these Swedes?

It is perhaps a certain Wilhelm Leibl,[1] an absolutely self-made man.

I have a reproduction of a picture with which he suddenly came out, I think it was at the exhibition in Vienna in '82. It represents three women in a pew, one seated figure of a young woman in a checkered dress (Tyrol), two kneeling old women in black, with kerchiefs round their heads. Its sentiment is beautiful and drawn like Memling or Quinten Matsys. That picture seems to have made a great sensation among the artists at the time, I do not know what became of Leibl since then. I found him very much like Thijs Maris. In England there was also a German of that kind, but less clever—Paul de Gassow, who reminds me a little of Oberländer, whose heads you certainly remember. Well, there still seem to be some good artists in Sweden.

I am longing again for your letter. As to what I wrote you about relations between women and their mothers, I can

[1] A mistake of the author; Wilhelm Leibl was a German.

assure you, in my case nine-tenths of the difficulties which I had with the woman originated directly or indirectly therein.

And yet those mothers are not exactly bad, though they act absolutely wrongly.

But they do not know what they are doing.

Women of about the age of fifty are often distrustful, and perhaps it is that very distrust and cunning that entangles them. If you care to hear them, I can tell you some particulars some day. I do not know whether all women become more serious in getting older, and then want to govern and correct their daughters, which they do in exactly the wrong way.

In some cases their system may have some raison d'être; but they ought not to fix as a principle and accept a priori that all men are deceivers and fools, for which reason women must cheat them and suppose they know everything better. If, by ill chance, the mother-system is applied to a man who is honest and of good faith, he is indeed badly off. . . .

Well, the time has not yet come when *reason,* not only in the sense of *raison,* but also of la conscience, is respected by everyone; to contribute towards bringing about that time is a duty, and in judging characters one of the first things that humanity demands is to take into consideration the circumstances of contemporary society.

How beautiful Zola is—it is especially *L'Assommoir* which I often think of. A propos, how far did you get in reading Balzac? I have quite finished *Les Misérables.* I know very well that Victor Hugo analyses in a different way than do Balzac and Zola, but he probes to the bottom of things just as well.

Do you know what I should prefer in the matter of relations between the woman and her mother—in my case where it has decidedly bad consequences—that the mother came to live with us entirely.

I proposed it this winter, when the mother was very hard up, and I said : If you are so much attached to each other, then come and live together, but I believe they, though worse off themselves, don't think our simple way of living good

L.V.G.

enough, one which I desire on principle and to which I am forced by circumstances.

Many people care more for the exterior than for the inward life of a family, thinking they act well in doing so. Society is full of that : people who strive to make a show instead of leading a true existence. I repeat : those people are not bad, but they are foolish. . . . A wife's mother is, in some cases, the representative of a meddlesome, slandering, aggravating family, and as such decidedly injurious and hostile, though she may not be so bad herself.

In my case, she would be much better off in my house than in the houses of other members of the family, where she is very often the victim of callous insolence and is incited to intrigues. . . .

Towards your patient you have been absolutely honest and straightforward : that is the principal thing, which keeps the future clear, whatever it may be : but even if one has acted rightly, difficulties may arise. Well, in the year that begins for you to-day, I wish you very few of those—on the contrary may all good be your share. Well, write soon if you have not written already, which I hope will be the case. Adieu, boy, with a hearty handshake,

<div align="right">Yours,
Vincent</div>

Dear Theo, [The Hague, end of July 1883]
To my surprise, yesterday I received a further letter from you enclosing a banknote. I need not tell you how glad I was, and I thank you heartily for it. But they refused to change the banknote because it was torn too much. However, they gave me ten guilders on it, and it has been forwarded to Paris. If the bank refuses it, I will have to pay back the ten guilders, for which I had to sign a receipt; but if the bank changes it, I will get the rest later.

You write in your letter about the conflict one sometimes feels on the question of whether one is responsible for the unlucky results of a good action, if it would not be better to

act in a way one knows to be wrong, but which at the same time will bring one out unscathed—I know that conflict too. If we follow our conscience—conscience is for me the highest reason—the reason within the reason—we are tempted to think we have acted wrongly or foolishly; we are especially upset when more superficial people jeer at us, because they are so much wiser and have so much more success. Yes, then it is sometimes difficult, and when circumstances occur which make difficulties rise to an overflowing tide, one is almost sorry to be as one is, and would wish to have been less conscientious.

I hope you don't think of me in any other way than having continually that same inward conflict, and often very tired brains too, and in many cases not knowing how to decide in questions of right and wrong.

When I am at work, I feel an unlimited faith in art, and that I shall succeed, but in days of physical prostration, or when there are financial obstacles, I feel that faith diminishing, and a doubt overwhelms me, which I try to conquer by setting to work again at once. It is the same thing with the woman and the children; when I am with them, and the little chap comes creeping towards me on all fours, crowing for joy, I have not the slightest doubt that everything is right.

How often has that child comforted me.

When I am at home, he can't leave me alone for a moment; when I am at work, he pulls at my coat or climbs up against my leg, till I take him on my lap. In the studio, he crows at everything, plays quietly with a bit of paper, a bit of string, or an old brush; the child is always happy. If he keeps this temperament all his life, he will be cleverer than I am.

Now what shall we say about the fact that there are times when one feels there is a certain fatality, that makes the good turn out wrong, and the bad turn out well.

I think one may consider those thoughts partly as a consequence of overwrought nerves, and if one has them, one must not think it one's duty to believe that things are really as gloomy as one supposes; if one did so, it would make one

mad. On the contrary, it is reasonable to strengthen one's physique then, and afterward set to work like a man, and if that does not help, *still one must always continue to use those two means,* and consider that melancholy as fatal. In the long run, one will then feel one's energy increase, and will bear up against the troubles. Mysteries remain, sorrow or melancholy remains, but that everlasting negative is balanced by the positive work which is thus achieved after all. If life were as simple, and things as little complicated as in the tale of Goody-Goody, or the hackneyed sermon of the average clergyman, it would not be so very difficult to make one's way. But it is not so, and things are infinitely more complicated, and right and wrong do not stand separate, any more than black and white do in nature. One must take care not to fall back upon opaque black, that is deliberate wrong; and still more, one has to avoid the whiteness of a white-washed wall, which means hypocrisy and everlasting Phari-saism[1]. He who tries courageously to follow reason, and especially conscience, the very highest reason—the sublime reason—and tries to remain honest, can scarcely altogether lose his way, I think, though he will not get off without mistakes, checks and disheartenments, and will not reach perfection.

And I think it will give him a deep feeling of pity and benevolence, broader than the narrow-mindedness which is the stock-in-trade of clergymen.

One may not be considered by either party as of the least importance, and one may be counted among the mediocrities and feel oneself to be a thoroughly ordinary man among ordinary people—in the end one will after all obtain a rather steady serenity. One will succeed in bringing one's conscience to a state of development such that it becomes the voice of a better and higher self, of which the ordinary self is the servant. And one will not return to scepticism or cynicism, nor belong among the foul mockers. But not at once. I think it a beautiful saying of Michelet's, and that one phrase of Michelet's expresses all I mean : " Socrate naquit un vrai satyre, mais

[1] See *Matthew* XXIII 27 and *Acts* XXIII 3.

par le dévouement, le travail, le renoncement des choses fri-
voles, il se changea si complètement qu'au dernier jour devant
ses juges et devant sa mort il y avait en lui je ne sais quoi
d'un dieu, un rayon d'en haut dont s'illumina le Parthénon."[1]

One sees the same thing in Jesus too, who was first an
ordinary carpenter and then raised himself to something else,
whatever it may have been, a personality so full of pity, love,
goodness, seriousness that one is still attracted by it. Gener-
ally a carpenter's apprentice becomes a master carpenter,
narrow-minded, dry, miserly, vain, and whatever may be said
of Jesus, he had another conception of things than my friend
the carpenter of the backyard, who has raised himself to the
level of house owner, and yet is much more vain and thinks
more highly of himself than Jesus did.

But I must not become too abstract. What I first want to
do is to renew my strength, and I think once it has come up
again from below the mark I will get new ideas for my
work, for trying to conquer that dryness.

When you come here we will talk it over. I do not think it
is a question of a few days.

In a few days, when I shall have taken some more nour-
ishing food than of late, I think I shall get rid of my *worst
depression,* but it is *deeper rooted* than that, and I wish I could
get so far that I had plenty of health and strength, which
after all is not impossible when one is much out of doors
and has work that one loves.

For it is a fact that at the moment all my work is *too
meagre and too dry.*

That has become as clear as daylight to me lately, and I
don't doubt in the least that a general thorough change is
necessary. I intend to talk it over with you *after you have
seen the work of this year,* to see whether you agree with me
about certain measures, and if you agree with me, I think we

[1] " Socrates was born a real satyr, but through devotion, toil and
the renouncement of frivolous things, he made such a complete change
in himself that when on that last day he stood before his judges and
faced death, some indefinable quality of godhood stood out in him, a
heavenly radiance that lit up the Parthenon."

shall succeed in overcoming the difficulties. We must not hesitate, but have " la foi de charbonnier."[1] I hope they will change the banknote. I am so glad you have managed to send something, for I think it saves me an illness. I will let you know how the story of the banknote ends. And it would be a good thing if you could send again as usual by the first of August. I always think that in looking through the work together it is possible that we shall hit on another plan for the future. I do not know what, as yet—but somewhere there must be work to do, which I can do just as well as anybody else. If London were nearer, I should try there.

Be sure that I should be enormously pleased if I could make something that was salable. I would have less scruples then about the money which comes from you, which after all you need as much as I do. Once more many thanks, goodbye,

<div style="text-align:right">Yours,</div>

<div style="text-align:right">Vincent</div>

Dear Theo [The Hague, early August 1883]

As I look forward to your arrival, there is hardly a moment when my thoughts are not with you.

These last days I have gone on to paint several studies, so that you may see them at the same time. And that change of work does me good, for though I cannot do literally as Weissenbruch does, and go and stay in the polders for a few weeks, yet I do do something like it, and to look at the green fields has a calming effect.

Besides, I decidedly hope in this way to make progress in terms of colour. The last painted studies seem to me firmer and more solid in colour. So for instance a few I made recently, in the rain, showing a man on a wet, muddy road, express the sentiment better, I think.

Well, we will see when you come.

Most of them are impressions of landscape, I dare not say as well done as those that sometimes occur in your letters, because still I am often checked by technical difficulties—yet there is something in them, I think—for instance, a silhouette

[1] " the faith of the miner."

of the city in the evening, when the sun is setting, and a towpath with windmills.

For the rest, it is miserable enough that I still feel very faint, when I am not hard at my work, but I believe it is receding. I will decidedly try hard to lay up a reserve of strength, for I shall need it to carry on the painting of the figure with a firm hand.

While painting, I feel of late a certain power of colour awakening in me, stronger and different from what I have felt till now.

It may be that the nervousness of these days is linked up with a kind of revolution in my way of working, for which I have been seeking and of which I have been thinking for a long time already.

I have often tried to work less drily, but it always turned into the same thing over again. But now that a kind of weakness prevents me from working in my usual way, this seems to help, rather than to hinder, and now that I let myself go a little, and look more through the eyelashes, instead of concentrating on the joints and analysing the structure of things, it leads me more directly to seeing things more like adjacent contrasting patches of colour.

I wonder what it will lead to, and how it will develop. I have sometimes wondered why I was not more of a colourist, because my temperament decidedly seems to indicate it—but up till now it developed very little.

I repeat, I wonder how it will develop—but I see clearly that my last painted studies are different.

If I remember rightly, you still have one from last year, of a few tree trunks in the wood.

I do not think that it is really bad, but it is not what one sees in the studies of colourists. Some colours there are correct, but though they are correct they do not have the effect they ought to have, and though the paint is here and there laid on thickly, even so the effect is too meagre. I take this one as an example, and now I think that the last ones which are less thickly laid on are nonetheless becoming more potent in colour, as the colours are more interwoven and the strokes

of the brush cover one another, so that it is mellower and more for instance like the downiness of the clouds or of the grass.

At times I have been greatly worried that I made no progress with colour, but now I am hopeful again.

We shall see how it will develop.

Now you will understand that I am very anxious for your coming, for if you also saw that there is a change, I should not doubt that we are on the right track. I dare not quite trust my own eyes as regards my own work. Those two studies, for instance, which I made while it was raining—a muddy road with a little figure—they seem to me exactly the opposite of some other studies. When I look at them I rediscover the sentiment of that dreary rainy day, and in the figure, though it is nothing but a few patches of colour, is a kind of life, that is not called forth by correctness of drawing, for there is in effect no drawing. What I mean to suggest is that in these studies I believe there is something of that mysteriousness one gets by looking at nature through the eyelashes, so that the outlines are simplified to blots of colour.

Time must pass over it, but at present I see in several studies something different in colour and tone.

Recently I often think of a story I read in an English magazine, a tale about a painter, in which there appears a person whose health suffered also in a time of trouble, and who went to a lonely place in the peat fields, and there, in that melancholy setting, found himself again, and began to paint nature as he felt and saw it. It was very well described in the story, evidently by a person who was well up in art, and it struck me when I read it, while now of late I sometimes think of it again.

At any rate I hope we shall soon be able to talk it over and consult together. If you can, write soon, and of course the sooner you can send the money, the better it would be for me.

With a handshake in thought,

Yours,
Vincent

Involuntarily, and without any definite motive, I add a thought that often occurs to me. Not only did I begin drawing relatively late in life, but it may also be that I shall not live for so very many years to come.

If I think of that, calculating coldly, as if I were making an estimate of something, it is in the nature of things that I cannot possibly know anything definite about it.

But in comparison with different people, whose lives one might happen to know, or in comparison with some people with whom one is supposed to have many things in common, one can draw some conclusions which are not altogether without foundation. Therefore, as to the time I have still before me in which I can work, I think I may presume without rashness: that my body will carry on for a certain number of years " quand bien même "[1]—a certain number, say between six and ten for instance. I can assume this the more safely as at the moment there is no immediate " quand bien même."

This is the period on which I count firmly; for the rest, it would be speculating too much at random to dare make a definite pronouncement about myself, because it depends especially on those, let us say, first ten years, whether there will be anything after that time or not.

If one wears oneself out too much in those years, one does not get beyond forty; if one is strong enough to resist certain shocks, which generally attack one then, to solve more or less complicated physical difficulties, then from forty to fifty one is again in a new relatively normal tideway.

But for the present such calculations are out of the question; one can as I said only take into account plans for a period of between five and ten years. I do *not* intend to spare myself, nor to avoid emotion or difficulties—I don't much care whether I live a longer or a shorter time, besides, I am not competent to take care of my physique as for instance a physician can.

Thus I go on like an ignoramus but knowing this one thing: " *in a few years I must finish a certain body of work.*"

[1] " however it be "

I need not overhurry myself, there is no good in that—but I must work on in full calmness and serenity, as regularly and concentratedly as possible, as concisely and economically as possible. The world only concerns me in so far as I feel a certain debt and duty towards it because I have walked that earth for thirty years, and, out of gratitude, want to leave some souvenir in the shape of drawings or pictures—not made to please a certain cult in art, but to express a sincere human feeling. So this work is the aim—and given concentration on that one idea, everything one does is simplified in so far as it is not a chaos, but done in its entirety with one aim in view. Now my work goes slowly—a reason the more to lose no time. Guillaume Régamey was somebody who left little reputation I think (you know there are two Régameys, F. Régamey paints the Japanese, and is his brother), but he was a personality for whom I have a great respect. He died at the age of thirty-eight, and a period of six or seven years had been exclusively devoted to the making of drawings that bear a very distinctive stamp, and were made while he was working under some physical difficulty.

That is one of many, a very good one among the very good.

I do not name him in order to compare myself to him. I cannot be ranked on a level with him—but I mention him as a special example of a certain self-possession and energy clinging to one inspiring idea, of one to whom difficult circumstances showed the way to accomplish good work in full serenity. It is in this way that I regard myself—as having to accomplish in a few years something with heart and love in it, doing this with energy.

If I live longer " tant mieux,"[1] but I do not count on it.

In those few years *something must be done,* that thought controls all my plans about my work. You will now better understand my desire to push on. At the same time, I have a firm resolve to use simple means. And perhaps you will also understand that I do not regard my studies as things apart, but always have in view my work as a whole.

[1] " so much the better "

Dear brother, [The Hague, mid August 1883]
 I wish you were able to see that in several things I must be
consistent.

You know what an error in one's point of view represents
in painting, viz. something far different and far worse than a
faulty drawing of such or such a detail. A single point
decides the greater or lesser gradient: the development more
to the right or left of the sideplanes of the objects through-
out the whole composition.

Well, in life there is something like this.

When I say I am a poor painter and have still years of
struggle ahead—my everyday life I must arrange " à peu
près "[1] like a farm labourer or a factory hand does; then this
is a fixed point, from which many things result, which one
tears from their roots, when one considers them otherwise but
comprehensively. There are painters in other circumstances
who can and must act differently.

Everyone must decide for himself. If I had had other
chances, had been in different circumstances, and if no deci-
sive things had happened, of course that would have influ-
enced my actions. Now however, and " à plus forte raison,"[2]
if there were even the slightest question of it being con-
sidered arrogance on my part to assume a right to which I had
no claim—even if I had this right as a matter of course—the
mere suggestion of the thing would have made me withdraw
of my own accord from any intercourse with people who
occupy a certain rank in life, even my own people.

So this is the fact: My firm resolve is to be dead to any-
thing except my work. But it is very hard for me to speak
about those things, simple in themselves, but which unfor-
tunately link up with much deeper things.

There is no anguish greater than the soul's struggle be-
tween duty and love, both in their highest meaning. When I
tell you I choose my duty, you will understand everything.

A simple word said about it during our walk,[3] made me

[1] " approximately " [2] " a fortiori "
[3] Theo had come on his long-promised visit a few days before.

feel that absolutely nothing is changed in me in that respect, that it is and remains a wound which I carry with me, while it lies deep and cannot be healed. After years it will be the same as it was the first day.

I hope you understand what battle I have had to fight within myself of late.

The upshot was this : ' quoiqu'il en soit "[1] (not taking the *quoi* as interrogative, for I have not the right to consider it so) I will do my utmost to remain an honest man and doubly attentive to *duty*.

I have never suspected her,[2] nor do I now, nor shall I ever suspect her of having had financial motives, more than is honest and just. She went as far as was reasonable, other people exaggerated. But for the rest, you understand that I do not hold any delusive convictions about love for me, and what we talked of on the road remains between us. Since then, things have happened that would not have taken place, if at a certain moment I had not had to face in the first place a decided "no," and secondly a promise that I would not stand in her way. I respected in her a sense of duty—I never have suspected, shall never suspect her of anything mean.

Of myself I know this one thing, that it is of the greatest importance not to deviaté from one's duty, and that one should not compromise with duty. Duty is absolute. The consequences? We are not responsible for them, but for the choice of *doing* or *not doing* our duty, we are responsible. This is the direct opposite of the principle : The end justifies the means.

And my own future is a cup that may not pass away from me except I drink it.[3]

So " Fiat voluntas."[4]

Good-bye—good luck on your journey—write soon—but you understand that I trust in the future with serenity, and without one line in my face revealing the struggle in the deepest depth— Yours,

Vincent

[1] " be that as it may" [2] Sien.
[3] See *Matthew* XXVI 42. [4] " Thy will be done."

You will understand, however, that I must avoid every-
thing which might tempt me to hesitate, so that I must avoid
everything and everybody that would remind me of *her*. In
fact that idea has made me this year sometimes more resolute
than I otherwise would have been, and you see that I can do it
in such a way that nobody understands the real motive.

Dear Theo, [Drenthe, Holland, mid September 1883]
Now that I have been here a few days, and have strolled
about in different directions, I can tell you more about the
neighbourhood where I have taken up my quarters. I enclose
a little scratch of my first painted study in these parts : a
cottage on the heath. A cottage made only of sods and sticks.
I saw also the interior of about six of that kind, and more
studies of them will follow.

How the outside of them appears in the twilight, or just
after sunset, I cannot express more directly than by reminding
you of a certain picture by Jules Dupré, which I think belongs
to Mesdag, with two cottages, the moss-covered roofs of which
stand out very deep in tone against a hazy, dusky evening sky.

So it is here. Inside those cottages, dark as a cave, it is
very beautiful. In drawings of certain English artists who
worked in Ireland on the moors I find shown most realistic-
ally what I observe here.

Alb. Neuhuys gives the same effect, but a little more
poetically than the actual first impression on the eye, but he
never makes a thing that is not fundamentally true.

I saw splendid figures out of doors—striking in terms of
their sobriety. A woman's breast, for instance, has that
heaving movement which is quite the opposite of voluptuous-
ness, and sometimes, when the creature is old or sickly,
arouses pity or respect. And the melancholy which things in
general have here is of a healthy kind, like in the drawings of
Millet. Fortunately the men here wear short breeches, which
show off the shape of the leg, and make the movements more
expressive.

In order to give you an idea of one of the many things

which gave me new sensations and feelings on my excursions,
I will tell you that one can see here peat barges in the *very
middle of the heath*, drawn by men, women, children, white
or black horses, just as in Holland, for instance, on the Rijs-
wijk towpath.

The heath is splendid. I saw sheepfolds and shepherds
more beautiful than those in Brabant.

The kilns are more or less like the one in Th. Rousseau's
"Communal Oven." They stand in the gardens under old
apple trees or between cabbages and celery. In many places
there are beehives too. One can see on many faces that the
people are not in good health; it is not exactly healthy here, I
believe; perhaps because of foul drinking water. I have seen
a few girls of seventeen, or younger still, perhaps, who look
very brisk and beautiful, but generally they look faded very
early on. But that does not interfere with the great noble
aspect of the figures of some, who, seen from nearby, are
already very faded.

In the village there are four or five canals to Meppel, to
Dedemsvaart, to Coevorden, to Hollands Veld.

As one sails down them one sees here and there a curious
old mill, farmyard, wharf, or lock, and always a bustle of
peat barges.

To give you an idea of the character in these parts—while
I was painting that cottage, two sheep and a goat came to
browse *on the roof* of this house. The goat climbed on the
top, and looked down the chimney. Hearing something on
the roof, the woman rushed out, and threw her broom at the
said goat, which jumped down like a chamois.

The two hamlets on the heath where I have been, and
where this incident took place, are called Sanddrift and
Blacksheep. I have been in several other places too, and
now you can imagine the originality here, as after all Hoo-
geveen is a town, and yet quite nearby already there are
shepherds, those kilns, those peat huts, etc.

I often think with melancholy of the woman and the
children,[1] if only they were provided for; oh, it is the woman's

[1] Vincent had parted from Sien on moving to Drenthe.

own fault, one might say, and it would be true, but I am afraid her misfortunes will prove greater than her offence. That her character was spoilt I knew from the beginning, but I hoped she would improve, and now that I do not see her any more, and ponder over some things I saw in her, it seems to me more and more that she was too far gone for improvement.

And that just makes my feeling of pity the greater, and it becomes a melancholy feeling, but it is not in my power to redress it.

Theo, when I meet on the heath such a poor woman with a child on her arm, or at her breast, my eyes get moist. It reminds me of her, her weakness; her untidiness, too, contributes to making the likeness stronger.

I know that she is not good, that I have a complete right to act as I do, that I *could not* stay with her over there, that I really could not take her with me, that what I did was even sensible and wise, whatever you like; but, for all that, it pierces right through me when I see such a poor little figure feverish and miserable, and it makes my heart melt within me. How much sadness there is in life, nevertheless one must not become melancholy, and one must seek distraction in other things, and the right thing is to work; but there are moments when one only finds rest in the conviction : " misfortune will not spare me either."

Adieu, write soon. Believe me,

Yours,
Vincent

Dear Theo, [New Amsterdam, end of September 1883]
This once I write to you from the very remotest part of Drenthe, where I came after an endless long voyage on a barge through the moors. I see no chance of describing the country as it ought to be done; words fail me for that, but imagine the banks of the canal as miles and miles of Michels or Th. Rousseaus, van Goyens or Ph. de Konincks.

Level planes or strips of different colour, getting narrower

and narrower as they approach the horizon. Accentuated here and there by a peat shed or small farm, or a batch of meagre birches, poplars, oaks—heaps of peat everywhere, and one constantly goes past barges with peat or bulrushes from the marshes. Here and there lean cows, delicate in colouring, often sheep—pigs. The figures which now and then appear on the plain are generally of an impressive character; sometimes they have an exquisite charm. I drew, for instance, a woman in the barge with crape over the gold plates on her headdress, because she was in mourning, and afterwards a mother with a baby; the latter had a purple shawl over her head. There are a lot of Ostade types among them: physiognomies which remind one of pigs or crows, but now and then a little figure that is like a lily among thorns.

Well, I am very pleased with this excursion, for I am full of what I have seen. This evening the heath was inexpressibly beautiful. In one of the Boetzel Albums there is a Daubigny which exactly gives that effect. The sky was of an indescribably delicate lilac white, no fleecy clouds, for they were more compact and covered the entire sky, but dashes of more or less glaring lilac, grey, white, a single rent through which the blue gleamed. Then at the horizon a glimmering red streak, under which ran the very dark stretch of brown moor, and standing out against the brilliant red streak a number of low-roofed little huts. In the evening this moor often shows effects which the English call " weird " and " quaint." Don Quixote-like mills, or curious great hulks of drawbridges, stand out in fantastic silhouettes against the vibrating evening sky. Such a village in the evening, with reflections of lighted windows in the water, or in the mud puddles, looks sometimes very cosy.

Before I started out from Hoogeveen, I painted a few studies there, among others a large moss-roofed farm. For I had had paint sent from Furnée, as I thought on the subject like you wrote in your letter, that by absorbing myself in my work, and quite losing myself in it, my mood would change, and it has already greatly improved.

But at times—like those moments when you think of going

to America—I think of enlisting for the East Indies; but those are miserable, gloomy moments, when one is overwhelmed by things, and I could wish you might see those silent moors, which I see here from the window, for such a thing calms one down, and inspires one to more faith, resignation, steady work. In the barge I drew several studies, but I stayed a while here to paint some. I am quite near Zweeloo, where, among others, Liebermann has been; and besides, there is a part here where you still find large, very old turf huts, that have not even a partition between the stable and the living room. I intend first of all to visit that part one of these days.

But what tranquillity, what expanse, what calmness in this landscape; one feels it only when there are miles and miles of Michels between oneself and the ordinary world. I cannot give you a permanent address as yet, as I do not exactly know where I shall be for the next few days, but by 12th October *I shall be at Hoogeveen,* and if you send your letter at the usual time *to the same address,* I shall find it there, on the 12th, at Hoogeveen.

The place where I am now is New Amsterdam.

Father sent me a postal order for ten guilders, which, together with the money from you, makes me able to paint a little now.

I intend to settle for a long time at the inn where I am now, if I can easily reach from there that district with the large old turf huts, as I should have better light and more space there. As to that picture you mention, by that Englishman, with the lean cat and the small coffin, though he got his first inspiration in that dark room, he would hardly have been able to paint it in that same spot, for if one works in too dark a room, the work usually becomes too light, so that when one brings it out to the light, all the shadows are too weak. I just had that experience when I painted from the barn an open door and a glimpse into the little garden.

Well, what I wanted to say is that there will be a chance to remove that obstacle too, for here I can get a room with good light, that can be heated in winter. Well, lad, if you do

not think any more about America, nor I of Harderwijk[1] I hope things will work themselves out.

I admit your explanation of C. M.'s[2] silence may be right, but sometimes one can be careless purposely. On the back of the page you will find a few scratches. I write in haste, it is already late.

How I wish we could walk here together, and paint together. I think the country would charm and convince you. Adieu, I hope you are well and are having some luck. During this excursion I have thought of you continually. With a handshake,

<div style="text-align: right">

Yours,
Vincent

</div>

[EXTRACTS ONLY]

Dear brother, [Drenthe, late October 1883]

My thoughts are always with you, no wonder that I write rather often.

Besides, my impressions have become more fixed, my thoughts are more collected, things adjust themselves, become more tangible. So I can write you about it in all calmness.[3] In the first place, I don't see much probability of your remaining on good terms with Goupil's. It is such an enormous business that it certainly will take a long time before one cannot put up with things any longer, before the corruption has penetrated *everywhere*. But, look here—in my opinion there has already been a very long period of corruption, so I would not be at all astonished if it were far advanced. . . .[4]

But after all, it is not exactly about the condition of the business—about the negative side of things—that I want to

[1] Place where Volunteers enlisted.

[2] His uncle C. M. van Gogh.

[3] Theo was considering leaving his business and becoming a painter himself.

[4] A paragraph is omitted here discussing other employees who had previously left Goupil's.

speak; leaving all that aside, it is about one single positive matter that I have something to say.

A few things have happened to you which I don't think unimportant. You have read in a different and better way than most people do the books of Zola—which I consider among the very best of the present time.

You once said to me " I am like that man in *Pot-Bouille* "; I said: "No. If you were like *that*, you would do well to enter a new business, but you are deeper than he, and I do not know whether you are in fact a man of business, actually deep down I see in you the artist, the true artist."

You have undergone mentally, unsought, deep harrowing emotions; now things are running their course. Why? Whither? To the renewed beginning of a similar career? My decided opinion is—no—there is something deeper than that. Change you must—but it must be a general renewal, not a repetition of the same thing. You were not wrong in the past, no, in the past you had to be as you were; that past was right. Does it follow from that that it was *not* simply a preparation, a basis, nothing but a schooling, and not the definite thing as yet? Why should not that follow? In my opinion it is just that.

I think things speak so much for themselves that it would be impossible for me to tell you anything that is not already quite evident, even to yourself. Besides, it strikes me as rather curious that there is a change in me too of late.

That just *now* I find myself in surroundings which so entirely engross me, which so order, fix, regulate, renew, enlarge my thoughts, that I am quite wrapped up in them. And that I can write you, full of what those silent, desolate moors tell me. Just at this moment, I feel within me the beginning of a change for the better. It isn't there yet, but I see in my work things—which I didn't have a little while ago. Painting comes easier to me. I am eager to try all kinds of things which I left undone till now. I know that circumstances happen to be so unsettled, that it is far from certain that I shall be able to remain here. Perhaps just because of your circumstances it might turn out differently. But

I should be sorry for it, though I would take it quite calmly.

But I cannot help imagining the future, with myself no longer alone, but you and I, painters, and working together as comrades, here in this moorland.

That idea presents itself to me in all its attractiveness. The thing ought to happen without the least fuss, without much disturbance like " une révolution qui est, puisqu'il faut qu'elle soit."[1] That's all—so I only say that I would not be in the least astonished if, after some time, we were *here* together. I feel that it *may* happen, without making any more disturbance than a piece of peat rolling from one place to another. One moment, and it lies perfectly still again, and nobody takes the least notice of it.

But a human being has his roots, transplantation is a painful thing, though the soil may be better in the place to which he is transplanted.

But is that soil better??? What the Puritans were of old, such are the painters in present-day society.

It is no foolish, artificial piety or bigotry; it is something simple and solid. I am speaking now more particularly of the Barbizon School,[2] and that tendency to paint rural life. I see in you, as a man, something that is irreconcilable with Paris. I do not know how many years of Paris have passed over it—yes, a part of your heart is rooted there—I admit it, but a something—a " je ne sais quoi "—is virgin still.

That's the artistic element. It appears to be weak now—but that new shoot bourgeons, and it will bourgeon quickly.

I am afraid the old trunk is split too much, and I say, bourgeon in a quite new direction, otherwise I am afraid the trunk will prove to lack the necessary vitality. It seems so to me—do you think differently?

The more so, because, *if* you became a painter, you would unintentionally have laid the foundation for it yourself, and for the first time, you would have company, friendship, a certain footing. I also think it would bring a change in my own

[1] " a revolution that exists, because it has to exist "
[2] Artists who had worked together in or near the forest of Fontainebleau earlier in the century.

work directly, for what I lack is companionship and encouragement in my work, a certain interchange of opinions with somebody who knows what a picture is. I have been so long quite without it that I think I need that stimulus.

I have so many plans that I hardly dare to undertake them alone—you would soon enough make out what they are, what they mean. Though I wish it were not so, I am extremely sensitive as to what is said of my work, as to what impression I make personally. If I meet with distrust, if I stand alone, I feel a certain void which cripples my initiative. Now, you would be just the person to understand it—I don't want the least flattery, or that people should say " I like it," if they did not; no, what I want is an intelligent sincerity, which is not vexed by failures. Which, if a thing fails six times, just when *I* begin to lose courage, would say: now you must try again a seventh time. You see, that's the encouragement I need, and cannot do without. And I think you would understand it, and you would be an enormous help to me.

And it is a thing you would be able to do, especially if you were obliged to do likewise. We should help each other, for I, for my part, would be the same to you, and that is of some importance. Two persons must believe in each other, and feel that it *can* be done and *must* be done, in that way they are enormously strong. They must keep up each other's courage. Well, I think you and I would understand each other.

I am not sure you could do it, if you were not a painter. The only obstacle is the doubt, which people generally try to raise: Tersteeg, for instance, who is naturally sceptical, who doesn't know what it is to believe.

Millet, however, is the type of a *believer*. He often used the expression " foi de charbonnier,"[1] and that expression was already a very old one. One must not be a City man, but a Country man, however civilized one may be. I cannot express it exactly. There must be a " je ne sais quoi " in a man, that keeps his mouth shut and makes him active—a certain aloofness even when he speaks—I repeat, an inward silence which leads

[1] " miner's faith "

to action. In that way one achieves great things, why?—because one has a certain feeling of come what may. One works—what next? I do not know——

I will not hurry you, I only want to say: don't thwart nature. What I wish is not foolish, but I have a faint hope that one might begin it in a reasonable way, not absolutely without money, but with only very little, just what is needed for board and lodging. And not wanting to cause an absolute calamity, but in case there is the smallest possibility, I say now:

" Follow that little point, that very slight possibility, there lies the road—follow it—drop all the rest. I do not mean drop all outward relations; you must keep them if you can, but stick to your conviction in saying: *I will become a painter;* so that what Tom, Dick and Harry say is like water on a duck's back."

I don't think you would then feel like a fish out of water, but that it would be like a coming home to your fatherland, that you would feel at once a great serenity—that you would feel surer about becoming a painter than about a new situation, more sure of yourself even than at Goupil's. . . .

[Two paragraphs are omitted here in which Vincent discusses Theo's nervous style and his new signs of trust in his brother.]

How things would go for me, should you *not* decide to become a painter, I cannot tell. If there were a place for me in Paris, I should have to take it, of course, and otherwise I should have to compromise with Father, so that I could live at home, and work in Brabant for a time. But oh, I can tell you that I do not think much about it now for the moment. I think only of my work, and about that plan for you. You are a man with a will, and a good, intelligent, clear head, with an honest heart. I think you may safely become a painter if you can hold out for a time. And I repeat, it would be a definite stimulus for my work.

To-day I have been walking behind the ploughers who were ploughing a potato field, with women trudging behind to pick up a few potatoes that were left.

This was quite a different field from the one I scratched yesterday for you, but it is a curious thing here—always exactly the same, and yet just enough variety, the same subjects like the pictures of artists who work in the same genre and yet are different. Oh, it is so curious here, and *so* quiet, *so* peaceful. I can find no other word for it but peace. Say much about it, say little about it, it is all the same, it does not matter at all. It is a question of wanting an entirely new thing, of undertaking a kind of renovation of yourself, in all simplicity with the fixed idea: ça ira.[1]

I don't mean to say that you will have no cares, things don't run so smoothly, but you must feel " I am doing what seems to me the simplest—I have done with all that is not simple; I don't want the city any longer, I want the country; I don't want an office, I want to paint." That's it. But it must be treated business fashion, though it is deeper, yes, infinitely deeper, but every thought must be fully concentrated on it.

In the future you must look on yourself and me as painters. There may be worries, there may be obstacles, yet *always consider us so—see your own work before you.* Look at a bit of nature and think: *I* will paint *that.* Give yourself up to the fixed idea: to become a painter.

All at once, people, even your best friends, become more or less like strangers. You are preoccupied by other things, exactly. All at once you feel, confound it, am I dreaming? I am on a wrong track, where is my studio, where is my brush? Thoughts like these are very deep; of course one says little or nothing about it, it would be a mistake to ask for advice about it, it wouldn't give you any light. . . .

Now art dealers have certain prejudices, which I think it possible that you have not shaken off yet, particularly the idea that painting is inborn—all right, inborn, but not as is supposed; one must put out one's hand and *grasp* it—that grasping is a difficult thing—one must not wait till it reveals itself. There is something, but not at all what people pretend. Practice makes perfect: by painting, one becomes a painter. If one wants to become a painter, if one delights in it, if one

[1] " It will work."

feels what you feel, one can do it, but it is accompanied by trouble, care, disappointment, periods of melancholy, of helplessness and all that, that's what I think of it. I think it all such a nuisance that I just had to make a little scratch to forget it.[1] Forgive me, I won't say anything more about it, it is not worth while. . . .

To the world, we would have to show so much courage, so much energy, so much serenity, not taking things too ponderously, you know; in spite of serious cares, we would have to be merry, like those Swedes of whom you spoke, like the masters of Barbizon. We would have to take things literally, energetically, thoroughly, not doubting, dreaming or hesitating. This is a plan I should like, for no other plan could I care so much. . . .[2]

It is a great risk, but neither you nor I are afraid to venture something. Just think it over, and, at all events, write soon. Good-bye, lad, with a handshake in thought,

<div style="text-align: right">Yours,
Vincent</div>

Dear Theo, [Nuenen, Holland, June/July 1884]
My hearty thanks for your letter, and the 200 francs enclosed. Thanks for giving the size of the frame, in which I intend to make a little spinner, after the large study.

I was glad to hear some good news about Breitner. The last impressions I had of him were, as you know, rather unfavourable, because of three large canvases which I saw at his studio, and in which I literally did not distinguish anything that might be located either in reality or in an imaginary world. But a few water-colours which he then had on hand, horses in the dunes, though very sketchy, were much better. And I saw things in it which make me understand quite well that the picture of which you speak must be good. As to the Society of Draughtsmen, firstly, I quite forgot it

[1] Here Vincent did a quick sketch on the page.
[2] Several paragraphs are omitted here, which recapitulate the general subject matter of the letter.

because I was busy painting those figures; secondly, now that your letter reminds me of it, I am not very keen on it, for, as I told you already last summer, I can only expect a refusal of my petition for membership, which refusal one can, however, consider as a kind of necessary evil that can be redressed next year, and as such the request perhaps has its *raison d'être*.

Besides, as I quite forgot it, I have not one water-colour on hand, and should have to start new ones in a hurry, if it were not already too late for this year.

And when I tell you that I am just now quite absorbed again in two new large studies of interiors of weavers, you will understand I am in no mood for it. Especially as it might cause new disagreements if I applied again to the gentlemen at The Hague.

As to these two treatments of weavers, one shows a part of the loom, with the figure and a small window.

The other is an interior, with three small windows, looking out on the yellowish verdure, contrasting with the blue of the cloth that is being woven on the loom, and the blouse of the weaver, which is again of another blue.

But what struck me most in nature of late I have not started on yet, for want of a good model. The half-ripe cornfields are at present of a dark golden tone, ruddy or gold bronze. This is raised to a maximum of effect by opposition to the broken cobalt tone of the sky.

Imagine in such a background women's figures, very rough, very energetic, with sun-bronzed faces and arms and feet, with dusty, coarse indigo clothes and a black bonnet in the form of a barret on their short-cut hair; while on the way to their work they pass between the corn along a dusty path of ruddy violet, with some green weeds, carrying hoes on their shoulders, or a loaf of black bread under the arm—a pitcher or brass coffee kettle. I have seen that same subject repeatedly of late, with all kinds of variations. And I assure you that it was really impressive.

Very rich, and at the same time very sober, delicately artistic. And I am quite absorbed in it.

But my colour bill has run up so high that I must be wary

of starting new things in a big size, the more so because it will cost me much in models; if I could only get suitable models, just of the type I want (rough, flat faces with low foreheads and thick lips, not sharp, but full and Millet-like) and with those very same clothes.

For it demands great exactness, and one is not at liberty to deviate from the colours of the costume, as the effect lies in the analogy of the broken indigo tone with the broken cobalt tone, intensified by the secret elements of orange in the reddish bronze of the corn.

It would be a thing that gave a good impression of summer. I think summer is not easy to express; generally, at least often, a summer effect is either impossible or ugly, at least I think so, but then, as opposition, there is the twilight.

But I mean to say that it is not easy to find a summer sun effect which is as rich and as simple, and as pleasant to look at as the characteristic effects of the other seasons.

Spring is tender, green young corn and pink apple blossoms.

Autumn is the contrast of the yellow leaves against violet tones.

Winter is the snow with black silhouettes.

But now, if summer is the opposition of blues against an element of orange, in the gold bronze of the corn, one could paint a picture which expressed the mood of the seasons in each of the contrasts of the complementary colours (red and green, blue and orange, yellow and violet, white and black).[1]

Well, I am longing to hear about your journey to London, etc.

Mother is making but little progress in walking. Goodbye, and once more thanks for your letter and the enclosed. Believe me,

Yours,
Vincent

The best thing I know—for the frame—is to take a few stretchers of that size, then we can see which turns out best.

[1] Vincent had been studying at this date the account of Delacroix's colour-theory by Charles Blanc.

Dear Theo, [Nuenen, September 1884]

I could not phrase my last letter differently than I did.[1]
But I want you to know that it always strikes me as being a
difference between you and me imposed by fate, rather than
one for which we ourselves are to blame.

You tell me that within a short time there will be an
exhibition of the work of Delacroix. All right. You will cer-
tainly see there a picture " La Barricade," which I know only
from biographies of Delacroix. I believe it was painted in
1848.[2] You also know a lithograph by De Lemud, I believe;
if it is not by him, then by Daumier, also representing the
barricade of 1848. I wish you could just imagine that you and
I had lived in that year 1848, or some such period, for at the
time of the *coup d'état* by Napoleon there was again some-
thing of the kind. I will not make any insinuations—that has
never been my object—I try to make it clear to you to what
degree the difference that has sprung up between us is con-
nected with the general drift of society, and, as such, is some-
thing quite different from premeditated reproaches. So take
that period of 1848.

Who were opposed to each other then, that can be taken as
types of all the rest? Guizot, minister of Louis Philippe, on
one side, Michelet and Quinet with the students on the other.

I begin with Guizot and Louis Philippe, were they bad or
tyrannical? Not exactly; in my opinion, they were people,
like for instance Father and Grandfather, like old Goupil.
In short, people with a very venerable appearance, deep—
serious—but if one looks at them a little more closely and
sharply, they have something gloomy, dull, stale, so much that
it makes one sick. Is this saying too much???

Except for a difference of position, they have the same mind,
the same character. Am I mistaken in this?

[1] Vincent had written Theo a very sharp and recalcitrant letter, in
reply to what he took for reproaches from his brother about his
involvement with Margot Begemann.

[2] The reference is to Delacroix's *Liberty at the Barricades,* which
in fact commemorated the rising of July 28th, 1830 and was shown
at the Salon of 1831.

Now Quinet or Michelet, for instance, or Victor Hugo (later), was the difference between them and their opponents very great? Yes, but seen superficially one would not have said so. I myself have formerly admired at one and the same time a book by Guizot and a book by Michelet. But in my case, as I got deeper into it, *I* found difference and *contrast,* which is stronger still.

In short, that the one comes to a dead end and disappears vaguely, and the other, on the contrary, has something infinite. Since then much has happened. But my opinion is, if you and I had lived *then,* you would have been on the Guizot side, and I on the side of Michelet. And both of us remaining set in our outlooks, with a certain melancholy, we might have stood as direct enemies opposite each other, for instance on such a barricade, you before it as a soldier of the government, I behind it, as revolutionist or rebel.

Now, in 1884, *the digits happen to be the same only just reversed,* we are standing *again* opposite each other, though there are no barricades now. But minds that cannot agree are certainly still to be found.

" Le moulin n'y est plus, mais le vent y est encore."[1]

And in my opinion we are in different camps opposite each other, that cannot be helped. And whether we like it or not, *you* must go on, *I* must go on. But as we are brothers, let us avoid killing each other for instance (in the figurative sense). But we cannot help each other as much as two people who are standing side by side in the same camp. No, if we come in each other's vicinity, we would be within each other's range. *My* sneers are bullets, not aimed at you who are my brother, but in general at the party to which you once and for all belong. Neither do I consider *your* sneers expressly aimed at me, but *you fire* at the barricade and think to gain merit by it, and I happen to be there.

Think this over if you like, for I do not believe you can say much against it; I can only say that I believe things are so. . . .

I hope you will understand that I am speaking figuratively.

[1] " The mill has gone, but the wind remains."

Neither you nor I meddle with politics, but we live in the world, in society, and involuntarily ranks of people group themselves. Can the clouds help whether they belong to one thunder shower or to another? whether they carry positive or negative electricity? now it is also true that men are no clouds. As an individual, one is a part of all humanity. That humanity is divided into parties. How far is it one's own free will, how far is it the fatality of circumstances, that makes one belong to one party or to its opposite?

Well, then it was " '48, now it is '84," " le moulin n'y est plus, mais le vent y est encore." But try to know for your-self where you really belong, as I try to know that for my-self. Good-bye,

<div align="right">Vincent[1]</div>

Dear Theo, [Nuenen, mid December 1884]
I am working very hard on the series of heads from the people, which I have set myself to make. I just enclose a little scratch of the last one; in the evening I generally scratch them from memory on a little scrap of paper, this is one of them.

Perhaps I will make them later on in water-colour too. But first I must paint them. Now just listen—do you remember how in the very beginning I always spoke to you about my great respect and sympathy for the work of Father de Groux ? Of late I think of him *more than ever*. One must not confront him only in his historical pictures, though these are also very good, nor in the first instance in a few pictures with the sentiment of, for instance, the author Conscience. But one must see his " Grace before Meat," " The Pilgrim-age," " The Paupers' Bench " and above all, the simple Bra-bant types. De Groux is appreciated as little as, for instance, Thijs Maris. He is different though, but this they have in common, that they met with violent opposition.

In these days—whether the public is wiser now I can't tell,

[1] A postscript criticising Theo's tactics as a dealer is omitted here.

but this much I know, that it is not at all superfluous to weigh seriously one's thoughts and one's actions.

And at this very moment I could tell you some new names of people that hammer again on the same old anvil on which de Groux hammered. If it had pleased de Groux at that time to dress his Brabant characters in mediæval costumes, he would have run parallel with Leys in genius, and also in fortune.

However, he did not do so, and *now,* years afterwards, there is a considerable reaction against that mediævalism, though Leys always remains Leys and Thijs Maris, Thijs Maris, and Victor Hugo's Notre Dame, Notre Dame.

But the realism *not wanted* then is *in demand* now, and there is more need of it than ever.

The realism that has character and a serious sentiment.

I can tell you that for my part I will try to keep a straight course, and will paint the most simple, the most common things.

For pity's sake, how is it possible that you do not seem able or willing to understand that by having fixed my studio here, and by keeping it here for the present, I have made it possible to have money enough for painting, and if I had done otherwise it would have been a failure for myself as well as for others. If I had not done so I would have had to drudge at least three years more, before I had definitely overcome the difficulties of colour and tone, just because of the expenses. It is now just a year ago since I came here, driven by necessity. It is certainly not for my *pleasure* that I live here at home, but for my painting, and this being so I think it a great mistake of yours if you were to rob me of an opportunity, if I had to leave here *now,* before I had found something else. For my painting I must stay here somewhat longer still, then as soon as I have made more definite progress, I am willing to go anywhere where I shall earn the same money that I have here.

To be put back is not what I need or deserve, nor do I feel the least inclination for it, you see.

And attempt to get rid of you, that I never did, but where you showed me too clearly how little chance there was

of our doing real business together, I do accept it for the future, that is true.

Recognize this once and for all, when I ask you for money, I do not ask it for *nothing*; the work which I carry out with it is at your disposal, and if *now* I am in arrears, I am on the right road even to achieving some leeway.

I write this once more, for the same reason as I did the earlier letters; I shall be quite at bay at the end of the month, for I have only enough for two or three days to pay my model.

And I am wretched that I shall again be handicapped for ten or twelve days this month.

And most seriously I repeat, can you not find a way to help me to 20 francs, for instance, to cover those last days? What I mind most, is the time I should otherwise forfeit. Goodbye.

<div style="text-align:right">Yours,
Vincent</div>

Dear Theo, [Nuenen, late January 1885]

You would greatly oblige me by trying to get for me:

Illustration No. 2174, 24th October 1884.

It is already an old number, but at the office you will probably be able to get it. In it there is a drawing by Paul Renouard, a strike of the weavers at Lyons. Also one from a series of Opera sketches (of which he has also published etchings)—called " The Harpist," which I like very much.

Then he has also done just recently, " The World of the Lawcourts," which I got from Rappard, you know it probably from the " Paris Illustré " by Damas.

But I think the drawing of the weavers the most beautiful of all, there is so much life and depth in it that I think this drawing might hold its own beside Millet, Daumier, Lepage.

When I think how he rose to such a height by working from the very beginning from nature, without imitating others, and how he is none the less in harmony with the very clever people, even in technique, though from the very first he had his own style, I find him again a proof that by truly following nature one's work improves every year.

And I am daily more convinced that people who do not in the first place wrestle with nature *never* succeed.

I think that if one has tried to follow attentively the great masters, one finds them all back at certain moments, deep in reality—I mean that their so-called *creations* will be seen by one in reality, if one has the same eyes, the same sentiment as they had. And I do believe that if the critics and connoisseurs were better acquainted with nature their judgment would be more correct than now, when it is the routine to live only among pictures, and to compare them mutually. Which of course, as one side of the question, is good in itself, but it lacks a solid basis if one begins to forget nature and looks only superficially. Can't you understand that I am perhaps not wrong in this, and to say more clearly still what I mean, is it not a pity that you, for instance, seldom or hardly ever enter those cottages, or associate with those people, or see that sentiment in landscape, which is painted in the pictures you like best. I do not say that you *can* do this in your position, just because one must look much and long at nature before one comes to the conviction that the most touching things the great masters have painted still find their origin in life and reality itself. A basis of sound poetry, which exists eternally as a fact, and can be found if one digs and seeks deeply enough.

" Ce qui ne passe pas dans ce qui passe,"[1] it exists.

And what Michelangelo said in a splendid metaphor, I think Millet has said without metaphor, and Millet can perhaps best teach us to see, and get "a faith." If I do better work later on, I certainly shall not work *differently* than now, I mean it will be the same apple, though riper; I shall not change my mind about what I have thought from the beginning. And that is the reason why I say for my part : if I am no good now, I shall be no good later on either, but if later on, then now too. For corn is corn, though people from the city may take it for grass at first, and also the other way round.

In any case, whether people approve or do not approve of what I do and how I do it, I for my part know no other way

[1] " The durable within the transitory "

than to wrestle so long with nature that she tells me her secret.

All the time I am working at various heads and hands.

I have also drawn some again, perhaps you would find something in them, perhaps not, I can't help it. I repeat, I know no other way.

But I can't understand that you say: perhaps later on we shall admire even the things done now.

If I were you, I should have so much self-confidence and independent opinion that I should know whether I could see *now* what there was or was not in a thing.

Well, you must know those things for yourself.

Though the month is not quite over, my purse is quite empty. I work on as hard as I can, and I for my part think that by constantly studying the model, I shall keep a straight course.

I wish you could send me the money a few days before the 1st for that same reason, that the ends of the month are always hard, because the work brings such heavy expenses, and I don't sell any of it. But this will not go on so for ever, for I work too hard and too much not to arrive eventually at the point of being able to defray my expenses, without being in a dependent position. For the rest, nature outside and the interiors of the cottages, they are splendid in their tone and sentiment just at present; I try hard not to lose time.

Goodbye,

Yours,
Vincent

Dear Theo, [Nuenen, April 1885]

By the same mail you will receive a number of copies of the lithograph. Please give Mr. Portier as many as he wants. And I enclose a letter for him, which I am afraid you will think rather long, and in consequence unpractical. But I thought that what I had to say couldn't be expressed in more concise terms, and that the chief point is to give him arguments for

L.V.G.

his own instinctive feelings. And in fact what I write to him I say also to you.

There is a school—I believe—of impressionists. But I know very little about it. But I do know who are the original and most important masters, around whom—as round an axis—the landscape and peasant painters will turn. Delacroix, Corot, Millet and the rest. That is my own opinion, not formulated as it should be.

I mean there are (rather than persons) rules or principles or fundamental truths for *drawing,* as well as for *colour,* upon which *one proves to fall back* when one finds out an actual truth.

In drawing, for instance—that question of drawing the figure beginning with the circle—that is to say taking as one's basis the elliptical planes. A thing which the ancient Greeks already knew, and which will continue to apply till the end of the world. As to colour, those everlasting problems, for instance, that first question Corot addressed to Français, when Français (who already had a reputation) asked Corot (who then had nothing but a negative or rather bad reputation) when he (F.) came to Corot, to get some information : " Qu'est-ce que c'est un ton rompu? Qu'est-ce que c'est un ton neutre?"[1]

Which can be better shown on the palette than expressed in words.

So what I want to tell Portier in this letter is my confirmed belief in Eugène Delacroix and the people of that time.

And at the same time, as the picture which I have in hand is different from lamplights by Dou or Van Schendel, it is perhaps not superfluous to point out how one of the most beautiful things done by the painters of this country has been the painting of *black,* which nevertheless has *light* in it. Well, just read my letter and you will see that it is not unintelligible, and that it treats a subject that just occurred to me while painting.

I hope to have some luck with that picture of the potato-eaters.

[1] " What is a broken tone? What is a neutral tone?"

I also have on hand a red sunset.

In order to paint rural life one must be master of so many things. But on the other hand I don't know anything at which one works with so much calm, in the sense of serenity, however much of a worry one may be having as regards material things.

I am rather worried just now about the moving, that's no easy job, on the contrary. But it had to happen some time, if not now, then later, and in the long run it is better to have a place of one's own, that's a fact.

To change the subject. How typical that saying is about the figures of Millet: " *Son paysan semble peint avec la terre qu'il ensemence!*"[1] How exact and how true. And how important it is to know how to mix on the palette those colours which have no name, and yet are the real foundation of everything. Perhaps, I daresay *for sure,* the questions of *colour,* and more exactly broken and neutral colours, will preoccupy you anew. Art dealers speak so vaguely and arbitrarily about it, I think. So in fact do painters too. Last week I saw at an acquaintance's a decidedly clever, realistic study of an old woman's head, by somebody who is directly, or indirectly, a pupil of the school of The Hague. But in the drawing, as well as in the colour, there was a certain hesitation, a certain narrow-mindedness, much greater, in my opinion, than one sees in an old Blommers or Mauve or Maris. And this symptom threatens to become more and more general. If one takes realism in the sense of *literal* truth, namely *exact* drawing and local colour. There are other things than that. Well, goodbye, with a handshake,

<div style="text-align:right">Yours,
Vincent</div>

Dear Theo, [Nuenen, June 1885]
 Thanks for your letter and the enclosure. It was just what

[1] " His peasant appears to be painted with the earth that he is sowing."

I wanted and helped me to work as hard at the end of the month as I did in the beginning.

I am very glad to hear that Serret is a painter, about whom you had already written things which I perfectly well remember, but the name had escaped me. I should like to write to you much more than I shall do in this letter, but of late, when I come home, I don't feel like writing, after sitting in the sun all day. As to what Serret says, I quite agree with him—I shall just send him a line, because I should like to become friends with him. As I told you already, I have been busy drawing figures recently; I will send them especially for the sake of Serret, to show him that I am far from indifferent to the unity and the form of a figure.

Do you ever see Wallis, is that water-colour of the auction perhaps something for him; if it were something for Wisselingh,[1] then *he* would certainly be the right one to take it. To Wisselingh I once gave a few heads and recently I have sent him that lithograph. But as he did not answer with a single word, I think if I sent him something more, I should get nothing but an insult.

It has just happened to me that Van Rappard,[2] with whom I have been friends for years, after keeping silent for about three months, writes me a letter, so haughty and so full of insults and so clearly written after he had been in The Hague, that I am almost sure I have lost him for ever as a friend.

Just because I tried it first at The Hague, that is in my own country, I have full right and cause to forget all those worries and to attempt something else outside my own country.

You know Wallis well, perhaps you can broach the subject à propos of that water-colour, but act according to your discretion. If I could earn something with my work, if we had some firm ground, be it ever so little, under our feet for our daily existence, and if then the desire to become an artist took

[1] Wallis and Wisselingh were art-dealers on friendly terms with the two brothers.

[2] Vincent had been corresponding with this artist since 1881, but just recently a radical fissure had developed between them.

for you the form of, let me say, Hennebeau in *Germinal*,[1] discounting all difference in age, etc.—what pictures you could still make then! The future is always different from what one expects, so one never can be sure. The drawback of painting is that, if one does not sell one's pictures, one still needs money for paint and models in order to make progress. And that drawback is a bad thing. But for the rest, painting and, in my opinion, especially the painting of rural life, gives serenity, though one may have all kinds of worries and miseries on the surface of life. I mean painting is a *home* and one does not experience that homesickness, that peculiar feeling Hennebeau had. That passage I copied for you lately had struck me particularly, because at the time I had almost literally the same longing to be something like a grassmower or a navvy.

And I was sick of the *boredom* of civilization. It *is* better, one *is* happier if one carries it out—literally though—one feels at least that one is really alive. And it is a good thing in winter to be deep in the snow, in the autumn deep in the yellow leaves, in summer among the ripe corn, in spring amid the grass; it is a good thing to be always with the mowers and the peasant girls, in summer with a big sky overhead, in winter by the fireside, and to feel that it always has been and always will be so.

One may sleep on straw, eat black bread, well, one will only be the healthier for it.

I should like to write more, but I repeat, I am not in a mood for writing, and I wanted to enclose a note for Serret besides, which you must read also, because I write in it about what I want to send before long, especially because I want to show Serret my complete figure studies. Goodbye,

Yours,

Vincent

Serret may agree with you that to paint good pictures and to sell them are two separate things. But it is not at all true. When at last the public saw Millet, all his work together, then the public both in Paris and in London was enthusiastic.

[1] A famous novel by Zola.

And who were the persons that had suppressed and refused Millet? The art dealers, the so-called *experts*.

Dear Theo, [Nuenen, July 1885]

I wish the four pictures[1] of which I wrote were gone.

If I keep them here long, I might paint them over again, and I think it would be better if you got them just as they come from the heath.

The reason why I do not send them is that I don't want to send them unfranchised at a moment in which you yourself are pinched perhaps, and yet I cannot pay the charge myself.

The little house in which Millet lived, I have never seen it, but I imagine that those four little human nests are of the same kind.

One is the residence of a gentleman, who is known under the name of the " mourning peasant "; the other is inhabited by a " good woman " who, when I came there, did no more mysterious thing than dig her potato pit, but she must also be able to do witchcraft, at any rate she bears the name of " the witch-head."

You remember in the book by Gigoux how it happened to Delacroix that 17 pictures of his were refused at the same time. One sees from this—at least I think so—that he and others of that period—placed before connoisseurs and non-connoisseurs, who none of them either understood or would buy—one sees from this, that those who in the book are rightly called " the valiant," did not call it fighting against hopeless odds, but went on painting. What I wanted to tell you once more, is that if we take that story about Delacroix as a starting-point, we must still paint a lot.

I am compelled into being the most disagreeable of all persons, namely I have to ask for money. And as I do not think things will all at once take a turn for the better in terms of selling, this is bad enough. But I ask you, is it not better after all for both of us to work hard, though it will bring difficulties, than to sit and philosophize at a time like that?

[1] A series depicting peasant huts.

I do not know the future, Theo, but I do know the eternal
law that everything changes; go back ten years, and things
were different, the conditions, the temperament of the people,
well, everything. And ten years hence, things will have
shifted again, I am sure.

But the thing one does remains, and one does not easily
repent having done a thing. The more activity the better,
and I would rather have a failure than sit and do nothing.

Whether Portier may or may not be the man who can do
something with my work, we want him now at any rate. And
this is what I believe. After having worked for a year or so,
we shall have a larger collection than now, and I know for
sure that my work will show the better, the more I complete
it. People who now have some sympathy for it, who speak
of it as he does and show it, they are useful because after my
having worked, for instance, another year, they will have
collected a few things that will speak for themselves, even if
they were totally silent about them. If you happen to see
Portier, tell him that, far from giving it up, I intend to send
him much more. You must also continue to show the things
if you meet likely people.

It won't be so very long before the things we can show
will become more important. You will notice yourself, and it
is a fact which pleases me enormously, that more and more
they begin to arrange exhibitions of one person, or of a very
few who belong together.

This is a development in the world of art which I am sure
contains more promise for the future than any other under-
taking. It is a good thing they begin to understand that a
Bougereau does not show off well next to a Jacque, a figure
of Beyle or Lhermitte does not do beside a Schelfhout or
Koekkoek. Disperse the drawings of Raffaëlli and judge for
yourself whether it would be possible to get a good idea of
that original artist.

He—Raffaëlli—is different from Régamey, but I think him
as impressive a personality.

If I kept my work here, I think I would go on repainting
it.

When I send it to you and to Portier just as it comes from the open air or from the cottages, there will now and then be one among them which is no good, but things will be kept together which would not improve if they were often repainted.

Now if you have these four canvases and a few smaller studies of cottages besides, and somebody saw no other work of mine but these, he would of course think that I painted nothing but cottages. And it would be the same for the series of heads. But rural life includes so many different things that when Millet speaks of "travailler comme *plusieurs nègres* "[1] this really must be the case, if one wants to complete the thing.

One may laugh at Courbet's saying "peindre des anges, qui est-ce qui a vu des anges?"[2] but I should like to add, for instance: "des justices au harem, qui est-ce qui a vu des justices au harem?[3] Des combats de taureaux, qui est-ce qui en a vu?" and so many other Moorish, Spanish things, Cardinals, and then all those historical paintings, which they keep on painting and painting, yard after yard. What is the use of it and why do they do it? After a few years it generally gets musty and dull, and becomes more and more uninteresting.

Well! Perhaps they are well painted, they may be; nowadays when critics stand before a picture, like that of Benjamin Constant, like a reception at the Cardinal's by I don't know what Spaniard, it is the custom to speak with a philosophical air about " clever technique." But as soon as those very same critics would come before a picture of rural life, or before a drawing by, for instance, Raffaëlli, they would criticize the technique with the selfsame air.

You think perhaps I am wrong to criticize this, but it strikes me that all those outlandish pictures are painted *in the studio*.

But just go and paint out of doors on the spot itself! then

[1] "working like a team of negroes"

[2] "Paint angels, who has ever seen them?"

[3] "Courts of justice in a harem, who has ever seen them? Bull fights, who has ever seen them?" The reference in the first half of this comment is to a painting by Benjamin Constant.

all kinds of things happen; for instance, from the four paintings which you will receive I had to wipe off at least a hundred or more flies, not counting the dust and sand, not counting that when one carries them for some hours across the heath and through the hedges, some thorns will scratch them, etc. Not counting that when one arrives on the heath after some hours' walk in this weather, one is tired and exhausted from the heat. Not counting that the figures do not stand still like the professional models, and that the effects one wants to catch change as the day wears on.

I don't know how it is with you, but as for myself, the more I work in it, the more I get absorbed with rural life. And I begin to care less and less either for those Cabanel-like things among which I count Jacquet also, and Benjamin Constant as he is to-day, or the so highly praised, but so inexpressibly dry technique of the Italians and Spaniards. *Imagiers!*[1] that term of Jacque's is one I often think of. Yet I have no *parti pris,* I feel for Raffaëlli who paints quite other things than peasants, I feel for Alfred Stevens, for Tissot, to name something quite different from peasants; I feel for a beautiful portrait.

Zola, though in my opinion he makes colossal blunders in his judgment about pictures, says in "Mes Haines" a beautiful thing about art in general: "dans le tableau (l'œuvre d'art) je cherche, j'aime l'homme—l'artiste."[2]

Look here, I think this perfectly true; I ask you what kind of a man, what kind of a prophet, or philosopher, observer, what kind of a human character is there behind certain paintings, the technique of which is praised; in fact, often *nothing*. But a Raffaëlli is a personality, Lhermitte is a personality, and before many pictures by almost unknown artists, one feels they are made with a *will,* a *feeling,* a passion and love. The technique of a painting from rural life or—like Raffaëlli— from the heart of city workmen—brings quite other difficulties

[1] " Image-makers "

[2] " in pictures (works of art) I search after and I love the man— the artist " (*Mes Haines* contained a collection of Zola's critical writings.)

than those attached to the smooth painting and pose of a Jacquet or Benjamin Constant. It entails living in those cottages day by day, being in the fields like the peasants, in summer in the heat of the sun, in winter suffering from snow and frost, not indoors but outside, and not during a walk, but day after day like the peasants themselves.

And I ask you, if one considers these things, am I then so far wrong when I criticize the criticism of those critics who these days more than ever talk humbug about this so *often* misused word : technique (it is getting a more and more conventional significance). Considering all the trouble and drudgery needed to paint the " rouwboerke "[1] and his cottage, I dare maintain that this is a longer and more fatiguing journey than many painters of exotic subjects (maybe " Justice in the Harem," or a reception at a Cardinal's) make for their most rarefied eccentric subjects. For in Paris any kind of Arabic or Spanish or Moorish models are to be had if one only pays for them. But he who paints the rag-pickers of Paris in their *own quarter,* like Raffaëlli, has far more difficulties and his work is more serious.

Apparently nothing is more simple than to paint peasants, rag-pickers and labourers of all kinds, but—no subjects in painting are so difficult as these everyday figures!

As far as I know there is not a single academy where one learns to draw and paint a digger, a sower, a woman setting the kettle over the fire, or a seamstress. But in every city of some importance there is an academy with a choice of models for historical, Arabic, Louis XV, in one word *all really nonexistent figures.*

When I send to you and Serret some studies of diggers or peasant women who weed, glean, etc., *as the beginning* of a whole series of all kinds of work in the fields, then it may be that either you or Serret will discover faults in them, which will be useful for me to know, and which I shall perhaps admit myself.

But I want to point out something which is perhaps worth while. All academic figures are constructed in the same way

[1] " peasant in mourning "

and let us say *on ne peut mieux*.[1] Irreproachably *faultless*. You will guess what I am driving at, they do not reveal to us anything new.

This does not apply to the figures of a Millet, a Lhermitte, a Régamey, a Daumier; they too are well constructed, but after all in a different way than the academy teaches.

But I think however correctly academic a figure may be, it will be superfluous these days, even though it were by Ingres himself (his " Source "[2] however excepted, because that really was, and is, and will always remain something new), when it lacks the essential modern note, the intimate character, the real *action*.

Perhaps you will ask, when will a figure not be superfluous, though there may be faults, great faults in it in my opinion?

When the digger digs, when the peasant is a peasant and the peasant woman a peasant woman.

Is this something new?—yes—even the figures by Ostade, Terborch[3] are not in action like those painted nowadays.

I should like to say a lot more about this, and I should like to say how much I myself want to improve my work and how much I prefer the work of some other artists to my own.

I ask you, do you know in the old Dutch school a single digger, a single sower??? Did they ever try to paint " a labourer "? Did Velasquez try it in his water-carrier or types from the people? No.

The figures in the pictures of the old masters do not *work*. I am drudging just now on the figure of a woman whom I saw last winter pulling carrots in the snow.

Look here, Millet has done it, Lhermitte, and in general the painters of rural life in this century—Israëls for instance —they find it more attractive than anything else.

But *even* in this century, how relatively few among the in-

[1] " incapable of being improved upon "

[2] A famous painting showing a nude female figure fetching water.

[3] Seventeenth century artists of the Low Countries; in fact Terborch was not one of the painters of " low-life " genre scenes, as Vincent implies.

numerable painters want the figure—yes, above all—for the
sake of the figure, that is to say for the sake of line and
modelling, *but cannot imagine* it otherwise than in action, and
want to do what the old masters avoided—even the old
Dutch masters who clung to many conventional actions—and
I repeat—who want *to paint the action for the sake of the
action.*

So that the picture or the drawing has to be a drawing of
the figure for the sake of the figure and the inexpressibly har-
monious form of the human body, but at the same time a
pulling of carrots in the snow. Do I express myself clearly?
I hope so, and just tell this to Serret. I can say it in a few
words : a nude by Cabanel, a lady by Jacquet and a peasant
woman, *not by Bastien Lepage himself,* but a peasant woman
by a Parisian who has learned drawing at the academy, will
always indicate the limbs and the structure of the body in one
selfsame way, sometimes charming—correct in proportion and
anatomy. But when Israëls, or when Daumier or Lhermitte
for instance draw a figure, the shape of the figure will be felt
much more, and yet—that is the reason why I like to count
in Daumier—the proportions will be sometimes almost
arbitrary, the anatomy and structure often quite wrong " in
the eyes of the academician." But it will *live.* And especially
Delacroix too.

It is not yet well expressed. Tell Serret that *I should be
desperate if my figures were correct,* tell him that I do not
want them to be academically correct, tell him I mean that if
one photographs a digger *he certainly would not be digging
then.* Tell him that I adore the figures by Michelangelo
though the legs are undoubtedly too long, the hips and the
backsides too large. Tell him that, for me, Millet and Lher-
mitte are the real artists, for the very reason that they do not
paint things as they are, traced in a dry analytical way, but
as *they*—Millet, Lhermitte, Michelangelo—feel them. Tell
him that my great longing is to learn to make those very
incorrectnesses, those deviations, remodellings, changes of
reality, so that they may become, yes, untruth if you like—
but more true than the literal truth.

And now I shall have to finish, but I wanted to say once more that those who paint rural life or the life of the people, though they may not belong to the men of the moment, perhaps in the long run they will nonetheless hold out longer than the painters of the exotic harems and Cardinal's receptions, painted in Paris.

I know that it is being very disagreeable to ask for money at inconvenient moments; my excuse, however, is that painting the apparently most common things is sometimes the most difficult and the most expensive.

The expenses which I must afford if I want to work are sometimes very high in proportion to what I have at my disposal. I assure you, if my constitution had not become in all winds and weather like that of a peasant, I should not be able to stand it, as for my own comfort absolutely nothing is left over.

But I don't want comfort for myself, just as little as many peasants want to live differently than they do.

But the amount I ask is for colours, and especially for models.

From what I write about the drawings of the figure, you can perhaps sufficiently judge how passionately I want to carry them out.

You recently wrote to me that Serret had spoken to you " with conviction " about certain faults in the structure of the figures of the potato-eaters.[1]

But you will have seen from my answer that my own criticism also disapproves of them on that point, but I pointed out that this was an impression gained after having seen the cottage in the dim lamplight for many evenings, after having painted forty heads, so it is clear that I started from a different point of view.

But now that we begin to discuss figure drawing, I have a great deal more to say. In Raffaëlli's words I find his opinion about " character "—what he says about this is good,

[1] Vincent had painted this subject in April-May 1885, to create his most ambitious canvas to date.

and in its place and it is illustrated by the drawings themselves.

But people who move in artistic, literary circles, like Raffaëlli in Paris, have after all different ideas than mine, for instance, here in the heart of peasant life.

I mean they want one word to encompass all their ideas; he uses for the figures of the future the word "character." I agree with it, with the *meaning* I think, but in the correctness of the word I believe as little as in the correctness of other words; as little as in the correctness or cogency of my own expressions.

Rather than say there must be character in a digger, I circumscribe it by saying: that peasant *must* be a peasant, that digger *must* dig, and then there will be something essentially modern in them. But I feel myself that from these very words conclusions may be drawn that I do not endorse, and would be even if I were to go on a great deal further.

Instead of diminishing the expenses for models, now already so heavy for me, I would think it better, much better, to spend a little more on them, for what I aim at is quite a different thing than being able to do a little figure drawing. To draw *a peasant's figure in action,* I repeat, that's an essentially modern image, the very heart of modern art, something neither the Greeks nor the Renaissance nor the old Dutch school have done.

This is a question which occupies me daily. But this difference between the great as well as the little masters of to-day (the great ones, like, for instance, Millet, Lhermitte, Breton, Herkomer: the little ones such as Raffaëlli and Régamey) and the old masters, I have not often found it openly expressed in the articles about art.

Just think over whether you don't find this to be true. They started a peasant's and a labourer's figure as a "genre," but at present, with Millet the great master as leader, this is the very heart of modern art, and will remain so.

People like Daumier, we must respect them, for they are among the pioneers. The simple *nude* but *modern* figure, like Henner and Lefèvre have renewed it, ranks high.

Baudry and especially the sculptors, like, for instance, Mercier, Dalou, that too is serious work.

But peasants and labourers are after all not nude, and it is improper to imagine them nude. The more painters begin to paint labourers' and peasants' figures, the better I shall like it. And I myself know nothing I like so well. This is a long letter and I do not know whether I have expressed clearly enough what I mean. I shall perhaps write a little word to Serret, if I do so I shall send you the letter for you to read, for I should like to make it very clear how high I rate that question of figure drawing.

Dear Theo, [Nuenen, late October 1885]

I read your letter about black with great pleasure, and it convinces me that you have no prejudice against black.

Your description of Manet's study, "The Dead Toreador," was well analysed. And the whole letter proves the same as your sketch of Paris suggested to me at the time, that if you put yourself to it, you can paint a thing in words.

It is a fact that by studying the laws of the colours, one can move from instinctive belief in the great masters to the analysis of why one admires—what one admires—and that indeed is necessary nowadays, when one realizes how terribly arbitrary and superficially people criticize.

You must just let me maintain my pessimism about the art trade as it is these days, for it does *not* at all include discouragement. This is my way of reasoning. Supposing I am right in considering that curious haggling about prices of pictures to be more and more like the bulb trade. I repeat, supposing that like the bulb trade at the end of the last century, so the art trade, along with other branches of speculation at the end of this century, will disappear as they came, namely rather quickly. The bulb trade may disappear—the *flower-growing* remains. And I for myself am contented, for better or for worse, to be a small gardener, who loves his plants.

Just now my palette is thawing and the frigidness of the first beginning has disappeared.

It is true, I often blunder still when I undertake a thing, but the colours follow of their own accord, and taking one colour as a starting-point, I have clearly before my mind what must follow, and how to get life into it.

Jules Dupré is in landscape rather like Delacroix, for what enormous variety of mood did he express in symphonies of colour.

Now a marine, with the most delicate blue-greens and broken blue and all kinds of pearly tones, then again an autumn landscape, with a foliage from deep wine-red to vivid green, from bright orange to dark havana, with other colours again in the sky, in greys, lilacs, blues, whites, forming a further contrast with the yellow leaves.

Then again a sunset in black, in violet, in fiery red.

Then again, more fantastic, what I once saw, a corner of a garden by him, which I have never forgotten : black in the shadow, white in the sun, vivid green, a fiery red and then again a dark blue, a bituminous greenish brown, and a light brown-yellow. Colours that indeed have something to say for themselves.

I have always been very fond of Jules Dupré, and he will become still more appreciated than he is. For he is a real colourist, always interesting, and so powerful and dramatic.

Yes, he is indeed a brother to Delacroix.

As I told you, I think your letter about black very good, and what you say about not painting local colour is also quite correct. But it doesn't satisfy me. In my opinion there is much more behind that not painting local colour.

" Les vrais peintres sont ceux qui ne font pas la couleur locale "[1]—that was what Blanc and Delacroix discussed once.

May I not boldly take it to mean that a painter does better to start from the colours on his palette than from the colours in nature? I mean, when one wants to paint, for instance, a head, and sharply observes the reality one has before one, then one may think : that head is a harmony of red-brown, violet,

[1] " The true painters are those who do not render local colour "

yellow, all of them broken—I will put a violet and a yellow and a red-brown on my palette and these will break each other.

I retain from nature a certain sequence and a certain correctness in placing the tones, I study nature, so as not to do foolish things, to remain reasonable—however, I don't mind so much whether my colour corresponds exactly, as long as it looks beautiful on my canvas, as beautiful as it looks in nature.

Far more true is a portrait by Courbet, manly, free, painted in all kinds of beautiful deep tones of red-brown, of gold, of colder violet in the shadow with black as repoussoir, with a little bit of tinted white linen as a repose to the eye—finer than a portrait by whomever you like, who has imitated the colour of the face with horribly close precision.

A man's head or a woman's head, well contemplated and at leisure, is divinely beautiful, isn't it? Well, that *general harmony* of tones in nature, one loses it by painfully exact imitation, one keeps it by recreating in an equivalent colour range, that may be not exactly or far from exactly like the model.

Always and intelligently to make use of the beautiful tones which the colours form of their own accord, when one breaks them on the palette, I repeat—to start from one's palette, from one's knowledge of colour-harmony, is quite different from following nature mechanically and obsequiously.

Here is another example: suppose I have to paint an autumn landscape, trees with yellow leaves. All right—when I conceive it as a symphony in yellow, what does it matter whether the fundamental colour of yellow is the same as that of the leaves or not? It matters *very little.*

Much, everything depends on my perception of the infinite variety of tones of one and the *same family.*

Do you call this a dangerous inclination towards romanticism, an infidelity to "realism," a "peindre de chic,"[1] a caring more for the palette of the colourist than for nature? Well, que soit. Delacroix, Millet, Corot, Dupré, Daubigny, Breton, thirty names more, are they not the heart and soul of

[1] "painting without copying reality"

the art of painting of this century, and are they not all rooted in romanticism, though they *surpassed* romanticism?

Romance and romanticism are of our time, and painters must have imagination and sentiment. Luckily realism and naturalism are not free from it. Zola creates, but does not hold up a *mirror* to things, he creates *wonderfully*, but *creates, poetises*, that is why it is so beautiful. So much for naturalism and realism, which nonetheless stand in connection to romanticism.

And I repeat that I am touched when I see a picture of about the years '30-'48, a Paul Huet, an old Israëls, like the "Fisherman of Zandvoort," a Cabat, an Isabey.

But I find so much truth in that saying: "ne pas peindre le ton local,"[1] that I far prefer a picture in a lower tonal scale than nature to one which is exactly like nature.

Rather a water-colour that is somewhat vague and unfinished than one which is worked up to simulate reality.

That saying: "ne pas peindre le ton local," has a broad meaning, and it leaves the painter free to seek for colours which form a whole and harmonize, which stand out the more in contrast to another combination.

What do I care whether the portrait of an honourable citizen tells me exactly the milk-and-watery bluish, insipid colour of that pious man's face—which I would never have noticed. But the citizens of the small town, where the above-mentioned individual has rendered himself so meritorious that he thought himself obliged to impress his physiognomy on posterity, are highly edified by the correct exactness.

Colour expresses something by itself, one cannot do without this, one must use it; that which is beautiful, really beautiful— is also correct; when Veronese had painted the portraits of his beau-monde in the "Marriage at Cana," he had spent on it all the richness of his palette in sombre violets, in splendid golden tones. Then—he thought still of a faint azure and a pearly-white—which does not appear in the foreground. He detonated it on in the background—and it was right, spontaneously it changes into the ambience of marble palaces and

[1] "do not paint local tone"

sky, which characteristically consummates the ordering of the figures.

So beautiful is that background that it arose spontaneously from a calculation of colours.

Am I wrong in this?

Is it not painted *differently* than somebody would do it who had thought at the same time of the palace *and* of the figures as one whole?

All that architecture and sky is conventional and subordinate to the figures, it is calculated to make the figures stand out beautifully.

Surely *that is* real painting, and the result is more beautiful than the exact imitation of the things themselves. To think of one thing and to let the surroundings belong to it and proceed from it.

To study from nature, to wrestle with reality—I don't want to do away with it, for years and years I myself have been so engaged, almost fruitlessly and with all kinds of sad results.

I should not like to have missed that *error*.

I mean that it would be foolish and stupid always to go on in that same way, but *not* that all the pains I took should be absolutely dismissed.

" On commence par tuer, on finit par guérir,"[1] is a doctor's saying. One starts with a hopeless struggle to follow nature, and everything goes wrong; one ends by calmly creating from one's palette, and nature agrees with it, and follows. But these two contrasts are not separable from one another. The drudging, though it may seem in vain, gives an intimacy with nature, a sounder knowledge of things. And a beautiful saying by Doré (who sometimes is so clever!) is: *je me souviens.*[2] Though I believe that the best pictures are more or less freely painted by heart, still I *cannot* divorce the principle that one can never study and toil too much from nature. The greatest, most powerful imaginations have at the same time made things directly from nature which strike one dumb.

[1] " One begins by killing, one ends by healing "
[2] " I remember "

In answer to your description of the study by Manet, I send you a still-life of an open—so a broken white—Bible bound in leather, against a black background, with a yellow-brown foreground, with a touch of citron yellow.

I painted that in *one rush,* during a single day.

This to show you that when I say that I have perhaps not plodded completely in vain, I dare say this, because at present it comes quite easily to me to paint a given subject unhesitatingly, whatever its form or colour may be. Recently I painted a few studies out of doors, of the autumn landscape. I shall write again soon, and send this letter in haste to tell you that I was quite pleased with what you say about black.

Goodbye,

Yours,
Vincent

[Antwerp, end of November 1885]

Dear Theo, Saturday evening

I want to write you a few more impressions of Antwerp.

This morning I had a fruitful walk in the pouring rain, the object of this trudge was to fetch my things from the custom house; the various dockyards and warehouses on the quays are very fine.

I have walked along the docks and the quays several times already, in all directions. Especially when one comes from the sand and the heath and the quiet of a peasant village, and has for a long time been in none but quiet surroundings, the contrast is curious. It is an unfathomable mêlée. One of de Goncourt's sayings was " Japonaiserie for ever." Well, those docks are a famous Japonaiserie, fantastic, peculiar, unheard of—at least one can take it in that way.

I should like to walk there with you, just to know whether we see alike. One could undertake everything there, town views—figures of most varied character—the ships as the principal thing, with water and sky a delicate grey—but most of all—Japonaiserie. I mean, the figures are always in action, one sees them in the queerest surroundings, everything fantas-

tic, and at all instants interesting contrasts present themselves.

A white horse in the mud, in a corner where heaps of merchandise are lying covered with oilcloth—against the old black smoky walls of the warehouse. Quite simple, but an effect of Black and White.

Through the window of a very elegant English bar, one will look out on the dirtiest mire, and on a ship from which, for instance, dainty merchandise like hides and buffalo horns is being unloaded by huge dock hands or exotic sailors; a very dainty and fair young English girl is standing at the window looking at it, or at something else. The interior with the figure altogether in tone, and for light—the silvery sky above that mud, and the buffalo horns, again a series of rather sharp contrasts. There will be Flemish sailors, with almost too healthy faces, with broad shoulders, strong and full, and thoroughly Antwerpian folk, eating mussels or drinking beer, and it will happen with a lot of noise and movement, while in contrast a tiny figure in black with her little hands against her body comes stealing noiselessly along the grey walls. Framed by raven-black hair—a small oval face, brown? orange-yellow? I don't know. For a moment she lifts her eyelids, and looks with a sideways glance from a pair of jet black eyes.

It is a Chinese girl, mysterious, quiet as a mouse—small, bug-like in character. What a contrast to that group of Flemish mussel eaters.

Another contrast—one passes through a very narrow street, between tremendously high houses, warehouses, and sheds. But down below in the street pubs of all nationalities with attending male and female individuals, shops with eatables, seamen's clothes, motley and crowded.

That street is long, every minute one sees something compelling. Now and again there is a row, when a quarrel is going on, intenser than elsewhere; for instance, there you are walking, looking about, and suddenly there arises a burst of cheering, and all kinds of shouting. In broad daylight a sailor

is being thrown out of a bordello by the girls, and followed by a furious fellow and a bunch of girls, of whom he seems rather afraid—at least I saw him scramble over a heap of sacks and disappear through a warehouse window.

Now, when one has had enough of all this tumult—at the end of the piers where the Harwich and Havre steamers lie at anchor, with the city to one's rear, one sees in front nothing, absolutely nothing but an infinite expanse of flat, half-inundated fields, awfully dreary and wet, waving dry rushes, mud, the river with a single little black boat, the water in the foreground grey, the sky, foggy and cold, grey—quiet as a desert.

As to the panorama of the harbour or a dock—at one moment it is more tangled and fantastic than a thorn hedge, so confused that one finds no rest for the eye and gets giddy, is forced by the whirling of colours and lines to look first here, then there, without it being possible, even by looking for a long time at one point, to distinguish one thing from another. But when one stands on a spot where one has a vague plot as foreground, then one sees the most beautiful quiet lines, and the effects which Mols, for instance, often paints.

Now one sees a girl who is of splendid health, and who looks on the face of it loyal, simple and jolly, then again a face so sly and false, that it makes one afraid, like a hyena's. Not to forget the faces damaged by smallpox, which wear the colour of boiled shrimps, with pale grey eyes, without eyebrows, and a little sleek thin hair, the colour of real pigs' bristles or somewhat more yellow; Swedish or Danish types. It would be fine to work there, but how and where?

For one would very soon get into a scrape.

However I have traversed quite a number of streets and back alleys without meeting with adventures, and I have sat and talked quite jovially to various girls that seemed to take me for a sailor.

I don't think it improbable that by painting portraits I shall get hold of good models.

To-day I got my things and drawing materials, for which I was longing very much. And so my studio is all fixed. If I could get good models for almost nothing, I should not be afraid of anything.

I do not think it so very bad either that I have not got so much money as to be able to force things by paying for them.

Perhaps the idea of making portraits, and having them paid for by posing, is the safer way, because in a city it is not the same as with peasants. Well, one thing is sure, that Antwerp is very curious and fine for a painter.

My studio is not bad, especially as I have pinned a lot of little Japanese prints on the wall, which amuse me very much. You know those little women's figures in gardens, or on the beach, horsemen, flowers, knotty thorn branches.

I am glad I made the move, and hope not to sit still this winter. Well, I feel safe now that I have a little den, where I can sit and work when the weather is bad.

But of course I shall not exactly live in immense luxury these days.

Try and send your letter off on the 1st, because I have provided myself with bread till then, but after that I should be in rather a fix.

My little room is better than I expected, and it certainly doesn't look dull. Now that I have here the three studies I took with me, I shall try and go to the picture dealers, who seem however to live in private houses, with no show window on the street.

The park is nice too, I sat and drew there one morning.

Well, so far I have had no ill luck, as to my lodgings I am well off, since by spending a few francs more I have got a stove and a lamp.

I shall not easily get bored, I assure you. I have also found the " October " of Lhermitte, women in a potato field in the evening, beautiful. But I have not seen " November," did you get it perhaps? I have also noticed that there is a *Figaro* illustrated with a fine drawing by Raffaëlli.

My address you know is 194, Rue des Images, so please

forward your letter there, and the second part of de Goncourt[1] when you have finished it.

Goodbye,

Yours,

Vincent

It is curious that my painted studies seem darker in town than in the country. Is that because the light everywhere in town is less bright? I don't know, but it may make a greater difference than one would superficially say, so it struck me, and I could understand that things you have look darker than I in the country thought they were. However, the ones I have with me now don't come out badly for all that, the mill, the avenue with autumn trees and a still-life and a few little ones.

Dear Theo, [Antwerp, end of December 1885]

It is high time for me to thank you for the 50 francs you sent which helped me to get through the month, though as from today it will be pretty much the same.

But—there are a few more studies made, and the more I paint the more progress I think I make. As soon as I received the money I took a beautiful model and painted her head life-size.

It is quite light except for the black, you know. Yet the head itself stands out simply against a background in which I tried to put a golden shimmer of light.

Here follows the colour scheme—a well-toned flesh-colour, in the neck rather bronze-like, jet black hair—black which I had to make with carmine and Prussian blue, reduced white for the little jacket, light yellow, much lighter than the white, for the background. A touch of scarlet in the jet black hair and a second scarlet bow in the reduced white.

This is a girl from a café chantant, and yet the expression which I sought was rather Ecce Homo-like.[2]

[1] The collection of essays on French painting by the de Goncourt brothers.

[2] viz, like the expression on the face of Christ when he was shown to the people by Pilate.

But as I want to remain *real*, especially in the expression, though I can let my fancy go, this is what I wanted to express in it.

When the model came, she had apparently been very busy the last few nights, and she said something that was rather characteristic: "Pour moi le champagne ne m'égaye pas, il me rend tout triste."[1]

Then I understood, and I tried to express something voluptuous and at the same time grievously afflicted.

From the same model, I began a second study in profile.

Then I made that portrait which I spoke about, the one that was promised to me, and I painted a study of that head for myself, and now these last days of the month I hope to paint another head of a man.

I feel quite cheerful, especially about the work, and it is good for me to be here.

I fancy that whatever those whores are like, one can make a profit from them more readily than in any other way. There is no denying that they are sometimes damned beautiful and that it is the spirit of the time that that kind of picture is on the way up more and more.

And even from the highest artistic point of view, nothing can be said against it; *to paint human beings,* that was the old Italian art, that was what Millet did and what Breton does.

The question is only whether one starts from the soul or from the clothes, and whether the form serves as a clothes-peg for ribbons and bows, or if one considers the form as the means of depicting impression and sentiment, or if one models for the sake of modelling, because it is so infinitely beautiful in itself.

Only the first is transitory, and the latter two are both high art.

What rather pleased me was that the girl who posed for me wanted me to paint a portrait for her to keep, on the same lines as the ones I did for myself.

[1] " Personally I am not cheered up by champagne, it makes me all sad."

And she has promised to let me paint as soon as possible a study of her in her room, in a dancer's dress.

She cannot do this now, because the owner of the café where she operates objects to her posing, but as she is going to live in rooms with another girl, both she and the other girl would like to have their portraits painted. And I fervently hope that she will come back, for she has an imposing face and is witty.

But I must train myself, given that it all depends on skilfulness and speed; for they have not much time or patience, although in any case the work need not be less well done for being done quickly, and one must be able to work even if the model does not sit rigidly still. Well, you see that I am at work with full vitality. If I sold something so that I earned a little more, I should work more vigorously still.

As to Portier, I do not lose courage yet, but poverty is at my back, and at present the dealers all rather suffer from the same evil, that of being more or less a "lost tribe," that is in eclipse. They have too much spleen, and how can one be expected to feel inclined to dip into all that indifference and dullness; besides, this complaint is catching.

For it is all nonsense that no business can be done, but one must work in any case, with conviction and with enthusiasm, in short with a certain warmth.

As to Portier, you wrote me yourself that he was the first to exhibit the impressionists, and that his thunder was completely stolen by Durand-Ruel.

Well, one might conclude from this that he is a man of initiative, not only saying things but doing them. Perhaps it is the fault of his sixty years, and for the rest his is perhaps one of the many cases in which, at the time when pictures were the fashion and business prospered, a lot of intelligent persons were wantonly put aside, as if they were of no importance and without talent, only because they could not bring themselves to believe in the stability of that sudden craze for pictures, and the enormous lift in prices.

Now that business is slack, one sees those very same dealers

who were so very enterprising, let us say ten years ago, pass into complete eclipse. And we are not yet at the end.

Personal initiative with little or no capital is perhaps the germ for the future. It remains to be seen.

Yesterday I saw a large photograph of a Rembrandt which I did not know, and which struck me tremendously; it was a woman's head, the light fell on the bust, neck, chin and the nostrils—the lower jaw.

The forehead and eyes under the shadow of a large hat, probably with red feathers. Probably also red or yellow in the low-cut jacket. A dark background. The expression, a mysterious smile like that of Rembrandt himself in his self-portrait, where Saskia is sitting on his knee and he has a glass of wine in his hand.

My thoughts are all the time full of Rembrandt and Hals these days, not because I see so many of their pictures, but because I see among the people here so many types that remind me of that time.

I still often go to those popular balls, to see the heads of the women, and the heads of the sailors and soldiers. One pays the entrance fee of 20 or 30 centimes, and drinks a glass of beer, for they drink very little spirits, and one can amuse oneself a whole evening, at least I do, by observing how these people enjoy themselves.

To paint much from the model—that is what I have to do, and it is the only thing that seriously helps to make progress.

I notice that I have been underfed too long, and when I received your money my stomach could not digest the food; but I will try to remedy that.

And it does not prevent my having all my energy and capacity when at work.

But when I am out of doors, the work in the open air is too much for me, and I feel too faint.

Well, painting is a thing that wears one out. But Dr. Van der Loo[1] told me, when I went to see him shortly before I came here, that I am after all fairly strong. That I need not despair of reaching the age which is necessary for producing a life's

[1] The physician at Eindhoven.

work. I told him that I knew of several painters who, not-withstanding all their nervousness etc., reached the age of sixty or even seventy, luckily for themselves, and that I should like to do the same.

Then I think that if one keeps one's serenity and good spirits, the mood in which one is acts as a great help. In that respect I have gained by coming here, for I have got new ideas and I have new means of expressing what I want, because better brushes will help me, and I am crazy about those two colours, carmine and cobalt.

Cobalt is a divine colour, and there is nothing so beautiful for putting atmosphere around things. Carmine is the red of wine, and it is warm and lively like wine.

The same with emerald-green. It is bad economy not to use these colours, the same with cadmium.

Something about my constitution which made me very glad was what a doctor in Amsterdam told me, whom I consulted once about a few things which sometimes made me fear that I was not going to last out for long, and whose opinion I did not ask straight out, but just to know the first impression of somebody who absolutely did not know me. This was the way of it, profiting from a small complaint I had then, in the course of conversation I alluded to my constitution in general—how glad I was that this doctor took me for an ordinary working man and said : " I suppose you are an iron-worker." This is just what I have tried to change in myself; when I was younger, I looked like one who was intellectually overwrought, and now I look like a bargee or an ironworker.

And to change one's constitution so that one gets " tough-skinned " is no easy matter.

But I must be careful nonetheless, and try to keep what I have, and gain in strength.

I want you above all to write me if the idea seems so absurd to you that one would gain in courage if one planted the germ of a business of one's own?

As to my work at present, I feel that I can do better; however, I need some more space and air, I mean—I ought to

be able to spend a little more. Above all, above all I cannot take in sufficient models. I could produce work of a better quality, but my expenses would be heavier. But is it not true that one needs to aim at something lofty, something true, of some distinction?

The women's figures which I see here among the people give me a tremendous urge, much more to paint them than to possess them, though indeed I should like both.

I read over again the book by de Goncourt. It is excellent. The preface to " Chérie ", which you will read, tells the story of what the de Goncourts went through, and how at the end of their lives they were melancholy, yes, but felt sure of themselves, knowing that they had *accomplished* something, that their work would remain. What fellows they were. If we thought more alike than we do now, if we could agree absolutely, why should not we *do the same*?

By the way, because I shall have in any case at the end of this year four or five days of absolute fast in everything, do send your letter on the first of January and not later. Perhaps you will not be able to understand, but it is true that when I receive the money my greatest appetite is not for food, though I have fasted, but the appetite for painting is stronger still, and I set out at once to hunt for models, and continue until all the money is gone. While all I have to live on is my breakfast from the people with whom I lodge, and in the evening for supper a cup of coffee and bread in the dairy, or else a loaf of rye that I have in my trunk.

As long as I am painting it is more than sufficient, but when the models have left there comes a feeling of weakness.

I am attached to the models here, because they are so different from the models in the country. And especially because their character is so entirely different, and the contrast gives me new ideas, especially for the flesh-colours. And what I have now arrived at in the last head I painted, though it is not yet such that I am satisfied with it, remains different from the former heads.

I know that you are convinced enough of the importance of being *true,* so that I can speak out freely to you.

If I paint peasant women I want them to be peasant women; for the same reason, if I paint harlots I want a harlot-like expression.

That was why a harlot's head by Rembrandt struck me so enormously. Because he had caught so infinitely beautifully that mysterious smile, with a gravity such as only he possesses, the magician of magicians.

This for me is a new thing, and it is essentially what I want. Manet has done it, and Courbet, damn it, I have the same ambition; besides, I have felt too strongly in bone and marrow the infinite beauty of the analyses of women by the very great men in literature, a Zola, Daudet, de Goncourt, Balzac.

Even Stevens does not satisfy me, because his women are not those I know personally. And those he chooses are not the most interesting, I think. Well, however that may be—I want to get on at all costs—and I want to be myself.

I feel quite obstinate, and I do not care any more what people say about me or about my work.

It seems very difficult here to get models for the nude, at least the girl I painted refused.

Of course that "refused" is perhaps merely relative, but at least it would not be easy, though I must say she would be splendid. From a business point of view I can only say that we are already in what is beginning to be termed the "end of a century," that women have a charm of the same kind as in a time of revolution—in fact have as much prestige—and one would be outside the trend if one kept them outside one's work.

It is everywhere the same, in the country as well as in the city; one must take the women into account if one wants to be up-to-date.

Goodbye, good wishes for the New Year. With a handshake,

Yours,
Vincent

Dear Theo, [Antwerp, January 1886]

I decidedly want to tell you that it would greatly alleviate me if you would approve of my coming to Paris much earlier than June or July. The more I think about it the more anxious I am to do so.

Just think that if all goes well, and if I had good food, etc., all that time, which will certainly leave something to be desired, even in that case it will take about six months before I shall have fully recovered.

But it would certainly take much longer still, if in Brabant from March to July I had to go through the same things as I have undergone these last months, and probably it would not be any different.

Now, at this moment, I feel terribly weak, even worse than that, from reaction after overwork, but that is the natural course of things and nothing extraordinary; as however it is a question of taking better nourishment, etc., you see that in Brabant I shall drain myself of money again by taking models; the same story will begin all over again, and I do not think that will be right. In that way we stray from our path. So please allow me to come sooner, I should almost say at once.

If I rent a garret in Paris, and bring my paint box and drawing materials with me, then I can finish at once what is most pressing—those studies from the antique, which will certainly help me a great deal when I go to Cormon's.[1] I can go and draw either at the Louvre or at the École des Beaux Arts.

For the rest, before settling in a new place, we could plan and arrange matters so much better. If it must be, I am willing to go to Nuenen for the month of March, to see how things are there and how the people are and whether or not I can get models there. But if there is no such need, as I presume, I should come straight to Paris after March, and begin to draw at the Louvre, for instance.

I have thought over well what you wrote about taking a studio, but I think it would be a good thing if we looked for it

[1] The artist in whose studio in Paris Vincent was to take lessons.

together, and if before we went to live together definitely, we did so temporarily, and if I began by renting a garret, from April for instance, till June.

I shall then feel at home again in Paris by the time I go to Cormon's.

And in this way I shall keep up my spirits better.

I must also tell you that, although I keep going there, it is often almost unbearable, that nagging of the people at the academy, for they remain decidedly spiteful.

But I try systematically to avoid all quarrels, and go my own way. And I fancy I am on the track of what I am seeking, and perhaps I should find it the sooner if I could go my own way over the drawing from plaster casts.

I am glad after all that I went to the academy, for the very reason that I have abundant opportunity to observe the results of *prendre par le contour*.[1]

For that is what they do systematically, and that is why they nag at me. "Faites d'abord un contour, votre contour n'est pas juste, je ne corrigerai pas ça, si vous modelez avant d'avoir sérieusement arrêté votre contour."[2]

You see how it always ends in the same fashion. And now you ought to see how flat, how lifeless and how insipid the results of that system are; oh, I can tell you I am very glad just to see it once at close quarters. Like David, or worse still, like Pieneman in full vigour. I wanted at least twenty-five times to say, "Votre contour est un truc, etc.,"[3] but I have not thought it worth while to quarrel. Yet though I do not say anything, I irritate them, and they me.

But this does not matter so much, the task is to go on trying to find a better working-system. So—patience and perseverance.

They go so far as to say, "La couleur et le modelé c'est peu

[1] " proceeding from the contour "
[2] " First make a contour, your contour is not correct, I will not correct your work, if you insist on modelling before you have seriously determined your contour."
[3] " To hell with your contour "

de chose, cela s'apprend très vite, c'est le contour qui est l'essentiel et le plus difficile."[1]

You see, one can learn something new at the academy. I never knew before that colour and modelling came so easily.

I finished just yesterday the drawing which I made for the competition of the evening class. It is the figure of Germanicus[2] which you know. Well, I am sure I shall come out bottom, because all the drawings of the others are utterly alike, and mine is absolutely different. But that drawing which they will think the best, I have seen how it was done. I was sitting just behind it and it is correct, it is whatever you like, but it is *dead,* and that is what all the drawings are which I saw.

Enough of this, but let it irritate us so much that it makes us enthusiastic for something nobler, and that we hasten to reach this.

You, too, need more vitality in your life, and if we might succeed in joining up, together we would know more than each apart, and would be able to do more.

Tell me, did you notice that subtle saying of Paul Mantz's: "Dans la vie les femmes sont peut-être la difficulté suprême."[3] It was in an article on Baudry.

We shall experience our share of it, besides the experience we may already have acquired.

It struck me in a chapter from "L'Œuvre," by Zola, printed in the Gil Blas, that the painter, Manet of course, had a scene with a woman who had posed for him, and afterwards he had become indifferent to her, oh—curiously well described. What one can learn in this respect from the academy here is never in that light to paint women.

They hardly ever use nude women models. At least not at all in the class, and only most exceptionally in private.

[1] "Colour and modelling matter very little, they can be picked up very fast; it is the contour that is essential and most difficult."

[2] The task was to make a drawing after a plaster cast of this famous Roman statue.

[3] "In life women probably present the supreme difficulty."
L.V.G.

Even in the antiquities class there are ten men's figures to one woman's figure. That is easy enough.

In Paris, of course, this will be better, and it seems to me that, in fact, one learns so much from the constant comparing of the masculine figure with the feminine, which are always and in everything so totally different. It may be " supremely " difficult, but what would art and what would life be without it?

Goodbye, write to me soon. With a handshake,

Yours,

Vincent

My being in Nuenen at least for the month of March would only be for the sake of the moving, and I have to be there anyhow for my change of domicile. But as to myself, I am quite willing not to go back there at all.

PARIS

Dear old boy, [Paris, summer 1887)][1]

Thank you for your letter and what it contained. It depresses me to think that even when it's a success, painting never pays back what it costs.

I was touched by what you wrote about home—" They are fairly well but still it is sad to see them." A dozen years ago one would have sworn that at any rate the family would always prosper and get on. It would give great pleasure to Mother if your marriage came off, and for the sake of your health and your work you ought not to remain single.

As for me—I feel I am losing the desire for marriage and children, and now and then it saddens me that I should be feeling like that at thirty-five just when it should be the opposite. And sometimes I have a grudge against this rotten painting. It was Richepin who said somewhere:

" The love of art means loss of real love"

(*L'amour de l'art fait perdre l'amour vrai.*)

I think that is terribly true, but on the other hand real love makes you disgusted with art.

And at times I feel already old and broken, and yet still enough of a lover not to be a real enthusiast for painting. To succeed one must have ambition, and ambition seems to me absurd. What will come of it I don't know; I would like above all things to be less of a burden to you—and that is not impossible in the future—for I hope to make such progress that you will be able to show my stuff boldly without compromising yourself.

[1] Vincent was in Paris for almost two years—March 1886 to February 1888—but the fact that he was living with Theo there meant that he wrote very few letters to his brother at this period. Indeed, it is for this very reason that the Paris period is the phase in Vincent's career about which least is known by way of exact detail.

And then I will take myself off somewhere down south,[1] to get away from the sight of so many painters that disgust me as men.

You can be sure of one thing, that I will not try to do any more work for the Tambourin.[2] I think besides that it is going into other hands, and I certainly shall not try to stop it.

As for the Segatori, that's very different. I still have some affection for her and I hope she still has some for me.

But just now she is in a bad way; she is neither a free agent nor mistress in her own house, and worst of all she is ill and in pain.

Although I would not say this openly, my own conviction is that she has procured an abortion (unless indeed she has had a miscarriage), but anyway in her position I should not blame her. In two months' time she will be better, I hope, and then perhaps she will be grateful that I did not bother her. Once she is well, mind you, if she refuses in cold blood to give me what belongs to me, or does me any wrong I shall not spare her—but that will not be necessary. I know her well enough to trust her still. And mind you, if she manages to keep her place going, from the point of view of business I should not blame her for choosing to be top dog, and not underdog. If in order to get on she tramples on my toes a bit, well, she has my leave. When I saw her again she did not trample on my heart, which she would have done if she had been as bad as people said.

I saw Tanguy[3] yesterday, and he has put a canvas I've just done in his window. I have done four since you left, and I have a big one on hand.

I know that these big long canvases are difficult to sell, but

[1] This idea would finally be put into effect some eight months later, when Vincent left for Arles.

[2] A café in Montmartre where Vincent had exhibited some of his work; he had also done some pictures for the decoration of the interior and these the concern had refused to give back after it went bankrupt. La Segatori was the proprietress.

[3] The owner of a shop which dealt in colours and also took pictures for possible sale; it was a great meeting-place for artists.

later on people will see that there is open air in them and
that they are good-humoured.

So now the whole lot would do for decorations for a dining-
room, or a country house.

And if you fall very much in love, and then get married, it
doesn't seem to me out of the question that you will rise to a
country house yourself some day, like so many other picture
dealers. If you live well you spend more, but you gain
more ground that way, and perhaps one gets on better these
days by looking rich than by looking shabby. It's better to
have a gay life of it than commit suicide. Remember me to
all at home.

 Yours,
 Vincent

ARLES

My dear Theo, [Arles, early March 1888]

This morning, at long last, the weather changed and turned milder—and likewise I have already had an opportunity for learning what a mistral is: I have been for several walks in the country round here but in this wind it is impossible ever to do anything. The sky is a hard blue with a great bright sun, which has melted almost the whole bulk of the snow, but the wind is cold and so dry that it gives you goose-flesh.

But all the same I have seen lots of beautiful things—a ruined abbey on a hill covered with holly, pines, and grey olives.[1]

We'll have a try at that soon, I hope.

I have just finished a study like the one Lucien Pissarro has of mine, but this time it is oranges. That makes eight studies so far. But this doesn't really count, because I haven't yet been able to work in any comfort or warmth. The letter from Gauguin which I meant to send you, and which I thought for the moment had got burnt with other papers, I have since found, and send it you enclosed.[2] But I have already written direct to him, and sent him Russell's address, also that of Gauguin to Russell, so that if they like they can deal with each other direct.

But how difficult for many of us—and assuredly we ourselves are among the number—the future still is! I firmly believe in victory at the last, but will the artists themselves obtain any advantage from it, and will they see less troubled days?

I have bought some coarse canvas here, and had it pre-

[1] The abbey of Montmajour, a few miles outside Arles.

[2] Gauguin had written from Brittany that he was ill and in desperate financial straits; he wanted Vincent to try and get help for him from Theo, who was his dealer at the time. John Russell was an Australian artist-friend who might, in Vincent's view, be able to help Gauguin.

pared for mat effects. I can get everything now almost at
the same prices as in Paris. Saturday evening I had a visit
from two amateur artists, a grocer who sells painting materials
as well, and a magistrate who seems a nice fellow, and intel-
ligent.

Worse luck, I can hardly manage to live any cheaper than
in Paris, I must reckon on 5 fr. per day.

I have not yet found any sort of small place where I could
have private board and lodging, but all the same something
of the kind must exist.

If the weather is milder in Paris too, it will do you good.
What a winter! I dare not roll up my studies yet because
they are hardly dry and there are some bits of impasto which
will take some time to dry.

I have just been reading "Tartarin on the Alps"[1] which
amused me hugely. Has that confounded Tersteeg written to
you yet? All to the good if he has. If he doesn't answer he
will hear of us all the same, and we shall see to it that he can
find no fault with our actions. For instance we will send a
picture to Mme. Mauve in memory of Mauve,[2] with a letter
from both of us, in which, supposing Tersteeg does not reply,
we shall not say a word against him, but we will manage to
convey that we do not deserve to be treated as if we were
dead.

But indeed it is not likely that Tersteeg will have any pre-
judice against us on the whole. Poor Gauguin has no luck.
I am very much afraid that in his case convalescence will last
even longer than the fortnight which he has had to spend in
bed.

My God! Will we ever see a generation of artists with
healthy bodies! Sometimes I am perfectly furious with my-
self, for it isn't good enough to be neither more nor less ill
than the rest; the ideal would be a constitution tough enough

[1] The sequel by Alphonse Daudet to "Tartarin de Tarascon."
Arles was in fact right in the Tartarin country.

[2] The artist who had given Vincent lessons in The Hague had just
died; Vincent sent one of his *Orchards in Blossom* to the widow.

to live till eighty, and besides that blood in one's veins that would be right good blood.

It would be some comfort, however, if one could think that a generation of more fortunate artists was to come.

I wanted to write to you at once that I am in hopes the winter is really over, and I hope that it is the same in Paris.

With a handshake,

Yours,
Vincent

My dear Theo, [Arles, first half of April 1888]
Thank you for your letter and the 100 franc note enclosed. I have sent you sketches of the pictures which are to go to Holland. Of course the painted studies are more brilliant in colour. I'm once again hard at it, still orchards in blossom.

The air here certainly does me good. I wish you could fill your lungs with it; one effect it has on me is comical enough; one small glass of brandy makes me tipsy here, so that as I don't have to fall back on stimulants to make my blood circulate, there will be less strain on my constitution. The only thing is that my stomach has been terribly weak since I came here, but after all that's probably only a matter of time. I hope to make progress this year, and indeed I greatly need to.

I have a fresh orchard, as good as the rose-coloured peach trees, apricot trees of a very pale rose. At the moment I am working on some plum trees, yellowish-white, with thousands of black branches. I am using a tremendous lot of colours and canvases, but I hope it isn't a waste of money all the same. Out of four canvases perhaps one at the most will make a *picture*, like the one for Tersteeg or Mauve, but the studies, I hope, will come in useful for exchanges.

When can I send you anything? I have a great mind to do a second version like Tersteeg's, because it is better than the Asnières[1] studies.

Yesterday I saw another bull fight, where five men played

[1] A locale where Vincent had painted while in Paris.

the bull with darts and cockades. One toreador crushed a
testicle jumping the barricade. He was a fair man with grey
eyes and plenty of sang-froid; people said he'll be ill long
enough. He was dressed in sky blue and gold, just like the
little horseman in our Monticelli, the three figures in a wood.
The arenas are a fine sight when there's sunshine and a crowd.

Bravo for Pissarro, I think he is right. I hope he will make
an exchange with us some day.

And Seurat the same. It would be a good thing to have a
study painted by him.

Well, I'm working hard, hoping that we can do something
with things of this kind.

This month will come hard on both you and me, but if
you can manage it will be to our advantage to make the most
we can of the orchards in bloom. I am well started now, and
I think I must have ten more, the same subject. You know I
am changeable in my work, and this craze for painting
orchards will not last for ever. After this it may be the
arenas. Then I must do a *tremendous* lot of drawing, because
I want to make some drawings in the manner of Japanese
prints. I can only go on striking for as long as the iron is
hot.

I shall be all in when the orchards are over, for they are
canvases of sizes 25 and 30 and 20. We would not have
too many of them, even if I could bring off twice as many.
It seems to me that this might really break the ice in Holland.
Mauve's death was a terrible blow to me. You will see that
the rose-coloured peach trees were painted with a certain
passion.

I must also have a starry night with cypresses,[1] or per-
haps surmounting a field of ripe corn; there are some wonder-
ful nights here. I am in a continual fever of work.

I'm very curious to know what the result will be at the end

[1] Vincent was not in fact to paint this subject until he was at
Saint-Rémy in June 1889, but meanwhile in September 1888 he
painted the Rhône under a starry night sky. Such a sky symbolised for
him God's beneficent and eternal surveillance of the universe—prob-
ably under the inspiration of the poetry of Walt Whitman; the
cypresses, as graveyard trees, were a symbol of death.

of a year. I hope that by that time I shall be less bothered with sick turns. At present I am pretty bad some days, but I don't worry about it in the least, as it is nothing but the reaction after last winter which was out of the ordinary. And my blood is coming right, that is the great thing.

I must reach the point when my pictures will cover what I spend, and even more than that, taking into account so much spent in the past. Well, it will come. I don't make a success of everything, I admit, but I'm getting on. So far you have not complained of my expenses here, but I warn you that if I continue to work on the same scale, I shall have real trouble ahead of me. But the work is really heavy.

If there should happen to be a month or a fortnight in which you were hard pressed, let me know and I will set to work on some drawings, which will cost us less. I mean you must not put yourself out unnecessarily, there is so much to do here, all sorts of studies, not the way it is in Paris, where you can't sit down wherever you want.

If you can support a rather heavy month so much the better, since orchards in bloom are the kind of thing one has some chance of selling or exchanging.

But it came to my mind that you have to pay your rent, so you must tell me if things are too steep.

I am still going about all the time with the Danish painter,[1] but he is soon going home. He's an intelligent lad, and all right as far as fidelity and manner goes, but his painting is still rather flabby. You will probably see him when he passes through Paris.

You did well to go and see Bernard. If he goes to serve in Algiers, who knows but that I might go there too to keep him company.

Is it at long last really over, this winter in Paris? I think what Kahn[2] said is very true, that I have not sufficiently considered values, but they'll be saying very different things in a little while—and no less true.

[1] Mourier Petersen.
[2] Gustave Kahn, an art-critic writing for some of the independent Parisian reviews.

It isn't possible to get values and colour.

Th. Rousseau did it better than anyone else, and with the mixing of his colours, the darkening caused by time has increased and his pictures are now unrecognizable.

You can't be at the pole and the equator at the same time.

You must choose your line, as I hope to do, and it will probably be colour. Goodbye for the present. A handshake to you, Koning[1] and the crowd.

Vincent

[Saintes-Maries-sur-Mer, second half of June 1888]
My dear Theo,

I am writing to you from Stes. Maries on the shore of the Mediterranean at last. The Mediterranean has the colouring of mackerel, changeable I mean. You don't always know if it is green or violet, you can't even say it's blue, because the next moment the changing reflection has taken on a tinge of rose or grey.

A family is a queer thing—quite involuntarily and in spite of myself I have been thinking here between whiles of our sailor uncle, who must many a time have seen the shores of this sea.

I brought along canvases and have covered them—two seascapes, a view of the village, and then some drawings which I will send you by post, when I return to-morrow to Arles.

I have board and lodging for 4 francs a day, although they began by asking 6.

As soon as I can I shall probably come back here again to make some more studies.

The shore here is sandy, no cliffs nor rocks—like Holland without the dunes, and bluer.

You get better fried fish here than on the Seine. Only there is not fish to be had every day, as the fishermen go off to sell it at Marseilles. But when there is some it is frightfully good.

If there isn't—the butcher is not much more appetising

[1] A Dutch artist-friend whom Theo had staying.

than the butcher fellah of M. Gérôme—if there is no fish it is pretty difficult to get anything to eat, as far as I can see.

I do not think there are 100 houses in the village, or town. The chief building, after the old church and an ancient fortress, is the barracks. And the houses—like the ones on our heaths and peat-mosses at Drenthe; you will see some specimens of them in the drawings.

I am forced to leave my three painted studies here, for they are naturally not dry enough to be submitted with safety to five hours' jolting in the carriage.

But I expect to come back here again.

Next week I would like to go to Tarascon to do two or three studies.

If you have not written yet I shall naturally expect the letter at Arles. A very fine gendarme came to interview me here, and the curé too—the people can't be very bad here, because even the curé looked almost like a decent fellow.

Next month it will be the season for open air bathing here. The number of bathers varies from 20 to 50. I am staying till to-morrow afternoon, I've still some drawings to make.

One night I went for a walk by the sea along the empty shore. It was not gay, but neither was it sad—it was—beautiful. The deep blue sky was flecked with clouds of a blue deeper than the fundamental blue of intense cobalt, and others of a clearer blue, like the blue whiteness of the Milky Way. In the blue depth the stars were sparkling, greenish, yellow, white, rose, brighter, flashing more like jewels, than they do at home—even in Paris: opals you might call them, emeralds, lapis, rubies, sapphires.

The sea was very deep ultramarine—the shore a sort of violet and faint russet as I saw it, and on the dunes (about seventeen feet high they are) some bushes of Prussian blue. Besides half-page drawings I have a big drawing, the companion to the last one.

Goodbye for the present only, I hope, with a handshake,

Yours,

Vincent

My dear Theo, [Arles, mid July 1888]
 I have come back from a day at Mont Majour, and my
friend the second lieutenant was with me. We explored the
old garden together and stole some excellent figs. If it had
been bigger it would have made me think of Zola's Paradou,
great reeds, vines, ivy, fig trees, olives, pomegranates with
lusty flowers of the brightest orange, hundred-year-old
cypresses, ash trees and willows, rock oaks, half-broken flights
of steps, ogive windows in ruins, blocks of white rock covered
with lichen, and scattered fragments of crumbling walls here
and there among the greenery. I brought back another big
drawing, but not of the garden. That makes three drawings.
When I have half a dozen I shall send them along.
 Yesterday I went to Fontvieilles to visit Bock and
McKnight,[1] only these gentlemen had gone on a little trip to
Switzerland for a week.
 I think the heat is still doing me good, in spite of the mos-
quitoes and flies.
 The grasshoppers—not like ours at home, but of this sort,[2]
like those you see in Japanese albums, and Spanish flies, gold
and green in swarms on the olives. The grasshoppers (I think
they are called cicadas) sing as loud as a frog.
 I have been thinking too that when you remember that I
painted old Tanguy's portrait, and that he also had the portrait
of his old lady (which they have sold), and of their friend (it
is true that I got 20 francs from him for this latter portrait),
and that I have bought without discount 250 francs' worth of
paints from Tanguy, on which naturally he made something,
and finally that I have been his friend no less than he has
been mine, I have very serious reason to doubt his right to
claim money from me; and it really is squared by the study he
still has of mine, all the more so because there was an express
arrangement that he should pay himself by the sale of a
picture.

[1] Two artist friends, one Belgian and the other American.
[2] A sketch was included here.

Xantippe,[1] Mother Tanguy, and some other good ladies have by some queer freak of Nature heads of silex or flint. Certainly these ladies are a good deal more dangerous in the civilized world they go about in than the poor souls bitten by mad dogs who live in the Pasteur Institute. And old Tanguy would be right a hundred times over to kill his lady . . . but he won't do it, any more than Socrates.

And for this reason old Tanguy has more in common—in resignation and long suffering anyhow—with the ancient Christians, martyrs and slaves, than with the present day rotters of Paris.

That does not mean that there is any reason to pay him 80 francs, but it is a reason for never losing your temper with him, even if he loses his, when, as you may do in this instance, you chuck him out, or at least send him packing.

I am writing to Russell at the same time. I think we know, don't we, that the English, the Yankees, etc. have this much in common with the Dutch, that their charity . . . is very Christian. Now, the rest of us not being very good Christians. . . . That's what I can't put out of my head writing again like this.

This Bock has a head rather like a Flemish gentleman of the time of the Compromise of the Nobles, William the Silent's time and Marnix's. I shouldn't wonder if he's a decent fellow.

I have written to Russell that I would send him my parcel in a roll direct to him, for our exchange, if I knew that he was in Paris.

That means he must in any case answer me soon. Now I shall *soon* need some more canvas and paints. But I have not yet got the address of that canvas at 40 francs for 20 metres.

I think it is well to work especially at drawing just now, and to arrange to have paints and canvas in reserve for when Gauguin comes.[2] I wish paint was as little of a worry to

[1] The wife of Socrates.
[2] The plan had now been mooted that Gauguin should join Vincent at Arles.

work with as pen and paper. I often pass up a painted study
for fear of squandering the colour.

With paper, whether it's a letter I'm writing, or a drawing
I'm working on, there's never a misfire—so many pages of
Whitman, so many drawings. I think that if I were rich I
should spend less than I do now.

Well, old Martin would say, then it's up to you to get
rich, and he is right, as he is about the masterpiece.

Do you remember in Guy de Maupassant the gentleman
who hunted rabbits and other game, and who had hunted so
hard for ten years, and was so exhausted by running after the
game that when he wanted to get married he found he was
impotent, which caused the greatest embarrassment and con-
sternation. Without being in the same state as this gentleman
as to its being either my duty or my desire to get married, I
begin to resemble him in physique. According to the worthy
Ziem, man becomes ambitious as soon as he becomes im-
potent. Now though it's pretty much all one to me whether I
am impotent or not, I'm damned if that's going to drive me to
ambition. It is only the greatest philosopher of his place and
time, and consequently of all places and all times, good old
master Pangloss,[1] who could—if he were here—give me
advice and steady my soul.

There—Russell's letter is in its envelope, and I have
written as I intended.

I asked him if he had any news of Reid, and I ask you the
same question.

I told Russell I left him free to take what he liked, and
from the first lot I sent as well. And that I was only waiting
for his explicit answer, to know whether he preferred to make
his choice at his or your place; that if, in the former circum-
stance, he wanted to see them at his own house, you would
send him along some orchards as well, and fetch the lot back
again when he had made his choice. So he cannot quarrel
with that. If he takes nothing from Gauguin it is because he
cannot. If he can I am inclined to anticipate that he will;
I told him that if I ventured to press him to buy, it was *not*

[1] The optimist in Voltaire's *Candide*.

because nobody else would if he didn't, but because Gauguin having been ill, and with the further complication of his having been laid up in bed and having to pay his doctor, it all fell rather heavily on us, and we were all the more anxious to find a purchaser for a picture.

I am thinking a lot about Gauguin, and I would have plenty of ideas for pictures, and about work in general.

I have a charwoman now for one franc, who sweeps and scrubs the house[1] for me twice a week. I am banking very much on her, reckoning that she will make our beds if we decide to sleep in the house. Otherwise we could make some arrangement with the fellow where I am staying now. Anyhow we'll try to manage so that it would work out as an economy instead of more expense. How are you now? Are you still going to Gruby?[2] What you tell me of the conversation at the Nouvelle Athènes is interesting. You know the little portrait by Desboutin that Portier has?

It certainly is a strange phenomenon that all the artists, poets, musicians, painters, are unfortunate in material things —the happy ones as well—what you said lately about Guy de Maupassant is a fresh proof of it. That brings up again the eternal question : is the whole of life visible to us, or isn't it rather that this side death we see one hemisphere only?

Painters—to take them only—dead and buried, speak to the next generation or to several succeeding generations through their work.

Is that all, or is there more besides? In a painter's life death is not perhaps the hardest thing there is.

For my own part, I declare I know nothing whatever about it, but to look at the stars always makes me dream, *as simply* as I dream over the black dots of a map representing towns and villages. Why, I ask myself, should the shining dots of the sky not be as accessible as the black dots on the map of

[1] Vincent had moved to the "Yellow House" in Place Lamartine in May, first using it for a studio where he also slept, and later starting to furnish it as the living- and working-quarters for himself and a companion.

[2] Theo's physician.

France? If we take the train to get to Tarascon or Rouen, we take death to reach a star. One thing undoubtedly true in this reasoning is this, that while we are *alive* we *cannot* get to a star, any more than when we are dead we can take the train.

So it seems to me possible that cholera, gravel, phthisis and cancer are the celestial means of locomotion, just as steamboats, omnibuses and railways are the terrestrial means. To die quietly of old age would be to go there on foot.

Now I am going to bed, because it is late, and I wish you good night and good luck.

A handshake.

<div style="text-align: right">

Yours,
Vincent

</div>

My dear Theo, [Arles, early August 1888]
I think you were right to go to our uncle's funeral, since Mother seemed to be expecting you. The best way to tackle a death is to swallow the image of the illustrious dead, whatever he was, as the best man in the best of all possible worlds, where everything is always for the best. Which not being contested, and consequently incontestable, it is doubtless allowable for us to return afterwards to our own affairs. I am glad that our brother Cor has grown bigger and stronger than the rest of us. And he must be stupid if he does not get married, for he has nothing but that and his hands. With that and his hands, and that and what he knows of machinery, I for one would like to be in his shoes, if I had any desire at all to be anyone else.

And meanwhile I am in my own hide, and my hide within the cog-wheels of the Fine Arts, like corn between the millstones.

Did I tell you that I had sent the drawings to friend Russell? At the moment I am doing practically the same ones again for you, there will be twelve likewise. You will then see better what there is in the painted studies in the way of drawing. I have already told you that I always have to fight against the mistral, which makes it absolutely impossible to

be master of your stroke. That accounts for the " haggard " look of the studies. You will tell me that instead of drawing them, I ought to paint them again on fresh canvases at home. I think so myself now and then, for it is not my fault in this case that the execution lacks a livelier touch. What would Gauguin say about it if he were here, would he advise seeking a more sheltered place?

I now have another unpleasant thing to tell you about the money, which is that I shall *not* manage this week, because this very day I am paying out 25 frs.; I shall have money for five days, but *not* for seven. This is Monday; if I get your next letter on Saturday morning there will be no need to increase the enclosure. Last week I did not one only but two portraits of my postman,[1] a half-length with the hands, and a head, life size. The good fellow, as he would not accept money, *cost more* eating and drinking with me, and I gave him besides the " Lantern " of Rochefort. But that is a trifling and immaterial evil, considering that he posed very well, and that I expect to paint his baby very shortly, for his wife has just been brought to bed.

I will send you, at the same time as the drawings that I have in hand, two lithographs by de Lemud, " Wine " and " The Café "; in " Wine " there is a sort of Mephistopheles, rather reminiscent of C.M.[2] when younger, and in " The Café . . ." it is Raoul exactly, you know that old Bohemian student type, whom I knew last year. What a talent that de Lemud had, like Hoffman or Edgar Poe.

And yet he is one who is little talked of. Perhaps you will not care tremendously for these lithographs at first, but it is just when you look at them for a long time that they grow on you. I have come to the end both of paints and canvas and I have already had to buy some here. And I must go back for still more.

So please do send the letter so that I'll have it on Saturday

[1] Roulin; in December Vincent would do portraits of the whole family.

[2] Vincent's uncle Cornelius.

morning. Today I am probably going to begin the interior of the Café where I eat, by gas light, in the evening.

It is what they call here a Café de Nuit (they are fairly frequent here), staying open all night. "Night prowlers" can take refuge there when they have no money to pay for a lodging, or are too tight to be taken in. All those things— family, native land—are perhaps more attractive in the imaginations of such people as us, who pretty well do without native land or family either, than they are in reality. I always feel I am a traveller, going somewhere and to some destination.

If I tell myself that the somewhere and the destination do not exist, that seems to me very reasonable and likely enough.

The brothel keeper, when he kicks anyone out, has similar logic, argues as well, and is always right, I know. So at the end of my course I shall find my mistake. Be it so. I shall find then that not only the Arts, but everything else as well, were only dreams, that one's self was nothing at all. If we are as *flimsy as that,* so much the better for us, for then there is nothing against the unlimited possibility of future existence. Whence comes it that, in the present instance of our uncle's death, the face of the dead was calm, peaceful, and grave, while it is a fact that while living he was scarcely like that, either in youth or age. I have often observed a like effect as I looked at the dead as though to question them. And that for me is *one* proof, though not the most serious, of a life beyond the grave.

And in the same way a child in the cradle, if you watch it at leisure, has the infinite in its eyes. In short, I know nothing about it, but it is just this feeling of *not knowing* that makes the real life we are actually living now like a one-way journey in a train. You go fast, but cannot distinguish any object very close up, and above all you do not see the engine.

It is rather curious that Uncle as well as Father believed in the future life. Not to mention Father, I have several times heard Uncle arguing about it.

Ah—but then, they were more assured than us, and were affirmers who got angry if you dared to go deeper.

Of the *future* life of artists *through their works* I do not think much. Yes, artists perpetuate themselves by handing on the torch, Delacroix to the impressionists, etc. But is that all?

If the kind old mother of a family, with ideas that are pretty well limited and tortured by the Christian system, is to be immortal as she believes, and seriously too—and I for one do not gainsay it—why should a consumptive or neurotic cab horse like Delacroix and de Goncourt, with broad ideas, be any less immortal?

Granted that it seems just that the most destitute should feel the most the springing of this unaccountable hope.

Enough. What is the good of worrying about it? But living in the full tide of civilization, of Paris, of the Arts, why should not one keep this " I " of the old women, if women themselves without their instinctive belief that " *so it is,*" would not find strength to create or to act?

Then the doctors will tell us that not only Moses, Mahomet, Christ, Luther, Bunyan and others were mad, but also Frans Hals, Rembrandt, Delacroix, and also all the dear narrow old women like our mother.

Ah—that's a serious matter—one might ask these doctors; where then are the sane people?

Are they the brothel keepers who are always right? Probably. Then what to choose? Fortunately there is no choice.

With a handshake.

Yours,
Vincent

My dear Theo, [Arles, mid August 1888]

You are shortly to make the acquaintance of Master Patience Escalier, a sort of " man with a hoe," formerly cowherd of the Camargue, now gardener at a house in the Crau. This very day I am sending you the drawing I have done after this painting, and also the drawing after the portrait of Roulin the postman. The colouring of this peasant portrait is not so black as in the " Potato Eaters " of Nuenen, but our highly civilized Parisian *Portier*—probably so called because

he chucks pictures out[1]—will find himself blocked by the same old thing. You have changed since then, but you will see that he has not, and it really is a pity that there are not more *sabot* pictures[2] in Paris. I do not think it would be an affront to the Lautrec you have to put my peasant beside it, and I even am bold enough to hope that the Lautrec would show up still more distinguished in the simultaneous contrast, and that mine would gain by the odd juxtaposition, because that sun-steeped, sun-burnt quality, tanned and swept with air, would show up more beside that rice powder and elegance.

What a mistake that Parisians have not acquired a palate for crude things, for Monticellis, for earthenware. But there, one must not lose heart because Utopia is not coming true. It is only that what I learnt in Paris *is leaving me*, and that I am returning to the ideas I had in the country before I knew the impressionists. And I should not be surprised if the impressionists soon find fault with my way of working, for it has been fertilized by the ideas of Delacroix rather than by theirs. Because, instead of trying to reproduce exactly what I have before my eyes, I use colour more arbitrarily so as to express myself forcibly. Well, let that be as a matter of theory, but I am going to give you an example of what I mean.

I should like to paint the portrait of an artist friend,[3] a man who dreams great dreams, who works as the nightingale sings, because it is his nature. He'll be a fair man. I want to put into the picture my appreciation, the love that I have for him. So I paint him as he is, as faithfully as I can, to begin with.

But the picture is not finished yet. To finish it I am now going to be the arbitrary colourist. I exaggerate the fairness of the hair, I get to orange tones, chromes and pale lemon yellow.

Beyond the head, instead of painting the ordinary wall of

[1] The pun is based on the fact that *portier* means *doorman*.

[2] i.e. pictures of peasants in their working attire.

[3] This idea was to produce the *Poet* of early September, for which Bock served as the model.

the mean room, I paint infinity, a plain background of the richest, intensest blue that I can contrive, and by this simple combination the bright head illuminated against a rich blue background acquires a mysterious effect, like a star in the depths of an azure sky.

In the portrait of the peasant I again worked in this way, but without wishing in this case to evoke the mysterious brightness of a pale star in the infinite. Instead, I think of the man I have to paint, terrible in the furnace of the full ardours of harvest, at the heart of the south. Hence the orange shades like storm flashes, vivid as red hot iron, and hence the luminous tones of old gold in the shadows.

Oh, my dear boy . . . and the nice people will only see the exaggeration as caricature.

But what has that to do with us, we have read *La Terre* and *Germinal*,[1] and if we are painting a peasant we would like to show that what we have read has come in the end very near to being part of us.

I do not know if I can paint the postman *as I feel him,* this man is like old Tanguy in so far as he is revolutionary, he is probably thought a good republican because he whole-heartedly detests the republic which we now enjoy, and because by and large he begins to doubt, to be a little dis-illusioned, as to the republican principle itself.

But I once watched him sing the *Marseillaise,* and I thought I was watching '89, not next year, but that of 99 years ago. It was a Delacroix, a Daumier, a straight old Dutchman.

Unfortunately he is unable to pose, and yet to make a picture you must have an intelligent model.

And now I must tell you that these days, as far as material things go, are cruelly hard. Living, no matter what I do, is pretty dear here, almost like Paris, where you can spend 5 or 6 francs a day and have very little to show for it.

If I have models, I suffer for it a good deal. But it does not matter, and I am going to continue. And I can assure you that if you happened to send me a little extra money some-times, it would benefit the pictures, but not me. The only

[1] Works by Zola.

choice I have is between being a good painter and a bad one.
I choose the first. But the needs of painting are like those of
a ruinous mistress, you can do nothing without money, and
you never have enough of it. That is why painting ought to
be done at the public expense, instead of the artists being
overburdened with it.

But there, we had better hold our tongues, because *no one
is forcing us to work,* indifference to painting being on fate's
decree widespread, and by way of being eternal.

Fortunately my digestion is so nearly all right again that I
have lived for three weeks in the month on ship's biscuits with
milk and eggs. It is the blessed warmth that is bringing back
my strength, and I was certainly right in going *at once* to the
south, instead of waiting until the evil was impossible to
remedy. Yes, really, I am as well as other men now, which
I have never been except momentarily at Nuenen for instance,
and it is rather pleasant. By other men I mean something like
the navvies, old Tanguy, old Millet, the peasants. If you are
well you must be able to live on a bit of bread while you are
working all day, and have enough strength to smoke and to
drink your whack at night, that's a necessary part of the thing.
And all the same to feel the stars and the infinite high and
clear above you. Then life is after all almost enchanted. Oh!
those who don't believe in this sun here are real infidels.

Unfortunately along with the good god sun three quarters
of the time there is this devil of a *mistral.*

Saturday's post has gone, damn it, and I never doubted but
I should get your letter. However you see I am not fretting
about it.

With a handshake.

Yours,
Vincent

My dear Theo, [Arles, mid August 1888]
Thank you very much for sending me the canvas and
paints which have just arrived. This time there was 9.80 fr.
carriage to pay, so I shan't go and get them out till I get your

next letter, not having the cash at the moment. But we must make sure that Tasset, who generally pays the bill in advance and does not fail to note the prepayment on his account, has refrained this time. In the same way I paid on the *last but one* consignment 5.60 fr., so if cost of transport was put down on the last bill but one it would be an overcharge. If he had made two separate parcels (usually the cost of carriage is about 3 francs) we should only have had to pay 5.60 fr.

Now if on the 10 metres of canvas I paint only masterpieces half a metre in size and sell them cash down and at an exorbitant price to distinguished connoisseurs of the Rue de la Paix, nothing will be easier than to make a fortune on this consignment.

I think it is likely that we are going to have great heat now without wind, since the wind has been blowing for six weeks. If so, it is a very good thing that I have a supply of paints and canvas, because already I have my eye on half a dozen subjects, especially that little cottage garden I sent you the drawing of yesterday.

I am thinking about Gauguin a lot, and I am sure that in one way or another, whether it is he who comes here, or I who go to him, he and I will like practically the same subjects, and I have no doubt that I could work at Pont-Aven,[1] and on the other hand I am convinced that he would tremendously like the country down here. Well, at the end of a year, supposing he gives you one canvas a month, which would make altogether a dozen per year, he will have made money on it, assuming that during the year he has not incurred any debts and has worked steadily without interruption; certainly he won't have been the loser, while the money which he will have had from us would be largely made good by the economies that will be possible if we set up house in the studio instead of both of us living in cafés. Besides that, provided we keep on good terms and are determined not to quarrel, we shall be in a stronger position as far as reputation goes.

If we each live alone it means living like madmen or criminals, in appearance at any rate, and also a little in reality.

[1] The locale in Brittany where Gauguin was based at the time.

I am happier to feel my old strength returning than I ever thought I could be. I owe this largely to the people of the restaurant where I have my meals at the moment, who really are extraordinary. Certainly I have to pay for it, but it is something you don't find in Paris, that you really do get something to eat for your money.

And I would very much like to see Gauguin here for a good long time.

What Gruby says about the benefit of doing without women and eating well is true, for if your very brain and marrow are going into your work, it is pretty logical not to expend yourself more than you must in love-making. But it is easier to put into practice in the country than in Paris.

The desire for women that you catch in Paris, isn't it somewhat the effect of that very enervation of which Gruby is the sworn enemy, rather than a sign of vigour? So one feels this desire disappearing just at the moment that one is one's self again. The root of the evil lies in the constitution itself, in the fatal weakening of families from generation to generation, and besides that, in one's unwholesome job and the dreary life of Paris. The root of the evil certainly lies there, and there's no cure for it.

I think that when the day comes that you get free of those futile accounts and the absurdly complicated management at Goupil's, you would gain enormously in influence with the collectors; these complicated systems of management are the very devil, and I think that no brain exists, no temperament, whoever the man on the job is, but loses 50% over it. Our uncle was quite right in what he said about it; a big concern with a few men in on it, and not a little concern with a lot in on it. Unluckily for him he was himself caught in the wheels.

This job of working among people so as to make sales is a job that needs observation and coolness. But if you are forced to give too much attention to the books, you lose some of your poise.

I do want to know exactly how you are. Anyway, provided the impressionists produce good stuff and make friends, there

is always the chance and the possibility of a more independent position for you later on. It's a pity that it cannot be from now on.

No letter from Russell yet, but now that he must have got the drawings he is bound to reply.

This restaurant where I am is very queer; it is completely grey; the floor is of grey bitumen like a street pavement, grey paper on the walls, green blinds always drawn, a big green curtain in front of the door which is always open, to stop the dust coming in. Just as it is it is a Velasquez grey—like in the *Spinning Women*—and the very narrow, very fierce ray of sunlight through a blind, like the one that crosses Velasquez's picture, even that is not wanting. Little tables, of course, with white cloths. And behind this room, in Velasquez grey you see the old kitchen, as clean as a Dutch kitchen, with floor of bright red bricks, green vegetables, oak chest, the kitchen range with shining brass things and blue and white tiles, and the big fire a clear orange. And then there are two women who wait, both in grey, a little like that picture of Prévost's you have in your place—you could compare it point for point.

In the kitchen, an old woman and a short, fat servant also in grey, black, white. I don't know if I describe it clearly enough to you, but it's here, and it's pure Velasquez.

In front of the restaurant there is a covered court, paved with red brick, and on the walls wild vine, convolvulus and creepers.

It is the real old Provençal still, while the other restaurants are so much modelled on Paris that *even when they have no kind of concierge whatever,* there's his booth just the same and the notice " Apply to the Concierge!"

It isn't always all vibrant here. Thus I saw a stable with four coffee-coloured cows, and a calf of the same colour. The stable bluish white hung with spiders' webs, the cows very clean and very beautiful, and a great green curtain in the doorway to keep out flies and dust.

Grey again—Velasquez's grey.

There was such quiet in it—the café au lait and tobacco

colour of the cows' hides, with the soft bluish grey white of the walls, the green hanging and the sparkling sunny golden-green outside to make a startling contrast. So you see there's something still to be done, quite different from anything I have done up to now.

I must go and work. I saw another very quiet and lovely thing the other day, a girl with a coffee-tinted skin if I remember rightly, ash blond hair, grey eyes, a print bodice of pale rose under which you could see the breasts, shapely, firm and small. This against the emerald leaves of some fig trees. A woman of the real country sort, every line of her virgin.

It isn't altogether impossible that I shall get her to pose in the open air, and her mother too—a gardener's wife—earth coloured, dressed just then in soiled yellow and faded blue.

The girl's coffee-tinted complexion was darker than the rose of her bodice.

The mother was stunning, the figure in dirty yellow and faded blue thrown up in strong sunlight against a square of brilliant flowers, snow white and lemon-yellow. A perfect Van der Meer[1] of Delft, you see.

It's not a bad place, the south. A handshake.

Yours,

Vincent

My dear Theo, [Arles, late August 1888]

I write in great haste, to tell you that I have had a note from Gauguin to say that he has not written much, but that he is quite ready to come south as soon as the opportunity occurs.

They are enjoying themselves very much painting, arguing, and fighting with the worthy English; he speaks well of Bernard's work, and B. speaks well of Gauguin's.

I am hard at it, painting with the enthusiasm of a Marseillais eating bouillabaisse, which won't surprise you when you know that what I'm at is the painting of some great sunflowers.

[1] More correctly Vermeer.

I have three canvases in hand—1st, three huge flowers in a green vase, with a light background, a canvas of size 15; 2nd, three flowers, one gone to seed, stripped of its petals, and another in bud against a royal blue background, canvas of size 25; 3rd, twelve flowers and buds in a yellow vase (canvas of size 30). The last is therefore light on light, and I hope will be the best. I probably shall not stop at that.[1] Now that I hope to live with Gauguin in a studio of our own, I want to make a decoration for the studio. Nothing but big sunflowers. Next door to your shop, in the restaurant, you know there is a lovely decoration of flowers; I always remember the big sunflower in the window there.

If I carry out this idea there will be a dozen panels. So the whole thing will be a symphony in blue and yellow. I am working at it every morning from sunrise, for the flowers fade so soon, and the thing is to do the whole at one go.

You were quite right to tell Tasset that he must give us some tubes of colour for the 15 francs carriage not prepaid on the two parcels. When I have finished these sunflowers I may need yellow and blue perhaps. If so I will send a small order to that effect. I very much like the ordinary canvas from Tasset which was 50 centimes dearer than Bourgeois's, it is very well prepared.

I am very glad that G. is well.

I am beginning to like the south more and more.

I have another study of dusty thistles on hand, with an innumerable swarm of white and yellow butterflies.

I have again missed some models which I had hoped to have over the last few days. Koning has written saying that he is going to live in The Hague, and that he means to send you some studies.

I have heaps of ideas for new canvases. I saw again to-day the same coal boat with the workmen unloading it that I told you about before, at the same place as the boats carrying sand of which I sent you the drawing. It would be a splendid subject. Only I am beginning more and more to try for a simple technique which is not perhaps impressionist. I would like

[1] In fact he was to do two more.

to paint in such a way that everybody, at least if they had eyes, would see it. I am writing in a hurry, but I wanted to send a line enclosed to our sister.

A handshake, I must get back to work.

Yours,

Vincent

Gauguin said that Bernard had made an album of my sketches and had shown it to him.

My dear Theo, [Arles, early September 1888]

I spent yesterday with the Belgian[1] again, who also has a sister among the " Vingtistes."[2] It was not fine, but a very good day for talking; we went for a walk and anyway saw some very fine things at the bull fight and outside the town. We talked more seriously about the plan, that if I keep a place in the south, he ought to set up a sort of post among the collieries. Then Gauguin and I and he, if the importance of a picture made it worth the journey, could change places— and so be sometimes in the north, but in familiar country with a friend in it, and sometimes in the south.

You will soon see him, this young man with the look of Dante, because he is going to Paris, and if you put him up— if the room is free—you will be doing him a good turn; he is very distinguished in appearance, and will become so, I think, in his painting.

He likes Delacroix, and we talked a lot about Delacroix yesterday. He even knew the violent study for the " Bark of Christ."[3] Well, thanks to him I have at last a first sketch of that picture which I have dreamt of for so long—the poet. He posed for me. His fine head with that keen gaze stands out in my portrait against a starry sky of deep ultramarine; for clothes, a short yellow coat, a collar of unbleached linen, and spotted tie. He gave me two sittings in one day.

Yesterday I had a letter from our sister, who has seen a

[1] Bock.

[2] A group of artists which organised exhibitions in Brussels.

[3] " Christ on the Lake of Gennaseret."

great deal. Ah, if she could marry an artist it would not be so bad. Well, we must go on inducing her to develop her personality rather than her artistic abilities.

I have finished *L'Immortel* by Daudet. I rather like the saying of the sculptor Védrine, that to achieve *fame* is something like ramming the lighted end of your cigar into your mouth when you are smoking. But I certainly like *L'Immortel* less, far less than *Tartarin*.

You know, it seems to me that *L'Immortel* is not so fine in colour as *Tartarin*, because it reminds me with its mass of true and subtle observations of the dreary pictures of Jean Bérend which are so dry and cold. Now *Tartarin* is *really great*, with the greatness of a masterpiece, just like *Candide*.

I do strongly ask you to keep my studies of this place as open to the air as possible, because they are not yet thoroughly dry. If they remain shut up or in the dark the colours will get devalued. So the portrait of "The Young Girl," "The Harvest" (a wide landscape with the ruin in the background and the line of the Alpilles), the little "Seascape," the "Garden" with the weeping tree and clumps of conifers, if you could put these on stretchers it would be well. I am rather keen on those. You will easily see by the *drawing* of the little seascape that it is the most thought out.

I am having two oak frames made for my new peasant's head and for my Poet study. Oh, my dear boy, sometimes I know so well what I want. I can very well do without God both in my life and in my painting, but I cannot, ill as I am, do without something which is greater than I, which is my life—the power to create.

And if, defrauded of the power to create physically, a man tries to create thoughts in place of children, he is still very much part of humanity.

And in a picture I want to say something comforting as music is comforting. I want to paint men and women with that something of the eternal which the halo used to symbolize, and which we seek to confer by the actual radiance and vibration of our colourings.

Portraiture so understood does not become like an Ary

Scheffer, just because there is a blue sky behind as in the "St. Augustine." For Ary Scheffer is so little of a colourist.

But it would be more in harmony with what Eug. Delacroix attempted and brought off in his "Tasso in Prison,"[1] and many other pictures, representing a *real* man. Ah! portraiture, portraiture with the thought, the soul of the model in it, that is what I think must come.

The Belgian and I talked a lot yesterday about the advantages and disadvantages of this place. We quite agree regarding both. And on the great advantage it would be to us if we could *move* now north, now south.

He is going to stay with McKnight again so as to live more cheaply. That, however, has I think one disadvantage, because living with a slacker makes one slack.

I think you would enjoy meeting him, he is still young. I think he will ask your advice about buying Japanese prints and Daumier lithographs. As to these—the Daumiers—it would be well to get some more of them, because later there will be none to be got.

The Belgian was saying that he paid 80 francs for board and lodging with McKnight. So what a difference there is in living together, since I have to pay 45 a month for nothing but lodging. And so I always come back to the same reckoning, that with Gauguin I should not spend more than I do alone, and be no worse off. But we must consider that they were very badly housed, not for sleeping, but for the possibility of work at home.

So I am always between two currents of thought, first the material difficulties, turning round and round to make a living; and second, the study of colour. I am always in hope of making a discovery there, to express the love of two lovers by a marriage of two complementary colours, their mingling and their opposition, the mysterious vibrations of kindred tones. To express the thought of a brow by the radiance of a light tone against a sombre background.

To express hope by some star, the eagerness of a soul by

[1] "Tasso in the Madhouse" is the normal title.

a sunset radiance. Certainly there is nothing in that of trompe l'œil realism, but is it not something that actually exists?

Goodbye for the present. I will tell you another time when the Belgian may be going through, because I shall see him again tomorrow.

With a handshake,

Yours,
Vincent

The Belgian says that his people at home have a de Groux, the study for the "Benedicité" in the Brussels Museum.

The portrait of the Belgian is something like the portrait of Reid which you have, in execution.

My dear Theo, [Arles, September 8 1888]

Thank you a thousand times for your kind letter and the 300 francs it contained; after some worrying weeks I have just had a much better one. And just as worries do not come singly, neither do the joys. For just because I am always bowed down under this difficulty of paying my landlords, I made up my mind to take it gaily. I swore at the said landlord, who after all isn't a bad fellow, and told him that to revenge myself for paying him so much money for nothing, I would paint the whole of his rotten shanty so as to repay myself. Then to the great joy of the landlord, of the postman whom I had already painted, of the visiting night prowlers, and of myself, for three nights running I sat up to paint and went to bed during the day. I often think that the night is more alive and more richly coloured than the day. Now, as for getting back the money I have paid to the landlord by my painting, I do not dwell on that, for the picture[1] is one of the ugliest I have done. It is the equivalent, though different, of the "Potato Eaters."

I have tried to express the terrible passions of humanity by means of red and green.

The room is blood red and dark yellow with a green

[1] The *Night Café*.

billiard table in the middle; there are four lemon-yellow lamps
with a glow of orange and green. Everywhere there is a clash
and contrast of the most alien reds and greens, in the figures
of little sleeping hooligans, in the empty dreary room, in
violet and blue. The blood-red and the yellow-green of the
billiard table, for instance, contrast with the soft tender Louis
XV green of the counter, on which there is a rose nosegay.
The white clothes of the landlord, on vigil in a corner of this
furnace, turn lemon-yellow, or pale luminous green.

I am making a drawing of it with the tones in water-
colour to send to you to-morrow, to give you some idea of it.

I wrote this week to Gauguin and Bernard, but I did not
talk about anything but pictures, just so as not to quarrel when
there is probably nothing to quarrel about.

But whether Gauguin comes or not, if I were to get some
furniture, henceforth I should have, whether in a good spot
or a bad one is another matter, a pied à terre, a home of my
own, which frees the mind from the dismalness of finding
oneself in the streets. That is nothing when you are an
adventurer of 20, but it is bad when you have turned 35.

To-day in the *Intransigeant* I noticed the suicide of M.
Bing Levy. It can't be the Levy, Bing's manager, can it?[1] I
think it must be someone else.

I am greatly pleased that Pissarro thought something of
the " Young Girl." Did Pissarro say anything about the
" Sower "? Afterwards, when I have gone further in these
experiments, the " Sower " will still be the first attempt in
that style. The " Night Café " carries on from the " Sower,"
and so also do the head of the old peasant and of the poet, if
I manage to do this latter picture.[2]

It is colour not locally true from the point of view of the
trompe l'œil realist, but colour to suggest some emotion of an
ardent temperament.

[1] Bing managed a gallery in Paris specialising in Oriental art,
which Vincent had much frequented.
[2] What Vincent had completed so far was only the study, and
not the final version; he did make an attempt at the latter, but sub-
sequently destroyed the result.
 L.V.G.

When Paul Mantz saw at the exhibition the violent and inspired sketch by Delacroix that we saw at the Champs Elysées—the " Bark of Christ"—he turned away from it, exclaiming in his article : " I did not know that one could be so terrible with a little blue and green."

Hokusai wrings the same cry from you, but he does it by his *line,* his *drawing*; as you say in your letter—" the waves are *claws* and the ship is caught in them, you feel it."

Well, if you make the colour exact or the drawing exact, it won't give you sensations like that.

Anyhow, very soon, to-morrow or next day, I will write to you again about this and answer your letter, and send you the sketch of the "Night Café."

Tasset's parcel has arrived. I will write to-morrow on this question of the coarse grained colour. Milliet[1] is coming to see you and pay his respects to you one of these days, he writes to me that he is coming back. Thank you again for the money you sent. If I went first to look for another place, would it not very likely mean fresh expense, equal at least to the expense of a removal? And then should I find anything better all at once? I am so very glad to be able to do the furnishing, and it can't but help me on. Many thanks then, and a good handshake, till tomorrow.

Yours,

Vincent

My dear Theo, [Arles, end of September 1888]

The fine weather of the last few days has gone and instead we have mud and rain, but it will certainly come back again before the winter.

Only the thing will be to make use of it, because the fine days are short. Especially for painting. This winter I intend to draw a great deal. If only I could manage to draw figures from memory, I should always have something to do. But if you take the cleverest figure of all the artists who sketch on

[1] The lieutenant of the Zouave regiment who had been quartered at Arles.

the spur of the moment, Hokusai, Daumier, in my opinion that figure will never come up to the figure painted from the model by those same masters, or other portrait painters.

And in the end, if models, especially intelligent models, are doomed to fail us too often, we must not despair for this reason or grow weary in the struggle.

I have arranged in the studio all the Japanese prints and the Daumiers, and the Delacroixs and the Géricaults. If you find the " Pietà " by Delacroix again or the Géricault I strongly advise you to get as many of them as you can. What I should love to have in the studio as well is Millet's " Work in the Fields," and Lerat's etching of his " Sower " which Durand-Ruel sells at 1.25 francs. And lastly the little etching by Jacquemart after Meissonier, the " Man Reading," a Meissonier that I have always admired. I cannot help liking Meissonier's things.

I am reading an article in the *Revue des deux Mondes* on Tolstoi. It appears that Tolstoi is enormously interested in the religion of his race, like George Eliot in England.

There must be a book of Tolstoi's about religion. I think it is called *My Religion,* it must be very fine. In it he is trying to find, so I understand from this article, what remains eternally true in the religion of Christ, and what all religions have in common. It appears that he does not admit the resurrection of the body, or even of the soul, but says, like the nihilists, that after death there is nothing more, yet with the man dead, and thoroughly dead, humanity, living humanity abides.

Anyway, not having read the book itself, I cannot say how exactly he understands the matter, but I think that his religion cannot be a cruel one which would increase our sufferings, but that on the contrary it must be very comforting, and would inspire serenity and energy and courage to live and heaps of things.

I think the drawing of the " Blade of Grass " and the carnations and the Hokusai in Bing's reproductions are *admirable.*

But whatever you say, the most common prints coloured

with a flat wash are admirable to me for the same reason as Rubens and Veronese. I know perfectly well that they are not true primitive art. But because the primitives[1] are admirable, that is no reason whatever for me to say, as it is becoming the fashion to do, "When I go to the Louvre, I cannot get beyond the primitives."

If one said to a *serious* collector of Japanese prints, to Levy himself, "My dear sir, I cannot help admiring these prints at 5 sous," he would more than likely be rather shocked, and would pity one for one's ignorance and bad taste. Just as formerly it appeared bad taste to like Rubens, Jordaens, and Veronese.

I think I shall end by not feeling lonesome in the house, and that during the bad days in the winter for instance, and the long evenings, I shall find some occupation that will take all my attention. Weavers and basket makers often spend whole seasons alone or almost alone, with their occupation for their only distraction.

But what makes these people stay in one place is precisely the feeling of domesticity, the *reassuring familiar look of things*. I should certainly like company, but if I have not got it, I shall not be unhappy because of that, and then too the time will come when I shall have someone. I have little doubt of it. I think that if you were willing to put people up in your house too, you would find plenty among the artists for whom the question of lodgings is a very serious problem. For my part I think that it is absolutely my duty to try to make money by my work, and so I see my work very clear before me.

Oh, if only every artist had something to live on, and to work on, but as that is not so, I want to produce, to produce a lot and with a consuming drive. And perhaps the time will come when we can extend our business and be more help to the others.

[1] At the period this was a blanket term for the earlier Italian schools, prior to Raphael, and for Flemish art of the fifteenth century.

But that is a long way off and there is a lot of work to get through first.

If you lived in time of war, you might possibly have to fight, you would regret it, you would lament that you weren't living in times of peace, but after all the necessity would be there and you would fight.

And in the same way we certainly have the right to wish for a state of things in which money would not be necessary in order to live. However, as everything is done by money now, one has got to think about making it so long as one spends it, but I have more chance of making it by painting than by drawing.

On the whole there are a good many more people who can do clever sketches than there are who can paint readily and can get at nature through colour. That will always be rarer, and whether the pictures are a long time in being appreciated or not, they will find a collector some day.

But about those pictures in rather thick impasto, I think they must be left longer *here* to dry. I have read that the Rubenses in Spain have remained infinitely richer in colour than those in the North. Ruins exposed to the open air remain white here, while in the north they become grey, dirty, black, etc. You may be sure that if the Monticellis had dried in Paris they would now be much duller. I am beginning now to see the beauty of the women here better, and then again and again I think afresh of Monticelli. Colour plays such a tremendous part in the beauty of the women here. I do not say that their shape is not beautiful, but it is not there that the special charm is found. That lies in the grand lines of the costume, vivid in colour and admirably carried, the *tone* of the flesh rather than the shape. But I shall have some trouble before I can do them as I begin to see them. Yet what I am sure of is that to stay here is to go forward. And to make a picture which will be really of the south, it's not enough to have a certain dexterity. It is looking at things for a long time that ripens you and gives you a deeper understanding. I did not think when I left Paris that I should ever find Monticelli and Delacroix so *true*. It is only now

after months and months that I begin to realize that they did not imagine any of it. And I think that next year you are going to see the same subjects over again, orchards, and harvest, but with a different colouring, and above all a change in the workmanship.

And these shifts and variations will always go on.

I feel that while going on working I must not hurry. After all, how would it be to put in practice the old saying— you must study for ten years, and then produce a few figures. That is what Monticelli did, however, not counting some of his pictures as studies.

But then figures such as the woman in yellow, and the woman with the parasol—the little one you have, and the lovers that Reid had, those are complete figure studies in which as far as the drawing goes there is nothing left but to praise. For in them Monticelli achieves a sweeping, magnificent drawing like Daumier and Delacroix. Certainly considering the price Monticellis are at, it would be an excellent speculation to buy some. The time will come when his beautifully *drawn* figures will be considered very great art.

I think that the town of Arles was infinitely more glorious once as regards the beauty of its women and the beauty of its costumes. Now everything has a worn and sickly look about it.

But when you look at it for long, the old charm revives.

And that is why I see that I lose absolutely nothing by staying where I am and being content to watch things pass, as a spider waits in its web for the flies. I cannot force anything, and now that I am settled in I can profit by all the fine days, and every opportunity for snatching a good picture from time to time.

Milliet has luck, he has as many Arlésiennes as he wants, but then he cannot paint them, and if he were a painter he would not get them. I must bide my time without rushing things.

I have read another article on Wagner—" Love in Music "—I think by the same author who wrote the book on Wagner. How one needs the same thing in painting.

It seems that in the book, *My Religion,* Tolstoi implies that whatever happens in the way of violent revolution there will also be a private and secret revolution in men, from which a new religion will be reborn, or rather something altogether new, which will have no name, but which will have the same effect of consoling, of making life possible, which the Christian religion used to have.

It seems to me that the book ought to be very interesting. We shall end by having had enough cynicism and scepticism and humbug, and we shall want to live more musically. How will that come to pass, and what will we really find? It would be interesting to be able to predict, but it is better still to be able to feel that kind of foreshadowing, instead of seeing absolutely nothing in the future beyond the disasters that are all the same bound to fall like terrible lightning on the modern world and on civilization, through a revolution or a war, or the bankruptcy of worm-eaten states. If we study Japanese art, we see a man who is undoubtedly wise, philosophic and intelligent, who spends his time how? In studying the distance between the earth and the moon? No. In studying the policy of Bismarck? No. He studies a single blade of grass.

But this blade of grass leads him to draw every plant and then the seasons, the wide aspects of the countryside, then animals, then the human figure. So he passes his life, and life is too short to do the whole.

Come now, isn't it almost an actual religion which these simple Japanese teach us, who live in nature as though they themselves were flowers?

And you cannot study Japanese art, it seems to me, without becoming much gayer and happier, and we must return to nature in spite of our education and our work in a world of convention.

Isn't it sad that the Monticellis have never yet been reproduced in good lithographs or vivid etchings? I would very much like to see what artists would say if an engraver like the man who engraved the Velasquez made a fine etching from them. Never mind, I think it is more our job to try to

admire and know things for ourselves, than to teach them to other people. But the two can go together.

I envy the Japanese the extreme clearness which everything has in their work. It is never wearisome, and never seems to be done too hurriedly. Their work is as simple as breathing, and they do a figure in a few sure strokes with the same ease as if it were as simple as buttoning your waistcoat.

Oh! I must manage somehow to do a figure in a few strokes. That will keep me busy all the winter. Once I can do that, I shall be able to do people walking the boulevards, along the streets, and heaps of new subjects. While I have been writing this letter I have drawn about a dozen. I am on the track of it, but it is very complicated because what I am after is that in a few strokes the figure of a man, a woman, a youngster, a horse, a dog, shall have head, body, legs, arms, all in keeping.

Good-bye for the present and a good handshake from

Yours,

Vincent

Mme. de Lareby Laroquette said to me once—" But Monticelli, Monticelli, why he was a man who ought to have been at the head of a great studio in the south."

I wrote to our sister and to you the other day, you remember, that sometimes I thought that I was the continuation of Monticelli here. Well, you see it happening now, that studio in question, we are founding it. What Gauguin does, what I do, will be in line with that fine work of Monticelli's, and we will try to prove to the good folk that Monticelli did not wholly die sprawled over the café tables of the Cannebière, but the good old chap's still alive. And the thing won't even end with us, we shall set it going on a pretty solid basis.

My dear Theo, [Arles, mid October 1888]

At last I am sending you a small sketch to give you at least an idea of the form which the work is taking. For today I am all right again. My eyes are still tired, but then I had a

new idea in my head and here is the sketch of it. Another canvas of size 30. This time it's just simply my bedroom, only here colour is to do everything, and giving by its simplification a grander style to things, is to be suggestive here of *rest* or of sleep in general. In a word, to look at the picture ought to rest the brain or rather the imagination.

The walls are pale violet. The floor is of red tiles.

The wood of the bed and chairs is the yellow of fresh butter, the sheet and pillows very light lemon-green.

The coverlet scarlet. The window green.

The toilet table orange, the basin blue.

The doors lilac.

And that is all—there is nothing in this room with closed shutters.

The broad lines of the furniture must again express inviolable rest. Portraits on the walls, and a mirror and a towel and some clothes.

The frame—as there is no white in the picture—will be white.

This by way of revenge for the enforced rest I have been obliged to take.

I shall work at it again all day tomorrow, but you see how simple the conception is. The shadows and the thrown shadows are suppressed, it is coloured in free flat tones like Japanese prints. It is going to be a contrast with, for instance, the Tarascon diligence and the night café.

I am not writing you a long letter, because tomorrow very early I am going to begin in the cool morning light, so as to finish my canvas.

How are the pains? Do not forget to tell me about them.

I hope that you will write one of these days.

I will make you sketches of the other rooms too some day. With a good handshake,

Yours,
Vincent

My dear Theo, [Arles, early November 1888]

Gauguin and I[1] thank you very much for the 100 fr. you sent and also for your letter.

Gauguin is very pleased that you like what he sent from Brittany, and that other people who have seen them like them too.

Just now he has in hand some women in a vineyard, altogether from memory, but if he does not spoil it or leave it unfinished it will be very fine and very unusual. Also a picture of the same night café that I painted too.[2]

I have done two canvases of falling leaves, which Gauguin liked, I think, and I'm working now on a vineyard all purple and yellow.[3]

Then I have an Arlésienne at last, a figure (size 30 canvas) slashed on in an hour, background pale lemon, the face grey, the clothes black, deep black, with perfectly raw Prussian blue, She is leaning on a green table and seated in an armchair of orange wood.[4]

Gauguin has bought a chest of drawers for the house, and various household utensils, also 20 metres of very strong canvas, and a lot of things that we needed, and that at any rate it was more convenient to have. Only we have kept an account of all he has paid out, which comes almost to 100 francs, so that either at the New Year or say in March we can pay him back, and then the chest of drawers etc. will naturally be ours.

I think this is right on the whole, since he intends to put

[1] Gauguin had finally arrived at Arles on October 23rd; he had sent off a number of works to Theo before leaving Pont-Aven, in preparation for a one man show at the Goupil Gallery which was to open shortly.

[2] That is, the canvas called *The Vineyard* or *Human Miseries*, now in the Ordrupgaard Collection in Denmark; and the *Night Café* now in The Hermitage, Leningrad.

[3] The *Red Vineyard*, usually referred to as the only canvas that Vincent ever sold (though another sale through Theo is recorded).

[4] This was a portrait of his friend Mme. Ginoux.

money by when he sells, till the time (say in a year) when he has enough to risk a second voyage to Martinique.[1]

We are working hard, and our life together goes very well. I am very glad to know that you are not alone in the flat. These drawings by de Haan are *very fine*, I like them very much. Yet to do that with colour, to manage so much expression without the help of chiaroscuro in black and white, damn it all, it is not easy. And he will even arrive at *a new type of drawing* if he carries out his plan of passing through impressionism *as a school*, considering his new attempts in colour merely as studies. But in my opinion he is right over and over again to do all this.

Only there are several so-called impressionists who have not his knowledge of the figure, and it is just this knowledge of the figure which will later on come again to the surface, and which he will be all the better for. I am very anxious some day to get to know de Haan and Isaäcson. If they ever came here Gauguin would certainly say to them—go to Java for impressionist work. For Gauguin though he works hard here is still homesick for hot countries. And then it is unquestionable that if you went to Java, for instance, with the one idea of working on colour, you would see heaps of new things. Then in those brighter countries, with a stronger sun, direct shadow, as well as the cast shadow of objects and figures, becomes quite different, and is so full of colour that one is tempted simply to suppress it. That happens even here. Yet I will say no more on the importance of painting in the tropics, I am already sure de Haan and Isaäcson will feel the importance of it.

In any case, to come here some time or other would do them no harm, they would certainly find some interesting things.

Gauguin and I are going to have our dinner at home to-day, and we feel as sure and certain that it will turn out well as that it will seem to us better or cheaper.

So as not to delay this letter I will finish up for today. I

[1] The first such expedition had been undertaken the previous year.

hope to write again soon. Your arrangement about money is quite right.

I think you will like the fall of the leaves that I have done. It is some poplar trunks in lilac cut by the frame where the leaves begin.

These tree-trunks are lined like pillars along an avenue where to right and left there are rows of old Roman tombs of a blue lilac.[1] And then the soil is covered, as with a carpet, by a thick layer of yellow and orange fallen leaves. And they are still falling like flakes of snow.

And in the avenue little black figures of lovers. The upper part of the picture is a bright green meadow, and no sky or almost none.

The second canvas is the same avenue but with an old fellow and a woman as fat and round as a ball.

But if only you had been with us on Sunday, when we saw a red vineyard, all red like red wine. In the distance it turned to yellow, and then a green sky with the sun, the earth after the rain violet, sparkling yellow here and there where it caught the reflection of the setting sun.

A handshake in thought from both of us, goodbye for the present, I will write again as soon as I can, and to our Dutchmen too.[2]

Yours,
Vincent

My dear Theo, [Arles, second half of December 1888]

Gauguin and I went yesterday to Montpellier to see the museum there and especially the Brias room.[3] There are a lot of portraits of Brias, by Delacroix, Ricard, Courbet, Cabanel, Couture, Verdier, Tassaert, and others. Then there are pictures by Delacroix, Courbet, Giotto, Paul Potter, Botticelli, Th. Rousseau, very fine. Brias was a benefactor of artists, I shall say no more to you than that. In the portrait

[1] The Alyscamps at Arles. [2] The two artists staying with Theo.
[3] Alfred Bruyas (or Brias) had left his personal collection to the Museum.

by Delacroix he is a gentleman with red beard and hair, con-
foundedly like you or me, and made me think of that poem
by de Musset—"*Partout ou j'ai touché la terre—un mal-
heureux vêtu de noir, auprès de nous venait s'asseoir, qui nous
regardait comme un frère.*"[1] It would have the same effect on
you, I am sure. Please do go to that bookshop where they
sell the lithographs by past and present artists, and see if you
could get, not too dear, the lithograph after Delacroix's
" Tasso in the Madhouse," since I think the figure there must
have some affinity with this fine portrait of Brias.

They have got some more Delacroixs, the study of a
" Mulatto Woman" (which Gauguin copied once),[2] the
" Odalisques," " Daniel in the Lions' Den "; and by Courbet :
first, the " Village Girls," magnificent, a woman seen from
behind, another lying on the ground in a landscape; second,
the " Woman Spinning," superb, and a whole heap more of
Courbet's. But after all you must know this collection exists,
or else know people who have seen it, and consequently be
able to talk about it. So I shan't say more about the museum
(except the Barye drawings and bronzes).

Gauguin and I talked a lot about Delacroix, Rembrandt,
etc. Our arguments are *terribly electric,* we come out of them
sometimes with our heads as exhausted as an electric battery
after it has run down. We were in the midst of magic, for
as Fromentin well says : Rembrandt is above all else a magi-
cian.

I tell you this in connection with our Dutch friends de
Haan and Isaäcson, who have so sought after and loved
Rembrandt, so as to encourage you all to pursue your
researches.

You must not be discouraged in them.

You know the strange and magnificent " Portrait of a
Man," by Rembrandt, in the Lacaze Gallery. I said to Gau-
guin that I myself saw in it a certain likeness in family or in

[1] " Wherever I touched the earth, a wretch clad in black came and
sat by us, scanning us like a brother."
[2] On an earlier visit to the museum, probably in 1883; this copy
has in fact recently come to light afresh.

race to Delacroix or to Gauguin himself. I do not know why, but I always call this portrait " The Traveller," or " The Man Come from Far." It is a similar and parallel idea to the one I've already spoken to you about, that I always look on the portrait of old Six, the fine portrait of the " Man with a Glove," as you in the future, and the etching by Rembrandt, " Six reading near a window in a shaft of sunlight," as you in the past and present. This is how things stand.[1] Gauguin was saying to me this morning when I asked him how he felt " that he felt his old self coming back," which gave me enormous pleasure. When I came here myself last winter, tired out and almost stunned in mind, before ever being able to begin to recover I had a strain of inward suffering too.

I do wish that some day you could see this Montpellier Museum—there are some very fine things.

Say to Degas that Gauguin and I have been to see the portrait of Brias by Delacroix at Montpellier, for we must make bold to believe that *what is is,* and the portrait of Brias by Delacroix is as like you and me as a new brother.

As for founding a way of life for artists chumming it together, you see such queer things, and I will wind up with what you are always saying—time will show. You can say all that to our friends Isaäcson and de Haan, and even boldly read them this letter. I should have written to them already if I had felt the necessary electric force.

A good hearty handshake all round from Gauguin as from me.

<div style="text-align:right">Yours,
Vincent</div>

If you should be thinking that Gauguin and I have facility in our work, I assure you that work does not always come easy, and that our Dutch friends may get no more discouraged than we do in their difficulties is my wish both for them and for you.

[1] Gauguin had been sick in the last few weeks with some disorder of the digestive system, and had written to Theo announcing that it was necessary for him to leave Arles, since he and Vincent could not get along together.

My dear Theo, [Arles, about December 23 1888]

Thank you very much for your letter, for the 100 fr. note enclosed and also for the 50 fr. order.

I think myself that Gauguin was a little out of sorts with the good town of Arles, the little yellow house where we work, and especially with me.[1]

As a matter of fact there are bound to be for him as for me further grave difficulties to overcome here.

But these difficulties are rather within ourselves than outside.

Altogether I think that either he will definitely go, or else definitely stay.

Before doing anything I told him to think it over and reckon things up again.

Gauguin is very powerful, strongly creative, but just because of that he must have peace.

Will he find it anywhere if he does not find it here?

I am waiting for him to make a decision with absolute serenity.

A good handshake.

 Vincent

[On the following day, December 24th, a telegram arrived from Gauguin that called Theo to Arles. Vincent, in a state of terrible excitement and high fever, had cut off a piece of his own ear, and brought it as a gift to a woman in a brothel. There had been a violent scene; Roulin the postman managed to get him home, but the police intervened, found Vincent bleeding and unconscious in bed, and sent him to the hospital. Theo found him there, " poor fighter and poor poor sufferer," and stayed over Christmas. Gauguin went back with Theo to Paris. By December 31st the news was better, and on the 1st, Vincent wrote this letter in pencil.]

[1] Gauguin had written to Theo that Vincent and he could not go on living together " in consequence of incompatibility of temper." The quarrel was made up, and Gauguin wrote another letter, speaking of the first as a bad dream.

My dear lad, [Arles, about January 1 1889]
I hope that Gauguin will completely reassure you, and a bit about the painting business too.

I expect to begin work again soon.

The charwoman and my friend Roulin had taken care of the house, and had put everything in order.

When I come out I shall be able to take the little old road here again, and soon the fine weather will be coming and I shall begin again on the orchards in bloom.

My dear lad, I am so terribly *distressed* at your journey. I should have wished you had been spared that, for after all no harm came to me, and there was no reason why you should put yourself to that trouble.

I cannot tell you how glad I am that you have made peace, and even more than that, with the Bongers.[1]

Say that to André from me, and give him my cordial regards.

What would I not have given for you to have seen Arles when it was fine, as it is you have seen it looking dismal.

However, keep good heart, address letters direct to me at Place Lamartine 2. I will send Gauguin's pictures that are still at the house as soon as he wishes. We owe him the money that he spent on the furniture.

A handshake, I must go back to hospital, but shall soon be out for good.

Yours,
Vincent

Write a line to Mother too for me, so that no one will be worried.[2]

[1] Theo was already engaged to Johanna Bonger, who had been staying with her brother, Andries, friend of Theo and Vincent in Paris. The news of the engagement seems in fact to have constituted one main cause of Vincent's breakdown, since a threat was involved that his financial backing from Theo would be cut off.

[2] On the back of this letter a short message to Gauguin was written out also.

My dear Theo, Arles, January 23 1889

Thank you for your letter and the 50 fr. note it contained. Of course I am now safe until the arrival of your letter after the 1st. What happened about that money was entirely pure chance and misunderstanding, for which neither you nor I are responsible. By just the same mischance I could not telegraph as you said, because I did not know if you were still in Amsterdam or back in Paris. It is over now with the rest, and is one more proof of the proverb that misfortunes never come singly. Roulin left yesterday[1] (of course my wire yesterday was sent off before the arrival of your letter of this morning). It was touching to see him with his children this last day, especially with the quite tiny one, when he made her laugh and jump on his knee, and sang for her.

His voice has a strangely pure and touching quality in which there was for my ear at once a sweet and mournful cradle-song, and a kind of far-away echo of the trumpet of revolutionary France. He was not sad, however. On the contrary, he had put on his brand new uniform which he had received that very day, and everyone was making much of him.

I have just finished a new canvas which almost has what one might call a certain *chic* about it, a wicker basket with lemons and oranges, a cypress branch and a pair of blue gloves. You have already seen some of these baskets of fruit of mine.

Look here—you do know that what I am trying to do is to get back the money that my training as a painter has cost, neither more nor less.

I have a right to that, and to the earning of my daily bread.

I think it just that there should be that return, I don't say into your hands, since what we have done we have done together, and to talk of money distresses us so much.

But let it go to your wife's hands, who will join with us besides in working with the artists.

[1] He was moving to a post in Marseilles.

If I am not yet devoting much thought to direct sales, it is because my count of pictures is not yet complete, but it is getting on, and I have set to work again with a nerve like iron.

I have good and ill luck in my production, but not ill luck *only*. For instance, if our Monticelli bunch of flowers is worth 500 francs to a collector, and it is, then I dare swear to you that my sunflowers are worth 500 francs too, to one of these Scots or Americans.

Now to get up heat enough to melt that gold, those flower-tones, it isn't any old person who can do it, it needs the force and concentration of a single individual whole and entire.

When I saw my canvases again after my illness the one that seemed the best to me was the "Bedroom."

The amount we handle is a respectable enough sum, I admit, but much of it runs away, and what we'll have to watch above all is that from year's end to year's end it doesn't all slip through the net. That is why as the month goes on I keep more or less trying to balance the outlay with the output, at least in relative terms.

So many difficulties certainly do make me rather worried and timorous, but I haven't given up hope yet.

The trouble I foresee is that we shall have to be very *prudent* so as to prevent the expenses of a sale lowering the sale itself, when the time for it comes. How many times we have had occasion to see just that mischance in the lives of artists.

I have in hand the portrait of Roulin's wife, which I was working on before I was ill.[1]

In it I had ranged the reds from rose to an orange, which rose through the yellows to lemon, with light and sombre greens. If I could finish it, I should be very glad, but I am afraid she will no longer want to pose with her husband away.

You can see just what a disaster Gauguin's leaving is,

[1] The *Woman rocking a Cradle*, begun in December.

because it has thrust us down again just when we had made a home and furnished it to take in our friends in bad times.

Only in spite of it we will keep the furniture, etc. And though everyone will now be afraid of me, in time that may disappear.

We are all mortal and subject to all the ailments there are, and if the latter aren't exactly of an agreeable kind, what can one do about it? The best thing is to try to get rid of them.

I feel remorse too when I think of the trouble that, however involuntarily, I on my side caused Gauguin. But up to the last days I saw one thing only, that he was working with his mind divided between the desire to go to Paris to carry out his plans, and the life at Arles.

What will come of all this for him?

You will doubtless be feeling that though you have a good salary, nevertheless we lack capital, except in goods, and that in order really to alter the unhappy position of the artists that we know, we need to be in a stronger position. But then we often run up against sheer distrust on their part, and the things they are perpetually scheming among themselves, which always end in—a *blank*. I think that at Pont-Aven they had already formed a new group of 5 or 6, perhaps already broken up.

They are not dishonest, it is something without a name and one of their enfant terrible faults.

Meantime the great thing is that your marriage should not be delayed. By getting married you will set Mother's mind at rest and make her happy, and it is after all almost a necessity in view of your position in society and in commerce. Will it be appreciated by the society to which you belong, perhaps not, any more than the artists ever suspect that I have sometimes worked and suffered for the community. . . . So from me, your brother, you will not want completely banal congratulations and assurances that you are about to be transported straight into paradise. And with your wife you will not be lonely any more, which I could wish for our sister as well.

That, after your own marriage, is what I should set my heart on more than anything.

When you are married, perhaps there will be other marriages in the family, and in any case you will see your way clear and the house will not be empty any more.

Whatever I think on other points, our father and mother were exemplary as married people.

And I shall never forget Mother at Father's death, when she only said one small word: it made me begin to love dear old Mother more than before. In fact as married people our parents were exemplary, like Roulin and his wife, to cite another instance.

Well, go straight ahead along that road. During my illness I saw again every room of the house at Zundert, every path, every plant in the garden, the views from the fields round about, the neighbours, the graveyard, the church, our kitchen garden behind—down to the magpie's nest in a tall acacia in the graveyard.

It's because I still have earlier recollections of those first days than any of the rest of you.[1] There is no one left who remembers all this but Mother and me.

I say no more about it, since it is better that I should not try to recall all that passed through my head then.

Only please realize that I shall be very happy when your marriage has taken place. Look here now, if for your wife's sake it would perhaps be as well to have a picture of mine from time to time at Goupil's, then I will give up my grudge against them, in this way:—

I said I did not want to go back to them with too naïve a picture.

But if you like you can exhibit the two pictures of sunflowers.

Gauguin would be glad to have one, and I should very much like to give Gauguin a real pleasure.[2] So if he wants

[1] Vincent was the eldest of the six children in his family.

[2] Gauguin had acquired two *Sunflowers* painted by Vincent in Paris, and the sunflowers of Arles bloomed again in Tahiti, when Gauguin in 1900 nostalgically ordered sunflower seeds from Paris, and did

one of the two canvases, all right, I will do one of them over again, whichever he likes.

You will see that these canvases will catch the eye. But I would advise you to keep them for yourself, just for your own private pleasure and that of your wife.

It is a kind of painting that rather changes in character, and takes on a richness the longer you look at it.

Besides, you know, Gauguin likes them extraordinarily. He said to me among other things—" That . . . it's . . . the flower."

You know that the peony is Jeannin's, the hollyhock belongs to Quost, but the sunflower is somewhat my own.

And after all I should like to go on exchanging my things with Gauguin even if sometimes it would cost me also rather dear.

Did you during your hasty visit see the portrait of Mme. Ginoux in black and yellow?[1] That portrait was painted in three-quarters of an hour. I must stop for the moment.

The delay of the money was pure chance, and neither you nor I could do anything about it. A handshake.

Yours,

Vincent

My dear Theo, [Arles, February 3 1889]

I should have preferred to reply at once to your kind letter containing 100 francs, but as I was very tired just then, and the doctor had given me strict orders to go out walking without doing any mental work, I'm in consequence only writing to you to-day. As far as work goes the month hasn't on the whole been too bad, and work distracts me, or rather keeps me in control, so that I don't deny myself it.

I have done the " Woman Rocking the Cradle" three times, and as Mme. Roulin was the model and I only the painter, I

still-lifes of the same subject as had decorated his room in the Yellow House.

[1] *The Arlésienne* of early November 1888.

let her choose between the three, her and her husband, but on condition that I should make another duplicate for myself of the one she chose, and I have this in hand now.

You ask me if I have read *La Mireille* by Mistral.[1] I am like you, I can only read it in fragments in the translation. But have you *heard* it yet, for you know perhaps that Gounod has set it to music, at least I think so. Naturally I do not know the music, and even if I heard it I should be watching the musicians rather than listening.

But I can tell you this, that in its words the language native to this region is extraordinarily musical in the mouth of an Arlésienne.

Perhaps in the " Woman Rocking" there's an attempt to get something of the *music* of the colouring here. It is badly painted and the chromos in the little shops are infinitely better painted technically, but all the same. . . .

By the way—this here so-called *good* town of Arles is such an odd place, that old Gauguin calls it with good reason " the dirtiest hole in the south."

And if Rivet[2] saw the population he would certainly have some bad moments, saying over and over again, " You are a sickly lot, all of you," just as he says of us; but if you catch the disease of the country, my word, you have caught it once and for all.

By which I mean that I have no illusions about myself any more. It is going very well, and I shall do everything the doctor says, but . . .

When I came out of the hospital with kind old Roulin, I thought that there had been nothing wrong with me, it was only *afterwards* that I felt I had been ill. Well, well, there are moments when I am wrung by enthusiasm or madness or prophecy, like a Greek oracle on its tripod.

And then I have great readiness of speech and speak like the Arlésiennes, but despite all this I feel so weak.

[1] Frédéric Mistral, the Provençal poet and collector of Provencal folk-lore.

[2] Doctor to the two brothers in Paris.

Once my bodily strength comes back, but also at the slightest grave symptom, I have already told Rey[1] that I would come back and put myself under the mental specialists at Aix, or under him.

Can anything come of it but trouble and suffering if we are not well, either for you or for me? So completely has our ambition foundered.

Then let us work on very quietly, let us take care of ourselves as much as we can and not exhaust ourselves in barren efforts of mutual generosity.

You will do your duty and I will do mine, since as far as that goes we have already both paid in other ways than in words, and at the end of the journey we may meet each other again with a quiet mind. But when that delirium of mine shakes up everything I dearly loved, I do not accept it as reality and I am not going to be a false prophet.

Illness or death, indeed, they have no terrors for me, but fortunately for us ambition is not compatible with the professions we follow.

But how comes it that you are thinking at this time both of the clauses of your marriage settlement and of the possibility of dying? Wouldn't it have been better quite simply to run your wife through beforehand?

After all that is the way of the north, and it is not for me to say that they have not good ways in the north.

It will all come right, indeed it will.

But I who have not a penny still say in this matter that money is one kind of coin and painting another. And I am already able to send you a consignment of the kind I spoke of in my previous letters. But it will be bigger if my strength returns.

But in case Gauguin, who has a perfect infatuation for my sunflowers, takes those two pictures from me, I should just like him to give your fiancée or you two of his own, not just average, but better than the average. And if he takes one version of the "Woman Rocking," he ought still more to give

[1] The house-surgeon at the Arles hospital.

something good in return. Without that I could not com-
plete this series of which I was telling you,[1] which should
be able to make its way into that same little window we have
so often gazed at.

As for the Indépendants[2] I think that six pictures is too
much by half. To my mind the " Harvest" and the " White
Orchard" are enough, with the little " Provençal Girl " or
the " Sower" if you like. But I don't greatly care. The one
thing I have set my heart on is some day to give you a more
heartening impression of this painting job of ours, by a
collection of 30 or so more serious studies. That will prove
again to our real friends like Gauguin, Guillaumin, Bernard,
etc., that we are producing something. Well, about the little
yellow house, when I paid my rent the landlord's agent was
very nice, and behaved like an Arlésien by treating me as an
equal. Then I told him that I had no need of a lease or a
written promise of reference, and that in case of illness I
should pay only as a matter of friendly agreement.

People here are sound at heart, and the spoken word is
more binding than the written word. So I am keeping the
house provisionally, since for the sake of my mental recovery
I need to feel here that I am in my own home. Now about
your removal from the Rue Lepic to the Rue Rodier, I can't
offer any opinion, as I have not seen it, but the chief thing is
that you too should lunch at home with your wife.

By staying in Montmartre you would the sooner be decor-
ated and a-Minister of the Arts, but as you are not keen on
that, it is better to have the peace of one's own home, so I
think you are quite right.

I am a little like that too. I always say to the people here
who ask after my health, that I shall start like them by
dying of it, and after that my illness will be dead.

This doesn't mean I shall not have long spells of respite,

[1] A decorative project for combining the *Sunflowers* and the
Women Rocking in alternate sequence.
[2] A special " Society of Independent Artists " had been founded
in Paris in 1884, for the organisation of annual exhibitions without
jury interference. Vincent had first shown in this company in
1888.

but once you are ill in earnest you know quite well that you cannot contract the same illness twice, you are well, or you are ill, just as you are young or you are old. Only be sure of it, like you, I do what the doctor tells me as much as I can, and I consider that as a part of my work and the duty which I have to fulfil.

I must tell you this, that the neighbours, etc., are particularly kind to me, as everyone suffers here either from fever, or hallucinations, or madness, we understand each other like members of the same family. I went yesterday to see the girl I had gone to when I went astray in my wits.[1] They told me there that in this country things like that are not out of the ordinary. She had been upset by it and had fainted but had recovered her calm. And they spoke well of her too.

But as for considering myself as altogether sane, we must not do it. People here who are ill like me have told me the truth. You may be old or young, but there will always be moments when you lose your head. So I do not ask you to say of me that there is nothing wrong with me, or that there never will be. Only the Ricord of this is probably Raspail.[2] I have not had the fevers of this country yet, and I may still catch them. But they are well up in all this already at the hospital here, and directly you have no false shame and say frankly what you feel, you cannot go wrong.

I finish this letter for this evening. A good handshake in thought.

<div style="text-align:right">

Yours,

Vincent

</div>

[Soon after this Vincent had his second attack, and was taken to the hospital imagining that people wanted to poison him; he recovered quickly to the point when he could resume his letters to Theo.]

[1] The girl at the brothel, Rachel, to whom Vincent had presented the detached part of his ear on December 23rd.

[2] i.e., his affliction was of a different kind from the one most common in those parts, venereal disease; Ricord in the United States had pioneered the study of the latter, while Raspail was a noted natural physician in Paris.

My dear Theo, [Arles, beginning of April 1889]

A few words to wish you and your fiancée all happiness
these days.[1] It is a sort of nervous affliction with me that on
festive occasions I generally find difficulty in formulating good
wishes, but you must not conclude from that that I wish you
happiness less earnestly than anyone else, as you well know.

I have still to thank you for your last letter, as well as for
the consignment of paints from Tasset and for several num-
bers of *Le Fifre* with drawings by Forain. These last especially
had the effect on me of making me see my own stuff as very
sentimental beside them.

I waited several days before answering, not knowing which
day you were leaving for Amsterdam. Besides I do not know
either if you are getting married in Breda or in Amsterdam.
But if as I am inclined to think it will be in Amsterdam, then
I have assumed that you would find this letter there by
Sunday.

By the way—only yesterday our friend Roulin came to see
me. He told me to give you many greetings from him and to
congratulate you. His visit gave me a lot of pleasure, he
often has to carry loads you would call too heavy, but it doesn't
prevent him, as he has the strong constitution of the peasant,
from always looking well and even jolly. But for me, who am
perpetually learning from him afresh, what a lesson for the
future it is when one gathers from his talk that life does not
grow any easier as one gets on in life.

I talked to him so as to have his opinion as to what I ought
to do about the studio,[2] which I have to leave in any case at
Easter, according to the advice of M. Salles[3] and M. Rey.

I said to Roulin that having done a good many things to
put the house into a far better state than when I took it,
especially as regards the gas I had put in, I considered it as a
definite piece of work.

[1] Their marriage was about to take place.

[2] Following his third attack in March, Vincent had remained in
the hospital for the time being.

[3] The Protestant clergyman who came on regular visits.

They are forcing me to leave—very well—but I should be pretty well justified in taking away the gas and making a rumpus about damages or something, only I haven't the heart to do it.

The only thing I feel I can do in this business is to tell myself that it was an attempt to make an abiding place for unknown successors. Besides, before seeing Roulin I had already been to the gas works to arrange it this way. And Roulin was of the same opinion. He expects to stay in Marseilles.

I am well just now, except for a certain undercurrent of vague sadness difficult to define—but anyway—I have rather gained than lost in physical strength, and I am working.

Just now I have on the easel an orchard of peach trees beside a road with the Alpilles in the background. It seems that there was a fine article in the *Figaro* on Monet; Roulin had read it and been struck by it, he said.

Altogether it is a rather difficult problem to decide whether to take a new flat, and even to find it, especially by the month. M. Salles has spoken to me of a house at 20 francs which is very nice, but he is not sure if I could have it.

At Easter I shall have to pay three months' rent, the removal, etc. All this is not very cheering or convenient, especially as there seems no prospect of any better luck anywhere.

Roulin said or rather hinted that he did not at all like the disquiet which has reigned here in Arles this winter, considered even quite apart from what has fallen on me.[1]

After all it is rather like that everywhere, business not too good, resources exhausted, people discouraged and . . . as you said, not content to remain spectators, and becoming nuisances from being out of work—if anybody can still make a joke or work fast, down they come on him.

And now, my dear lad, I do believe I shall soon not be ill enough to have to stay shut up. Otherwise I am beginning to get used to it, and if I had to stay for good in an asylum, I

[1] The neighbours had petitioned that Vincent should not be left at liberty.

should make up my mind to it and I think I could find subjects for painting there as well.

Write to me soon if you can find the time.

Roulin's family was still in the country and though he earns slightly more, the separate expenses are greater in proportion, and so they are not really a farthing better off, and he was not without very heavy anxieties.

Fortunately the weather is fine and the sun glorious, and people here quickly forget all their griefs for the time being and then they brim over with high spirits and illusions.

I have been re-reading Dickens' " Christmas Books " these days. There are things in them so profound that one must read them over and over, there are tremendously close connections with Carlyle.

Roulin, though he is not quite old enough to be like a father to me, has all the same a silent gravity and tenderness for me such as an old soldier might have for a young one. All the time—but without a word—a something which seems to say, we do not know what will happen to us to-morrow, but whatever it may be, think of me. And it does one good when it comes from a man who is neither embittered, nor sad, nor perfect, nor happy, nor always irreproachably right. But such a good soul and so wise and so full of feeling and so trustful. I tell you I have no right to complain of anything whatever about Arles, when I think of some things I have seen there which I shall never be able to forget.

It is getting late. Once more I wish you and Jo plenty of happiness, and a handshake in thought.

Yours,
Vincent

SAINT-REMY

My dear Theo, [Saint-Rémy, early June 1889]

I must beg you again to send me as soon as possible some ordinary brushes, of about these sizes.[1] Half a dozen of each, please; I hope that you are well and your wife too, and that you are enjoying the fine weather a little. Here at any rate we have splendid sunshine.

As for me, my health is good, and as for my brain, that will be, let us hope, a matter of time and patience.

The director mentioned that he had had a letter from you and had written to you; he tells me nothing and I ask him nothing, which is the simplest.

He's a gouty little man—several years a widower, with very dark spectacles. As the institution is rather dead and alive, the man seems to get no great amusement out of his job, and besides he has enough to live on.

A new man has arrived, who is so worked up that he smashes everything and shouts day and night, he tears his shirts violently too, and up till now, though he is *all day long* in a bath, he gets hardly any quieter, he destroys his bed and everything else in his room, upsets his food, etc. It is very sad to see, but they are very patient here and will end by seeing him through. New things grow old so quickly—I think that if I came to Paris in my present state of mind, I should see no difference between a so-called dark picture and a light impressionist picture, between a varnished picture in oils and a mat picture done with solvent.

I mean by this that by dint of reflection, I have come by slow degrees to believe more than ever in the eternal youth of the school of Delacroix, Millet, Rousseau, Dupré and Daubigny, as much as in that of the present, or even in that of the artists to come. I hardly think that impressionism will ever do more than the romantics for instance. Between that and

[1] A sketch was enclosed.

admiring people like Léon Glaize or Perrault there is certainly a margin.

This morning I saw the country from my window a long time before sunrise, with nothing but the morning star, which looked very big. Daubigny and Rousseau have depicted just that, expressing all that it has of intimacy, all that vast peace and majesty, but adding as well a feeling so individual, so heartbreaking. I have no aversion to that sort of emotion.

I am always filled with remorse, terribly so, when I think of my work as being so little in harmony with what I should have liked to do. I hope that in the long run this will make me do better things, but we have not got to that yet.

I think that you would do well to wash the canvases which are quite, quite dry with water *and a little spirits of wine* to take away the oil and the spirit in the impasto. The same for " The Night Café " and " The Green Vineyard " and especially the landscape that was in the walnut frame. " Night " also, but that has been retouched recently and might run with the spirits of wine.

It's almost a whole month since I came here, not once has the least desire to be elsewhere come to me, only the wish to work is getting a scrap stronger.

I do not notice in the others either any very definite desire to be anywhere else, and this may well come from the feeling that we are too thoroughly shattered for life outside.

What I cannot quite understand is their absolute idleness. But that is the great fault of the South and its ruin. But what a lovely country, and what lovely blue and what a sun! And yet I have only seen the garden and what I can look at through my window.

Have you read the new book by Guy de Maupassant, " Strong as the Dead," what is the subject of it? The last thing I read in that category was Zola's " The Dream "; I thought the figure of the woman, the one who did embroidery, very very beautiful, and the description of the embroidery all in gold, just because it is as it were a question of the colour of the different yellows, whole and broken up. But the figure of the man did not seem very lifelike and the great cathedral

also gave me the blues. Only that contrast of lilac and blue-black did, if you like, make the blonde figure stand out. But after all there are things like that in Lamartine.

I hope that you will destroy a lot of the things that are too bad in the batch I have sent you, or at least only show what is most passable. As for the exhibition of the Indépendants, it's all one to me, just act as if I weren't there. So as not to be indifferent, and not to exhibit anything too mad, perhaps the " Starry Night " and the landscape with yellow verdure, which was in the walnut frame. Since these are two with contrasting colours, it might give somebody else the idea of doing those night effects better than I have.

But you must absolutely set your mind at rest about me now. When I have received the new canvas and the paints, I am going off to see a little of the country.

Since it is just the season when there are plenty of flowers and consequently colour effects, it would perhaps be wise to send me five metres more of canvas.

For the flowers are short lived and will be replaced by the yellow cornfields. Those especially I hope to catch better than I did at Arles. The mistral (since there are some mountains) seems much less tiresome than at Arles, where you always got it at first hand.

When you receive the canvases that I have done in the garden, you will see that I am not too melancholy here.

Goodbye for the present, a good handshake in thought to you and Jo.

Yours,
Vincent

My dear Theo, [Saint-Rémy, early September 1889]
I so like your letter, what you say of Rousseau and artists such as Bodmer, that they are in any case men, and such men that you would like to see the world peopled with the like of them—yes, certainly that is what I feel too.

And that J. H. Weissenbruch knows and does the muddy towpaths, the stunted willows, the foreshortening, the strange

and subtle perspective of the canals as Daumier does lawyers, I think that is perfect.

Tersteeg has done well to buy some of his work; why people like that do not sell is, I think, because there are too many dealers trying to sell different stuff, with which they deceive the public and lead it astray.

Do you know that even now, if by chance I read an account of some energetic manufacturer or even more of a publisher, then I feel the same indignation, the same wrath as I used to feel when I was with Goupil and Co.

Life passes like this, time does not return, but I am dead set on my work, just for the very reason that I know the opportunities of working do not return.

Especially in my case, in which a more violent attack may destroy for ever my ability to paint.

During the attacks I feel a coward before the pain and suffering—more of a coward than I ought, and it is perhaps this very moral cowardice which, while formerly I had no desire to get better, makes me now eat like two, work hard, limit myself in my relations with the other patients for fear of a relapse—altogether I am now trying to recover like a man who has meant to commit suicide and, finding the water too cold, tries to regain the bank.

My dear brother, you know that I came to the South and threw myself into my work for a thousand reasons. Wishing to see a different light, thinking that to look at nature under a brighter sky might give us a better idea of the Japanese way of feeling and drawing. Wishing also to see this stronger sun, because one feels that without knowing it one could not understand the pictures of Delacroix from the point of view of execution and technique, and because one feels that the colours of the prism are veiled in the mist of the North.

All this is still somewhat true. Then when to this is added the natural inclination towards this South which Daudet described in *Tartarin,* and that here and there I have found besides friends and things here which I love.

Can you understand then that while finding this malady horrible, I feel that all the same I have fashioned myself links

with the place that are perhaps too strong—links that may cause me later on to hanker to work here again—even though it may well be that in a comparatively short time I shall return to the North.

Yes, for I will not hide from you that in the same way that I take my food now with avidity, I have a terrible desire that comes over me to see my friends again and to revisit the northern countryside.

My work is going very well, I am finding things that I have sought in vain for years, and feeling that, I am always thinking of that saying of Delacroix's that you know, that he discovered painting when he no longer had either breath or teeth.

Well, with this mental disease I have, I think of the many other artists suffering mentally and I tell myself that this does not prevent one from exercising the painter's profession as if nothing was amiss.

When I realize that here the attacks tend to take an absurd religious turn, I should almost venture to think that this even *necessitates* a return to the North. Do not talk too much about this to the doctor when you see him—but I do not know if this does not come from living for so many months, both in the Arles hospital and here, in these old cloisters. In fact, I really must not live in such an atmosphere, one would be better off in the street. I am not indifferent, and even during the suffering religious thoughts sometimes bring me great consolation. Thus this last time during my illness a misfortune happened to me—that lithograph of Delacroix's, the "Pietà," together with some other sheets, fell into some oil and paint and was ruined.

I was distressed at this—so in between times I have occupied myself with painting it, and you will see it some day. I made a copy of it on a canvas of size 5 or 6, which I hope has feeling.

Besides having seen not long ago the "Daniel" and the "Odalisques" and the portrait of Brias and the "Mulatto Woman" at Montpellier, I still feel the impression which these created.

L.V.G.

That is what braces me, as with reading a fine book like Beecher Stowe's or Dickens', but what annoys me is to keep on seeing these good women who believe in the Virgin of Lourdes and make up things like that, and to think that I am a prisoner under a management of that sort, which very willingly fosters these sickly religious aberrations, when the proper thing would be to cure them. So I say again, better to go, if not into a prison, at least into the army.

I reproach myself for my cowardice, I ought rather to have defended my studio, even if it meant fighting with the police and the neighbours. Others in my place would have used a revolver, and certainly if as an artist one had killed some rotters like that, one would have been acquitted. I should have done better so, and as it is I have been cowardly and drunk.

Ill as well, yet I have not been brave. Then face to face with the suffering of these attacks I feel very frightened too, and I do not know if my zeal is anything different from what I said, it is like someone who meant to commit suicide and finding the water too cold, struggles to regain the bank.

But listen, to be confined, as I saw happen to Braat[1] in the past—fortunately that was long ago—no and again *no*. It would be different if old Pissarro or Vignon for instance would like to take me in with them. Well, I'm a painter myself, that might be arranged, and it is better that the money should go to support painters than to the excellent sisters of mercy.

Yesterday I asked M. Peyron pointblank—since you are going to Paris, what would you say if I suggested you should be kind enough to take me with you? He replied evasively—it was too sudden, he must write to you first. But he is very kind and very indulgent towards me, and while not the absolute master here—far from it—I owe many liberties to him. After all you must not only make pictures, but you must also see people, and from time to time by means of the company of others recover your balance and stock yourself with ideas. I have put aside the hope that it will not come back—on the

[1] A close friend of Theo's and an employee of the same firm.

contrary, we must expect that from time to time I shall have an attack. But even at those times it would be possible to go to a nursing home or even into the town prison, where there is generally a cell.

Do not fret in any case—my work goes well and look here, I can't tell you how it rekindles me to tell you sometimes how I am going to do this or that, cornfields, etc. I have done the portrait of the warder, and I have a duplicate of it for you. This makes a rather curious contrast with the self-portrait I have done, in which the look is vague and veiled, while he has something military in his small quick black eyes.

I have made him a present of it, and I shall do his wife too if she is willing to sit. She is a faded woman, an unhappy, resigned creature of small account, so insignificant that I have a great desire to paint that blade of dusty grass. I have talked to her sometimes when I was doing some olive trees behind their little house, and she told me then that she did not believe that I was ill—and indeed you would say as much yourself now if you saw me working, my brain so clear and my fingers so sure, that I have drawn that " Pietà " by Delacroix without taking a single measurement, and yet there are those four hands and arms in the foreground in it—gestures and torsions of the body not exactly easy or simple.

I beg you, send me the canvas soon if it is possible, and then I think that I shall need 10 more tubes of zinc white. All the same, I know well that healing comes—if one is brave —from within, through profound resignation to suffering and death, through the surrender of your own will and of your self-love. But that is no use to me, I love to paint, to see people and things and everything that makes our life— artificial—if you like. Yes, real life would be a different thing, but I do not think I belong to that category of souls who are ready to live and also ready at any moment to suffer.

What a queer thing *touch* is, the stroke of the brush.

In the open air, exposed to wind, to sun, to the curiosity of people, you work as you can, you fill your canvas anyhow. Then, however, you catch the real and the essential—that is the most difficult. But when after a time you take up this study

again and arrange your brush strokes in the direction of the objects—certainly it is more harmonious and pleasant to look at, and you add whatever you have of serenity and cheerfulness.

Ah, I shall never be able to convey my impressions of some faces that I have seen here. Certainly this is the road on which there is something new, the road to the South, but men of the North have difficulty in penetrating it. And already I can see myself in the future, when I shall have had some success, regretting my solitude and my wretchedness here, when I saw between the iron bars of the cell the reaper in the field below. Misfortune is good for something.

To succeed, to have lasting prosperity, you must have a temperament different from mine; I shall never do what I might have done and ought to have wished and pursued.

But I cannot live, since I have this dizziness so often, except in a fourth or fifth rate condition. When I realize the worth and originality and the superiority of Delacroix and Millet, for instance, then I am bold to say—yes, I am something, I can do something. But I must have a foundation in those artists, and then produce the little which I am capable of in the same direction.

So old Pissarro is cruelly smitten by these two misfortunes at once.[1]

As soon as I read that, I thought of asking him if there would be any way of going to stay with him.

If you will pay the same as here, he will find it worth his while, for I do not need much—except to work.

Ask him straight out, and if he does not wish it, I could quite well go to Vignon's. I am a little afraid of Pont-Aven, there are so many people there, but what you say about Gauguin interests me very much. And I still tell myself that Gauguin and I will perhaps work together again.

I know that Gauguin is capable of better things than he has done, but to make that man comfortable!

I am still hoping to do his portrait.

Did you see that portrait that he did of me, painting some

[1] Pissarro had lost his mother and had trouble with his eyes.

sunflowers? Subsequently my face got much brighter, but all told it was really me, very tired and charged with electricity as I was then.

And yet to see the country, you must live with the poor people and in the little homes and public houses, etc.

And that was what I said to Bock, who was complaining of seeing nothing that tempted him or impressed him. I went for walks with him for two days and I showed him thirty pictures to be done as different from the North as Morocco would be. I am curious to know what he is doing now.

And then do you know why the pictures by Eug. Delacroix —the religious and historical pictures, the " Bark of Christ," the " Pietà," the " Crusaders," have such a hold on one? Because Eug. Delacroix when he did a " Gethsemane" had first been to observe on the spot what an olive grove was, and the same for the sea whipped by a strong mistral, and because he must have said to himself—these people of whom history tells us, doges of Venice, crusaders, apostles, holy women, were of a character and lived in a manner analogous to those of their present descendants.

And I must tell you—and you can see it in the " Woman Rocking," however much of a failure and however feeble that attempt may be—had I had the strength to continue, I should have made portraits of saints and holy women from life who would have seemed to belong to another age, and they would have been middle-class women of the present day and yet they would have had something in common with the first early Christians.

However, the emotions which that rouses are too strong, I shall stop at that, but later on, later on I do not say that I shall not return to the task.

What a great man Fromentin[1] was—for those who want to see the East—he will always remain the *guide*. He was the first to establish a link between Rembrandt and the Midi, between Potter and what he saw himself.

You are right a thousand times over—I must not think of

[1] Author of *The Masters of Past Time,* a collection of artistic essays which Vincent had read in 1884.

all that—I must create—were it only studies of cabbages and salad, to get calm, and once calm, then—whatever I might be capable of. When I see them again, I shall make duplicates of that study of the "Tarascon Diligence," of the "Vineyard," the "Harvest," and especially of the "Red Cabaret," that night café which is the most characteristic of all in its colour. But the white figure right in the middle must be done over as to colour, and better constructed. But that—I venture to say—is the real Midi, and a deliberated combination of greens with reds.

My strength has been exhausted too quickly, but I see in the distance the possibility for others of doing an infinite number of fine things. And again and again this idea remains true, that to make travel easier for others it would have been well to found a studio somewhere in this neighbourhood. To make the journey in one stage from the north to Spain, for instance, is not good, you will not see what you should see there—you must *get your eyes accustomed* first and gradually to the different light.

I have not much need to see Titian and Velasquez in the galleries, I have seen living types that have informed me better what a Midi picture is now, than before my little journey.

Good Lord, Good Lord, the good people among the artists who say that Delacroix is not of the real East. Look here, is the real East the kind of thing that Parisians like Gérôme have done?

Because you paint a bit of a sunny wall from nature and well and truly according to our way of seeing *in the North,* does that prove equally that you have seen the people of the East? Now that is what Delacroix was seeking, but it in no way hindered him from painting walls in the "Jewish Wedding" and the "Odalisques." Isn't that true?—and then Degas says that it is paying too dear for it, to drink in the cabarets while you are painting pictures, I don't deny it, but would he then like me to go into cloisters or churches, it is there that I am afraid. That is why I make an attempt to

escape in writing this letter; with many handshakes to you
and Jo.

Yours,

Vincent

I still have to congratulate you on the occasion of Mother's
birthday. I wrote to them yesterday, but the letter has not yet
gone because I have not had the presence of mind to finish it.
It is queer that already, two or three times before, I had had
the idea of going to Pissarro's; this time, after your telling me
of his recent misfortunes, I do not hesitate to ask you this.

Yes, we must finish with this place, I cannot do the two
things at once, work and take no end of pains to live with
these queer patients here—it is upsetting.

In vain I tried to force myself to go downstairs. And yet it
is nearly two months since I have been out in the open air.

In the long run I shall lose the faculty for work here, and
that is where I begin to call a halt, and I shall send them
then—if you agree—about their business.

And then to go on paying for it, no, then one or other of
the artists who is hard up will agree to keep house with me.
It is fortunate that you can write saying you are well, and
Jo too, and that her sister is with you.

I very much wish that, when your child comes,[1] I might
be back—not with you, certainly *not,* that is impossible, but in
the neighbourhood of Paris with another painter. I could
mention a third alternative, my going to the Jouves, who
have a lot of children and quite a household.

You understand that I have tried to compare the second
attack with the first, and I only tell you this, it seemed to me
to stem from some influence or other from outside, rather
than from within myself. I may be mistaken, but however it
may be, I think you will feel it quite right that I have rather
a horror of all religious exaggeration. The good M. Peyron
will tell you heaps of things, probabilities and possibilities,
and involuntary acts. Very good, but if he is more precise than
that I shall believe none of it. And we shall see then *what*

[1] Jo had announced her pregnancy.

he will be precise about, if he is precise. The treatment of patients in this hospital is certainly easy, one could follow it even while travelling, for they do absolutely *nothing*; they leave them to vegetate in idleness and feed them with stale and slightly spoiled food. And I will tell you now that from the first day I refused to take this food, and until my attack I ate only bread and a little soup, and as long as I remain here I shall continue this way. It is true that after this attack M. Peyron gave me some wine and meat, which I accepted willingly the first days, but I wouldn't want to be an exception to the rule for long, and it is right to respect the regular rules of the establishment. I must also say that M. Peyron does not give me much hope for the future, and this I think right, he makes me realize properly that *everything* is doubtful, that one can be sure of nothing beforehand. I myself expect it to return, but it is just that work takes up my mind so thoroughly, that I think that with the physique I have, things may continue for a long time in this way.

The idleness in which these poor unfortunates vegetate is a pest, but there, it is a general evil in the towns and countryside under this stronger sunshine, and having learnt a different way of life, certainly it is my duty to resist it. I finish this letter by thanking you again for yours and begging you to write to me again soon, and with many handshakes in thought.

My dear Theo, [Saint-Rémy, mid November 1889]
I have to thank you very much for a parcel of paints, which was accompanied also by an excellent woollen jacket.

How kind you are to me, and how I wish I could do something good, so as to prove to you that I would like to be less ungrateful. The paints reached me at the right moment, because those I had brought back from Arles were almost exhausted. The thing is that I have worked this month in the olive groves, because they[1] have maddened me with their Christs in the Garden, with nothing really observed. Of course with me there is no question of doing anything from

[1] Bernard and Gauguin, who had sent records of their recent work.

the Bible—and I have written to Bernard and Gauguin too that I considered that to think, not to dream, was our duty, so that I was astonished looking at their work that they had let themselves go so far. For Bernard has sent me photos of his canvases. The trouble about them is that they are a sort of dream or nightmare—that they are erudite enough—you can see that it is someone who is mad on the primitives—but frankly the English Pre-Raphaelites did the thing much better, and then Puvis and Delacroix, much more healthily than the Pre-Raphaelites.

It is not that it leaves me cold, but it gives me a painful feeling of collapse instead of progress. Well, to shake that off, morning and evening these bright cold days, but with a very fine and clear sun, I have been knocking about in the orchards and the result has been 5 canvases of size 30, which, with the 3 studies of olives that you have, make up at least an attack on the problem. The olive is as mutable as our willow or pollarded osier in the north, you know the willows are very striking, in spite of them seeming monotonous, it is the tree in character with the country. Now what the willow is at home, that is just what the olive and the cypress signify here. What I have done is a rather hard and coarse realism beside their abstractions, but it will give the feeling of the country and will smell of the soil. How I would like to see Gauguin's and Bernard's studies from nature, the latter talks to me of portraits—which doubtless would please me better.

I hope to get myself used to working in the cold—in the morning there are very interesting effects of white frost and fog; then I still have a great desire to do for the mountains and the cypresses what I have just done for the olives, and have a good go at them.

The thing is that these have rarely been painted, the olive and the cypress, and from the point of view of marketing the pictures, they *ought* to go in England, I know well enough what they look for there. However that may be, I am almost sure of this, that in this way I'll do something tolerable from time to time. It is really my opinion more and more, as I said

to Isaäcson, that if you work diligently from nature without saying to yourself beforehand—"I want to do this or that," if you work as if you were making a pair of shoes, without artistic preoccupations, you will not always do well, but the days you least anticipate it you find a subject which holds its own with the work of those who have gone before us. You learn to know a country which is fundamentally quite different from its appearance at first sight.

Contrariwise you say to yourself—"I want to finish my pictures more, I want to do them with care," lots of ideas like that, confronted by the difficulties of weather and of changing effects, are reduced to being impracticable, and I end by resigning myself and saying that it is the experience and the meagre work *of every day* which alone ripens in the long run and allows one to do things that are more complete and more true. Thus slow long work is the only way, and all ambition and resolve to make a good thing of it, false. For you must spoil quite as many canvases when you return to the onslaught every morning, as you succeed with. To paint, a regular tranquil existence would hence be absolutely necessary, and at the present time what can you do, when you see that Bernard for instance is hurried, hurried, endlessly hurried by his parents? He cannot do as he wishes, and many others are in his predicament.

You can say to yourself, I will not paint any more, but then what is one to do? Oh, we must invent a more expeditious method of painting, less costly than oil and yet lasting. A picture . . . will end by becoming as commonplace as a sermon, and a painter will become like a creature left over from last century. All the same, it is a pity it should be so. Now if the painters had understood Millet better as a man, as some like Lhermitte and Roll have grasped him, things would not be like this. We *must* work as much and with as few pretensions as a peasant, if we want to last.

And it would have been better than having grandiose exhibitions to address oneself to the people and work so that each one could have in his home some pictures or some reproductions which would be lessons, like the work of Millet.

I am quite at the end of my canvas and as soon as you can I beg you to send me 10 metres. Then I shall attack the cypresses and the mountains. I think that this will be the core of the work that I have done here and there in Provence, and then we can conclude my stay here when it is convenient. It is not urgent, for Paris after all only distracts. Yet I don't know—not being always a pessimist—I keep thinking that I have it still in my heart to paint some day a bookshop with its frontage yellow and rose, at evening, and black passers-by —it is such an essentially modern subject. Because it seems, imaginatively speaking, such a wellspring of light—I say, there would be a subject that would go well between an olive grove and a cornfield, the seed time of books and prints. I have a great longing to do it, like a light in the midst of darkness. Yes, there is a way of seeing Paris as beautiful. But after all bookshops do not run away like hares, and there is no hurry, and I am quite willing to work here for another year, which would probably be wiser.

Mother must have been a fortnight in Leyden. I have delayed sending you canvases for her, because I will include them with the canvas of the " Cornfield " for the Vingtistes.[1]

Warm regards to Jo, she is doing admirably in going on being well. Thank you again for the paints, and the woollen jacket, and a good handshake in thought.

<div style="text-align: right">Yours,
Vincent</div>

[Saint-Rémy, beginning of February 1890]

My dear Theo,

I have just to-day received the good news that you are at last a father, that the most critical time is over for Jo, and lastly that the little boy is well. That does me more good and gives me more pleasure than I can put into words. Bravo —and how pleased Mother is going to be. The day before yesterday I received a fairly long and very contented letter

[1] A group of Vincent's works was going to the exhibition of this society in Brussels.

from her too. Anyhow, here it is, the thing I have for so long so much desired for you. No need to tell you that I have often thought of you these days and it touched me very much that Jo had the kindness to write to me the very night before. She was so brave and calm in her danger, it touched me profoundly. Well, it contributes much to helping me forget those last days when I was ill, I don't know in those instances where I am and my mind wanders.

I was extremely surprised at the article on my pictures which you sent me.[1] I needn't tell you that I hope to go on thinking that I do not paint like that, but I do instead see in it how I ought to paint. For the article is very right inasmuch as it indicates the gap to be filled, and I think that really the writer wrote it more to guide not only me, but the other impressionists as well, and even partly to make the breach at a good place. So he proposed an ideal collective personality to the others quite as much as to me; he simply tells me that here and there there is something good, if you like, even in my work which is at the same time so imperfect, and that is the consoling side, which I appreciate and for which I hope to be grateful. Only it must be understood that my back is not broad enough to bear such an undertaking, and in the concentration of the article on me, there's no need to tell you how steeped in flattery I feel; and in my opinion it is as exaggerated as what a certain article by Isaäcson said about you, that at present the artists had given up squabbling and that an important movement was silently getting under way in the little shop on the Boulevard Montmartre. I admit that it is difficult to speak out, to express one's ideas differently—in the same way as you cannot paint things as you see them—and so I do not mean to criticize the daring of Isaäcson or that of the other critic, but as far as we are concerned, really, we are *posing* a bit for *the model,* and indeed that is a duty and a part of one's job like any other. So if some sort

[1] Article by Albert Aurier in the *Mercure de France* of January 1890, entitled *Les Isolés.* Vincent's art was treated there in terms of its symbolist content.

of reputation comes to you and to me, the thing is to try to keep some sort of calm and, if possible, presence of mind.

Why not say what he said of my sunflowers, *with far more grounds,* of those magnificent and finished hollyhocks of Quost's, and his yellow irises, or those splendid peonies of Jeannin's? And you will foresee as I do that praise like this *must* have its opposite, the reverse of the medal. But I am glad and grateful for the article, or rather *" le cœur à l'aise "*[1] as the song in the *Revue* has it, since one may need it, as one may really need a medal. Besides, an article like that has its own merit as a critical work of art, in which light I think it is to be respected, and the writer *must* heighten the tones, syncopate his conclusions, etc. But from the beginning you must beware of bringing up your young family *too much* in an artistic ambience. Old Goupil managed his household pretty well in the Parisian briar-patch and I expect you will many a time afresh be thinking of him. Things have changed so, his cold aloofness would be shocking to-day, but his power to resist so many storms, that really was something.

Gauguin proposed, very vaguely it is true, to found a studio in his name, he, de Haan and I, but he said that first he is going through to the bitter end with his Tonkin project, and seems to have cooled off greatly, I do not exactly know why, in order to continue to paint. And he is just the sort to be off to Tonkin, he has a sort of need for expansion and he finds —and there's some justification for it—the artistic life ignoble. With his repeated experience of travel, what can one say to him?

But I hope he will feel that you and I are indeed his friends, without counting on us too much, which indeed he in no way does. He writes with much reserve, more gravely than last year. I have just written a line to Russell once more, to remind him a little of Gauguin, for I know that Russell as a man has much gravity and strength. Gauguin and Russell are countrymen at heart; not uncouth, but with a certain innate sweetness of far-off fields, more so probably than you or I, that is how they look to me.

[1] " my heart is at ease "

It is necessary—I admit—sometimes to believe in it a little in order to see it. If for my part I wanted to go on—let us call it *translating* certain sheets by Millet,[1] then to prevent anyone being able, not to criticize me, that wouldn't matter, but to make it awkward for me or hinder me by pretending that it is producing copies—then I need someone among the artists like Russell or Gauguin to carry this thing through, and to make a serious thing of it.

I have scruples of conscience about doing the things by Millet which you sent me, for instance, and which seemed to me perfectly chosen, and I took the pile of photographs and sent them without hesitation to Russell, so that I should not see them again until I have thought it over. I do not want to do it until I have heard a little of your own opinion, and a few other people's too, on the ones that will soon be reaching you.

Without that I should have scruples of conscience, a fear lest it should be plagiarizing. And not now, but in a few months' time, I shall try to get a candid opinion from Russell himself on the usefulness of the thing. In any case Russell gets roused, he grows angry, he says something true, and that is what I need sometimes. You know I find the " Virgin " so dazzling that *I have not dared* to look at her. All at once I felt a " not yet." My illness makes me very sensitive now, and I do not feel myself capable for the moment of continuing these " translations," when it concerns such masterpieces. I am calling a halt over the " Sower " which is in hand, and is not coming along as I should wish. While ill, I have thought a lot all the same about continuing this work, and how *when* I do it, I do it calmly, you will soon see when I send the five or six finished canvases.

I hope that M. Lauzet[2] will come, I have a strong desire to make his acquaintance. I have confidence in his opinion when he says it is Provence, there he touches on the difficulty, and like the other one he indicates a thing to be done rather than

[1] Vincent had been doing variations on some of his favourite Millet compositions.

[2] A publisher of prints.

a thing already done. Landscapes with cypresses! Ah, it
would not be easy. Aurier speaks of it too, when he says that
even black is a colour, and their flame-like appearance—I
think about it, but haven't the daring either, and I say with the
cautious Isaäcson—I do not yet feel that we can get to that.
You need a certain dash of inspiration, a ray from on high,
things not in ourselves, in order to do beautiful things. When
I had done those sunflowers, I looked for the opposite and yet
the equivalent, and I said—it is the cypress.

I will say no more—I am a little worried about a friend who
is still apparently ill, and whom I should like to go round to;
it is the one whose portrait I did in yellow and black, and
she had so altered. It is nervous attacks and the complications
of a premature change of life, altogether very painful. Last
time she was like an old grandfather. I promised to return
within a fortnight and was taken ill again myself. Anyway
the good news you have sent me and this article and heaps
of things have made me feel quite well in myself to-day. I
am sorry too that M. Salles did not find you. I thank Wil[1]
once more for her kind letter. I should have liked to answer
today, but I am putting it off until several days from now;
tell her that Mother has written me another long letter from
Amsterdam. How happy she too will be.

Meantime I remain with you in thought, though I am
finishing my letter. May Jo long remain for us what she is.
Now as for the little boy, why don't you call him Theo in
memory of our father, to me certainly it would give so much
pleasure.[2]

A handshake.

Yours,

Vincent

If you see him, start by thanking M. Aurier very much for
his article; I will send you a line for him of course and a
study.

[1] Their sister.
[2] In fact the boy was to be christened Vincent.

AUVERS-SUR-OISE

[Auvers-sur-Oise, late May 1890]
My dear Theo, my dear Jo,

Thank you for your letter which I received this morning, and for the fifty francs which were in it.

To-day I saw Dr. Gachet[1] again and I am going to paint at his house on Tuesday morning, then I shall dine with him and afterwards he will come to look at my painting. He seems very sensible, but he is as discouraged about his job as a country doctor as I am about my painting. Then I said to him that I would gladly exchange job for job. Anyway I am ready to believe that I shall end up being friends with him. He said to me besides, that if the depression or anything else became too great for me to bear, he could quite well do something to diminish its intensity, and that I must not find it awkward to be frank with him. Well, the moment when I shall need him may certainly come, however up to now all is well. And things may yet get better, I still think that it is mostly a malady of the South that I have caught, and that the return here will be enough to dissipate the whole thing. Often, very often, I think of your little one and then I start wishing he was big enough to come to the country. For it is the best system to bring them up there. How I do wish that you, Jo and the little one would take a rest in the country instead of the customary journey to Holland.

Yes, I know quite well that Mother will insist on seeing the little one, and that is certainly a reason for going, but she would surely understand if it was really better for the little one.

Here one is far enough from Paris for it to be real country, but nevertheless how changed since Daubigny. Yet not changed in an unpleasant way, there are many villas and

[1] The specialist to whose care Vincent had been committed; he was an art collector and had known Cézanne personally.

various modern bourgeois dwelling houses, very radiant and sunny and covered with flowers.

This in an almost lush country, just at the moment when a new society is developing in the old, is not at all unpleasing; there is much well-being in the air. I see or think I see in it a quiet like that of Puvis de Chavannes, no factories, but lovely greenery in abundance and well kept.

Please tell me sometime, which is the picture that Mlle. Bock has bought? I must write to her brother to thank them and then I shall suggest exchanging two of my studies for one of each of theirs. I have a drawing of an old vine, from which I intend to make a canvas of size 30, and a study of pink chestnuts and one of white chestnuts. But if circumstances allow it, I hope to work a little at the figure. Some pictures present themselves vaguely to my mind, which it will take time to get clear, but that will come bit by bit. If I had not been ill, I should have written to Bock and Isaäcson long ago.

My trunk has not yet arrived, which annoys me. I sent a wire this morning.

I thank you in advance for the canvas and paper. Yesterday and to-day it has been wet and stormy, but it is not unpleasant to see these effects again. The beds have not arrived either. But in spite of these annoyances, I feel happy at not being far from you two and my friends any longer. I hope you are well. It seemed to me however that you had less appetite than formerly,[1] and according to what the doctors say, constitutions like ours need very solid nourishment. So be sensible about this, especially Jo too, having her child to nurse. Really she ought to eat at least double, it would not at all be overdoing it when there are children to bring into the world and rear. Without that it is like a train going slowly where the line is straight. Time enough to reduce steam when the line is more uneven.

A handshake in thought from

Yours,
Vincent

[1] He had spent three days in Paris on his way through to Auvers.

[Auvers, early July 1890]

Dear brother and sister,

Jo's letter was really like a gospel to me, a deliverance from the agony which had been caused by the hours I had shared with you which were a bit difficult and trying for us all.[1] It was no slight thing when all of us alike felt our daily bread to be in danger, no slight thing when for other reasons than that we felt that our manner of existence was frail.

Back here, I too still felt very sad and continued to feel the storm which threatens you weighing on me as well. What is to be done—look here, I generally try to be fairly cheerful, but my life too is threatened at the very root, and my steps too are unsteady.

I feared—not altogether, but nevertheless a little—that being a burden on you, you found me forbidding, but Jo's letter proves to me clearly that you understand that for my part I am in toil and trouble as much as you are.

There—once back here I set to work again—though the brush almost slipped from my fingers, and knowing exactly what I wanted, I have since painted three big canvases already.

They are vast stretches of corn under troubled skies, and I did not need to go out of my way to try to express sadness and the extreme of loneliness. I hope you will see them soon—for I hope to bring them to you in Paris as soon as possible, since I almost think that these canvases will tell you what I cannot say in words, the health and fortifying power that I see in the country. Now the third canvas is Daubigny's garden, a picture I have been contemplating since I came here.

I hope with all my heart that the intended journey will give you a little distraction.

I often think of the little one. I think it is certainly better to bring up children than to give all your nervous energy to making pictures, but there is nothing for it, I am—at least I feel—too old to go back on my steps or to desire anything different. That desire has left me, though the mental suffering from it remains.

[1] Earlier in the month Vincent had gone on his last visit to Paris.

I am very sorry not to have seen Guillaumin again, but I am pleased that he has seen my canvases.

If I had waited, I should probably have stayed talking with him long enough to miss my train.

Wishing you luck and courage and comparative prosperity, I beg you tell Mother and our sister that I think of them very often, also I have a letter from them this morning and will reply soon.

Handshakes in thought,

Yours,

Vincent

My money will not last me very long this time, as on my return I had to pay the freight of the luggage from Arles. I retain very pleasant memories of that journey to Paris, for several months I had hardly dared to hope to see my friends again. I think that Dutch lady[1] has a lot of talent. Lautrec's picture, the portrait of a musician, is amazing, I was very moved by it.

My dear brother, [Auvers, late July 1890][2]

Thanks for your kind letter and for the 50 fr. note it contained. . . . Since the thing that matters most is going well, why should I say more about things of less importance; my word, *before we have a chance of talking business more collectedly, there is likely to be a long way to go.* . . .

The other painters, whatever they think of it, instinctively keep themselves at a distance from discussions about actual trade.

Well, the truth is, we can only make our pictures speak. But still, my dear brother, there is this that I have always told you, and I repeat it once more with all the earnestness that can be imparted by an effort of a mind diligently fixed on trying to do as well as one can—I tell you again that I shall

[1] The sculptress S. de Swart.
[2] This letter, evidently his penultimate one to Theo, was found on Vincent's body after his suicide on the 27th. Several sentences dealing with the state of Theo's business are omitted.

always consider that you are something other than a simple dealer in Corot, that through my mediation you have your part in the actual production of some canvases, which even in the cataclysm retain their quietude.

For this is what we have got to, and this is all or at least the chief thing that I can have to tell you at a moment of comparative crisis. At a moment when things are very strained between dealers in pictures by dead artists, and living artists.

Well, my own work, I am risking my life for it and my reason has half-foundered owing to it—that's all right—but you are not among the dealers in men so far as I know, and you can choose your side, I think, acting with true humanity, but what's the use?

SUMMARY CHRONOLOGY
OF THE LIFE OF
VINCENT VAN GOGH

Early Years

1853 March 30th, birth of Vincent in the parsonage at Groot Zundert in North Brabant, as the eldest child of Theodorus van Gogh, pastor of the parish.

1857 May 1st, birth of his brother Theo.

1869 July 30th, enters the firm of Goupil and Co., art dealers in The Hague.

1872 August, beginning of the extant correspondence with Theo.

1873 May, is transferred by the firm to London; meanwhile in January Theo had entered the Brussels branch. During the summer he is rejected by Ursula Loyer, the daughter of his London landlady.

1874 Temporarily transferred to the Paris branch of the firm in October, then back to London in December.

1875 May, is sent once more to the Paris branch. Clashes with his employers. The period of his religious mysticism.

1876 January, given three months' notice by the firm. April, goes to England in a schoolmastering post, teaching at Ramsgate and then at Isleworth. Returns to Etten in North Brabant to see his family (who have now moved there) over Christmas—and remains in Holland.

1877 Takes a position in a bookshop in Dordrecht. May 9th, moves to Amsterdam to study for the University entrance examination and so gain entry to the Theological Seminary.

1878 July, gives up his studies after fifteen months—to enter an Evangelical school in Brussels; leaves after three months only. December, undertakes to go as a preacher among the miners of the Borinage, in South Belgium, at his own expense; stays at Pâturages, preaching and working among the sick.

1879 January, obtains a temporary nomination for six

months as a lay preacher at Wasmes, in the Borinage.
July, dismissed for excessive zeal. Works at his own
expense at Cuesmes nearby.

1880 July/August, finds his vocation as an artist and begins
to draw miners. October, goes to Brussels and takes
lessons in anatomy and perspective. The payments for
his support from Theo begin at this time.

Holland, 1881-1885

1881 April 12th, returns to Etten and lives with his parents.
Suffers the disappointment of rejection by his cousin,
Kee Vos. October, beginning of his correspondence
with the artist Anthon van Rappard. December,
settles in The Hague, and takes lessons with the
successful painter of The Hague school, Anton Mauve.

1882 January, takes in the prostitute Clasina Maria Hoornik
(Sien) and lives with her. Falls out with Mauve after
only a few weeks of working with him. Starts to build
a large collection of lithographs and woodcuts from
English magazines. Sells twelve *Views of The Hague*
commissioned by his uncle C. M. van Gogh.

1883 September, Theo comes and exerts pressure to induce
him to part from Sien. Moves to Drenthe, a province
in the north-east of Holland, and roams the moorland
regions there for two and a half months. December,
goes to stay with his family at Nuenen, a village in
Brabant near Eindhoven (his father now being
appointed there).

1884 At Nuenen. The period of the relationship with his
neighbour Margot Begemann; family objections and
the woman's attempt at suicide bring the affair to a
tragic end. Does still-lifes, treatments of weavers and
peasants, studies of heads. Theo finally accepts, after
some hesitation, a proposal originally made by Vincent
in March: namely that Theo should consider all works
sent to him thereafter as his property, so that his
monthly dispatches of 150 francs would become a pur-
chase price rather than a gift or loan.

1885 At Nuenen. March 27th, death of his father. April/ May, paints the *Potato-Eaters*. November, moves to Antwerp.

1886 January, enters the Academy at Antwerp. February, leaves for Paris.

Paris, February 1886—February 1888

1886 Welcomed by Theo and lives with him in the Rue de Laval. Joins the Atelier Cormon. June, moves with Theo to Montmartre, 54 Rue Lepic. There follows the period of his friendly relations with the many Parisian artists, and of his prolonged exposure to Japanese art.

1887 Exhibits his work informally in various places, without success. June, works at Asnières, a suburb of Paris, with Emile Bernard.

Arles, February 1888—May 1889

1888 February 20th, leaves for Arles in Provence. Takes a room there over the Restaurant Carrel. March, begins a regular correspondence with Bernard. May, rents a four-room house, 2 Place Lamartine. June, spends a week working at Saintes-Maries-sur-Mer. September, moves into the "Yellow House." October 23rd, arrival of Gauguin from Brittany. December, Theo gives advance news of his engagement to Johanna Bonger. December 23rd, first mental crisis; Gauguin leaves for Paris on the 27th, Vincent spends two weeks in hospital.

1889 January 7th, returns to the house and begins to paint again soon after. February 4th, suffers his second crisis; this lasts about two weeks, and is followed by a third attack towards the end of the month. Under pressure from the people of Arles, who had petitioned that he should remain in confinement, he stays on at the hospital into April. April 17th, Theo gets married. Vincent agrees to move to the nearby asylum of Saint-Paul-de-Mausole at Saint-Rémy.

Saint-Rémy, May 1889—May 1890

1889 May 8th, admitted to the asylum. There he has long periods of lucidity, interspersed by two violent attacks; one of these lasts from early July to around mid August, the other from about Christmas to about New Year's Day.

1890 January, an article by Albert Aurier commending Vincent's work appears in the periodical *Mercure de France*; late in the month occurs the sixth crisis (about a week in duration). January 31st, birth of a son to Theo (christened Vincent Willem). Mid February, his seventh crisis, which lasts until mid April. March, sells his *Red Vineyard* in Brussels for 400 francs. May 16th, leaves for Paris, in order to retire to Auvers. May 17th, visits Theo for three days in Paris.

Auvers-sur-Oise, May-July 1890

1890 May 21st, arrives at Auvers. Dr. Gachet takes care of him there. July 1st, visits Theo in Paris. July 27th, shoots himself, and dies on the 29th. July 30th, buried in the small cemetery at Auvers; Theo himself is to die on January 25th, 1891.

INDEX

MARK ROSKILL was the holder of scholarships to Eton and to Trinity College, Cambridge, where he graduated in Classics with first class honours. He then turned to the study of art history and has had teaching posts in the United States: at Princeton and now at the Fogg Art Museum, Harvard. He is the author of a book on English Painting and *Van Gogh, Gauguin and the Impressionist Circle* (1970).